C000172525

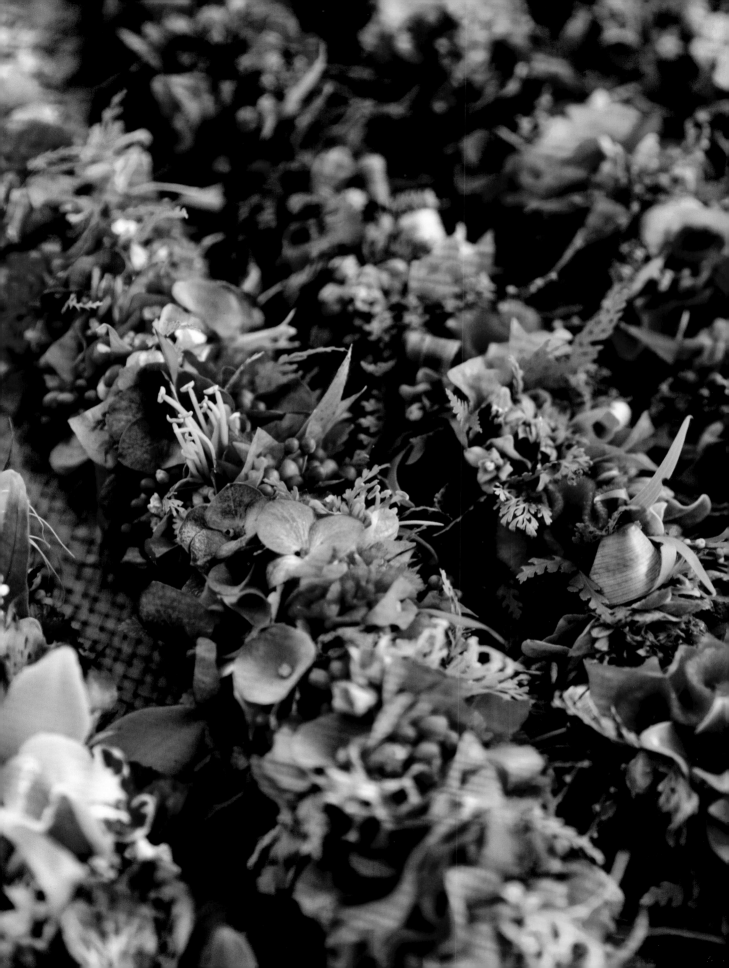

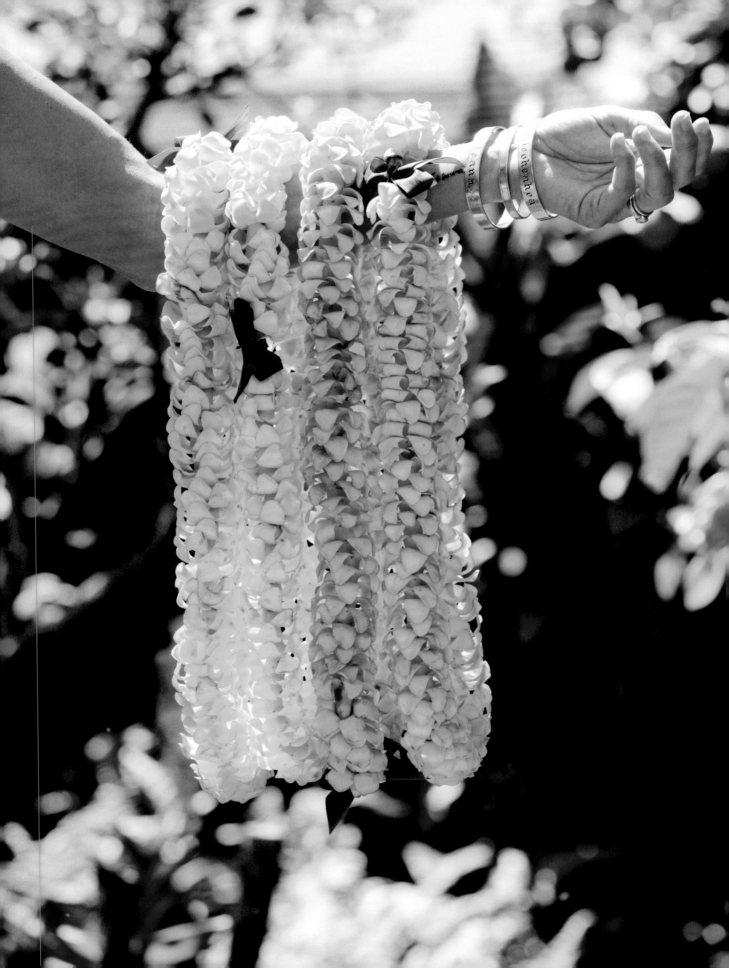

Lei
ALOHA

Celebrating the Vibrant
Flowers and Lei of Hawaiʻi

Meleana Estes
with Jennifer Fiedler

Photographs by Tara Rock

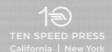

TEN SPEED PRESS
California | New York

With love for my ʻohana in remembrance of my tūtū, who inspired our love of lei

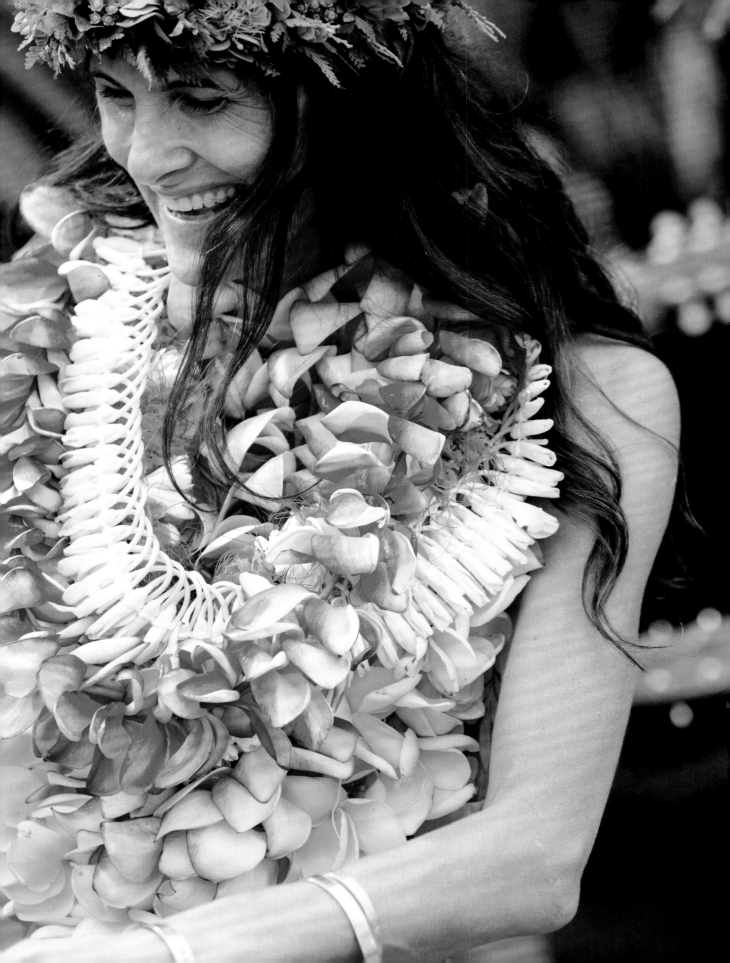

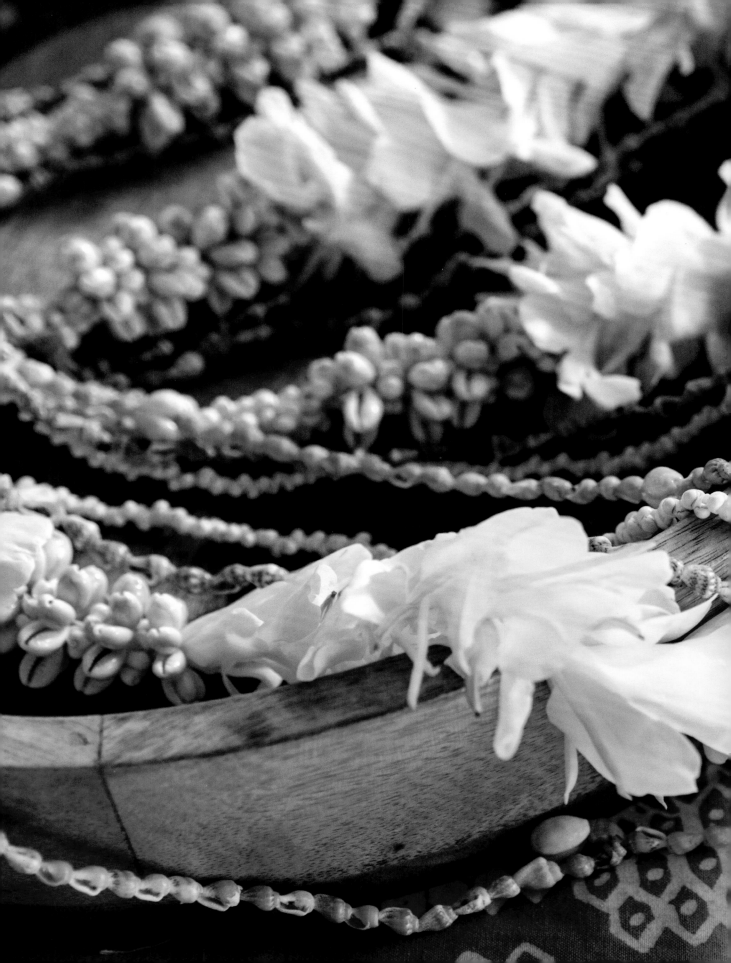

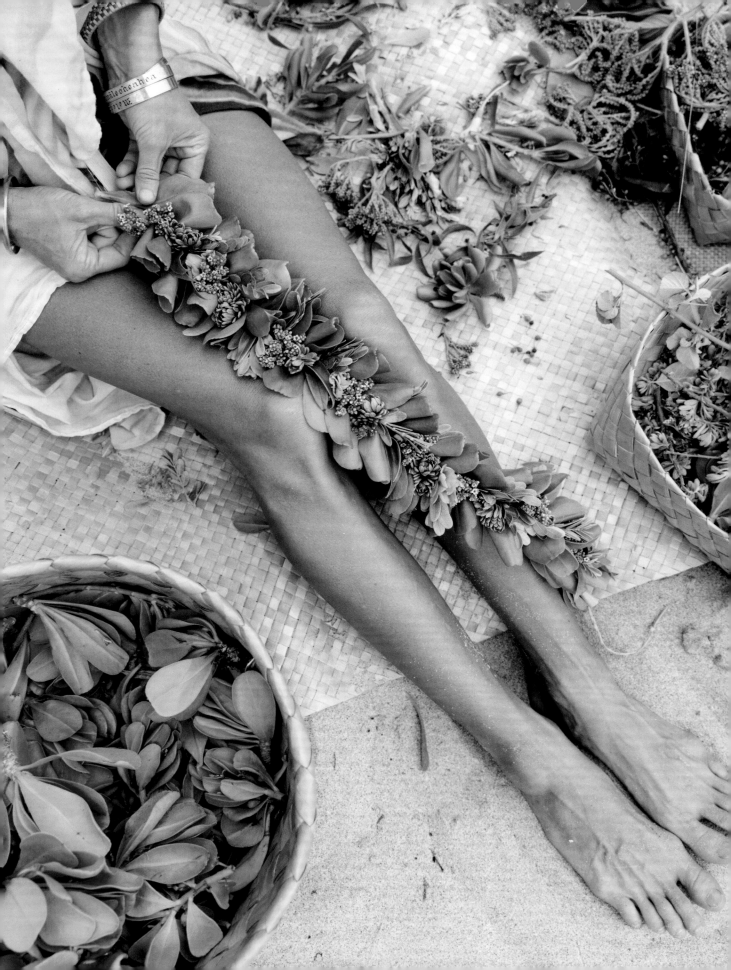

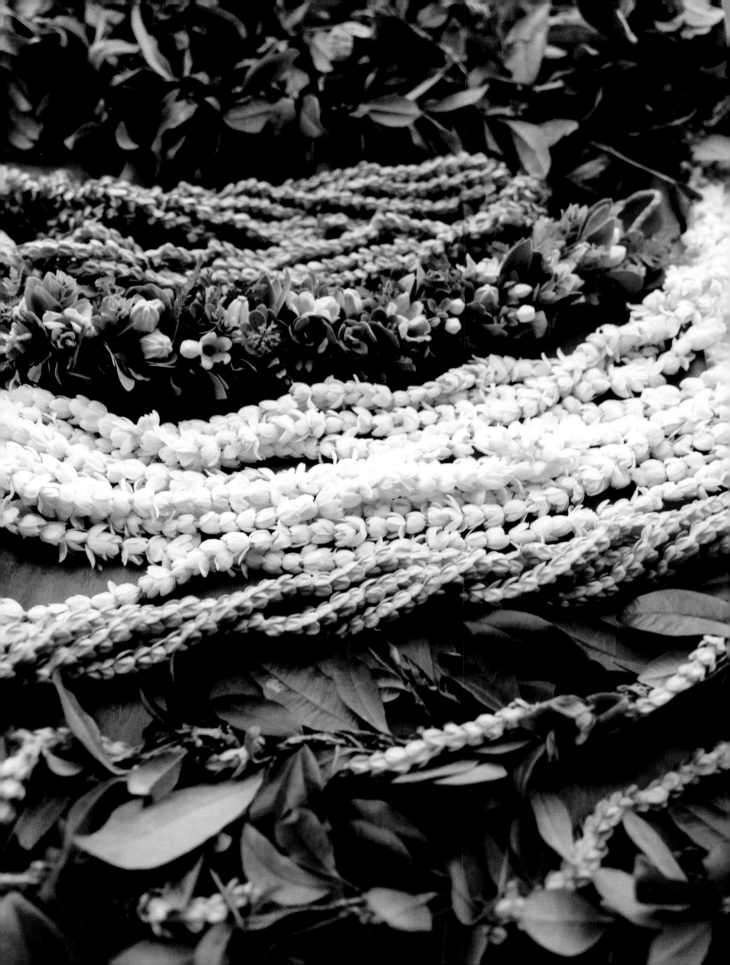

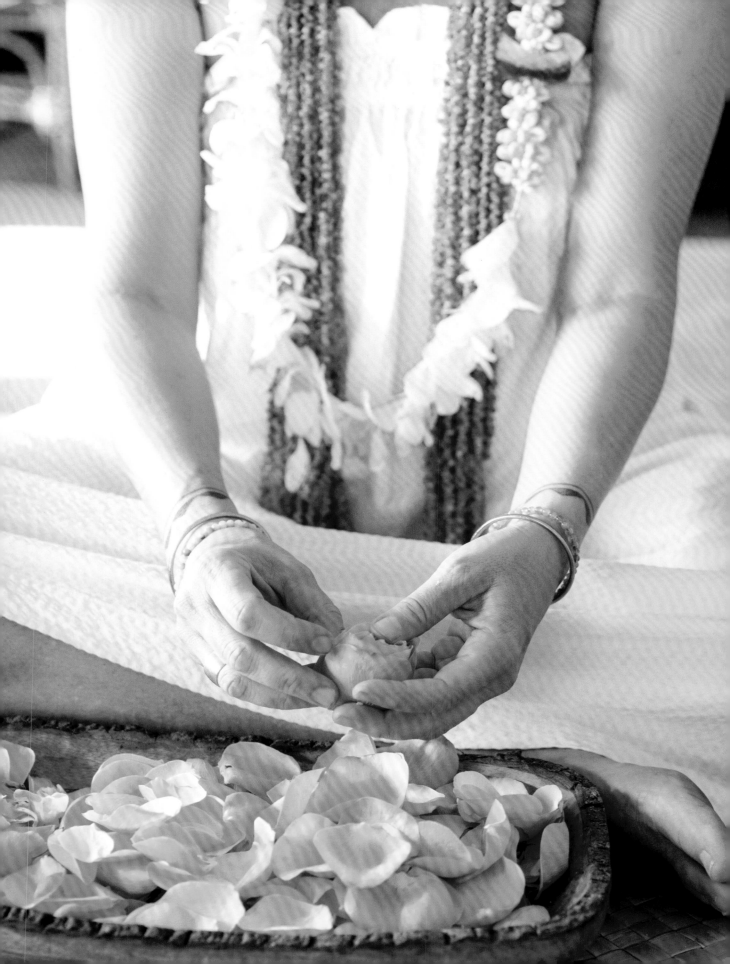

Contents

Haku Aloha
Weaving Aloha

So many of my favorite memories of growing up in Hawaiʻi revolve around lei. Delicate, white feather-style ginger at a family lūʻau. Mom's favorite fragrant lei pakalana brought home by my dad on a Friday after a long workweek. Lei palapalai (a native fern) gathered and made as we hiked along a trail in Kōkeʻe. Brown paper bags, speckled with water spots holding plumeria lei made the night before for our May Day performance. Running to the ocean's edge, laden with lei haku made of multicolored ti, to greet a canoe paddling in from the finish line at a state canoe regatta. Pua kenikeni lei hanging from Tūtū's outstretched arms ready to hug us in her big squeeze of aloha (love) and fragrance, when we drove up to her home in Mānoa after flying to Oʻahu from Kauaʻi.

My ʻohana's (family's) banana and citrus farm on the north shore of Kauaʻi was an abundant world of green. Lauaʻe and palapalai fern, kukui, ʻulu, wide swaths of white and yellow ginger, and tall coconut trees all mixed in with our carefully planted pua kenikeni and plumeria trees, essential flowering trees for our lei-making family. It was my Honolulu-based tūtū, my grandmother, Amelia Ana Kaʻōpua Bailey, who taught her entire family to truly love all things lei and to plant lei flowers everywhere we lived as ʻohana. A seamstress and costume designer by trade, Tūtū had an eye for color combinations, texture, and pattern. She made lei kui (sewn) her whole life. My mom remembers wearing lei poepoe (strung in a round style), made from white plumerias grown in the backyard, to school over her handmade muʻu (short for muʻumuʻu) on May Day. Because she learned her signature wili (wrapped) style later in life, she would begin every lei workshop she taught by saying she was "a renaissance lei maker." She meant that she got into lei making as it was re-emerging along with many other Hawaiian arts during the 1960s. She did not learn from her kūpuna (grandparents). She was proud that her moʻopuna (grandchildren) could say that we did.

Tūtū became captivated by traditional Hawaiian lei when my mom and dad chose to have a Hawaiian wedding, which was not common at the time. Dad and the groomsmen wore long-sleeve aloha shirts; Mom wore a holokū (a style of dress with a high neck, yoke, long sleeves, and modest train). She wanted a lei poʻo (head lei) and for her bridesmaids to carry lei rather than bouquets. It was hard to find anyone making lei haku (lei braided with more than one material) in Honolulu in 1968, so Tūtū and a friend from the garden club wired white kukui blossoms together and invented one. Tūtū was hooked. After the wedding, she took apart the thick green lei from the Big Island that my mother and her bridesmaids carried to see how they were made. She started going to the Bishop Museum to find historical photos of lei. She sought out great Hawaiian lei-making masters, Barbara Meheula and Marie McDonald, and sat for hours cleaning materials for them, learning by watching.

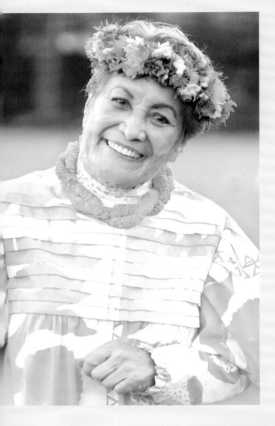

Tūtū made all styles of lei, but her specialties were the lei kui made from the pua kenikeni she grew in her yard, climbing on her ladder to pick her blossoms well into her seventies, and her intricate lei po'o done in the wili style. She would arrive at any party or ladies' luncheon with armfuls of lei pua kenikeni to give to the hosts, the chef, her friends, and any other lucky passersby. At Thanksgiving, she made sure her daughter (my mom), her four daughters-in-law, and her six mo'opuna kaikamāhine (granddaughters) each had a fresh lei po'o. Even the wooden ducks my family would bring out at Christmas were adorned with their own neck lei. Every canoe race, volleyball game, or track meet came with another Tūtū Bailey lei, including one for each of our lucky teammates and our coach. When we were on the mainland for college, she shipped lei po'o and strands of pua kenikeni, carefully packed in wet newspaper lined with ti, all the way to the East Coast for our birthdays, including extras for our roommates.

At the time, I didn't realize how lucky I was—things you routinely enjoy as a child often feel commonplace—making and giving lei was just the way our 'ohana showed our aloha for one another and others. But I have come to understand the true event that receiving a Tūtū Bailey lei was and the extra care she took to make the whole experience of lei special and personalized.

My tūtū would gift her finished lei po'o wrapped in ti leaf pū'olo (a bundle containing a gift). She would tie the top with a nosegay in matching colors, a teaser to the treasure wrapped inside. Every detail in her lei was tailored specifically to the recipient and made with extra aloha and care.

My cousins, my sister, and I all learned by watching her meticulous but fast hands prepping and sorting the ferns and flowers. Only when her lei table was organized—stems trimmed to size, palapalai soaking in her plastic fish-shaped tub, and raffia hanging readily available by a clothespin—would she pull her metal stool, padded with layers of fabric, to the table to sit and start her lei wili. We would sit next to her on the cool cement basement steps and watch her hands work while she talked, her stories interrupted by polite requests: "Mele, can you clip a bunch of purple hydrangea from fridge for Tūtū?" A formal lesson from Tūtū was not offered often. There was usually a deadline, "Auntie is coming at noon for her lei." But when she felt we were ready and if we caught her at that just right moment, she would say, "Come, it's time for YOU to make a lei." We stood, quickly grabbed the other (not padded) wooden stool, and hurried to sit by her side and wait for instruction.

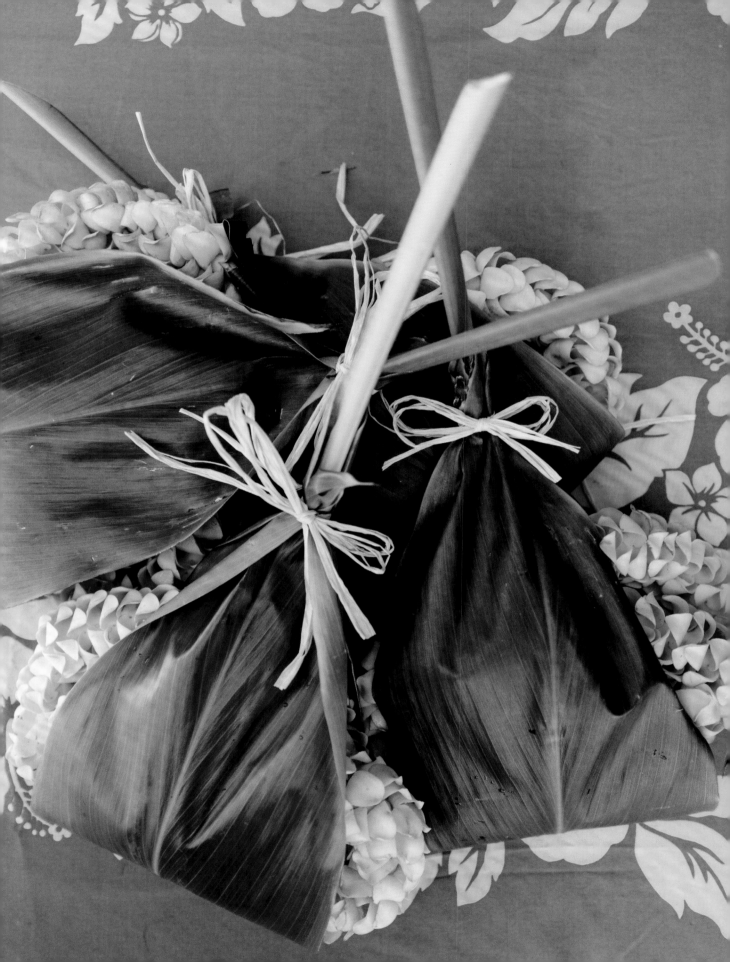

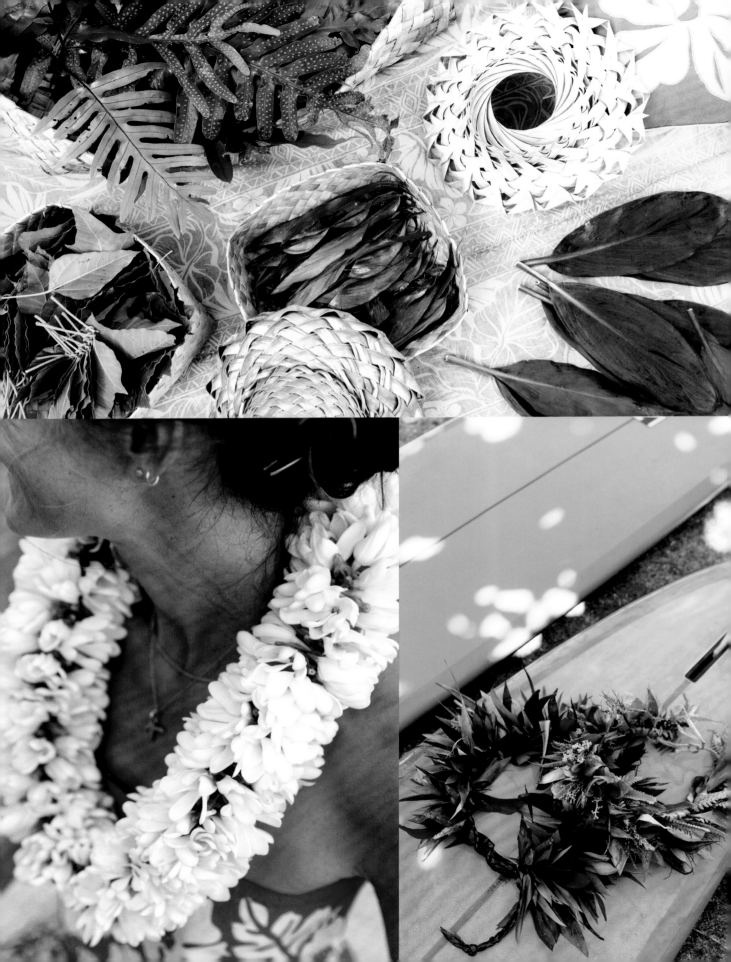

Beyond the lessons on technique in kui and wili, we learned her incredible work ethic. Tūtū tackled her day by taking on the hardest tasks first. We observed her picking buckets of pua kenikeni blossoms before the sun came up, cleaning her palapalai patches with her Japanese sickle, watering her laua'e (fern), loading her station wagon (with her vanity plate "Haku") with tables and baskets and coolers of lei for a wedding or funeral, and sweeping the garage and cleaning her worktable after each lei, even when she made multiple lei that day.

Making lei is how Tūtū taught us to show aloha to our neighbors, community, and family. Decades later, many people tell me how the special touch of Tūtū's lei made life celebrations (both happy and sad) or even just regular days more memorable.

The art of lei making was brought to the Hawaiian islands by Polynesian voyagers, thought to have sailed from Tahiti between 1200 and 500 AD. Lei-making techniques are so distinct that analyzing them allows anthropologists to trace migratory patterns throughout the Pacific based on the way lei maile were twisted together or the different methods of stringing lei hala, according to *Ka Lei,* by Marie A. McDonald. In "pre-contact" Hawai'i (before the arrival of Captain James Cook put these very isolated islands in all the world on European explorers' maps), without jewels or precious metals, lei made of natural materials—seeds, flowers, feathers, and shells—were used as personal adornments, in ceremonies, and as offerings for gods. Every material used developed its own meaning, often with accompanying chants, legends, and protocols that surrounded the harvesting, crafting, presentation, and wearing of the lei itself.

Beautiful yellow and red feathers from Hawaiian honeycreepers, for example, were reserved for ali'i (royalty). Forest plants like maile, palapalai, lapalapa, and its more oval-leafed cousin 'ōlapa (which also translates to "dancer") were associated with Laka, goddess of both the forest and hula, and were used to adorn a kuahu (altar) in hālau hula (hula schools), as well as the dancers themselves. The lehua flower, which grows throughout the islands but is prolific on the slopes of the volcanoes on the island of Hawai'i, came to be associated with Pele, the volcano goddess, and her favorite sister, Hi'iaka. Lei made from the delicate 'ilima flower, which grows on dry coastlines, and requires more than five hundred flowers for a single-strand lei, were rare, treasured.

When tourists began to arrive in the islands on steamer ships in the late nineteenth century, they were commonly greeted with flower lei by lei vendors, which helped fuel the escalation of the commercial lei industry. Lei shops opened in Chinatown, adjacent to the harbor, to fulfill demand. Fields of introduced flowers, such as carnations, a favorite lei of the times, were planted around O'ahu. When air travel started, lei sellers set up along Lagoon Drive near the airport. Today the outdoor lei stands—many run by the descendants of the original store owners—sit in a long row on a street right next to airport arrivals. Friends and family can quickly pull in to buy a lei for their incoming visitors.

Lei became so entwined with the idea of Hawai'i that in 1928, Don Blanding, a local poet, proposed a state holiday devoted to lei. With its own iconic song, "May Day Is Lei Day in Hawai'i," the first of May became a beloved celebration in the islands. Across Hawai'i, lei contests, hula concerts, and school pageants still mark this festive day.

By the 1950s and '60s, strung flower lei were everywhere: adorning Elvis in the movie *Blue Hawaii* and at his *Aloha from Hawaii* concert in 1973 and being worn by Martin Luther King Jr. as he marched from Selma to Montgomery in 1965. Coinciding with a cultural and political Hawaiian renaissance in the 1960s and '70s, older types of lei—including the haku and wili styles—began to be worn again. Nonprofits and schools started having lei booths at annual fundraisers, selling colorful lei po'o made by volunteers. A resurgence of interest in feather, shell, and seed lei brought old art forms back to life.

Today, lei culture—both traditional and commercial—remains vibrant throughout Hawai'i. But certain aspects have changed, even within my lifetime. Rising real estate prices have forced many flower growers to sell or develop their land, and fewer people have access to backyards where they can grow their own flowering trees, shrubs, and vines. Most tourists receive only imported orchid lei, the flowers grown and sewn in Asia, mainly purple or white, but sometimes spray-painted in all the colors of the rainbow. Lei made of ribbon, yarn, plastic kukui nuts, and candy have become commonplace. At the same time, a new generation of interest in creating and wearing lei has a handful of "modern" lei makers reviving old methods and adapting the forms to make something new and contemporary, selling traditional lei alongside avant-garde and creative styles never seen before. Instagram is filled with photos of beautiful lei po'o and creative mixed-flower lei kui. Learning to make lei has become an essential part of a trip to Hawai'i for many malihini (visitors). In some ways, even though access to flowers has never been more challenging, the art of lei making is at its most exciting.

When I moved home to Hawai'i after starting my career in fashion design in New York, I again felt pulled to make lei—just as my tūtū had taught me—for friends' birthdays or their babies' lū'au. A few years later a friend suggested I teach a workshop to other friends on the wili style of lei making. Following the workshop, one friend who attended and owned Paiko, a then brand-new floral shop in Honolulu's hip, up-and-coming Kaka'ako neighborhood, asked me to hold a lei po'o workshop for the public, which to my surprise quickly sold out. That first event led to more classes and workshops offered as part of bridal showers, parties, hotel activities, corporate retreats, and charity auctions. By 2018, I was teaching more than 1,500 people annually around the Hawaiian islands, on the mainland, and abroad.

I open each workshop the same way my tūtū began the many workshops and classes she taught. She would always proclaim, "Today is the first day of your new life as a lei maker." And while that may sound dramatic, it's true. Once you learn how to kui or haku or wili flowers and greenery together, you become more attuned to your natural world. You begin to notice every plant or flower for its potential to become a lei. You befriend that neighbor with the hottest pink bougainvillea or find yourself making mango chutney to thank your other neighbor for allowing you to pick their yellow lehua blossoms. A common green hedge might catch your eye for its clustered, oval-shaped leaves, just right for a rounded accent in a lei po'o. You pull your car over when you see people trimming their coconut trees and ask to gather up the clippings. You may find, as I do, that making lei increases your awareness of the changing seasons. Even here in the tropics, where it's warm most of the time, flowers grow and bloom in distinct seasons: spring for gardenia; early summer for plumeria, midsummer for pua kenikeni, and late summer for pakalana. Perhaps you'll begin to learn how to cultivate native plants and

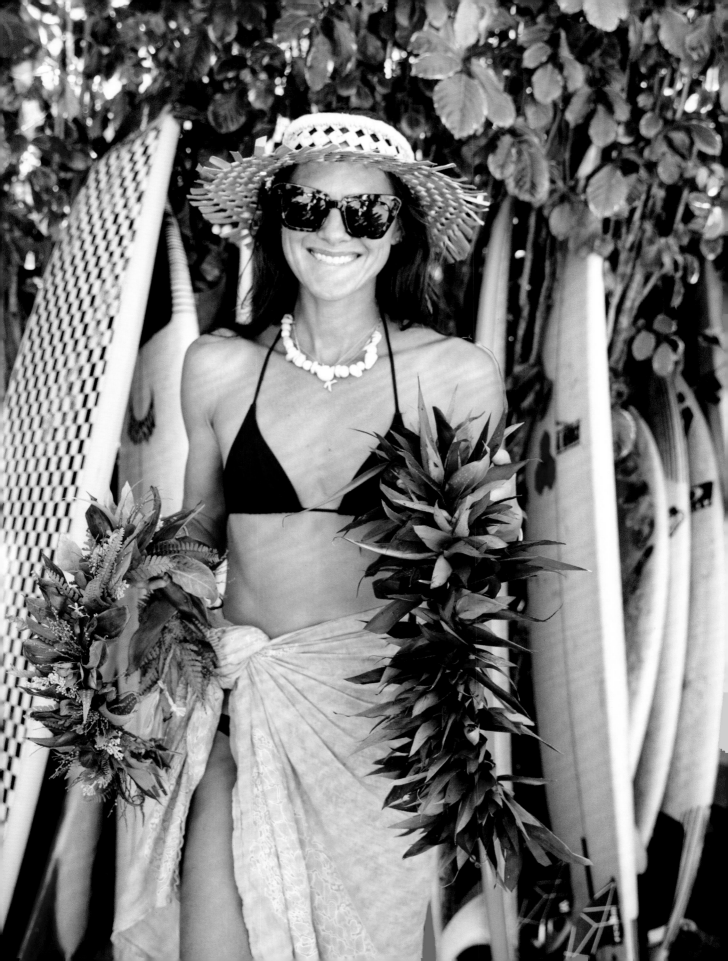

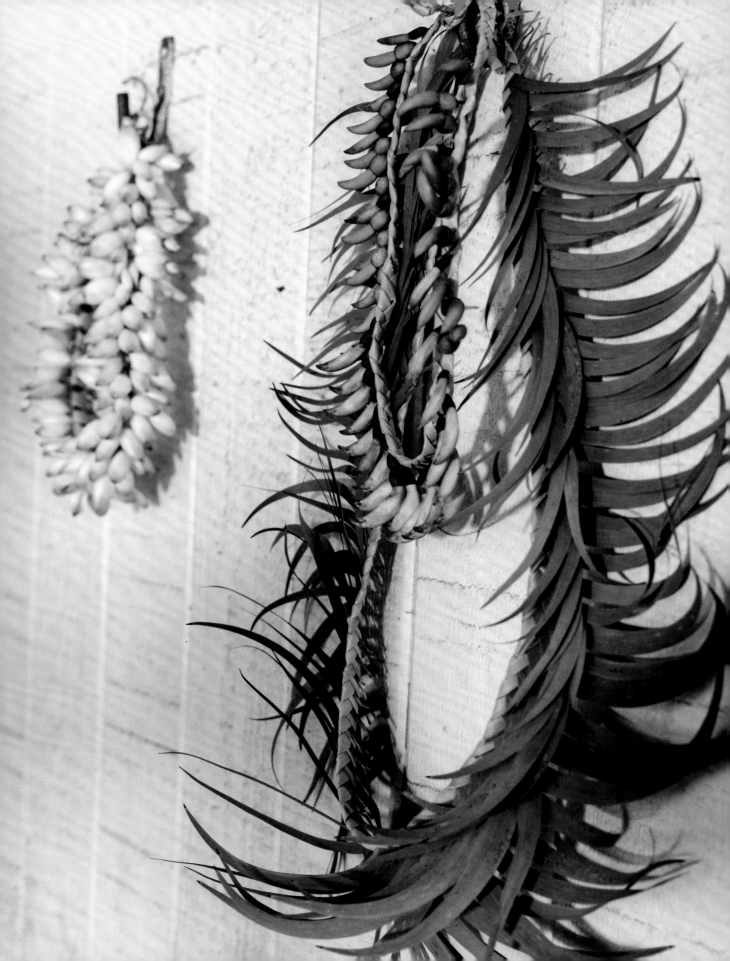

the traditional ways of using them. Maybe you'll want to learn cultural protocol for gathering materials and sharing lei and start to notice that many favorite songs compare a loved one to a lei. Maybe you'll feel inspired to grow your own lei garden at home.

As much as I love teaching people how to make lei, the one thing missing is the recipient. Lei making is more than just the finished product; it's a step in the cycle of planting and watering, picking and designing; it's part of an occasion, part of our relationships, part of our cycle of life. We make lei for weddings and for baby lūʻau, when a child turns one. For my fortieth birthday, my sister helped track down enough flowers to make bright pink plumeria lei for my forty best friends. When my tūtū passed, her friends and relatives crowded into the garage to make lei for three nights leading up to her funeral so that her entire extended ʻohana wore exquisite lei poʻo at her service, and so that my sister and I could focus on adorning the front of the chapel, Tūtū's picture, and urn. Sometimes, we make lei simply because the flowers are blooming, knowing that just the right recipient will appear—then the giving becomes the occasion.

In this book, I want to share these occasions with you—the ʻohana parties and graduations; the hula competitions; and the magic of May Day—along with the lei we choose to celebrate each event. However, there is no such thing as one "correct" lei for any celebration, just as there is no one way to make any given lei. Every lei holds different meanings and memories for both the giver and the one who wears it. The flowers that make up each lei are less important than the aloha that goes into its sharing. Here in Hawaiʻi, lei are more than a gift, a cultural practice, or the flowers; they bring people together, they hold relationships, community, gratitude, and protection. Lei are how we haku, or weave, our memories—strings of scent and color that weave our lives together. In these chapters, I hope to share a peek into a part of our culture that is shaped by lei.

Cultural meaning does not always translate across languages with absolute clarity. In the text, I have tried to use certain Hawaiian language terms and phrases in the cultural context in which the people interviewed brought them up. This book is not an exhaustive exploration of the variations of lei making in Hawaiʻi (or of all lei uses) but I hope, one of many possible beginnings to understanding the history and culture of Kānaka.

When I'm making a lei to gift someone, I'm thinking of my tūtū, my mom, and my sister; my whole ʻohana; and my lei-making community. I'm thinking about the person the lei is for and the ʻāina (land) from which I've picked the flowers and foliage. I'm thinking about the day we are celebrating and how the lei will become a part of that story. I'm thinking about how blessed I am to be a part of this tradition. A lei is our ultimate expression of aloha. I hope that as you read this, you feel the aloha in this lei haku of moʻolelo (story of lei we have weaved together) to share with you. He haku aloha.

—*Meleana Estes*

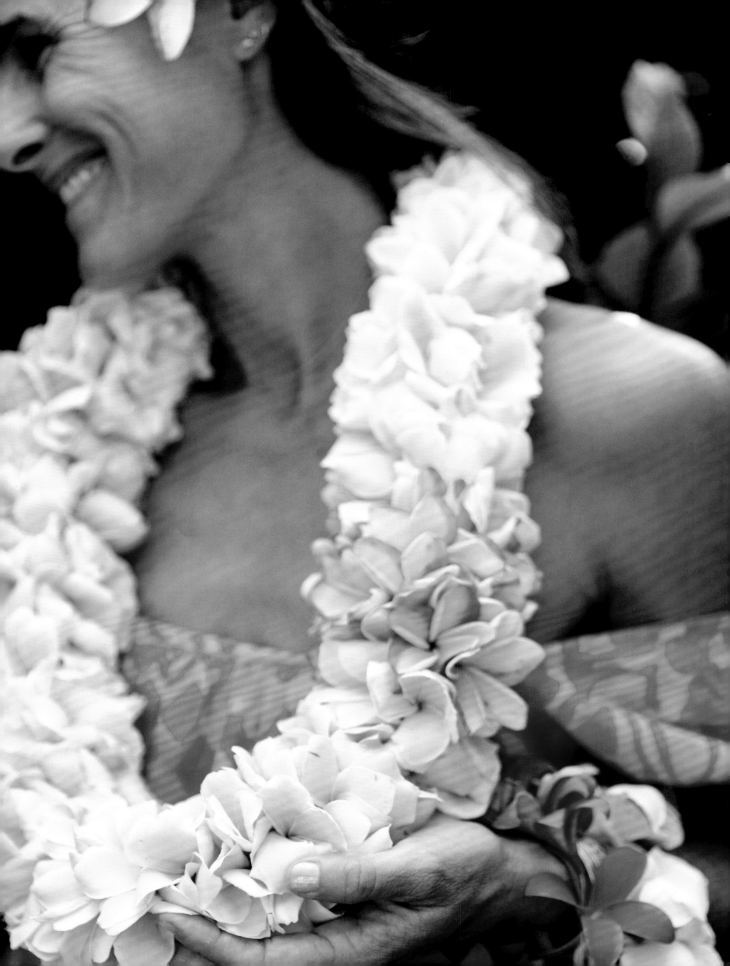

Lā Mei

May Day Is Lei Day

"Make a lei, wear a lei, give a lei."

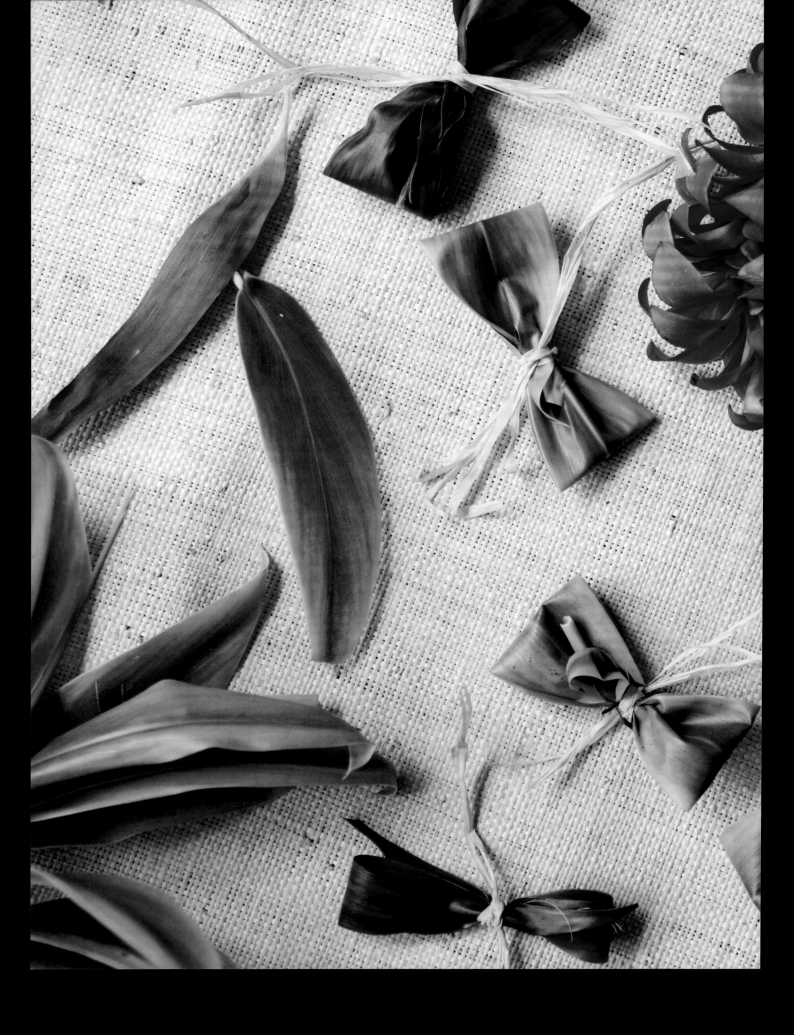

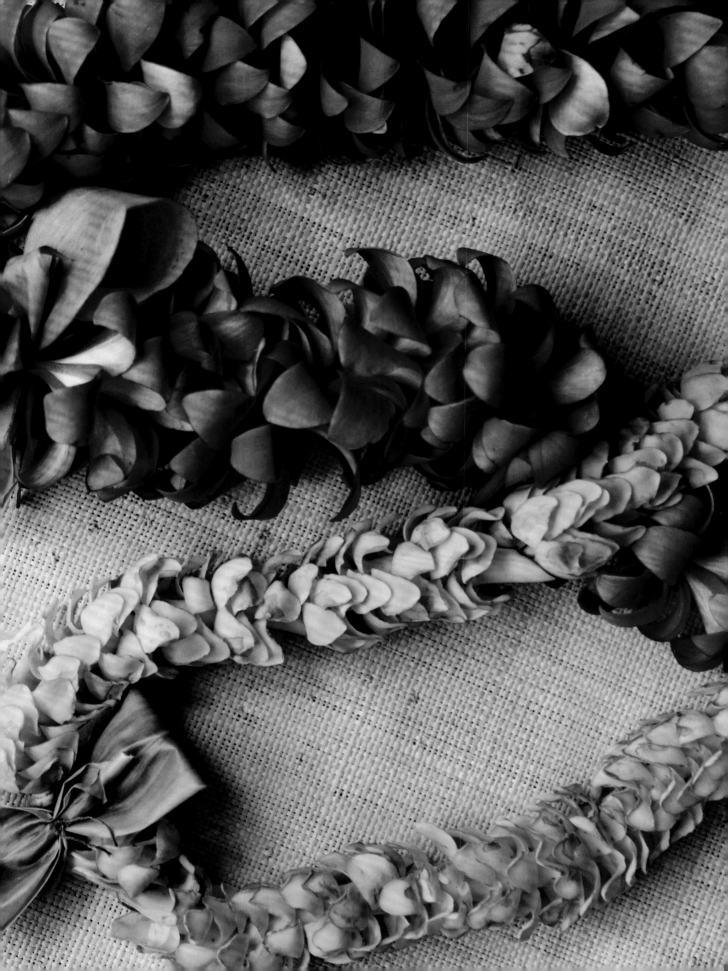

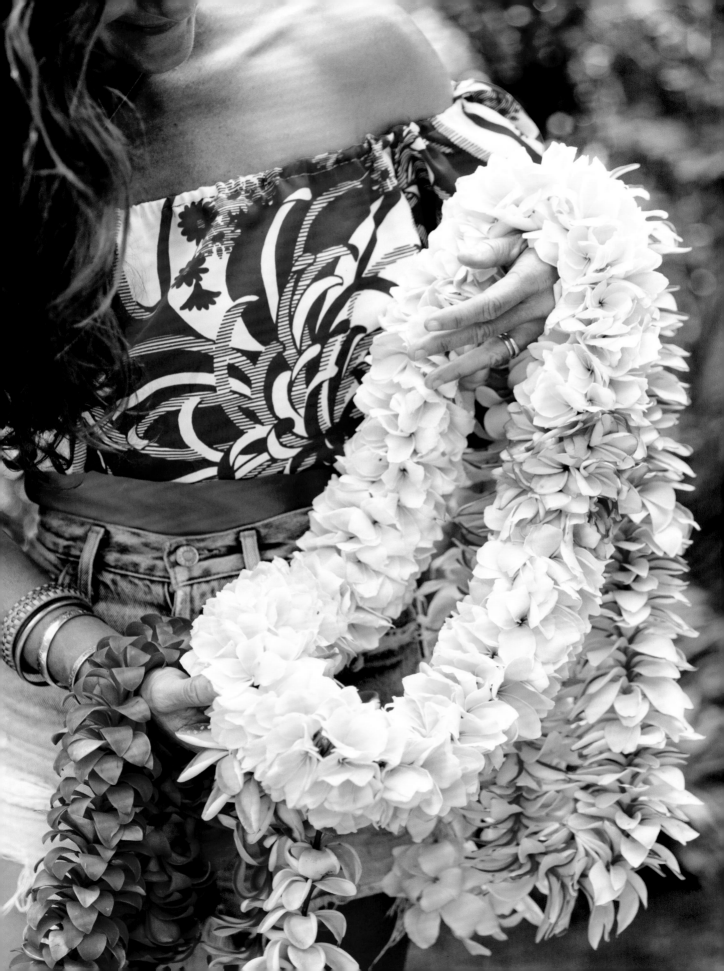

To me, the fragrance of pua melia (plumeria) is May Day or Lei Day, a celebration of lei observed every May 1 in Hawai'i. The smell takes me right back to stringing the sweet, heavy scented flowers on a long lei needle, sticky with the milky white sap, with my mom and sister on our back porch, for Kīlauea Elementary's May Day celebration. I was so excited to bring one lei to wear and one to share with my teacher on the one day of the year our entire school wore aloha attire.

The whole day was so festive, sharing our class mele (song) and hula taught to us by our kumu (teacher), Naomi Yokotake, with our classmates and parents. The day's performance always ended with "May Day Is Lei Day in Hawai'i," a song that the crowd joyously joined in.

May Day, packed with lei-making contests, school pageants, and Hawaiian music concerts, was my tūtū's absolute favorite day of the year. She loved—truly loved—it all. Before I was born, she served as a judge in the Honolulu Parks and Recreation Department lei contest in Kapi'olani Park. For my high school's May Day pageant, she spent days decorating the gym with flowers, assisting the May Day Court with their lei and kāhili (a feather-decorated pole signifying royalty that is sometimes decorated with flowers) to represent each island. After I graduated and she was retired, I would drive Tūtū to the city's May Day festivities—all decked out in a mu'umu'u, fresh lei po'o, and pua kenikeni lei—to visit her lei-making friends, eat Hawaiian food, and enjoy the Honolulu lei queen pageant. In the evening, the festive day found a perfect ending as our family gathered for the legendary Brothers Cazimero May Day concert at the Waikīkī Shell.

"When I think of May Day, I see a big lei [of people] around the Waikīkī Shell, all the way out to the grass," said Robert Cazimero, kumu hula (hula teacher) and beloved entertainer, when I called to ask him about his favorite memories of lei. His annual concert, which began in 1978 and ran for thirty years, capped a day of May Day festivities in Kapi'olani Park and was a treasured tradition for many Honolulu families, including mine. "All kinds of people. Local

people, mainland people, but everybody taking the opportunity to have a big party. Why? Because we all love lei. We all love to make lei, wear lei, give lei."

Cazimero's favorite lei is pīkake, a beautifully scented jasmine, which he has adored since he was a child. But he says he loves them all: "It can be as simple as a yellow plumeria lei, which to me, which to us means . . . I can't even explain the depth of the importance, of the beauty, of the signification of a yellow graveyard plumeria lei." Cazimero remembers making plumeria lei for his sister's hula performances by picking flowers at the local fire station and then raking and watering the tree in return. "The art of knowing when to pick it—there's so much silly little knowledge that comes along that helps to make it even more precious."

A single strand of yellow and pink sunrise plumeria. The sweet scent of ivory white stephanotis. The rich perfume of fresh pua kenikeni. The sculptural beauty of crown flower. There are more complicated, rare, and ornate lei in Hawaiʻi's vast catalogue, but none, perhaps, as sweet as a simple lei kui made from flowers commonly grown in local backyards. For many who grew up in the islands, this type of lei, where individual blooms are sewn by needle and thread into a garland to be worn around one's neck, is the first type of lei they learned to make. This style of stringing lei kui—and, importantly, gathering to make lei together—is deeply nostalgic for many.

"For me, pakalana is my childhood," says Ipolani Vaughan, a Native Hawaiian cultural practitioner who grew up in Mōʻiliʻili on Oʻahu. "My grandmother and I would get up at six in the morning [to pick flowers]. She had a wire fence and she had pakalana growing all along the fence," says Vaughan. The pair would pick buds, collect them in empty one-gallon mayonnaise jars, then take them inside the fridge to store until night, when her grandmother would have time to string the lei.

"My grandmother always said, 'ʻAʻohe lei puʻupuʻu kau i ka ʻāʻī—There is no lei that is ugly that is placed upon the neck. I remember the first pakalana lei that I ever made. It was horrible. I was seven years old, but trying to get that lei needle in. I looked at that and I looked at my grandmother's. But she said, 'ʻAʻohe lei puʻupuʻu kau i ka ʻāʻī.' And it's true.'"

Vaughan, who won the title of Lei Queen at the Honolulu City and County Lei Day celebration in 1990, excels in making many types of lei, specializing in intricate Niʻihau shell lei. But the simple lei kui are still among her favorite—not only because of the fragrance, but because they remind her so much of a particular time and place. "Lei represents to me tradition, those that have come before us, the stories that have come that are connected with that type of lei," she says. "[The pakalana] reminds me of my grandmother and of the many things that we used to do, and being the only girl, not realizing [that I was the] punahele (favorite) until she was gone."

To have a lei flower tree of one's own—or to have access to one—is a treasure to a lei maker, not only for the material but for the memories it creates in making, giving, or teaching someone how to make lei. My mother, Beryl Bailey Blaich, remembers when my tūtū, who fell in love with lei making in her fifties, replanted her yard with lei plants and trees. "There used to be day lilies coming all along the walkway to the front door," she says. "But in the era of my mother's haku madness, the crotons went out and the kukui came in. The pua kenikeni have taken over the universe. Pakalana went up to the trellis. The backyard suddenly became all those flowers, including lehua trees. The thing I thought was the coolest is that she was still planting the lehua when she was eighty-five."

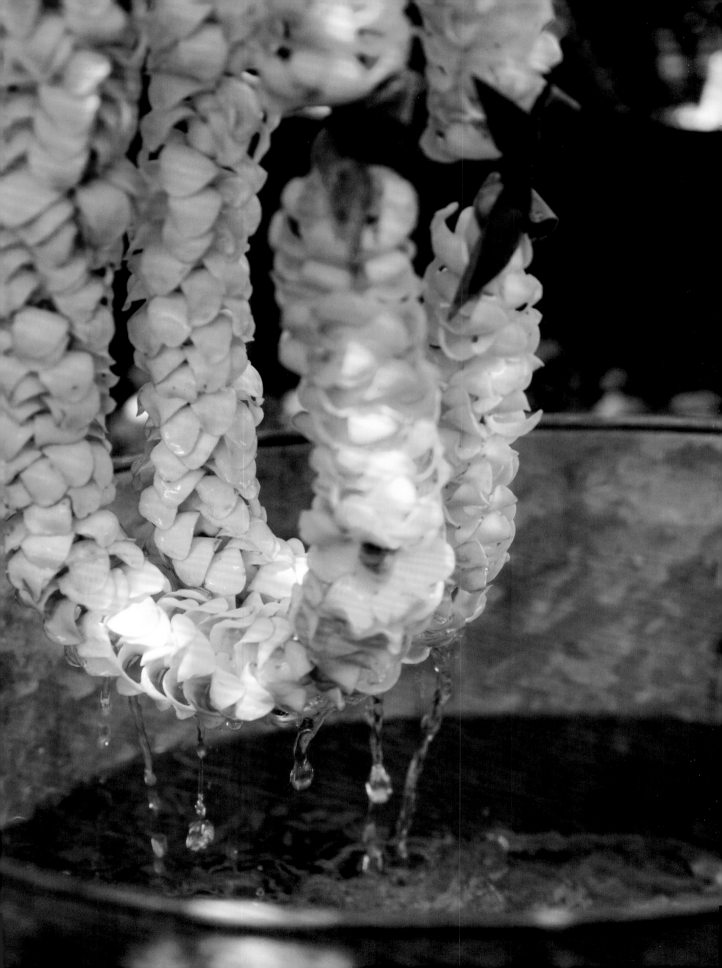

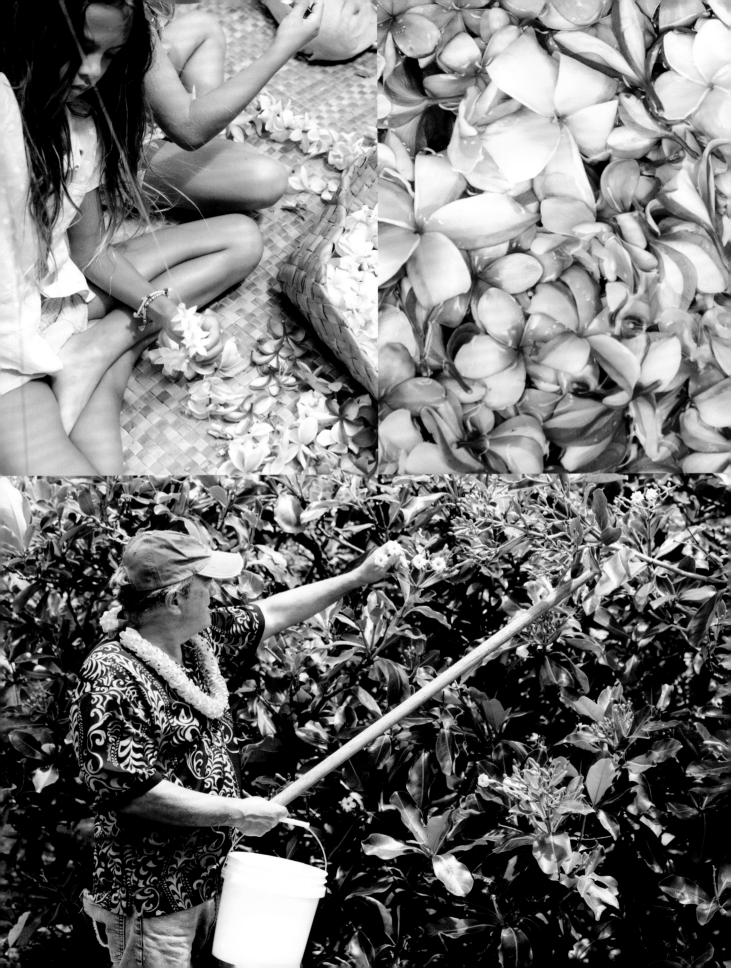

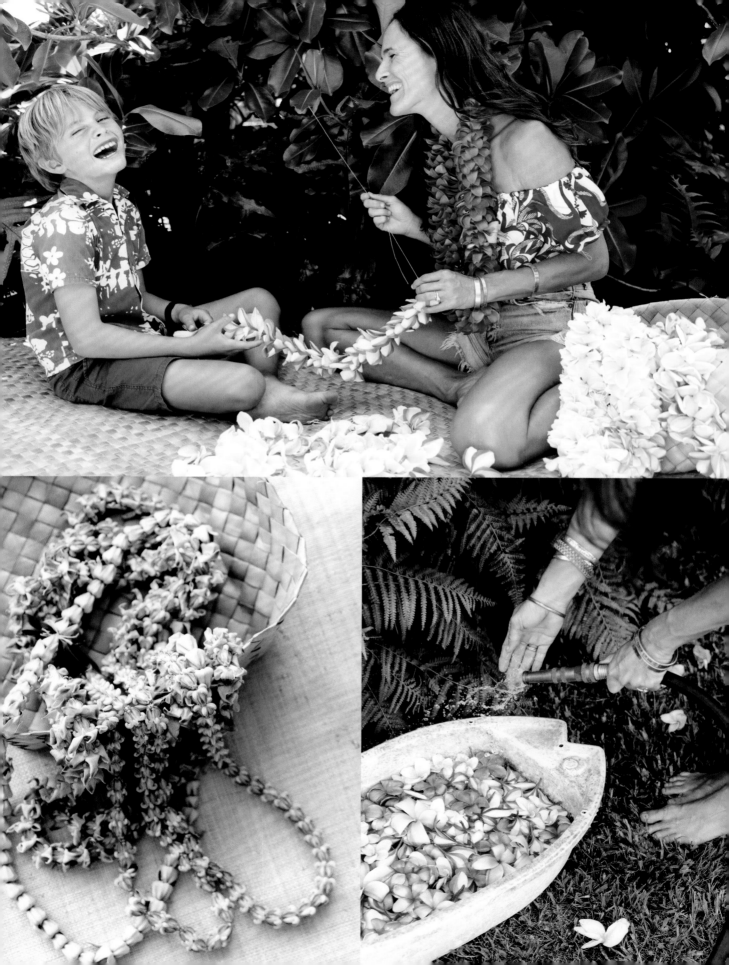

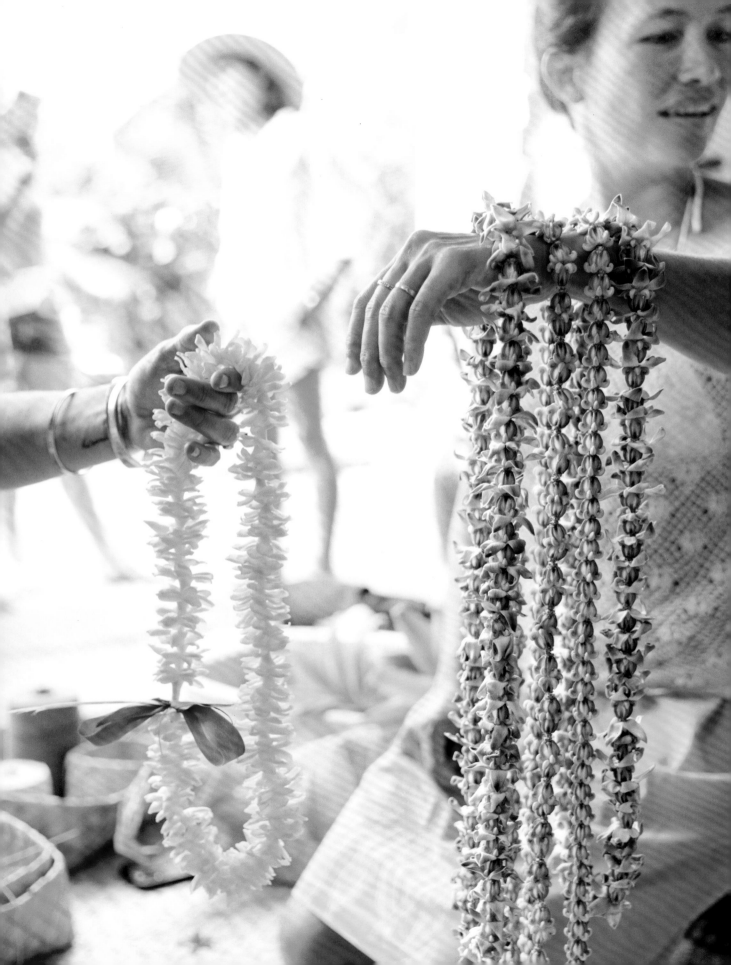

William "Speedy" Bailey, my uncle and the longtime caretaker of the pua kenikeni my tūtū planted, says there is an art to a lei that begins well before you begin stringing the flowers—and that begins with regularly tending to the trees. "The more you pick, the more they grow," he says. When he picks a flower, he also picks the green bulb at the base. If unpicked, the bulb will grow into fruit the size of a quarter and turn red, sending a signal to the plant to slow down. "It is a cycle of reward because the flowers take care of the tree, then you take care of the tree and you get more flowers."

Golden lei pua kenikeni with a green ti leaf bow became our family's signature. "[My mom] made lei for every gig we did," says my uncle, who works as the head of the American Medical Response here in Hawai'i but plays mandolin and guitar in Hawaiian music bands for joy. "It was never asked for. It was simply, 'When are you playing?' And then lei would be there."

My uncle says it takes around 120 pua kenikeni flowers to make a lei and the flowers change color depending on the day they are harvested—which is a factor he takes into consideration when picking. "Everybody has their preference on what color is their favorite. I think my mom liked them really orange. I like them a little on the creamier, creamsicle [side]. Sometimes there's a perfect color, but timing is the key right there. It's going to get more orange [once you pick]. Ideally for [a lei on] Friday, [you pick] flowers Wednesday probably, and then you make the lei Thursday, and you give it to them on Friday."

Once harvested, the flowers are soaked in water, then kept between damp towels or paper in a dark, cool place—but never in the refrigerator, which will make the blooms turn brown. To make a lei kui, the stem should be cut on an angle with scissors. Cutting the stem of the pua kenikeni bloom closer to the petals will lead to a tighter and more densely packed lei. The lei maker sews each bloom through the top of the flower toward the base, stacking flowers tightly together. Like the flower, pua kenikeni trees require gentle handling and steady care, but keeping the trees thriving is worth it. "The art of picking, I always kind of joke about this and talk about the cycle of life, but it's meditation. You have to like it, you have to enjoy it, or otherwise it's not fun," says Bailey.

Established pua kenikeni trees, like we have at my tūtū's house, will bloom throughout the year. But the most abundant season is summer, just as with plumeria, stephanotis, crown flower, and a number of easy-to-kui flowers. The rush of summer flowers tends to arrive just in time for a series of important lei-making events, including Mother's Day, Memorial Day, and school graduations, but none are more central to lei culture than Lei Day.

In some schools across the islands, students start in January to prepare costumes, hula, and performances for a May Day, or Lei Day, pageant. "Our kindergarten class, the whole grade level actually, still makes lei every year," says Lauli'a Ah Wong, who coordinates the Punahou School May Day and Holokū Programs with her sister, Leilehua Utu. With development and higher real estate prices, fewer students have access to flower trees and purchasing lei can be costly, but Ah Wong and Utu still try to source materials like plumeria or ti to have students learn to make their own. "[The] kids are so busy right now and the time it takes to teach them how to gather, to sit, and to create lei in the right way—it's not impossible because we still do it from time to time—it just takes a lot more time and energy." Ah Wong credits the labor of love required from volunteers, families, and the community, which makes the May Day pageant possible.

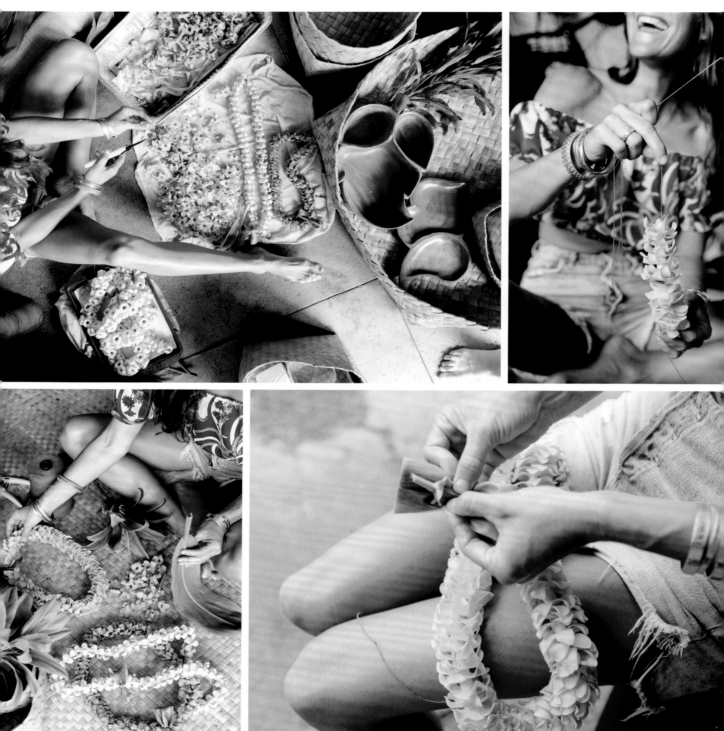

"It is a cycle of reward because the flowers take care of the tree, then you take care of the tree and you get more flowers."

—William "Speedy" Bailey

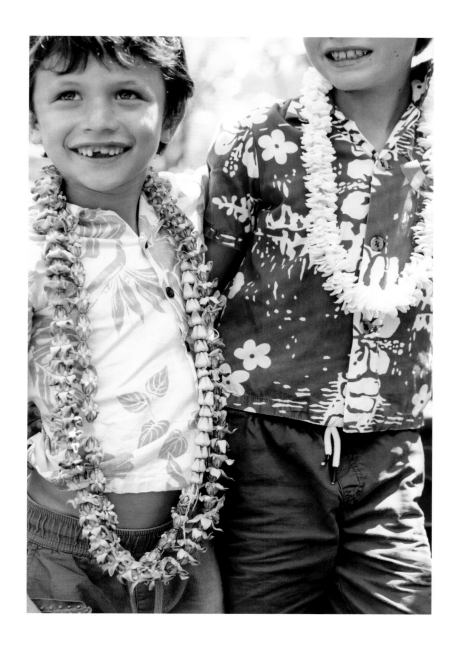

Right: Beyond plumeria and pua kenikeni, the beautifully scented white stephanotis flower (right), which grows as a vine on trellises or fences, is another popular back-yard option that's easy to pick and kui. Crown flower (left), which comes in purple or white, can be taken apart to sew into many different styles, and was said to be a favorite of Queen Lili'uokalani.

Opposite, bottom right: While commercial lei sellers often affix a ribbon as an accent to lei, handmade ti leaf bows offer a beautiful, natural, and compostable option.

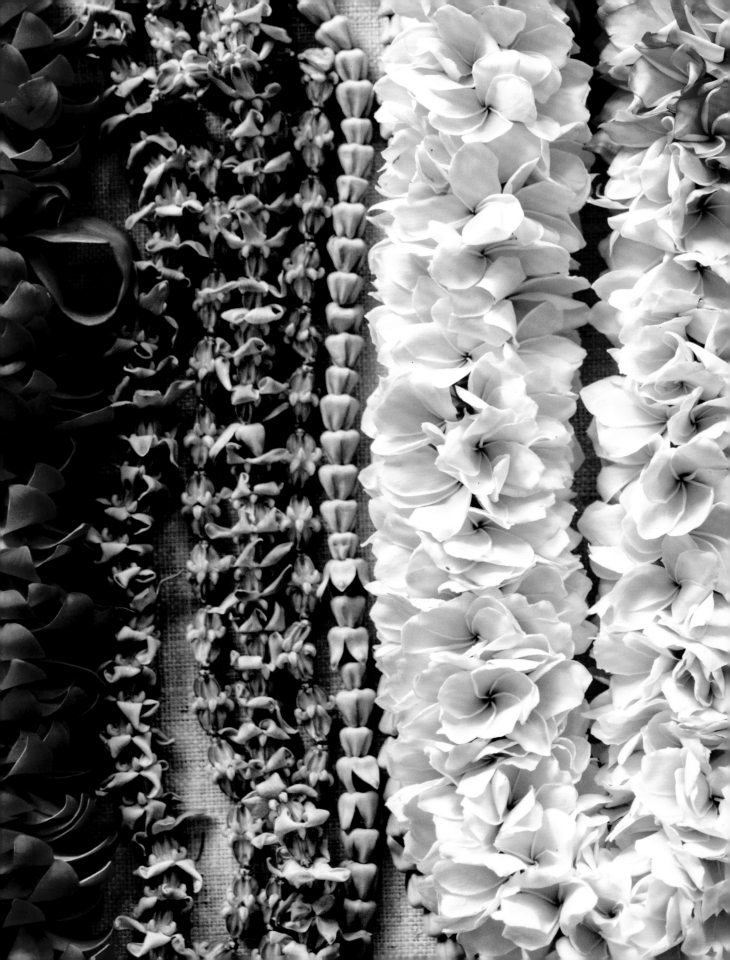

Lei Day in Honolulu

In many cultures around the world, including in England, Greece, and Spain, May has traditionally been a time for festive spring celebrations. Around the turn of the twentieth century, Hawai'i had its own slate of events, including floral parades, school pageants that incorporated dances and traditions from the many cultures on the islands, and events with a royal court. In 1909, for example, the Ka'ahumanu Society, a Hawaiian civic club, held a performance in which each island was represented by its color and flower. But the creation of the enduring Lei Day celebration on May 1 is generally attributed to Don Blanding, an Oklahoma-born poet, who fell in love with the islands' lei culture and in 1928 suggested a formal day to honor the tradition of making and giving lei. Grace Tower Warren, his colleague at the *Honolulu Star-Bulletin*, suggested a May 1 date and came up with the phrase, "May Day is Lei Day." A now-iconic song of the same name by Leonard and Ruth Hawk soon followed. That mele is still taught in schools and played on the radio.

Combining elements from pageants and festivals held across the islands during that era, the first Lei Day was held by the Bank of Hawai'i in 1928. In 1929, the state declared May 1 a day of celebration, and by 1931, May Day events were held at its current location in Kapi'olani Park on O'ahu under the direction of the Department of Parks and Recreation. Today, May Day at the park features free lei workshops, a lei-making contest, live Hawaiian music, and the presentation of an elected Lei Court with a king or queen and several princes or princesses—the template of which is modeled by many schools for their own May Day pageants.

"Participation in the May Day court offers another opportunity to educate students," Ah Wong says. The court is comprised of a mōʻī (king), mōʻī wahine (queen), and aloaliʻi (royal court), along with eight nā kamāliʻi wāhine (princesses) and paʻa kāhili (kāhili bearers). The eight represent each island, wearing the island's corresponding flower: Oʻahu (ʻilima), Kauaʻi (mokihana berry), Molokaʻi (kukui), Maui (lokelani rose), Hawaiʻi (ʻōhiʻa lehua), Niʻihau (white pūpū shell), Kahoʻolawe (hinahina kū kahakai), and Lānaʻi (kaunaʻoa), which were designated by the state in 1923. "It's so important to acknowledge and recognize each moku (island), and each particular island flower for our students," Ah Wong says, noting that the flowers play an integral part in teaching students moʻolelo (stories) about each island's geography and history. While it can be a challenge to hunt down the exact flower, generally because of the cost and the fact that each flower is more abundant on its respective island, the volunteers who help decorate the kāhili have found creative solutions, like using sea grapes instead of mokihana to "represent the essence of the flower, the significance of the place using the flower."

Ah Wong, who wrote a dissertation on the school's event, says that in interviewing past participants she learned there were several major themes that students took away: from an increased sense of belonging to a place and a community to an enriching sense of Hawaiʻi through historical connections and compassion for traditions. She sees opportunity in the program to choose songs that teach history from the Native Hawaiian perspective, like "Kaulana Nā Pua," a protest song that opposed the annexation of Hawaiʻi to the United States, originally entitled "Mele ʻAi Pōhaku." Utu and Ah Wong have also used program themes, like Hōpoe Ka Lehua, to highlight the immense biocultural and ecological significance of the ʻōhiʻa lehua through moʻolelo, mele, and hula. Ah Wong explains, "We took it as an opportunity to talk about rapid ʻōhiʻa death and how to conserve. We look for those opportunities to educate others. It is our kuleana (responsibility) to do better for our community.

"I think for some individuals, especially for the Lāhui, our Native Hawaiians, [May Day] can be a sensitive subject. May Day was conceptualized by poet Don Blanding to honor the custom of making and wearing lei. As this tradition took root and evolved, it has become a cultural and historical celebration. This commemoration may feel sensitive for Native Hawaiians as our kingdom was overthrown, our people died, and many of our traditional practices have been lost," Ah Wong says, noting that schools approach the event differently. "I think we try to live amid that tension and do our part to honor the people, our place, and our language as best we can." Utu, Ah Wong's sister, explains, "it's always been a place of good as it comes from our aloha. We have the best of intentions to perpetuate our Hawaiian culture and give others the opportunity to experience a love for Hawaiʻi through music and dance."

Roen McDonald Hufford, a master Hawaiian artisan, who grew up on the windward side of Oʻahu, sees May Day similarly, as an opportunity to teach Hawaiian culture. May Day was a significant event at Hufford's house when she was growing up. Marie A. McDonald, her mother, was one of the foremost experts on lei in the islands, publishing two widely respected lei reference books (photographed by Hufford), *Ka Lei* and *Nā Lei Makamae*, and winning a National Endowment for the Arts award for her role in documenting lei culture in 1990. McDonald, who grew up on Molokaʻi, taught her whole family—siblings, children, nieces, nephews, and cousins—how to make lei and they in turn would teach others. Hufford recalls her uncle Walter Pomeroy

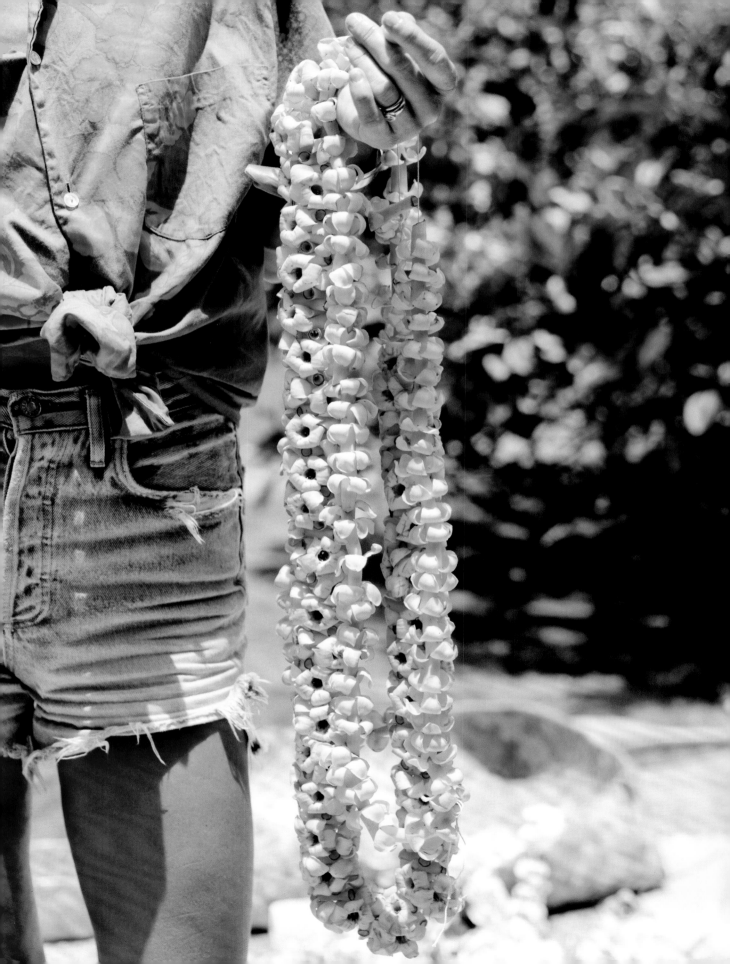

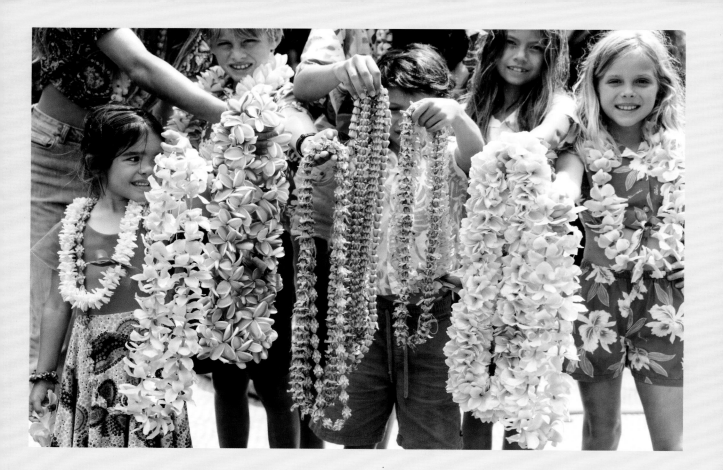

getting his class from Kamehameha Schools involved for May Day. "They would have a big party [where] everybody was up all night making lei," she recalls.

At the University of Hawaiʻi, which Roen McDonald Hufford attended in the late 1960s during the Hawaiian cultural renaissance and a revival of Hawaiian arts, student groups conscripted her into leading lei-making demonstrations for Lei Day. "I got my friends together and we scoured the town for all this stuff and we sat there and anyone who wanted to—students, faculty, whoever— we made lei," highlighting the importance of using the celebration as a venue to teach Native Hawaiian crafts and culture.

After running a floral shop that sold many lei on Oʻahu for many years, Hufford now lives with her husband in high-elevation Waimea on the island of Hawaiʻi, growing vegetables and fruit to sell at the local farmers' market. She doesn't make lei often anymore, preferring to practice kapa cloth making, a Native Hawaiian art of making and decorating fiber cloth. But when asked to choose a favorite lei, Hufford's taste veers toward the simple: a green lei wili of palaʻā or a single strand of plumeria. "I'm always in awe of the people who live in other parts of the island who have different materials that I don't have, and I know I'll never have because it doesn't grow up here, like pua kenikeni, pīkake, and ʻilima," she says.

But for Hufford, the type of flower matters less than the intent. "My mother used to say that lei show our regard for each other. They tell how someone feels about you.... [A lei says] you love me, that you miss me.' You do it by connecting with the plants that are right around you or are important to you because they give you mental peace and emotional joy. And if you don't have enough, then choose something else. Make it out of what there's lots of."

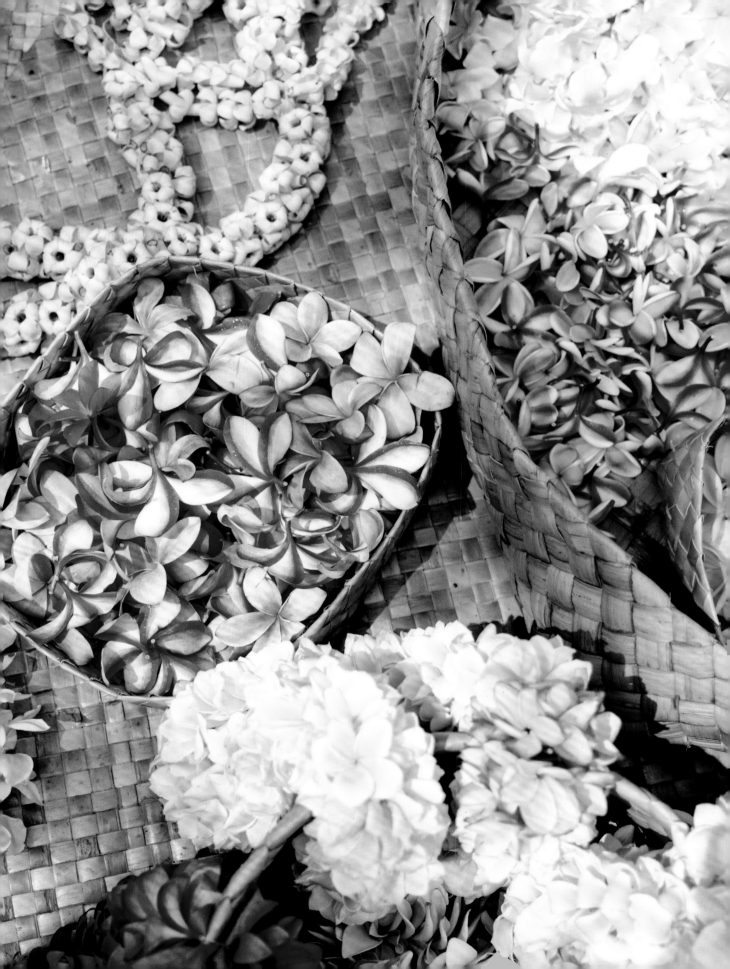

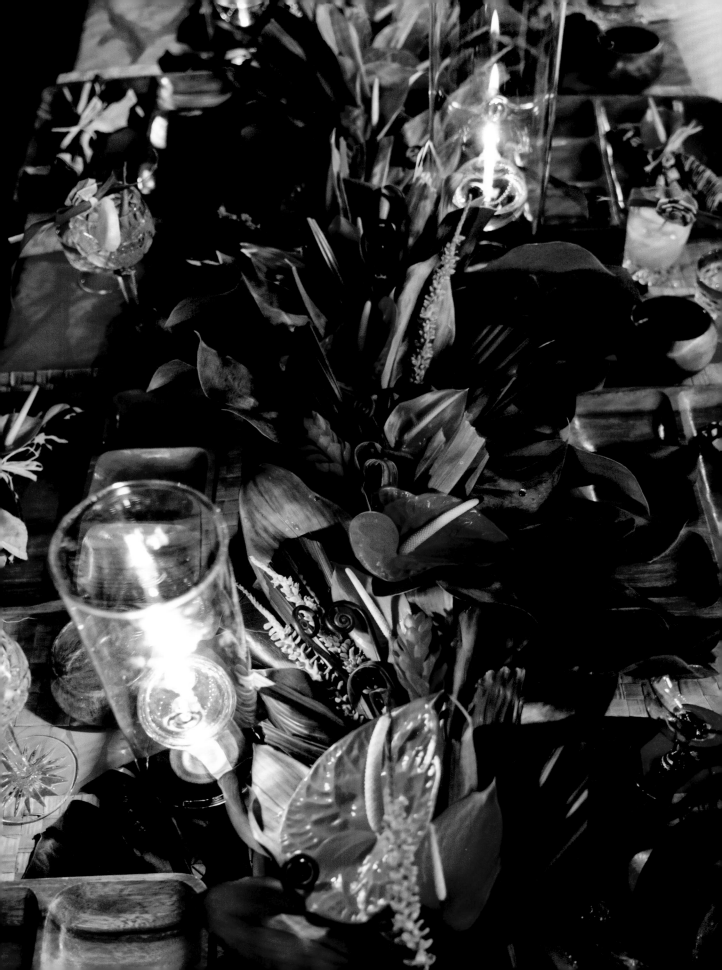

Pā'ina

Island Gatherings

"Anytime you have a gathering,
is a time for a lei."

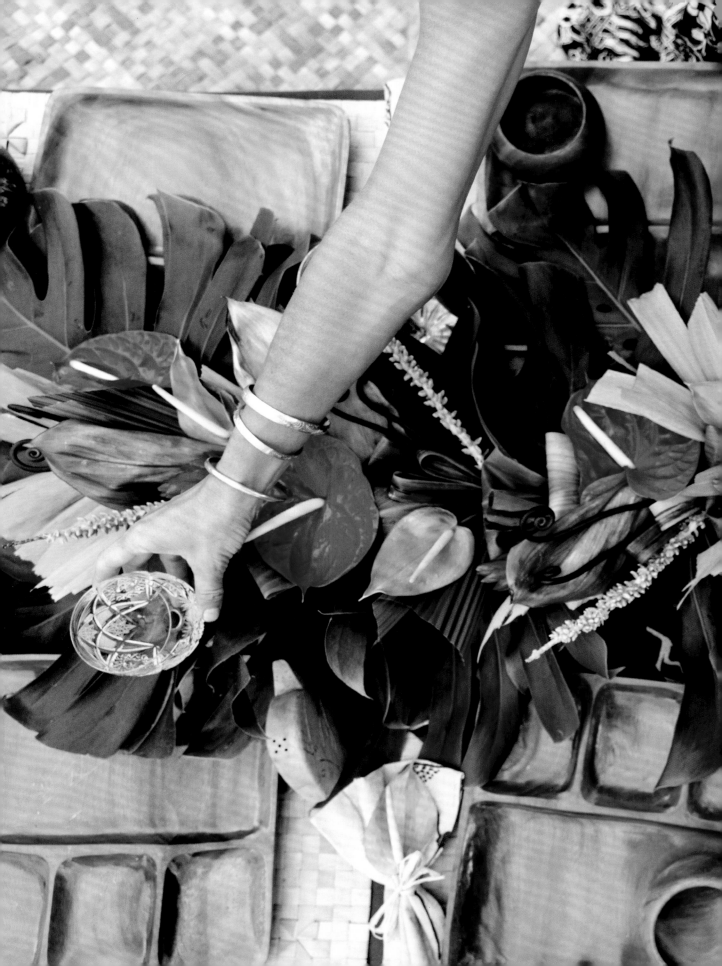

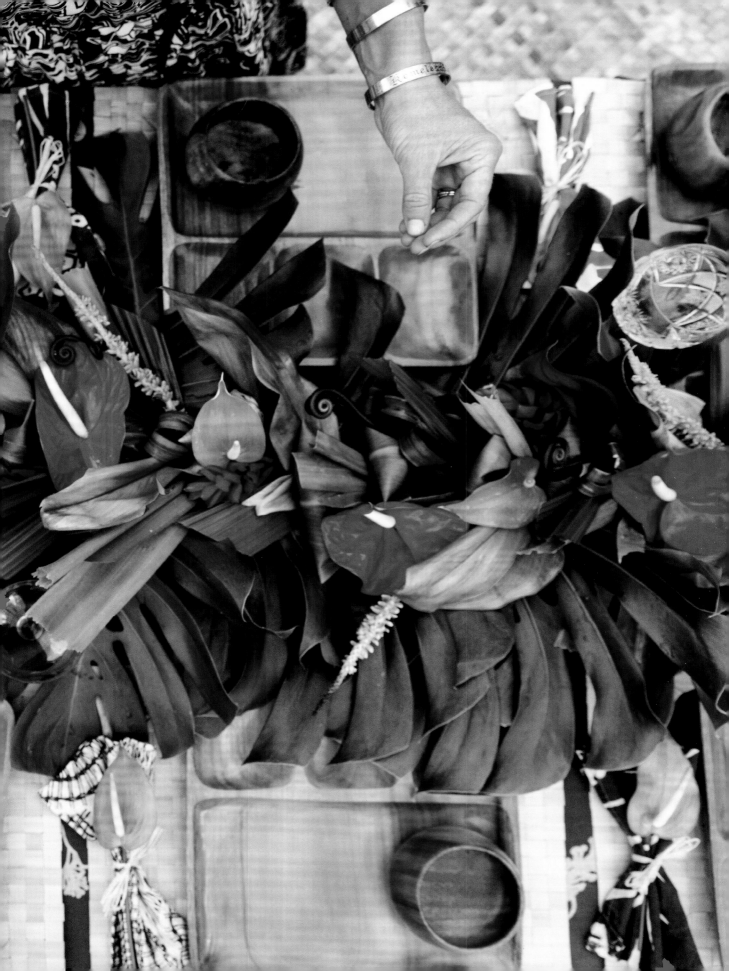

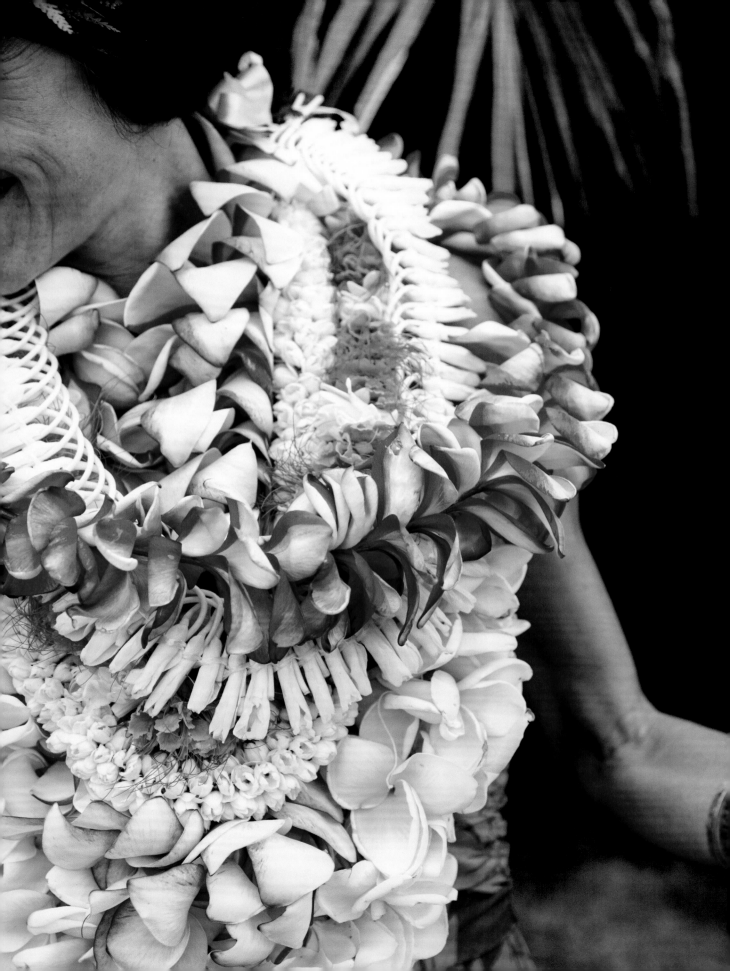

My favorite part of any celebration, from a huge family lūʻau to a backyard dinner party with friends, is sharing lei, showing love and appreciation through flowers for all the friends and relatives who attend. This tradition comes from my family. "Tūtū always had it in her head—who's the family, who are all the people who will be there that need to be adorned," my sister, Mehana, says about how for every event, the first item to be considered was always making enough lei for people, a practice she continues today. "I'll be at an occasion, looking around, thinking 'Do all the people have lei who should? Should I have made three more?' That aspect of adorning people as part of an occasion is really ingrained in us."

Lūʻau are one of the most important celebrations in Hawaiʻi—sometimes put on as a wedding reception, birthday party, anniversary, or retirement party. The setting can be in a backyard, a beach, a park, or under a tent or a canopy of trees; the musicians informal or professional; the food catered or prepared by the family—but lei are always part of the occasion. "You know when you've been to a good party, that the lei were fabulous, the music was awesome, the food was delicious, all the right people were there," says kumu hula and entertainer Manu Boyd.

For many, bringing a lei to share on any occasion, including lūʻau, is part of the fabric of being raised in Hawaiʻi. "In the 1960s and '70s, everybody had a lei on," says Maile Meyer, about growing up in Kailua, surrounded by her cousins in the Meyer-Aluli family who all lived next to one another on Mōkapu Boulevard. "You could tell at a party who was from Kailua, because the women always wore flowers in their hair. That was a trademark of Kailua."

Meyer, who owns Native Books Hawaiʻi in Honolulu, recalls learning to kui lei from ginger and plumeria early in life. Her father, Harry King Meyer, started as the manager of the Hawaiiana Hotel in Waikīkī in the early 1950s. He paid her and her siblings twenty-five cents a day to make lei for the hotel guests.

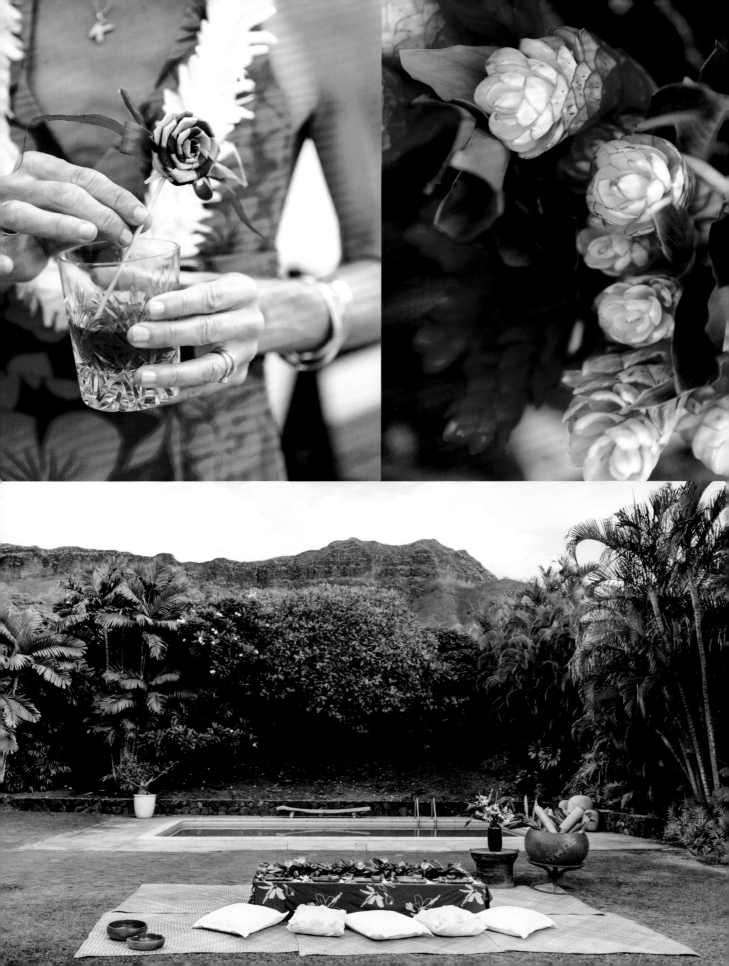

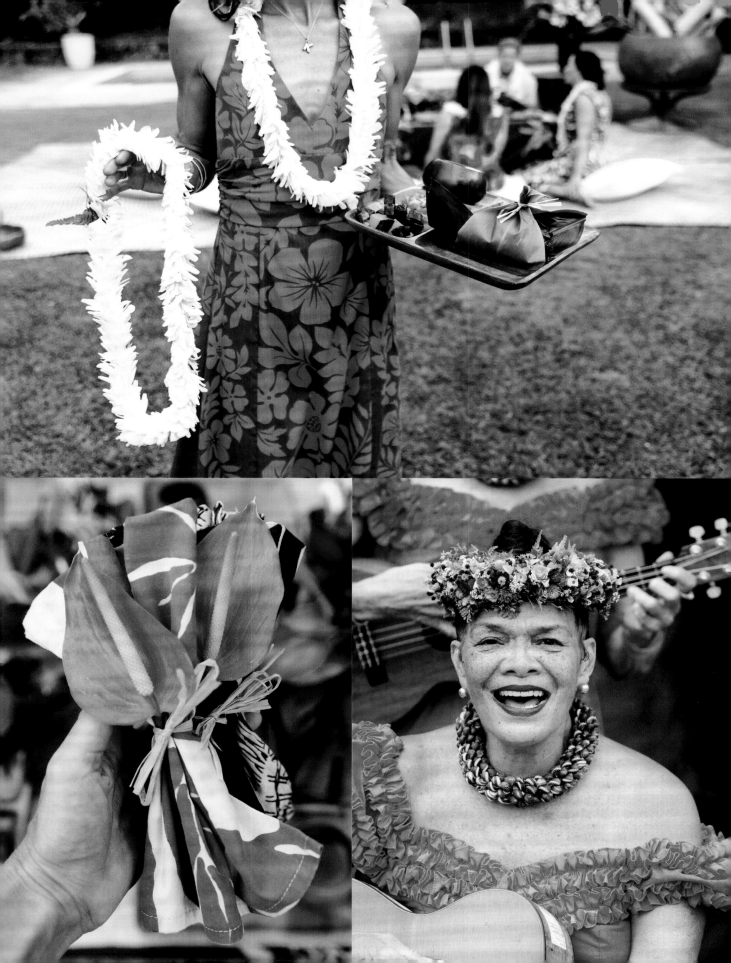

Her parents taught her that part of being gracious when visiting someone was to always bring a gift. For her family, that gift was a lei whenever possible, a tradition that she continues today. "Whenever I can, I make a lei. I look for whatever flowers are growing, starting at my home. I always have a lei needle in my car. If I can't make one, I'll go down to Maunakea Street and buy a lei from generational lei sellers. I tell them, 'Just give it to me so I can put it on my arm,'" forgoing the plastic bags shops often use to wrap lei. "I like to walk around with lei on my arm and then come into an event."

"You always go with a lei. You always wear a lei. And you always give a lei," echoes Meyer's cousin, Mihana Souza, singer and guitarist for Hawaiian music group Puamana, a beloved fixture at kama'āina backyard lū'au for three generations. Though she loves flower lei—plumeria, ginger, and pīkake in particular—she used to keep plenty of shell lei on hand for last-minute invites when she wouldn't have the time to pick up or make something fresh. "I [have] tons of shell leis because you want to give a lei to everybody," she says, noting that at old-time Hawai'i lū'au, there would be an exchange of lei between guest and host, with some families making more than four hundred plumeria lei to give out to friends and relatives who came.

I love the ritual of making a special lei for the guest of honor at a celebration—finding the exactly right hot pink shade of plumeria to kui for one of my girlfriends or making a lei po'o with lokelani rose, Maui's flower, for someone with roots in Kula. The time it takes to make the lei also gives me space to reflect on our relationship and put my love for them into the lei before I get to the party.

"You definitely need to have a clear mind and all the right spiritual bracings before you make your lei," says Ane Bakutis, a conservationist who learned to make lei through the hālau hula she attended as a child growing up in Wai'anae, O'ahu. "Why are you making this? Who are you making it for? What do the plants in it represent? What is the mana [spirit] that those plants bring to the lei?" Bakutis considers materials, like koa, for strength, or mauka (inland or mountainside) plants, if the recipient is a mauka person. When she made lei for hula, her class would pule (say a prayer) before beginning, to clear their minds and make sure their attention was on the lei and its purpose. She says that mindset is still important, even outside of the hālau hula. "[The lei] still carries the intention and everything that you're putting into your lei is intentional."

"I like trying to do [something] different, for example, the hīpu'u [knotted] and hilo [twisted] styles," says Malia Nobrega-Olivera, a cultural practitioner and educator. "[I'm] always trying to bring those back." These traditional styles, which use no outside material other than the plants, are less commonly seen. Hīpu'u, usually made from kukui, involves knotting the stem of each leaf to each other to form a chain, while in hilo, the lei material, commonly ti leaves, is twisted together in a rope.

For her fiftieth birthday, Malia Nobrega-Olivera, who won the title of Lei Queen in 1995, gathered enough lapalapa to make fifteen lei in the hīpu'u style and brought them to O'ahu to celebrate with her friends. She wants to make these old techniques as popular as the lei po'o and wili style. "We were just having fun and taking pictures. Everybody was looking at us like, 'Why are you guys wearing all these leaves?'"

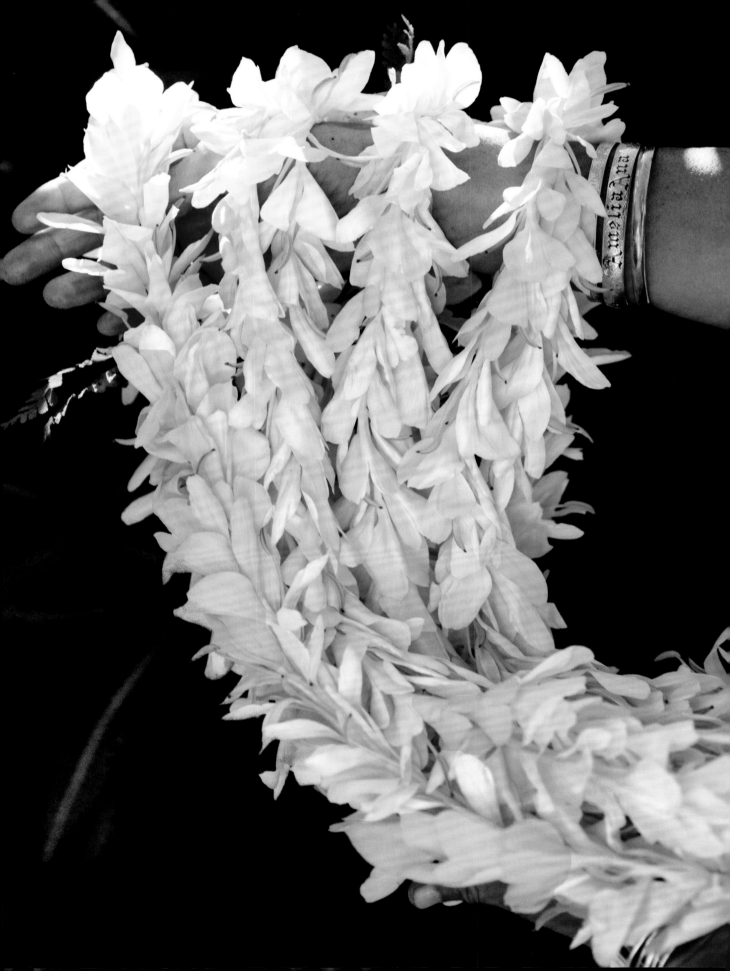

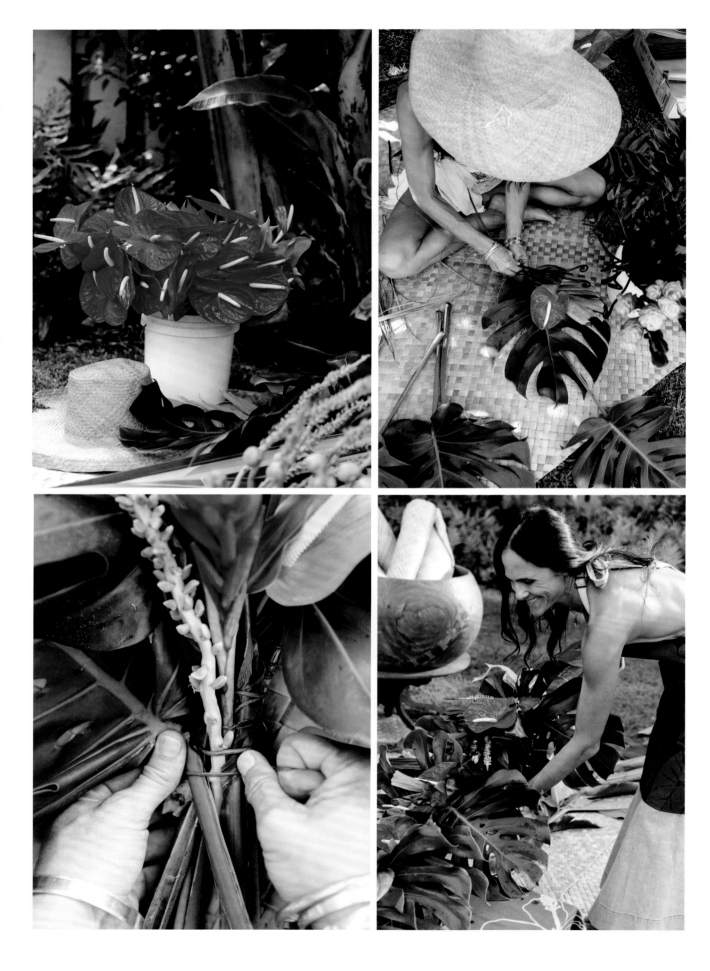

An event's importance is often a consideration when choosing lei to make or bring. "It's always something when it's the most special occasion or someone means so much more to you—that's when you're trying to get the five-strand pīkake or the twenty-strand pakalana," says Honolulu lei maker Amanda Iaukea, about selecting extra-special lei for people at important events and celebrations. "It's [any lei] that takes more thought and care—something that's harder to pick or harder to take care of."

Even so, she says there's "nothing better than when you're making it from your own house and your own garden." These days, Iaukea is especially enamored with the simple single strand white ginger lei—especially when it's handmade. "The people, you can see that it touched them. We all have fun making [lei] so fancy. But it doesn't have to be, right? The most simple lei made are the ones where people cry the most."

My auntie Conne Sutherland, who ran an event-planning business for years, loved anything with fragrance for parties: pua kenikeni, plumeria, or pakalana. For sit-down dinners with "old-timers," she would give out delicate ginger, one of my mother's favorites. "I started doing ginger because the feather ginger lei was so pretty. It takes way more flowers, but it's so beautiful. You feel like royalty when you wear it," Sutherland says about the kui-style lei sewn so that the petals fan out, making the lei fuller. I love to give guests ginger because the paper-thin flowers drape beautifully and their neutral color—in ivory white or pale yellow—make an elegant touch for any outfit.

"I like it short," says Sutherland, about her preferred length of thirty inches. "It goes over your head and it's closer to you, close to your sense, you can smell it. It's aromatherapy. I always say the flowers are smiling, whether you make it an arrangement or lei, it smiles at you."

Because so much thought, aloha, and mana go into the gathering and making of lei, etiquette extends beyond lei giving to how you wear and even care for the lei long after the party. "You wear it the whole night of celebration in [the giver's] honor instead of throwing it on a chair or table or tossing it aside," Sutherland says about how a recipient should treat a lei—even if they have lei piled up to their eyes.

However, keeping lei on is not the only way to honor these precious gifts and their givers. "You can share the lei abundance with your friends and guests," Sutherland explains. "I remember my grandma telling me that when someone gave me lei, I had to ask permission before I could give it to someone else. The lei is [the giver's] wish for you."

Opposite, bottom right: For my ʻohana's parties, we adorn everything from the guests, to the host, to the table. I love to make a long lei for the table using the wili technique. The lei takes more than half a day to make so the materials need to last. Sturdy, large leaves, like monstera, make a good base, while bright anthurium blooms and niu (coconut) seeds make colorful and textural accents.

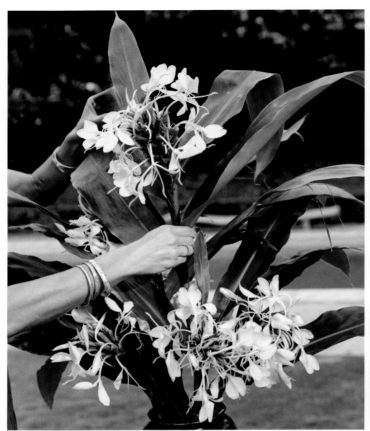

Aloha Attire Requested

Along with lei, aloha attire was important at any family lūʻau. Tūtū made the men in our family dress in matching Nakeʻu Awai aloha shirts she bought for important events. Tūtū, our mother, aunties, and even us girls, wore muʻumuʻu.

The name "muʻumuʻu" has become a catchall for many eras of Hawaiian dresses. High-necked, long-sleeve holokū date to nineteenth century missionary influences, while loose and flowy, loudly flowered A-frame dresses emerged in the 1960s. "There really is a muʻu out there for every occasion and every person," says my friend, Shannon Hiramoto, a champion of the muʻumuʻu whose latest venture is the Muʻumuʻu Archive, an online compilation of muʻumuʻu photos and moʻolelo (stories).

For local designers, who draw inspiration from the colorful flowers and plants in the islands, the beautiful prints are a way of celebrating our culture of lei. "We just did an ʻilima for Auntie Honey Kailio, who was always selling ʻilima lei," says my auntie, Manuhealiʻi founder Danene Lunn. Nakeʻu Awai, recognized as the first Kanaka designer and a friend of my tūtū, has a back catalog full of botanical-style prints: mokihana maile, ʻulu, hāpuʻu fern, ʻilima, gardenia, and double maidenhair.

"You could be as understated as you like or you could be as overly dressed as you like and still pull it off," Lunn says about dress codes, noting that dressing up in the islands is what you make of it, with one exception. "You have to wear lei. It doesn't even have to be on your neck, it could be on your head, your arm." Awai, who says his style is half traditional and half modern, has designed everything from monarchy inspired holokū muʻu with long trains to one-shouldered shifts, echoes that sentiment. "A lei completes a muʻu."

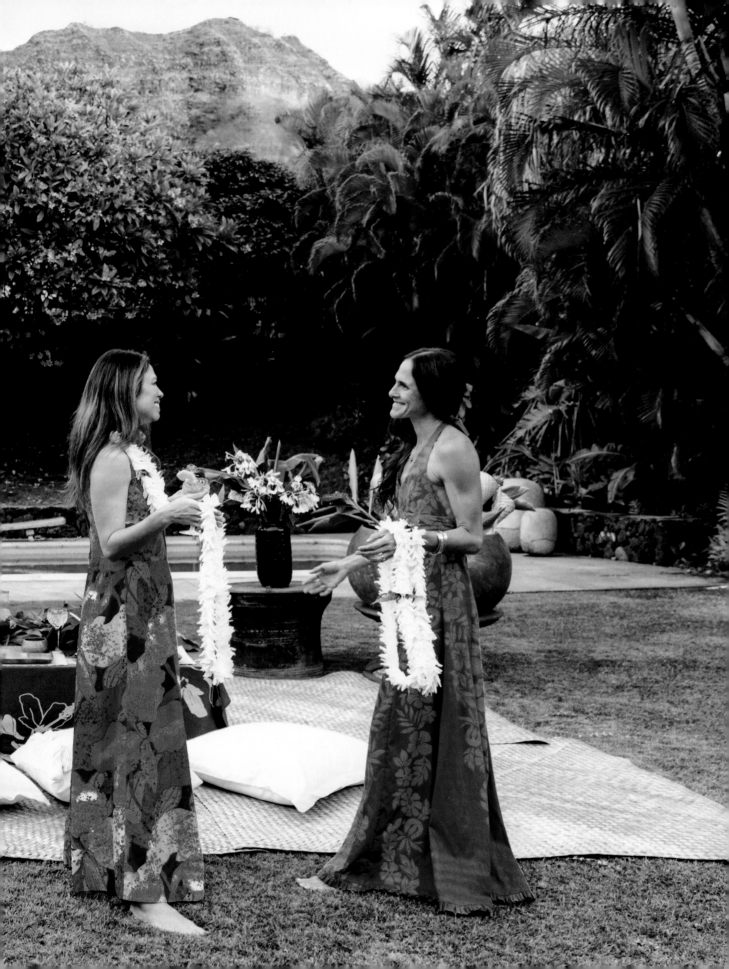

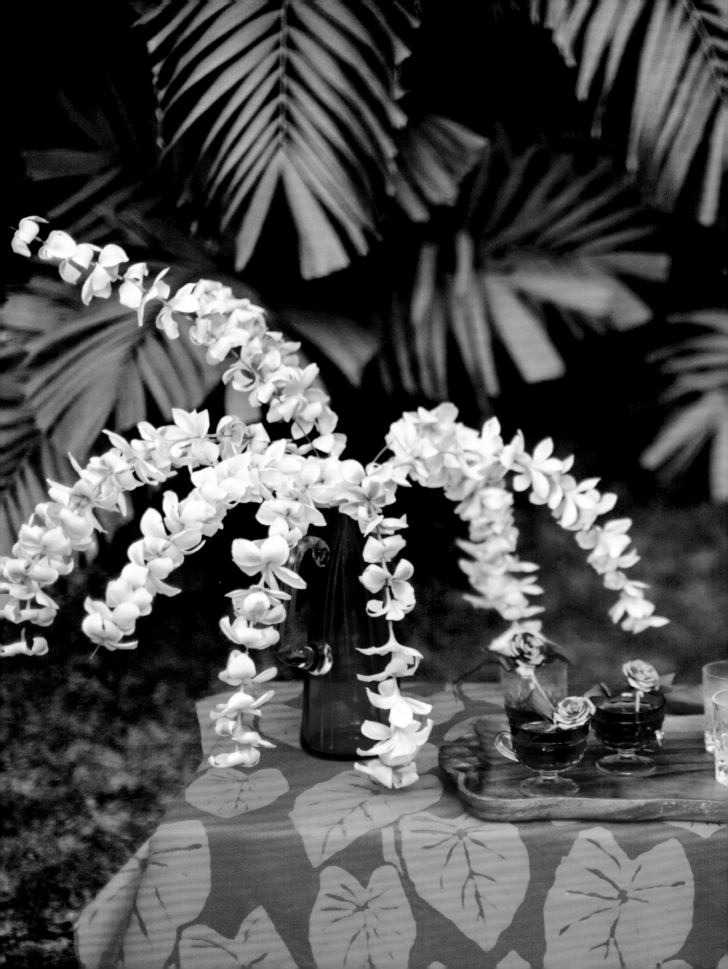

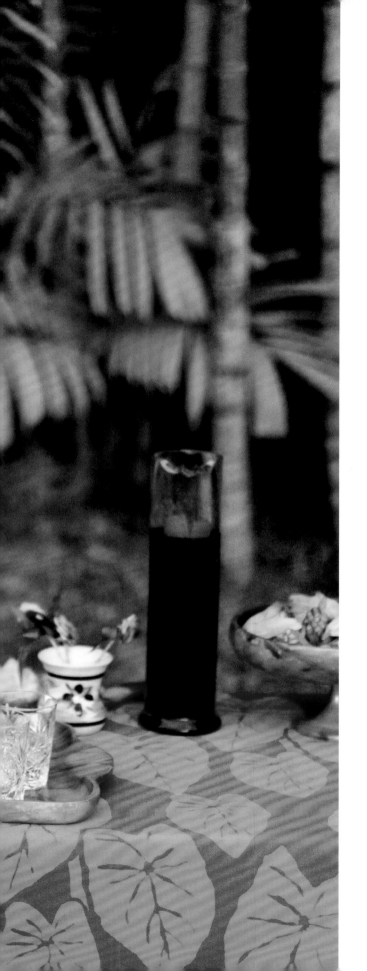

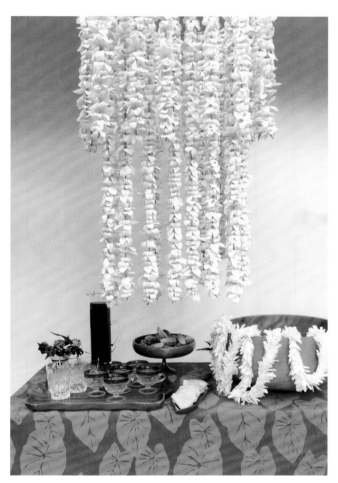

Above: Lei, like these made from pua melia, make a beautifully fragrant chandelier.

Opposite: "Plumeria on the nīʻau [coconut frond ribs] is a great way to decorate for poi supper and weddings," says Auntie Conne Sutherland, who helped island ʻohana plan lūʻau to celebrate weddings and other special family occasions for more than twenty-five years. "You just go with shorter nīʻau, depending on the width of your table. Then sometimes at parties, at these weddings, someone took the nīʻau and they [put] it in their . . . ponytail. It was sticking out and they were dancing, wild dancing."

Kumu hula Robert Cazimero learned a similar yet slightly different lesson about giving away lei from his kumu hula Maiki Aiu Lake. He had made a special lei wili out of blue hydrangea for one of her performances, but she gave it to someone else. "I guess I couldn't hide my disappointment very well," he says. Noticing his reaction, Auntie Maiki told him, "They'll never have a lei like that. But now they can tell people that they did, and that I gave it to them, and that you were the one who made it." Cazimero still wasn't happy but experienced the reverse at another show months later, when Lake gifted him with three strands of hala that had been made for her by someone else.

"I do it all the time now. Especially, when I have lots of pīkake, at the end of the night, I give them all away to different people. Sometimes they'll say to me, 'Why are you giving your lei away? That person just gave it to you. I'm nobody.' I say, 'but you're somebody to me at this time.' That is one of the lessons about the lei that stands out to me for this very day."

For family parties, our passion for adorning people with lei and flowers extended beyond giving lei to the decor, too, almost like giving a lei to the party. "Our job for our branch of the family was the adorning: adorning the people, adorning the tables, adorning the tent, the poles, and the stage," says my sister about the way our extended family would designate roles for a big pā'ina (party), like a lū'au. "We love to eat and we love our food, but our strength as a family wasn't making the lū'au food." That was done by Tūtū's sisters' families, Auntie Nan and Auntie Marcella, and is carried on by Marcella's daughter Nancy Souza. "My auntie, she always made the cakes, and my mom helped her, my grandmother made the chicken long rice," reminisces Souza, who used to attend lū'au in Waimānalo on the Bredy side of her family. The work would begin the week before, with her father, who loved to dive, gathering the squid and tako (octopus) and doing the prep work on the imu (underground oven). "My grandfather always would work the squid, to soften it and everything, and one of my uncles, he made the squid lū'au. We always had lomi salmon, so I think everyone pitched in to cut tomatoes and onions and everything." Everyone got assigned a role—even down to the decorations. "I had one auntie who would always weave the coconut [fronds] to use as backdrop."

While there are no rules when it comes to lei or decoration, it's common for friends and family to pitch in to help set up, arriving with their car loaded with materials, often utilizing heartier plants and flowers found in backyards: ti leaf, coconut fronds, laua'e, torch ginger, and any type of flower in bloom. Talented hands might be charged with making lei for the table, wrapping pū'olo (bundles) with a neighbor's citrus inside.

"If [the lū'au] was for the opening of the salt season, they would have an imu and then they would all invite everybody to come," says Malia Nobrega-Olivera, about the gatherings her grandparents would have at their property in Hanapēpē Valley on Kaua'i. Her grandfather was the first president of Hui Hana Pa'akai o Hanapēpē, an organization dedicated to protecting the historic site of the salt flats in Hanapēpē, where Native Hawaiians have gathered sea salt for centuries. "Besides the imu, which was a big part for the guys, for us as the wāhine, it was all the decorating, like how Tūtū always did, and we all had to jump in."

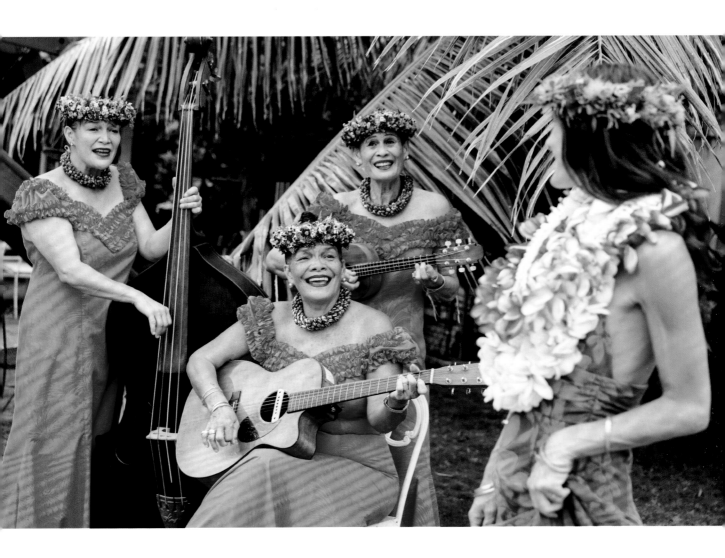

*"When [Tūtū Amelia] walked in, you knew her
song. You knew what Auntie Mae [Loebenstein]'s song
was. You sang that song. If they wanted to dance, then
they danced. It was that whole connection again—
giving a lei by singing a song."
—Kumu hula Robert Cazimero*

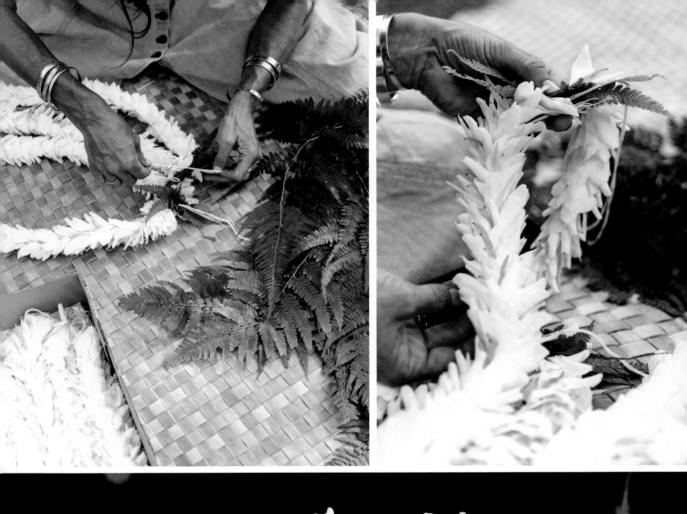

Nobrega–Olivera, a cultural practitioner, former Lei Queen, and educator at the University of Hawai'i, remembers building tents with bamboo poles and weaving coconut fronds to use as decoration at these parties. She describes the scene as "flowers on the table, ti leaves all over, just a lot of greenery."

"People came decked out and just ready to party. Even though it was just to Mr. and Mrs. Chu's house next door, or in walking distance, they came with their beautiful mu'us, their lauhala bag as if they're going today to the Hawai'i Theatre," she says, noting that at the time it was more common to see lei kui rather than lei po'o worn. "When I look back at all the old pictures, it's just so beautiful."

To keep the kids busy at the lū'au, Nancy Souza remembers, they were usually in charge of laying out laua'e leaves and sprinkling plumeria over the table. "I remember making the little ti bowls and then putting in the flowers—that's where creativity comes in. You let kids do it and they want to decorate each leaf." They also strung small plumeria lei to hang from the coconut weaving.

"It was huge for me," says Souza about her experiences at these parties as a child. She founded a catering business with many of the recipes she learned from her family, serving 150-person lū'au on wooden plates to Governors George Ariyoshi, John Waihe'e, and Benjamin Cayetano. "It wasn't anything difficult to do because I'd been doing it my whole life, so to cater a lū'au was, was easy and simple. And I had a lot of success with that and that's because it's what I learned growing up from my mom, my aunties, my uncles."

Meanwhile, our tūtū, who would throw lū'au for birthdays, weddings, and anniversaries in her yard in Mānoa, had decorating down to a script. My sister, Mehana, remembers, "There were always poles to be ti-leafed, stages to decorate." Many of the decorations were done with greens, like ti and laua'e, though occasionally flowers would be incorporated. "Auntie Haunani was always in charge of making the yellow ginger arrangements. Those were a lot of work. You have to clean them and take off all the wilted ginger and prepare them so the new gingers are blooming during the party."

At smaller gatherings where there are enough people for one or two long tables, we often decorate with table runners, essentially a big lei for the table. My tūtū's table runners were more precise, while my mom's were more freewheeling. I like to make them with the event in mind—choosing pink and red accent flowers when I know people are showing up in the bright colors of vintage mu'umu'u and aloha shirts, whites and ivories for a wedding, or subtle greens and browns for a more dressy event.

Opposite, bottom: The full and fragrant feather style of ginger lei is a longtime favorite of my 'ohana to share at gatherings.

Pūʻolo

My tūtū had a way of making the act of gifting lei into its own event. She wrapped each lei in a ti leaf pūʻolo, a bundle, adorned with a small matching nosegay. When I'm taking lei to a party, I make pūʻolo tied with a ti bow or a full lei ʻāʻī (neck lei) draped around the top.

At parties we use pūʻolo to decorate tables. We fill them with oranges, lychees, lemons, or avocados from the yard, top them with small lei wili, then give them to guests to take home at the end of the party. Though strikingly beautiful on its own, it is the act of filling a pūʻolo that makes it more than an arrangement of ti leaves. "The pūʻolo has become a symbol, but people will use the pūʻolo by itself empty as a hoʻokupu [ceremonial offering]," warns kumu hula Manu Boyd. "To me, the pūʻolo is kind of the Ziploc bag of our kūpuna. Sometimes you can put a little lei around the neck, but there has to be something on the inside."

To make a ti leaf pūʻolo, gather seven to ten ti leaves and place them on a flat surface in a circle, overlapping one by one, bone side up with the stems in the center. Tie the stems together at their base. Place your lei, fruit, or whatever's in season to be shared on the leaves in a circle around the stems. Beginning with the last ti leaf you laid down, bring the tip of the leaf up to meet the stems. Repeat until all leaves are wrapped in, forming a package. Tie all of the leaves to the stems with raffia or twine. It helps to have two sets of hands for this. Then add something to decorate the top and VOILÀ!

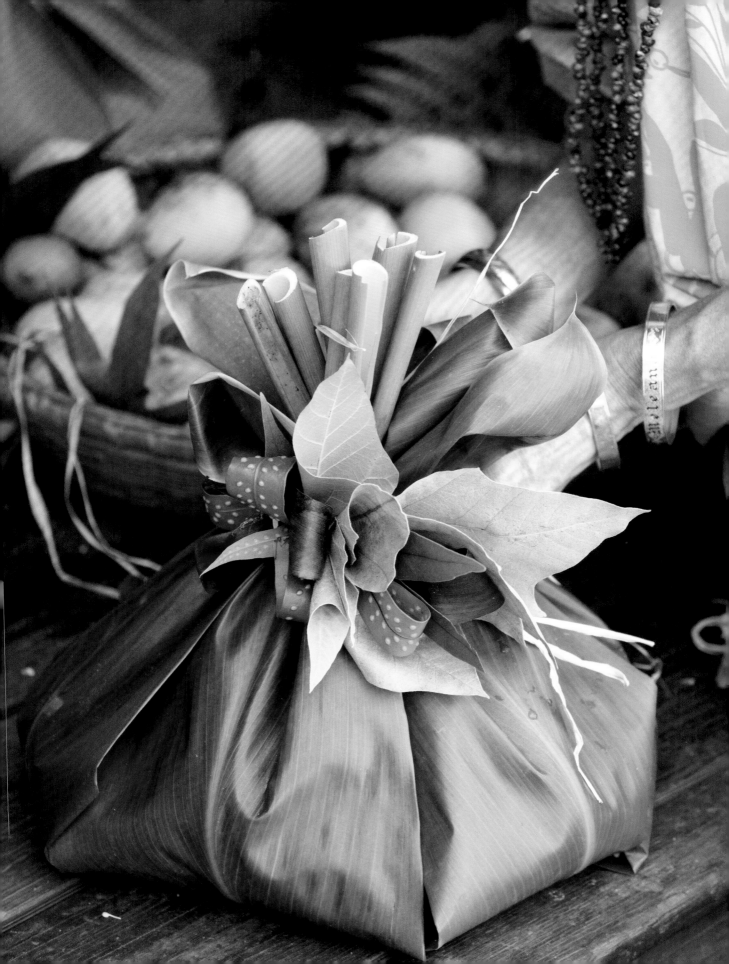

I always start either the day before or the morning of the gathering, using a base of sturdy greens: monstera, laua'e, or even kukui. From there, I wrap in pieces for texture, like coconut fiber. Anything that might wilt over the course of a day can be added in at the last minute. Often while I'm sitting under the tent making these giant lei, I'll be looking around the yard for inspiration, my cutters nearby, ready to incorporate an interesting-looking palm frond or fern.

A lei for an event is more than just an accessory; lei and flowers influence everything from the way we dress to the music we play and the hula we dance. At my family lū'au, where my uncles sing and play music, my aunties and cousins jump up one at a time to offer hula to their signature song—"Nani Kaua'i" or "Hula o Makee" are classic favorites. And there are hundreds, if not thousands, of mele about lei and flowers. "If I'm playing piano at an event and people walk in wearing a certain kind of lei, I'll go right into that kind of a song—that's a very Hawaiian thing to do," says Cazimero. "'My Sweet Pīkake Lei,' 'Aloha Kaua'i' with that mokihana, 'Maile Lei' . . . I just have too many."

Like certain lei, songs and hula can also become personal signatures, their performance not unlike sharing a lei. Cazimero explains, "When [Tūtū Amelia] walked in, you knew her song. You knew what Auntie Mae [Loebenstein]'s song was. You sang that song. If they wanted to dance, then they danced. It was that whole connection again—giving a lei by singing a song. That goes back to kahiko [ancient] times. You write a song as a symbolic lei to give to whomever you're honoring at the time. Lei is deep."

One of the most important traditions around gifting and receiving lei happens not at a party, but after. "How our lei leave us is something that [is important]. I have a pōhaku [stone] in my hale [home]. I always put my lei there until the mana is gone. [The mana goes into] the pōhaku and then I let the lei go," says Meyer, who explains that the memory of the party lingers when she looks at the lei. "I think about the party, the people, and the kūpuna I spend time with. I'm always very grateful that that little bit of Hawaiian culture is still with me. Lei—it's part of our clothing. It's part of our body's extension. It has our mana." To throw a lei away is to disrespect the person who gave it to you, the flowers picked for you, the 'āina that grew them. After an event, I hang my lei on a tree outside of my home to wait for the flowers to dry and fall to the ground, returning to the soil. As I come and go daily, I'm reminded of the fragrance, the festivities, and my friends' aloha.

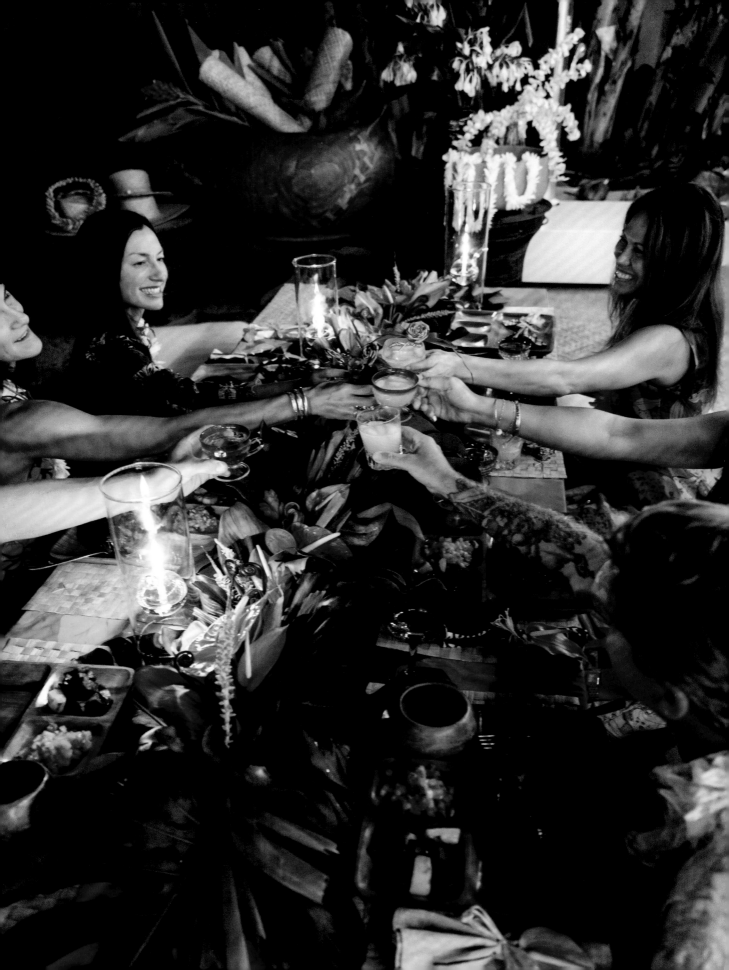

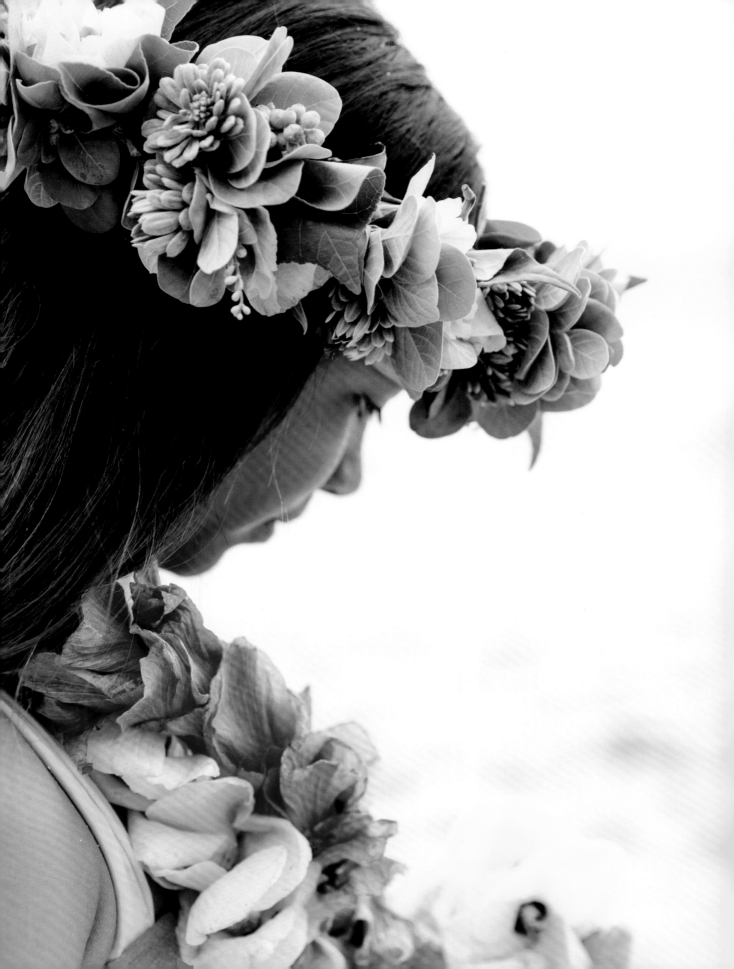

ʻĀina Aloha

Beloved Land

"Using whatever is in abundance and around
you—wherever you are in the world—
is an important lei making skill."

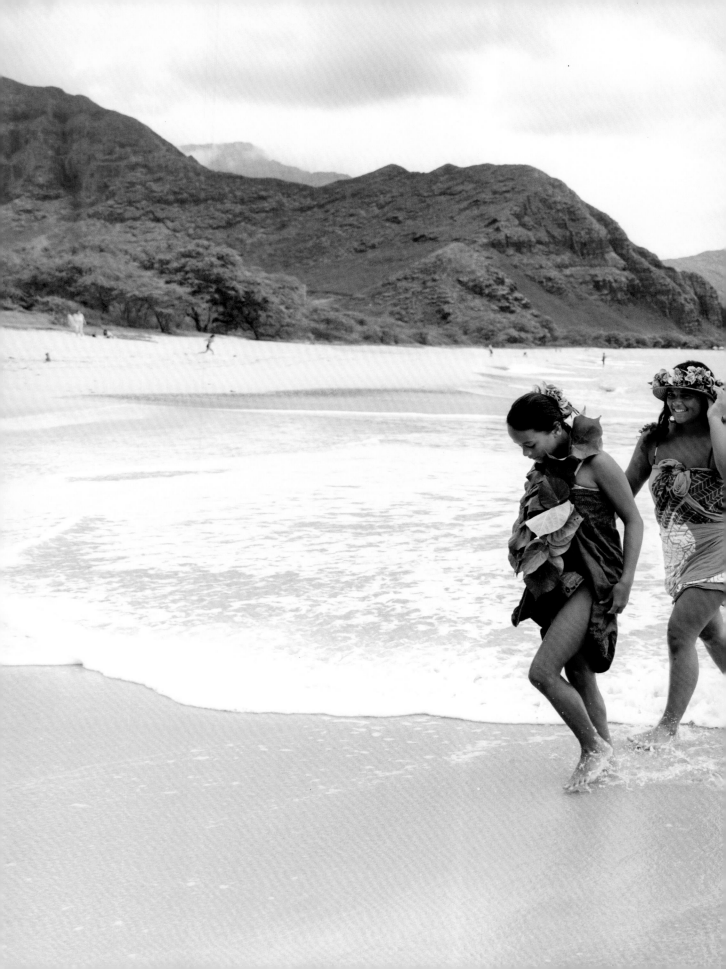

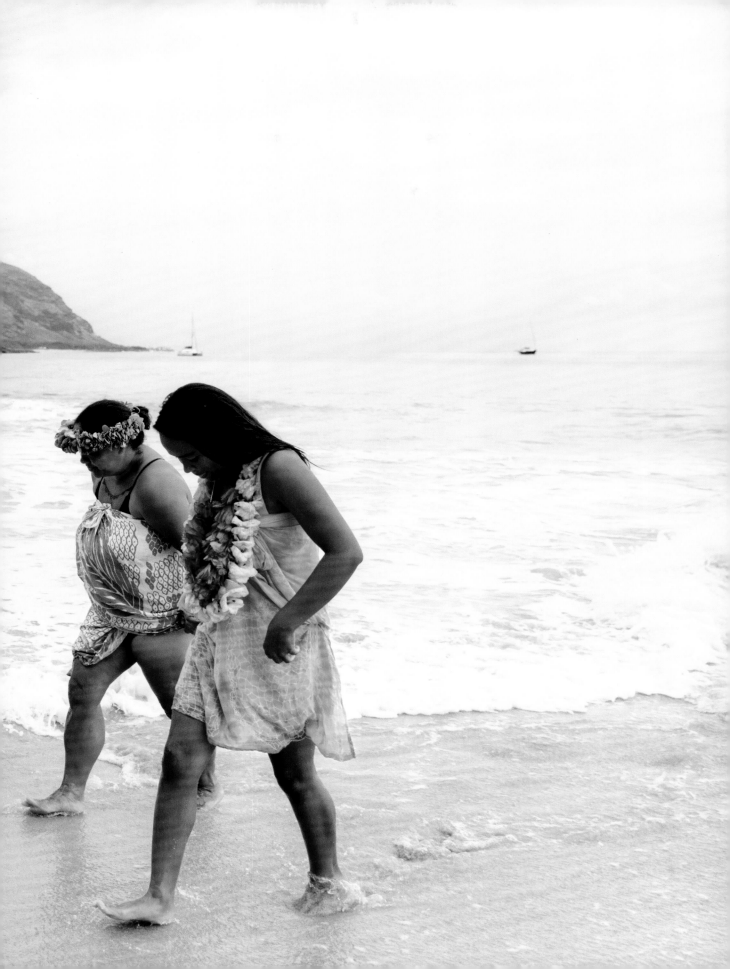

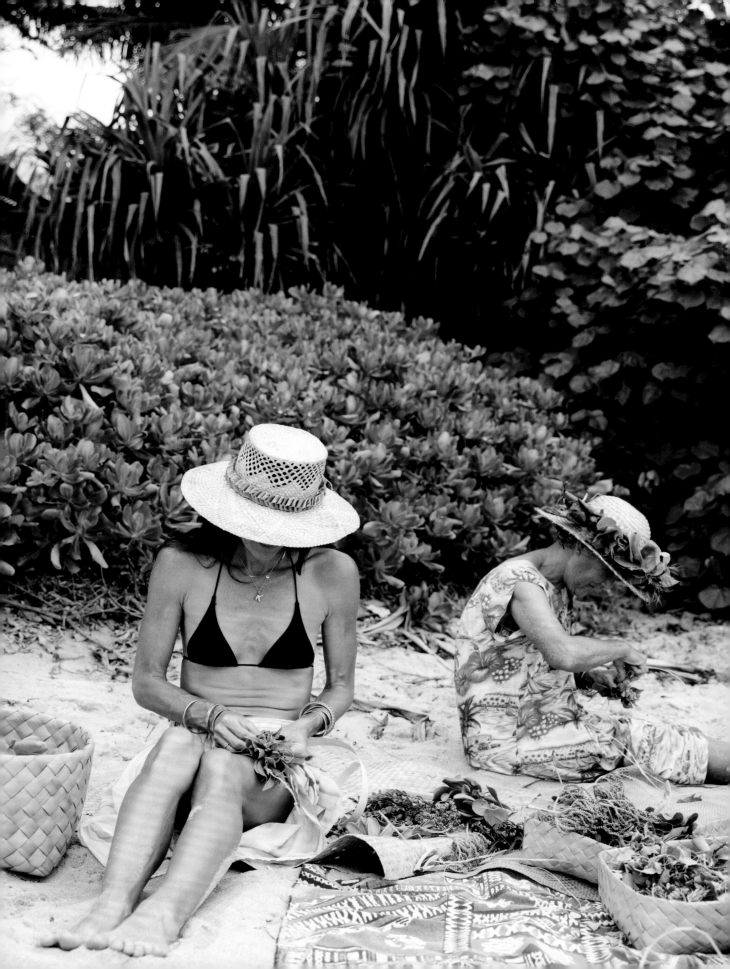

The beaches on the west side of Kaua'i were one of my father's favorite places to visit. With vast white sands stretching to the sheer cliffs of Miloli'i and Nā Pali, ocean currents run parallel to the beach and northwest swells break on long sandbars only twenty yards from shore. The sand dunes of Nohili, a sacred resting site for ancient Hawaiian remains, preside over the endless beach below, their ominous presence softened by rows of stringy deep golden kauna'oa and sprawling silver dollar leaf pōhinahina speckled with dark pink berry-like buds and dainty purple blossoms.

Our dad loved the wild open feel with views of Ni'ihau and took my sister and me as kids to watch honu (turtles) eating limu (seaweed) on the sandstone shelf and hear the sand barking under our footsteps. He wanted us to know the beauty and wahi pana (storied places) on all of our Hawaiian islands. He felt so lucky to be born and raised in Hawai'i and thought it a privilege to raise two Hawaiian daughters here as well.

Our dad passed away twelve years ago, but I still feel his excitement for island adventure when we drive to the west side. I always think of him when I hear the mele "Nohili E," which celebrates the place. This past Thanksgiving, we stayed on the west side and took a day trip to the beach. My sister and I picked kauna'oa and pōhinahina from the sand dunes. I twisted the kauna'oa into a lei to place over his photo at my mom's house in Kīlauea, a lei touched with the 'ehu kai (sea spray) and salt air from this place he loved so much.

From the pūkiawe of Kula to hydrangea of Kōke'e to 'a'ali'i of upcountry ranches on Hawai'i island, there are plants that I associate so deeply with certain places that it's hard to not make them into lei whenever I visit, just to celebrate the occasion of being there. Sometimes I leave a finished lei as an offering to the place, as we did with my tūtū on hikes when we would hili (braid with one material) a lei from pala'ā, a native lace fern, picked on the trail.

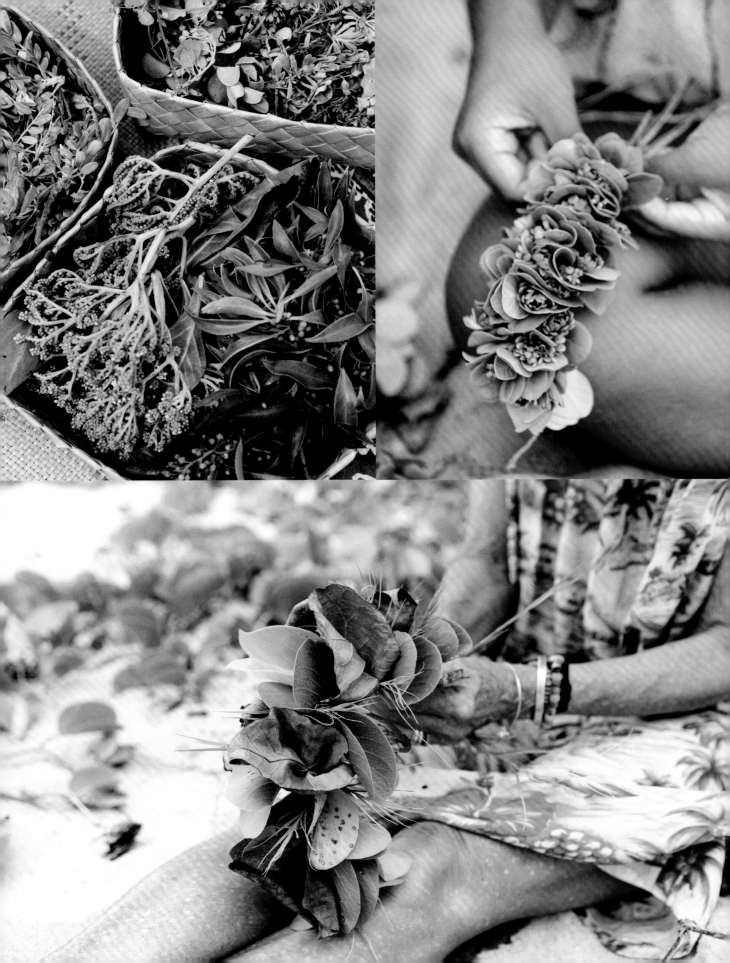

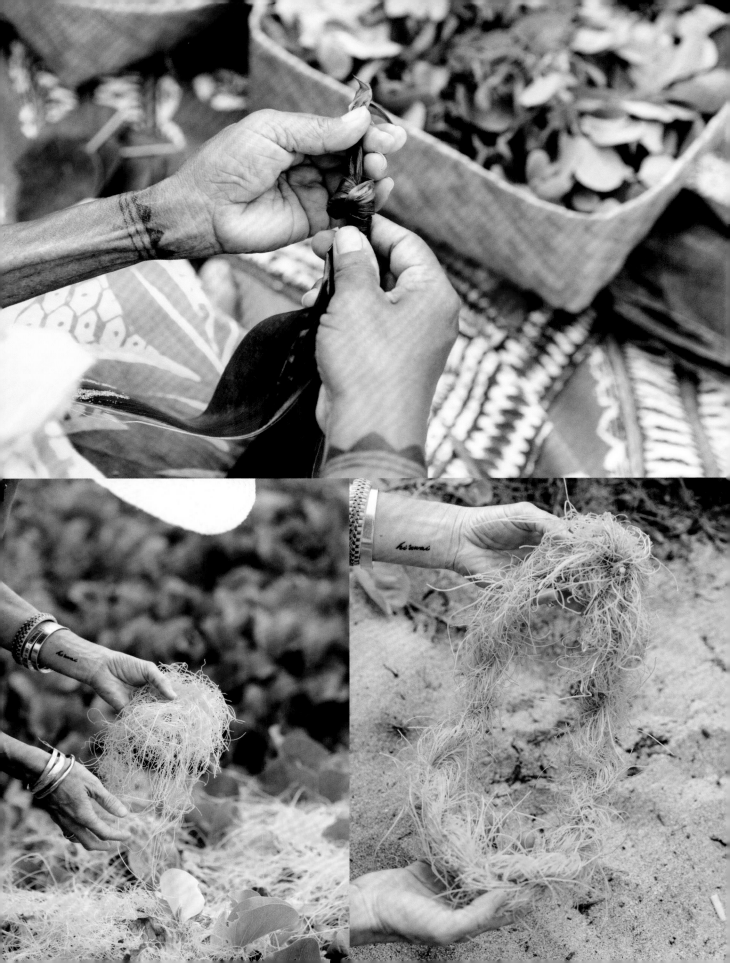

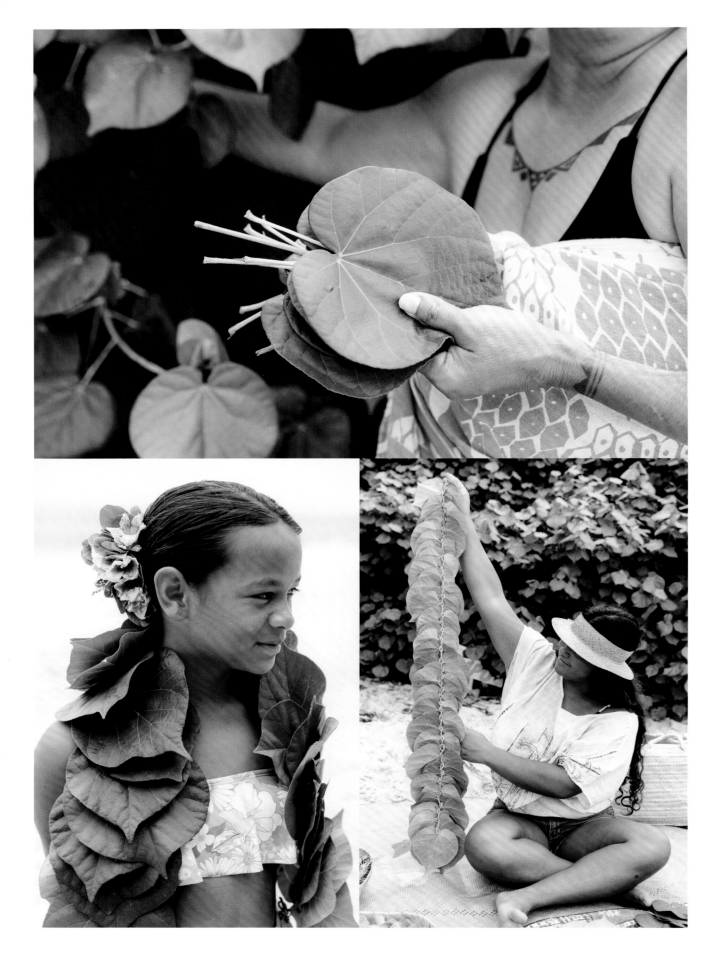

Gathering to make a special lei of place, like any gathering in Hawai'i, requires a relationship with that place across generations in order to take care of it and understand what abundance looks like. Hawai'i's first written laws limited gathering to those who lived within an ahupua'a (island division that usually extends from the uplands to the sea). The idea of "take care before you take," remains fundamental today and all those sharing their stories in this chapter have relationships to and help take care of the places they gather.

For Ānuenue Pūnua, a Hawaiian cultural practitioner and lei maker, Mākua on the island of O'ahu is a storied place cared for by generations of 'ohana. "There are stories that say that you could smell [the maile] just being on the shore—that's how prevalent it was," she says of the maile lau li'i (small leaf) that grows in Ko'iahi, a ravine in Mākua after which she named her eldest daughter. Her second daughter is named for Ma'aloa, an endemic endangered shrub, a particular variety of which only grows in that valley, and her third daughter, Kūla'ila'i, for a rock outcropping in the water—names she explains form a chain, or lei, from valley to sea.

Mākua has great cultural significance for many Hawaiians with several important legends attached to the area. Archaeological reports show the valley was a site for fishing and canoe landing. The valley was used as ranch land in the 1860s, post-missionary contact. In the 1920s, the United States military began utilizing Makua Valley for training, eventually signing a sixty-five-year lease with the Territory of Hawai'i, then conducting live-fire training and bombing until 2004, destroying cultural and ecological sites.

Pūnua's family has deep kuleana to the area. Her daughters' great-grandfather on their father's side, Fred Dodge, a local physician, helped found Mālama Mākua, a nonprofit that helped stop the bombing and continues to lobby for the land, which has been occupied by the US Army for nearly a century, to be returned to the Native Hawaiians. Their hānai (adopted) auntie, Leandra Wai, lived in a camp in the area in the 1990s with hundreds of other Hawaiians before being evicted by the state, but she still returned daily to tend to the coastal plants in the area she called her home. Wai was a gifted lei maker who would frequently use these plants in her craft. "When we would come down here, we'd help her trim," remembers Pūnua, pointing to an area filled hau, naupaka, hala, kauna'oa, and pōhuehue vines when I joined her family on a beach day. "Under all of this brush, there's a beautiful rock garden. She would find pōhaku (stones) that would come up and she would make her own little wall."

Years of observation of the area has allowed Pūnua to have a deeper understanding of the plants. "What I've been told about hau is, wherever hau is there's always a fresh water source." She indicates a particularly abundant bush on the beach with no visible water around. "If you just swim right out here," she points out to the ocean, "there's a little patch ... you'll see bubbles [from the fresh water source] coming out into the ocean."

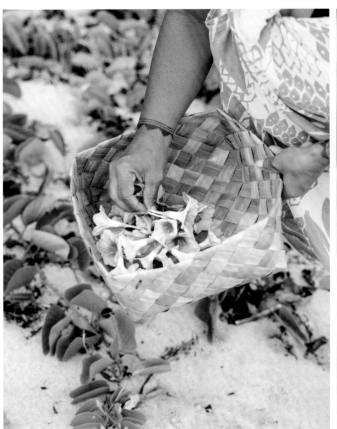

Hau, a member of the hibiscus family, can be a versatile plant for lei makers, though it's rarely found in a lei shop. On the day I joined them at Mākua, in between jumping into the water to cool off from the heat and body surfing in the rolling shore break, Pūnua and her three daughters sat on the beach and made an impromptu lei set out of hau. Koʻiahi tied the stems of the oval leaves together in a knotted style called hipuʻu that is often made with kukui or ʻōlapa leaves. Maʻaloa strung the delicate yellow flowers, which turn a burnished mahogany shade when they fall or are picked, together in the kui pololei style (strung in a straight row). For another lei, she strung stacks of the individual petals together for a fuller look. Pūnua used both the leaves and the yellow flowers in a lei haku, using ti to braid in other coastal plants including pōhinahina and naupaka. With just this one plant, they had come up with four different ways to represent Mākua.

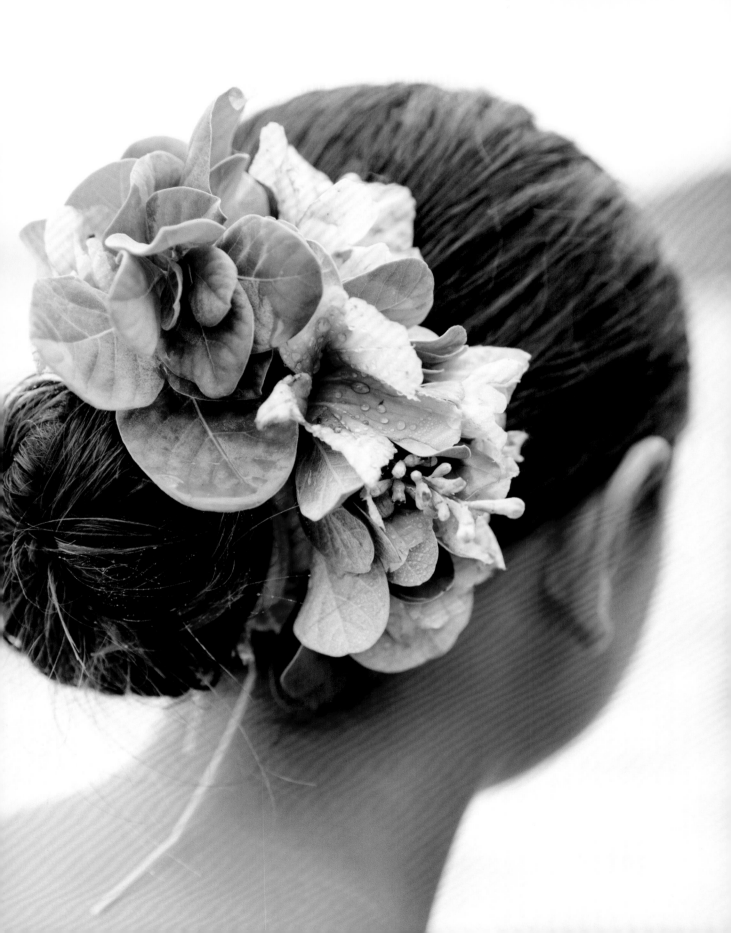

Make with What You Have

When I left Hawai'i to attend college on the mainland, a lei sent from home cured my homesick heart. For my birthday, my tūtū would make lei po'o from materials in her Mānoa yard—one for me and one for my roommate—take them for an inspection at the airport agricultural station (necessary if you want to ship plant material out of Hawai'i), and send them in the mail. When I opened the carefully packed box, lei placed between layers of ti to keep them cool and fresh, it was like being transported back home. I felt her love as clearly as if I was standing on the cool cement floor of her basement garage as she tied lei po'o on my head before school on a birthday morning.

One beautiful thing about lei making is that flowers are everywhere. Once you are a lei maker, you see the world as full of lei possibilities.

Using what is in abundance around you—wherever you are in the world—is an important lei-making skill. I always travel with raffia and a lei needle in case I feel called to make a lei with whatever beautiful material I might come across. I've made lei from bright pink bougainvillea in India, hydrangeas in the Hamptons, and Aspen leaves in Colorado, which reminded me of broad lapalapa leaves at home.

Entertainer and kumu hula Robert Cazimero remembers traveling on the mainland for shows with his lead dancer, fellow kumu, and dear friend, Leinā'ala Kalama Heine. They would pull over on the side of the road in San Francisco or Seattle to gather blue and purple hydrangea for wili. "She would be the one saying, 'Stop the car.'" He smiles about how they couldn't pass up the opportunity to use one of his favorite flowers for making lei wili.

"I don't have the luxury as much as you do in Hawai'i, but there are wonderful things that we get here that I know," says Los Angeles–based lei maker Leilani Huggins, who makes lei under the name Leis by Leilani. Born in Los Angeles, her family lived on Maui for a brief part of her childhood, and at the age of six she returned to live in Los Angeles. But her Native Hawaiian side of the family made sure she learned the craft of lei on regular visits to the islands. Now she runs a successful lei-to-order business in Southern California using materials bought at markets, like gardenia, anthurium, and orchids, as well as plants sourced from her neighborhood.

Though far from her island roots, Huggins finds abundant beauty in the flowers growing in her own home area, and in weaving them into a practice shared across generations of her family. "[There's bougainvillea] on the Pacific Coast Highway, so I was able to stop and grab a gorgeous gold [color] on my way home, just to add into the lei that I had," she enthuses, reminding us that lei can be made anywhere, and teaching us to see the places we love in a new light. "It's using what we've got."

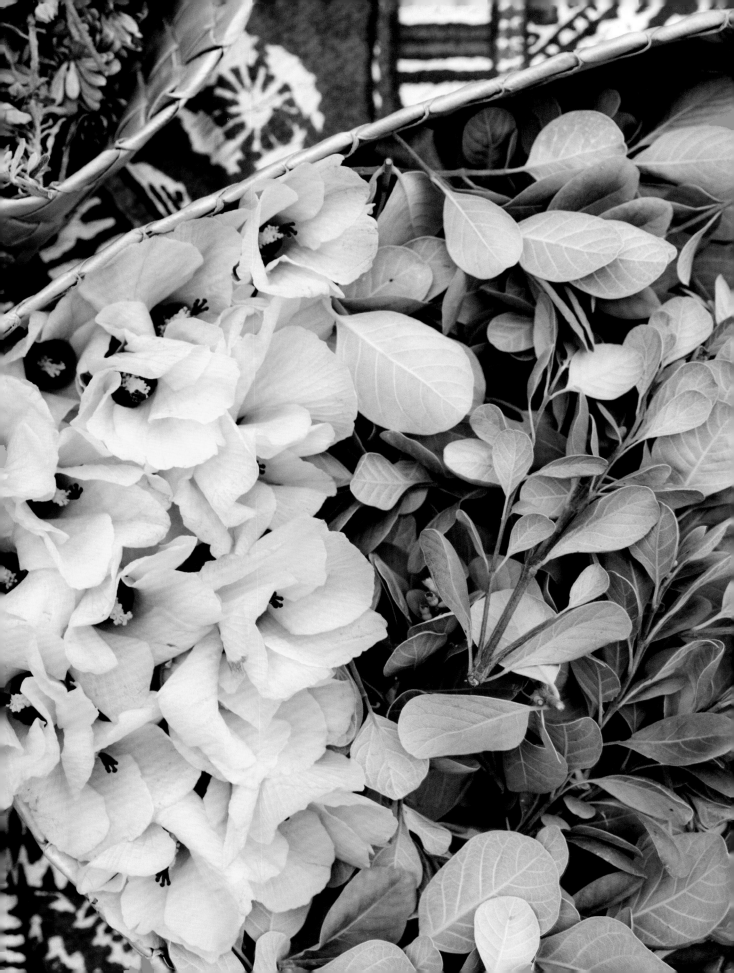

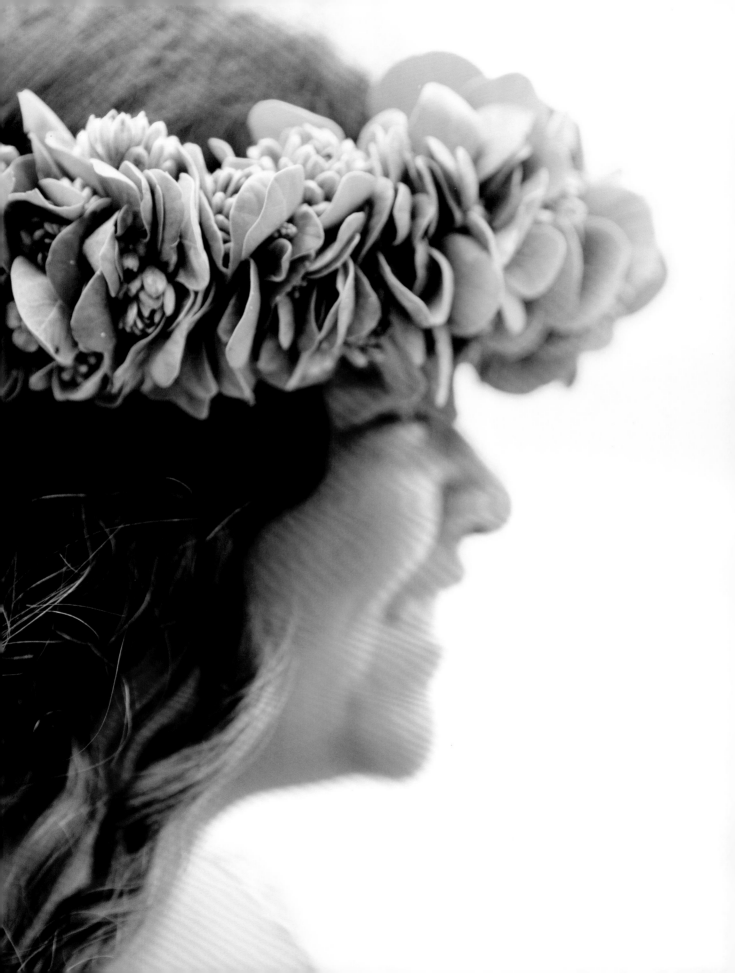

This idea of lei connected to a place is documented in Hawaiian song and music, with many mele written about a lei or flower that blooms in a particular area. "In the old days, when an ali'i was visiting a district or an area, that was a big deal and they would compose these mele called a lei, or mele lei," says Kimo Keaulana, a musician, Hawaiian scholar, and kumu hula, about the connection between music and lei. "The Hawaiian belief is that a lei of flowers and leaves would eventually die, but a lei of poetry will live on forever.

"The lei was shown to the ali'i, and if the ali'i wanted to wear it, then the lei was handed to an attendant. The attendant would put it around the neck of the ali'i, being careful that his or her hands not go above the head of the ali'i, because the ali'i is sacred. Then this mele lei would be performed. It was always done as a seated hula so that you are in a humble position, at the feet of a beloved ali'i, dancing these mele lei," Keaulana explains, noting that there are several of these types of song and dances still practiced today.

"'Lei No Kapi'olani' is a very rare dance that takes us to Ka'uiki, on the island of Maui, when Queen Kapi'olani was presented a lei of hala," he says, describing one example. "This very rare red hala was from the hala tree in Wailua, by Ke'anae, [which] grew on a cliff. To get the hala, you [have] got to climb this cliff and climb that tree—very dangerous, but for Queen Kapi'olani, of course you're going to do that for her. To memorialize this, this mele lei was composed for her."

Malia Nobrega-Olivera, a cultural practitioner who occasionally writes her own mele, says she found inspiration in a lei she makes every year in remembrance of her Ka'ai'ōhelo, her child, who was stillborn. "I always go up mauka in Kōke'e and I always can find if not just the liko [leaf bud] of the 'ōhelo, I find the berries as well," she says, referring to the endemic shrub with bright red berries that grows in high elevations after which she named her daughter.

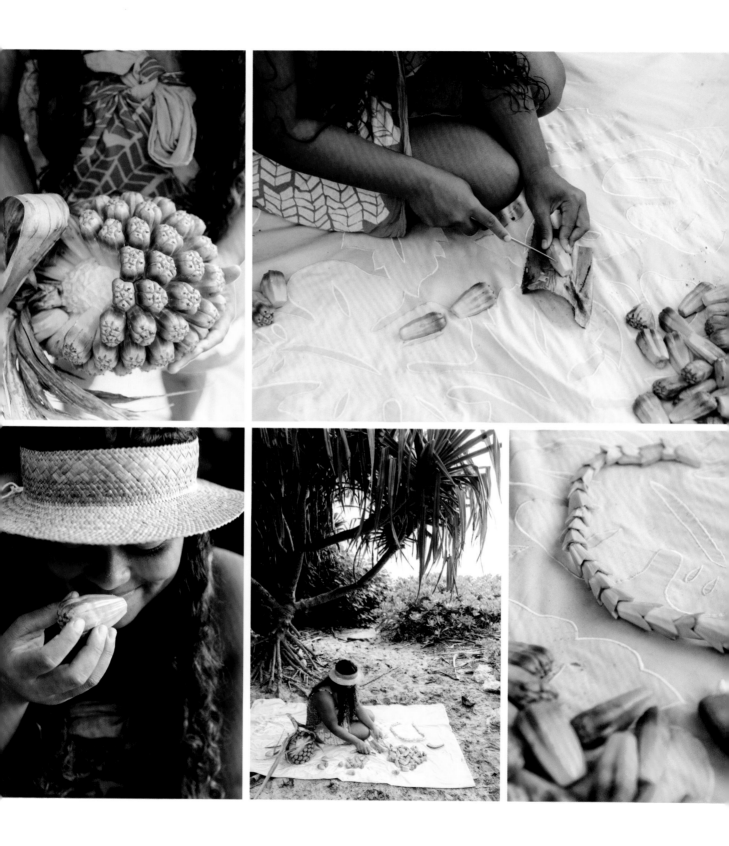

"When I went to gather the last time, I started to formulate a mele in my mind, which I haven't penned yet, but it was all about 'Ōhelo being with all of her cousins and playing. It was that kind of imagery of being up there in Kōke'e and seeing the 'ōhelo because you're always going to have to look underneath the lehua. [The 'ōhelo is not] this big bush. They're really tiny sometimes. When it catches my eye, I think she's playing with her cousins."

Lei associated with a particular place, either through a song or because it grows in abundance, are often given to visitors to the area. "I know all the lei from all the mele from certain wahi pana to mokupuni [an island]," says contemporary Hawaiian musician and lei maker Kuana Torres-Kahele. As a traveling musician, he would often be given a lei of the area in which he was playing a show. "Whenever I would go to Ka'ū, I would always get a lei kīkānia," he says. The bright orange and red fruit of the kīkānia grows plentifully in the arid climates on the south side of the island of Hawai'i, but important lei will vary, even within short distances on the island. "If you go farther into Wai'ōhinu, guaranteed you'll get kīkānia. If you stay more on the Nā'ālehu side, you get 'a'ali'i. And if you stayed lower down Punalu'u side, you get maile."

Ane Bakutis, who co-owns the Hawaiian clothing company Kealopiko and works in native plant conservation, believes that giving lei made from native plants—if you know how to harvest them properly—can be a form of education about special places and the need to preserve the forests. "When you have the chance and you know you can collect without harm, making the native lei is so important because so many people don't know what our native species look like." Hawai'i has more endemic and endangered species than anywhere else in the world. "Sharing that in a lei you can tell the story, 'This is this and it grows here, and so we need to mālama (care for) this area. Mālama this plant for the future.'"

Just as the principles of lawai'a pono (ethical fishing practices) are reasserting themselves in Hawai'i today—in community rules for harvest within local fisheries, social media hashtags, and dinner-table discussions across the islands—gathering materials for lei has its own rules of respect. While these rules vary for different practitioners and teachers, some common elements include: asking first, gathering only from places you return to regularly and taking the time to weed and care for the plants (your own yard is best!), cleaning clippers and shoes with alcohol to avoid spreading diseases, and picking only a few sprigs from each plant then moving on.

Opposite, top right: The versatile hala tree has many uses: the leaves can be dried and woven into mats, cordage, or bags. Seeds from the fruit make a strikingly beautiful lei when carved. Because the word *hala* translates as "to pass," the lei is given most often at graduations, funerals, and occasions that celebrate both closure and new beginnings.

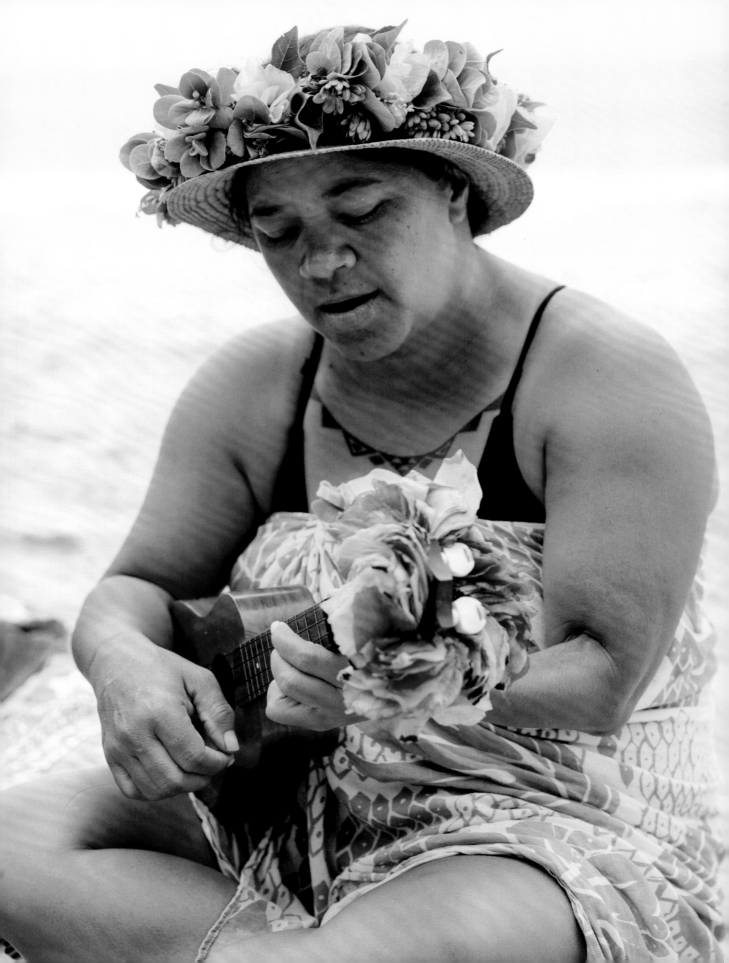

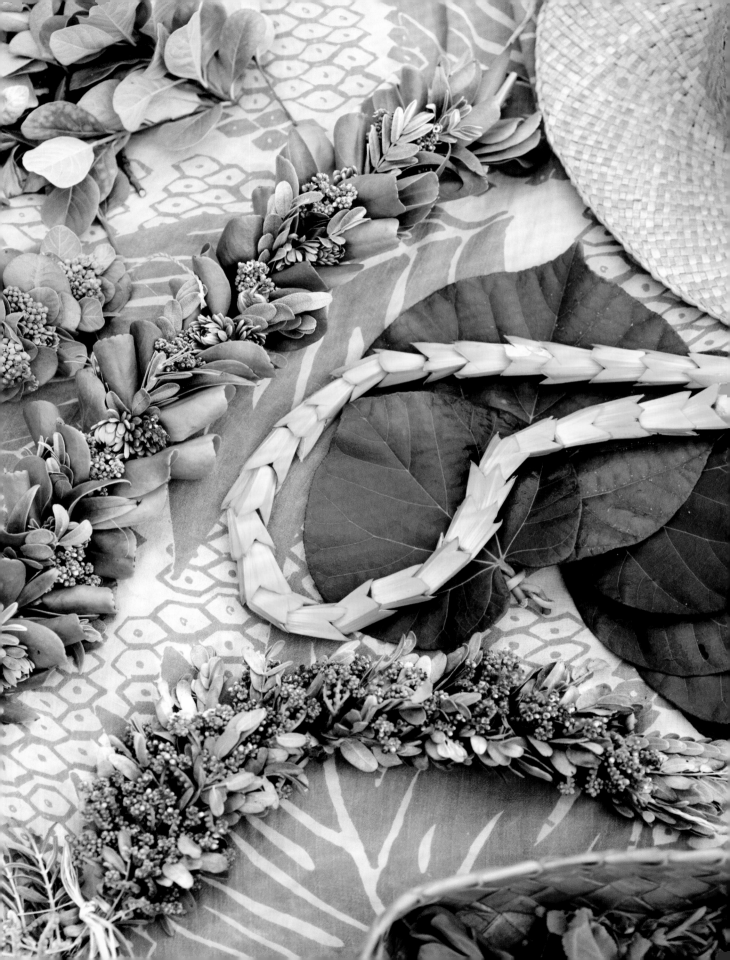

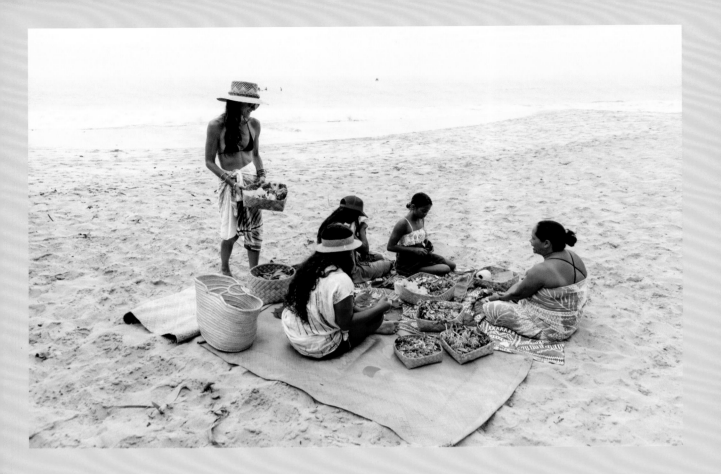

Other aspects of pono gathering include clipping material to size on-site so that you leave most of the nutrients in place and watching for changes in abundance and health to know when to let plants rest.

My sister, Mehana Vaughan, who is a professor of Hawaiian and community resource management, explains, "I see so many new rusts and galls on the leaves of all kinds of native forest species, not just ʻōhiʻa. I think it is because the forest is getting warmer, which allows new invasive pests up the mountain. When something is not growing healthily, you let it rest, so most forest plants these days I just leave alone."

Botanist Ane Bakutis also emphasizes pono (respectful) gathering, observing kapu (times of closure) to rest species, and harvesting from a variety of trees or patches of ferns, rather than from one tree. She urges respecting scarce resources by using species whose populations are healthy and in less demand, especially invasives, or plants you can grow yourself. "It's fun to use species or plants that you wouldn't normally use or you wouldn't think to use. Keeping that innovation moving forward is really exciting." She emphasizes thinking beyond the flowers typically used in making commercial lei. Kealopiko has a small lei stand and Bakutis is continually inspired by the creative lei her friends bring in to sell. One lei in particular, made from unfurled buds of a native hibiscus plant from a friend's garden, has stuck in her memory. "I was floored. I had never thought to ever use the Hawaiian hibiscus because it always wilts so quickly, but even when it was old, it looked beautiful. Just using plants you wouldn't think of in an old style is just fun and refreshing, and I think [we] need to continue to be innovative in our lei making."

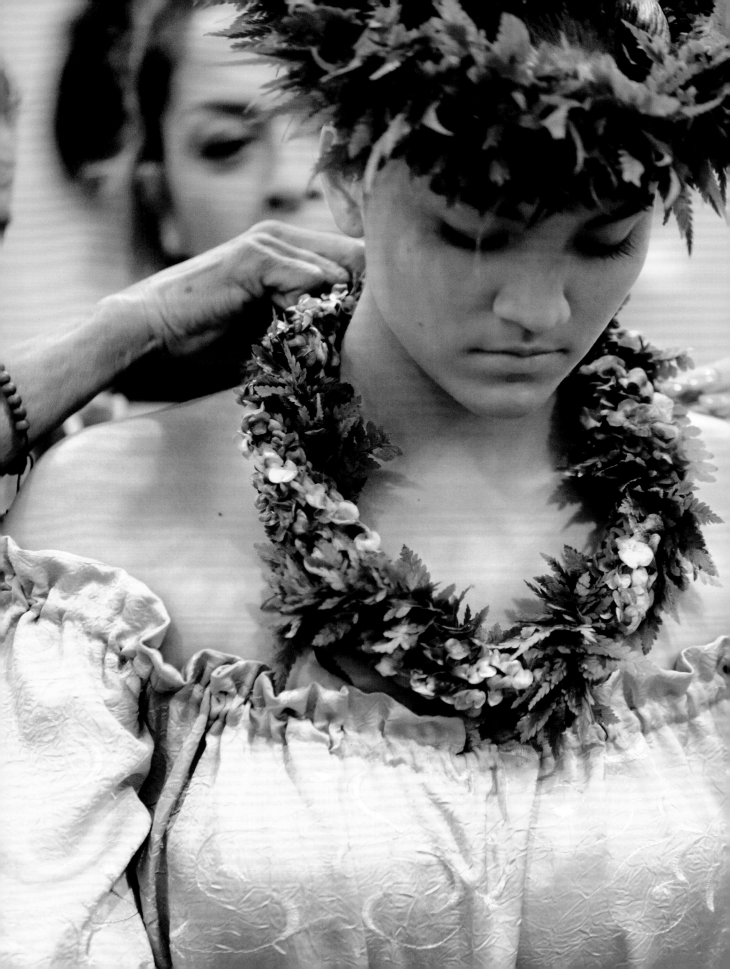

'Ōlapa

Dancer

"When you are a hula dancer . . . you are actually dressing yourself as an offering."

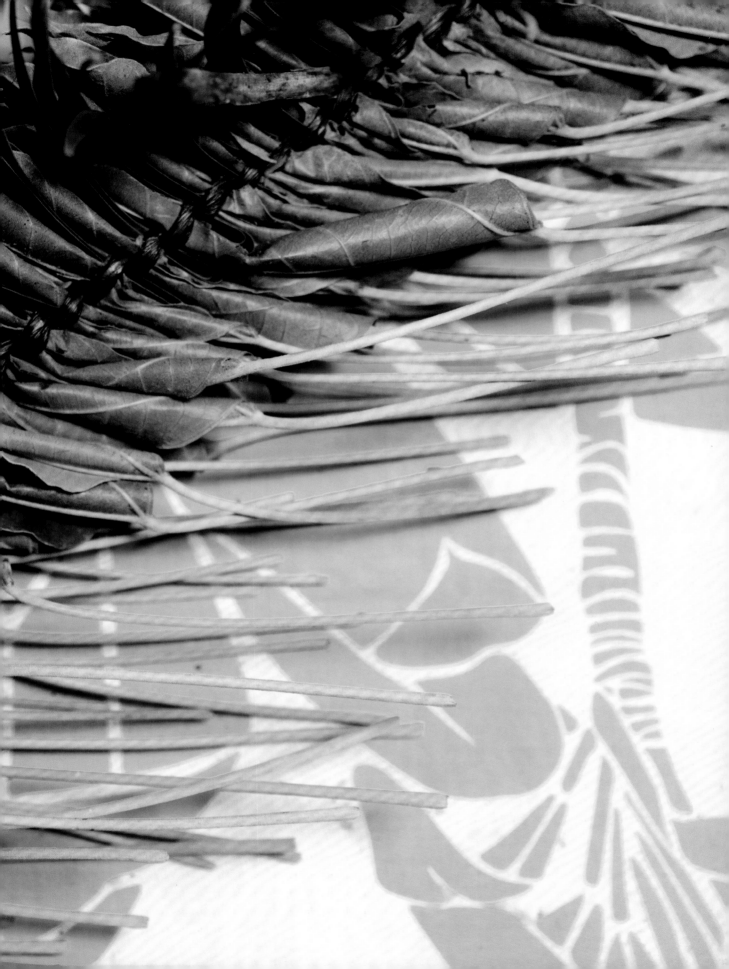

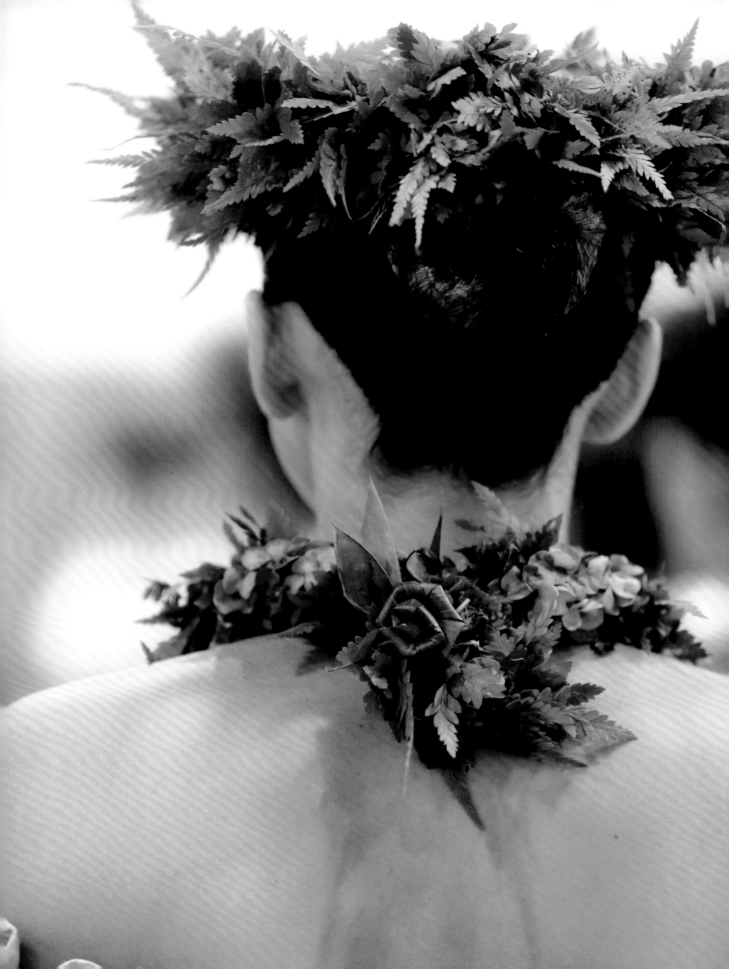

When I have had the privilege of watching hālau hula prepare their lei for their performance, I am always humbled by the intention, tradition, and thoughtfulness that goes into every step of the process, from material choice to the methods of making to care for the lei. I always learn something new from each hālau about lei making and its relationship to hula that is a part of their tradition.

"Hula and lei are intrinsic to each other because of what it embodies and the story it tells of the plants and abundance that is important to us," says Kuhaoimaikalani "Kuhao" Zane, a Hilo-based artist and designer. "When you are a hula dancer, you are an embodiment of the kuahu, the altar we have in the hālau, so when you're interacting and performing, you are actually dressing yourself as an offering," he says about dancing a traditional form of hula.

"Without all of these lei, we don't have the mist that sits on the mountains," he says, describing a dance as a metaphor for the water cycle in which an island forest catches evaporating water and turns it to condensation, slowly trickling water into the aquifer system. Laka, the hula goddess, has the nomenclature of mist. When you think about a hula dancer, when they're dancing and giving their fullest, they're heating their body up, and the perspiration that happens is a mimicry of that evaporation," he explains, describing the lei worn as a representation of the forest.

Zane began dancing with Hālau o Kekuhi, his mother Nalani Kanaka'ole's hālau hula, as a child, and learned the practice of lei making within their hula traditions. In Hawai'i, there are many ways to learn to dance hula—from friends and family, community centers, or dance studios. The most formal is the hālau, in which a kumu teaches the knowledge that he or she gained in their own hula education. With lineages of hula passed down from kumu to kumu, each hālau has a slightly different style and approach.

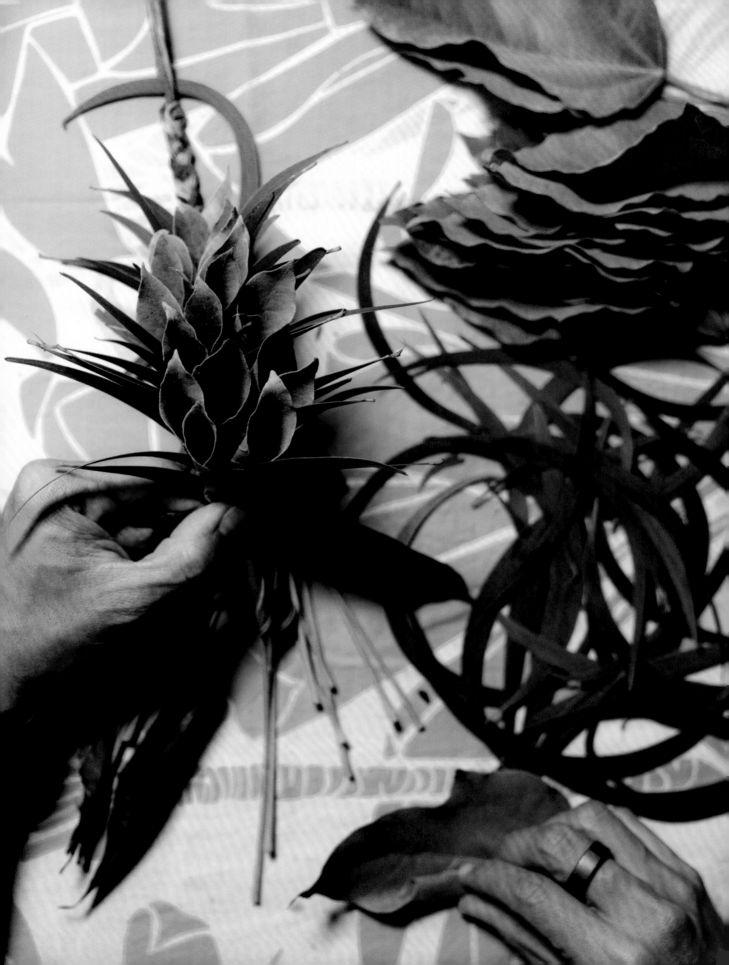

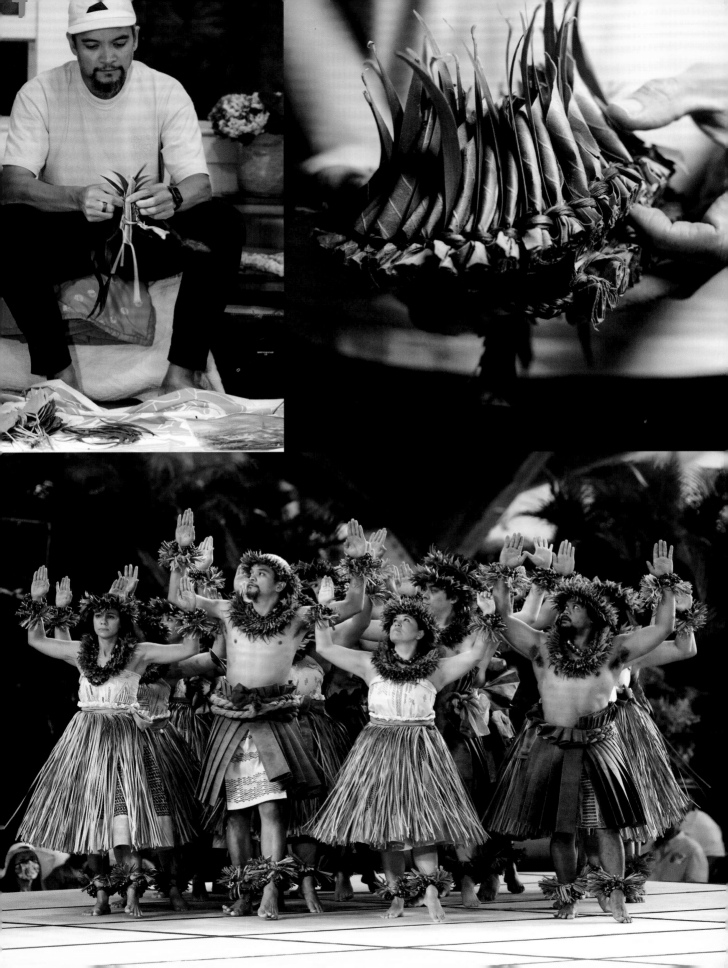

Dressing the kuahu at Zane's hālau is an honor reserved for those who have graduated to the rank of 'ōlapa. The dancers take two-week shifts to decorate the kuahu through the year with fresh lei and cuttings of the plant kino lau (manifestations of Hawaiian gods) important to the hālau. In Hawaiian culture, the many gods and goddesses present themselves in the physical world as kino lau, which translates roughly to "many forms." These forms can be almost anything—moons, wind, rain, plants, or animals—but Laka, the Hawaiian goddess most often associated with hula, is thought to be embodied by a selection of native forest plants. Zane's hālau uses a combination of nine for the kuahu, including 'ōlapa, maile, 'ie'ie, and palapalai. "You never get perfect at it, you just get a little more efficient," Zane says about making lei for the kuahu and honing his lei-making, harvesting, and conservation skills. "I think that that's the time where it starts to really sink in because learning how to make lei, in general, it's a long-term practice."

Iliahi Anthony, who began dancing at Hālau o Kekuhi at age four, says that years of making lei for hula has allowed her to deepen her understanding of a plant's life cycle. "There's a right brown ti leaf to pick, which seems so silly to somebody who just sees dead leaves lying all over the ground," she explains about selecting leaves that will form the braid of her lei haku. "You can't pick the ones that are too old. You want the ones that just fell because you want them to still be a little bit soft, but they've got to be strong."

Zane says that heightened understanding is what he hopes to pass on to the younger members of his hālau. "It's important to actually take the kids [to harvest] because it builds that detailed context, and then they have that relationship over time, with that space. That's the thing that I feel like there's a disconnect in the modern world."

"If you don't care for the smallest thing, how are you going to care for the big things? What you do with the smallest thing is just a reflection of how you are in the greater world," says kumu hula Māpuana de Silva. The process of making lei, that teaches us more than just the craft, from gathering to wearing to returning the flowers to the earth after an event. "If you look back on our history and who we are and how we do things, if you look at all of the traditional arts of our people, every step is important. Every piece is important."

Born and raised in Kailua on O'ahu, de Silva learned to make lei from master lei maker Marie McDonald and from her kumu hula, Maiki Aiu Lake, an influential hula master and revered proponent of older hula techniques and traditions during the Hawaiian cultural renaissance in the 1960s and '70s who graduated many of today's kumu hula and their teachers. Maiki's style has deeply influenced how de Silva teaches her own hālau, Hālau Mōhala 'Ilima.

Opposite, top left: Ipolani Vaughan helps her granddaughter, Nohealeimano Vaughan-Darval.

Opposite, bottom: The dancers of Hālau Hulu Ka Lehua Tuahine prepare for their Merrie Monarch Festival performance.

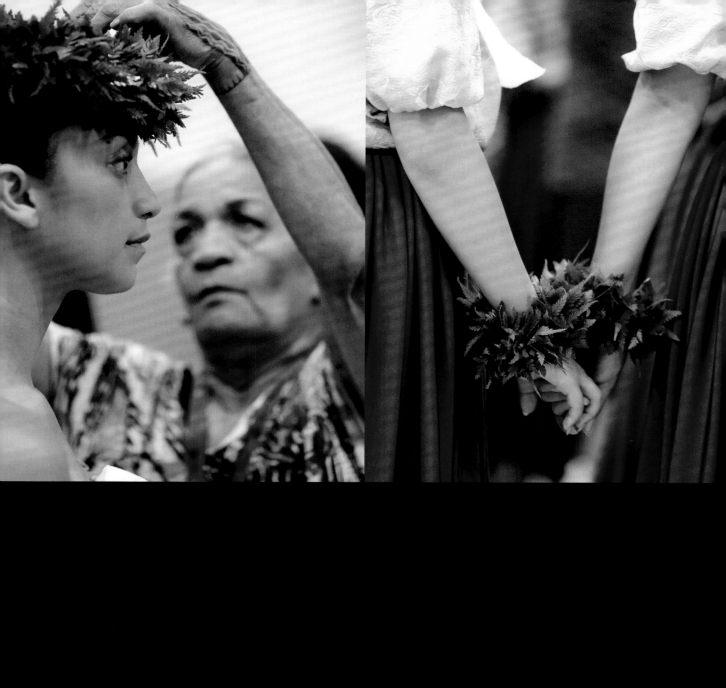
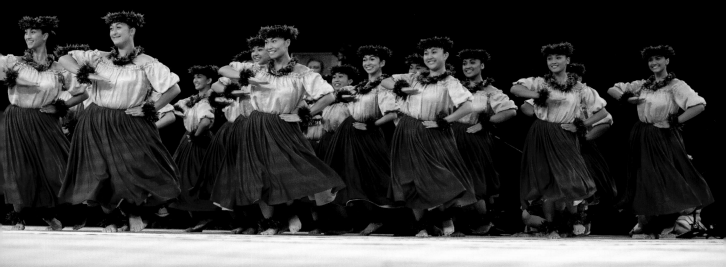

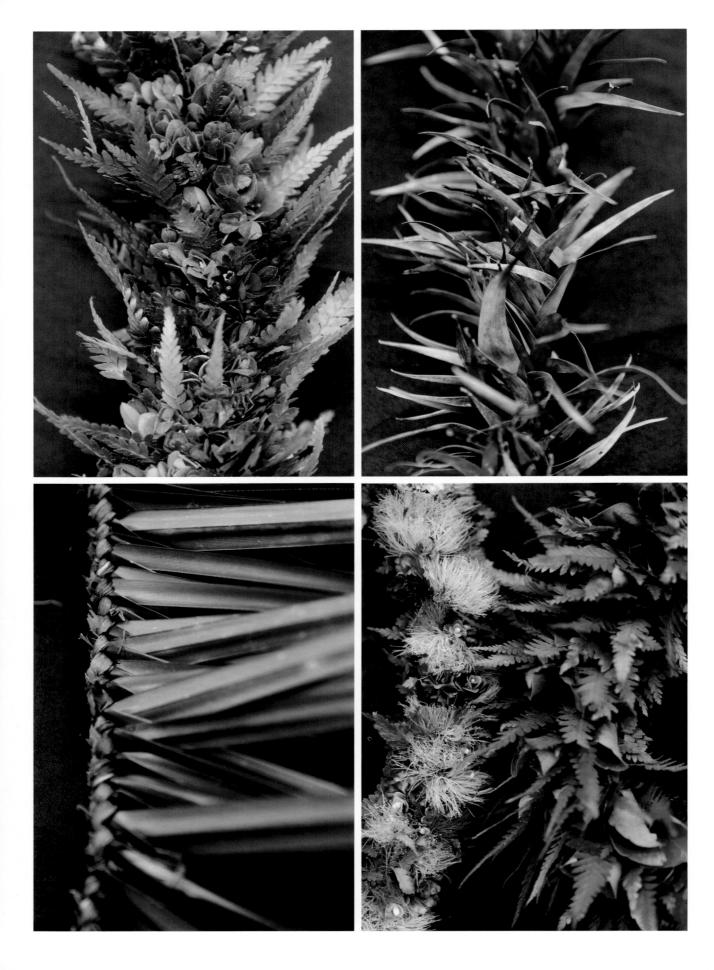

For de Silva, lei making is an essential part of the hula experience, and it begins before students enter the classroom. "You have to start with a plan," she says, comparing making lei to the process of building a house. "You can't just go pick and then come back and only use half of what you picked. In the beginning, you should underpick so that you don't overpick. Then you count and make adjustments as needed so that by the time you make that lei the twentieth time, you know exactly how many fronds or pua [flowers] you need."

Caring for the materials at their source—ferns, ti, even pua melia—are all part of the education. She and her hālau have been tending to a patch of palapalai in the upcountry forests of Oʻahu alongside a conservation group for more than thirty years. She encourages her students to grow their own lei plants at home so that they have access to the materials they need. Before harvesting, she teaches her students to give thanks. "When you gather, your promise is that 'I'm going to share you with the greater world that wouldn't be able to see you, that would appreciate you.'

"You should come in with a Hawaiian mindset, with a Hawaiian frame of reference, with a perspective about time and about the protocols, meaning that there is a certain order in which things need to happen," de Silva explains. At each stage, it's important to anticipate how much time it will take to complete your work. "When we're preparing and we're going to go gather, we think, okay, it's going to take this amount of time. Then we double it, because we want to make sure we give enough time so that if there's a glitch, we're not rushing at the end. [If] we think it's going to take this much time to make our lei, we add four hours to that."

When de Silva's students arrive at the hālau to make lei, she wants them to be in the right frame of mind before they enter the building or she will send them outside to regroup. "So often, people just focus on what they're doing, the task itself, and not on what their intention is, what their mindset is, what they feel, how they've prepared their bodies to do that work," she explains about the importance of setting a positive intention for making lei. "The most important things when we make lei are the unseen. All the things that you don't see, that we don't talk about are more important than what you actually do and what you actually see. If everything in your space is right, then everything that's visible will go well."

Once inside the hālau, she sets each student up on a beach towel, introduces the lesson and the materials, and guides them in placing their materials carefully in piles, not huikau (haphazard). Throughout the session, she will remind them to quiet down if the volume of chatter rises to keep the focus on the lei and respecting the materials and the process. In the spirit of lōkahi (unity), every student must stay until the last person finishes their lei.

Opposite: Besides the hula competition, the week of the Merrie Monarch Festival also features a craft fair, concerts, hula demonstrations, and lei-making contests. In 2022, entries of lei from native plants included ʻaʻaliʻi, dried koa, ʻōhiʻa lehua, ʻieʻie and palapalai.

"I think the biggest lesson I would tell everyone about lei making is, don't look at the lei as you are making it. Listen to the voices of the flowers, of the pua and the fern, of whatever it is you're using. Allow those pua to come together in a family, and understand that your hands are just the means for all of that to happen."
—Kumu hula Mapuana de Silva

For her younger students, de Silva teaches basic lei, like kui pololei or braiding lā'i (ti leaves), so that by the time they are in high school, they should be able to wili their lei. Her advanced students, like the class that will dance at the Merrie Monarch Festival in April, the premier hula competition in Hawai'i, will make their own lei for performances.

"I teach the art of lei making from a very basic perspective and I tell my students, 'This is what works for me. After you've made about twenty lei, then you'll figure out what works for you. There might be things that you do a little differently than I do, but [you want the] end result [to be] the same on the top and the bottom, not just what you're showing the world. The inside, underneath, is just as important as the top.'"

Kumu hula Allison "Hiwa" Ka'ilihiwa Kaha'ipi'ilani Vaughan-Darval says the lessons she learned about lei making as a hula student helped shift her perspective on both hula and lei. Vaughan-Darval comes from a lei-making background—her mother, Ipolani, was a lei queen and rode pā'ū (see page 100) and her father, Palani Vaughan, was a world-renowned Hawaiian musician. But even with all her lei experience—the first lei her mother taught her was lei poepoe of bougainvillea—she found that being taught lei in the hula tradition helped her think about lei in new and profound ways, where the purpose and construction of the lei goes beyond the purely ornamental to the spiritual.

"Everything is a test—everything," she says about the way her teacher, Mae Kamāmalu Klein, who also learned from Maiki Aiu Lake, would instruct lei making for hula. She recalls making lei wili of palapalai for a performance and Klein would pick it up and swing it around in the air. "If something fell out, she would say, 'Take it apart and do it again with the same stuff

you made it with the first time.'" She notes how important it is for a lei to stay on the body of the dancer. "If a lei should fall from the dancer [during a performance], it is the kuleana of the kumu and the hālau to retrieve the lei and have it return with us."

As part of the ʻūniki (graduation) process to become an ʻōlapa, each week, her class was required to make complete sets of lei: poʻo (head), ʻāʻī (neck), hands, feet. One time, as they got close to a performance, Klein gave them each ten fronds of palaʻā and asked them to come back with a full set as a challenge. "Imagine over a seven-day period, just in freak-out mode. I literally took apart every piece of that frond. It was the skinniest lei of all time, but I showed up," Vaughan-Darval says.

"My job as a kumu is to teach my haumana (students), otherwise they'll never know," she says about her role in leading Hālau Hula Ka Lehua Tuahine on Oʻahu. She teaches her students tips on backing materials, or if they're going through the ʻūniki process to not wear lei made of heʻe berry. Wearing heʻe might cause the ʻike (knowledge) to "slip out," she was taught, as the bright red berry shares its name with the slippery squid. "I remember getting scoldings for sitting on the cooler that the lei are in. I sat down, [and Uncle Melvin said,] 'Hey, get off that, the lei are in there.' I pay that forward to my haumana, reminding them that those lei are so important that they need care whether they're on the body or they're sitting in the cooler waiting for their moment to shine."

When it comes to selecting lei for a performance, whether at Merrie Monarch or an exhibition, the decision about which lei to wear and materials to use is often deeply personal to the hālau. For Vaughan-Darval, the song, choreography, clothing, and lei all must work together to tell a story through their hula. "Our job is to make somebody feel something. You want whoever is watching to feel something. If you can't feel anything, then they can't feel anything."

For hula ʻauana (contemporary hula often performed to songs played with guitar, ukulele, and upright bass), a hālau can be more creative about the lei they choose to wear. Some choices are tied to the lyrics or meaning of the song; for a song honoring Queen Liliʻuokalani, the dancers may choose to wear her favorite lei of crown flower. Vaughan-Darval's dancers chose tuberose for their 2015 Merrie Monarch performance of "Pua Tuberose," a song by Kimo Kamana.

Sometimes the most obvious lei choice isn't available and must be replaced with something similar in spirit. "When we danced 'Leināʻala,' a song written for Leināʻala Kalama Heine to honor her after she passed away, we wanted to wear yellow ginger, because that is the lei we associated with her," de Silva says, noting that yellow ginger can be more challenging to find than white ginger, especially around the time of the contest.

Opposite, top right: Kumu hula Kaʻilihiwa Vaughan-Darval practices with her hālau.

Opposite, bottom: Hālau Mōhala ʻIlima performs hula ʻauana at the Merrie Monarch Festival.

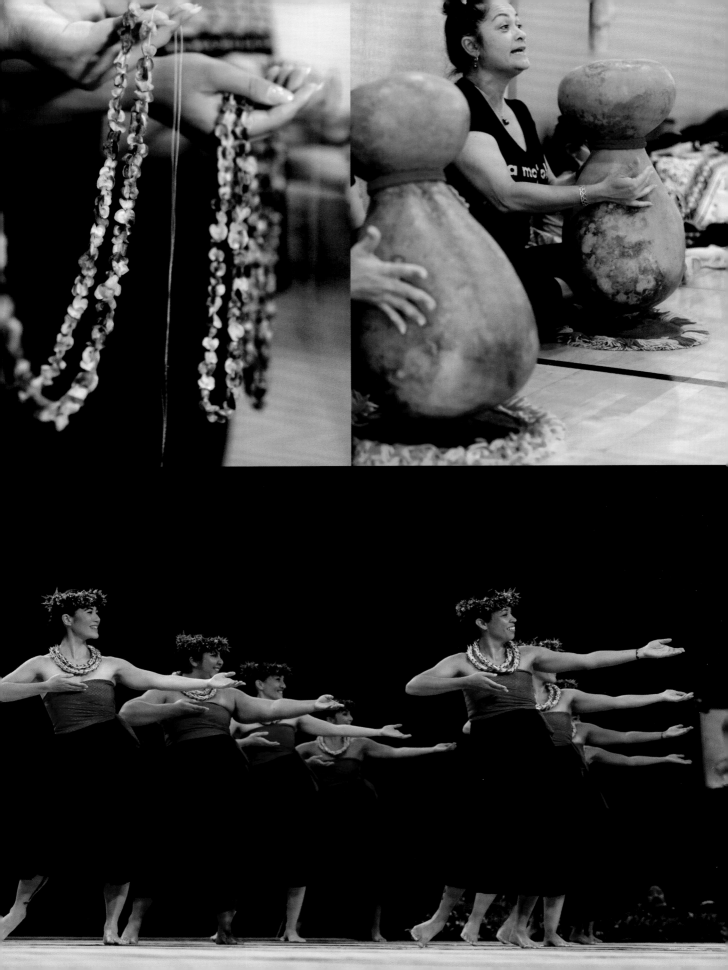

'Ōhi'a Lehua and Rapid 'Ōhi'a Death

One of my most favorite materials to use for lei po'o is 'ōhi'a lehua, both the flowers and, even more so, the liko, the young leaves that form small rosette buds. In the last few years, however, the once abundant 'ōhi'a forests throughout the islands have become threatened by Rapid 'Ōhi'a Death, or ROD, caused by fungi that blocks water from being carried from the roots to the upper canopy of the tree. The change has been swift and dramatic. I traveled to Hawai'i island for Merrie Monarch a few years ago and stood under a lehua forest where the trees were the tallest I'd ever seen and filled with beautiful deep red lehua blossoms as big as your closed fist. I have a photo in this exact spot, looking up in awe. The next year after ROD began its devastation, my friends and I returned to the same place, and it looked like a forest fire had swept through, not even one small liko remaining on the ashen-gray trees.

"It's super frustrating because lehua is our number one native tree in our forest," says Ane Bakutis, about how she still sometimes sees people transporting 'ōhi'a lehua from island to island, which can spread the fungus. Bakutis, a conservationist who works on the island of Moloka'i, says the damage began in Puna on the island of Hawai'i and has now spread as far as the forests of Kaua'i and is most easily seen by helicopter. "You see that upper canopy of the lehua dying first and then the lower branches will die later because [the fungus is] inhibiting the movement [of water] upward," she says, noting that it is most often carried from tree to tree by beetles, though the wind can also play a role, as well as people transporting "anything from flowers, leaves, lei, to wood for construction, wood for ceremony" from areas where the disease is prevalent.

'Ōhi'a lehua has traditionally been an important plant for lei making in hula. "Lehua is one of the great representations of Pele [the volcano goddess] and Hi'iaka [Pele's sister]," says Kuhao Zane. A descendant of "fire lineage," Zane says his family is one of around four that have permission by the government to perform ceremonies at the Halema'uma'u crater in what is now the Hawai'i Volcanoes National Park, access that was granted only after they petitioned in court. His family has kept ancient chants alive in their repertoire and in recent years has been dissecting and reinterpreting the chants' meaning through makawalu (literally "eight eyes") the process of examining something from multiple perspectives. Zane explains, "In the data of these chants it was pulled out that lehua has a specific chemical makeup that helps to break down lava rock [into soil] so that the forest can grow.

"[These ceremonies] are the honoring of the lehua and the honoring of how the lehua feeds our aquifers and how it attracts the clouds—all of that—but also to understand that on the Hawaiian scientific level the functionality of the lehua is to allow the rest of the forest to grow."

But because of ROD, there has been a concerted effort to not use ʻōhiʻa lehua for hula competitions like Merrie Monarch in recent years. Kumu hula Kaʻilihiwa Vaughan-Darval echoes that idea. "I feel like we should just stay away from it period so that we can send that message across the board. We need to let our lehua heal. They need to heal themselves. I feel like they're all connected, it doesn't matter what island we're on. If we just give [the lehua] a break, we may be able to recover."

Zane says his perspective on lei—and the flowers used in lei—has shifted in recent years. "For me, when I see pua māmane I know where it grows and I know where they picked it from," he says about when he sees a lei at a performance.

"Maybe rather than looking at lei as this form of gifting and giving, maybe [we should be] looking at lei as a metric reporting system of our ahupuaʻa or the area where they came from." The absence of lehua in recent competition tells of the health of the forest. "Each of these kino lau are important to our water cycle. [We should be] looking at lei as a metric report of how healthy our palapalai is, how health our koa is, how healthy our ʻieʻie is, how healthy our maile is—and from that then we can ensure [the] abundance of this forest."

Kumu hula Māpuana de Silva would rather choose what's in abundance than what's mentioned explicitly in the song—even if the Merrie Monarch Festival judges dock points from the overall performance. "What [our] lei maker did was use some yellow ginger and added yellow 'ohai ali'i between the yellow ginger. It feathered the ginger and I thought they were even more beautiful."

For hula kahiko, a traditional style of dance, performed with non-stringed instruments in the pre-contact style, the lei material and style are integral to the dance, often chosen from among the important kino lau, like maile or palapalai. "When we're presenting our legacy hula, hula that have been passed on through the generations to us, not hula that we create ourselves, certain types of lei are worn as adornments to help protect us the (dancer) and to connect us to nature and the elements."

However, at times, in regard to important native plants, meaning can shift from hālau to hālau. "We had to defend [the wearing of hala], because one meaning of the word *hala* is death," says de Silva, about a performance at Merrie Monarch in the early 1980s. De Silva had chosen a song written by her husband, Kīhei, about hala and wanted to perform to it using the lei, even though some people felt that because the lei is used at funerals it shouldn't be worn for hula. "Hala is [also] so associated with Kailua," she says about the famous hala grove of Kekele that used to grow in the area before being ripped out for development. "The hala is still there in the earth under those houses." In performing the song with the hala, she wanted to help people remember the way the land had looked before and know that the essence of hala still remains. "That's why songs are important, the stories are important. Just because you don't see it doesn't mean it's not there."

"If you can call to something higher than you, older than you, that gave you permission, nobody can tell you otherwise," says Vaughan-Darval, about choosing material for lei. After performing with hala lei for a song her mother wrote about Kaua'i at Merrie Monarch, Vaughan-Darval had the chance to ask the judges their feelings about the lei. "Some were very clear, 'We never use hala. That's against our . . .' Then we had Uncle Cy Bridges who said, 'All through my life, hala was only present at the funerals.' He recalled a memory of being at these funerals where there were mounds of hala lei on top of the casket . . . At the end of him saying that, he goes, 'But 'Iolani Luahine, she wore hala lei. If 'Iolani Luahine wore hala lei, we should be able to wear hala lei,'" she remembers him telling her about the legendary kumu hula and cultural practitioner.

"Our job is to make somebody feel something. You want whoever is watching to feel something. If you can't feel anything, then they can't feel anything." —Kumu hula Ka'ilihiwa Vaughan-Darval

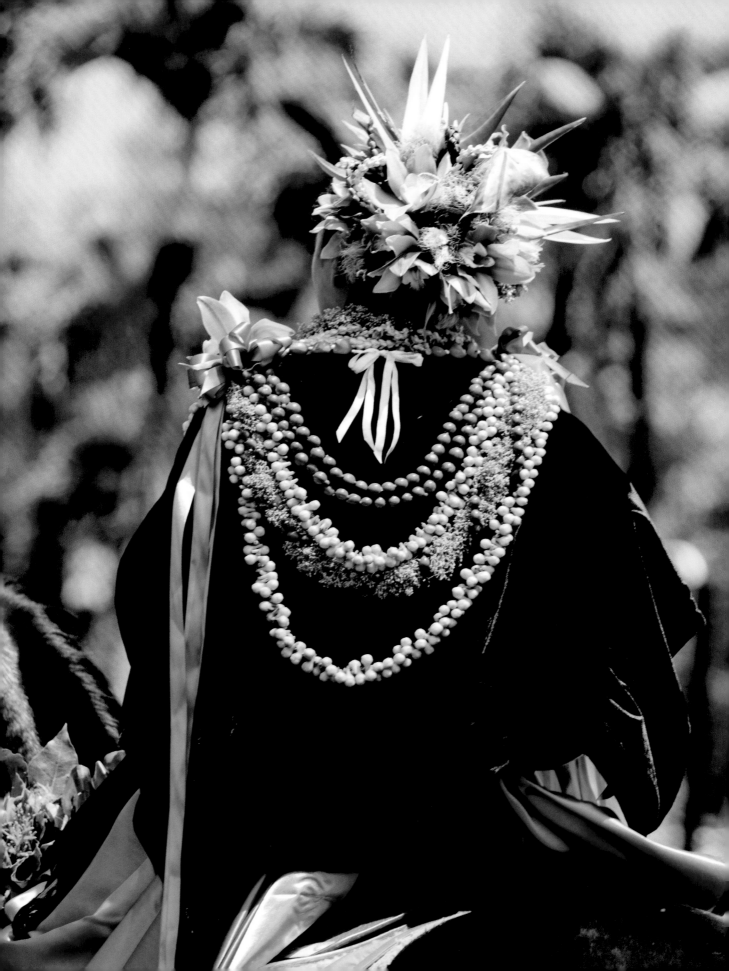

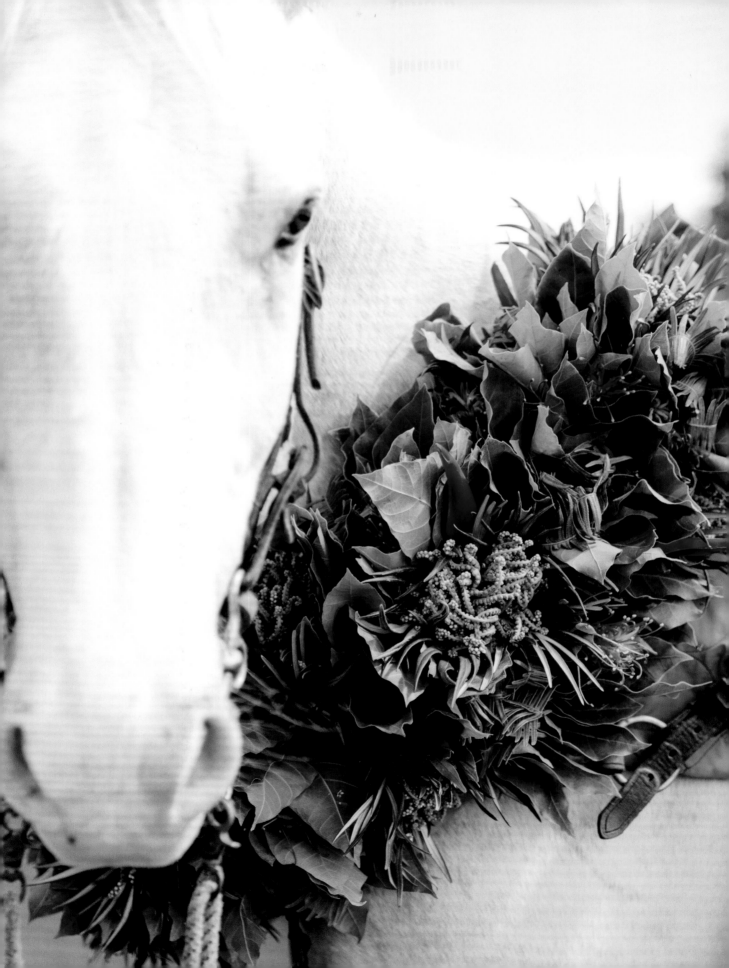

Pā'ū Riding

In the tight lei-making community of practitioners often asked to help the hālau with their competition lei, many also work together to make lei for pā'ū riding. For more than a century, Hawai'i has celebrated important local events with pā'ū parades.

In each parade, usually for Kamehameha Day in June, the Merrie Monarch Festival in spring, and the Aloha Festival in October, there will be units, one for each major island of Hawai'i, plus a queen, and they all will have attendants, usually from their family. The costume for both horse and rider is based on the color and lei designated for each island, like yellow and the 'ilima flower for O'ahu, or pink and lokelani rose for Maui (see page 26). For some parades, if you won the previous year, you get to pick your island first the next year, but you can never repeat.

Pā'ū riding gets its name from the pā'ū skirt, a cloth that female riders would wear to cover their clothes while traveling by horseback. After the arrival of automobiles, the practice turned more into pageantry for parades, like on Kamehameha Day which started in 1906.

"I don't think anybody can touch [my mom] when it comes to organizing a lei session," says kumu hula Ka'ilihiwa Vaughan-Darval, about the gatherings she used to attend as a child when her mother, Ipolani Vaughan, competed in pā'ū riding. "There would be this huge wall and it would be all written out," she says about her mother's prep sessions, listing which person was assigned to all the jobs that needed to happen, like making backing or lei for a particular float or horse.

Vaughan-Darval later realized that all the people who used to attend, whom she simply called "auntie" or "uncle," were renowned in the lei-making world, and the lei creations that they would make were outrageously inventive and over-the-top. "They all wore strands and strands of mokihana on their chest, nothing underneath," says Vaughan-Darval, about one particularly memorable event when her mother was riding as the princess of Kaua'i, traditionally represented by mokihana berries, which have a beautiful scent but phototoxic properties that can leave burns on the wearer's skin. "By the time they were done—I just remember this so well—everybody had burns on their chest."

Ipolani Vaughan began riding pā'ū in her early twenties after modeling on horseback in an ad for Hawaiian designer Allen Akina. She became immersed in the boisterous lei culture. To make lei that would be draped around the neck of the horse, they would use banana stumps or burlap as the base that they would cover in little bouquets of flowers. "We didn't do individual flowers—we made little bouquets, and then the bouquets were spread across, because actually you're doing a half lei poepoe. You have to really be careful of how you construct your lei, it's not only beautiful to look at, but safe for the animal,

safe for the rider," Ipolani says, recalling one year when she fell off while trying to correct the way a lei was tied—the only year she didn't win first place and came in second.

Buzzy Histo, a hula instructor and prolific lei maker on the island of Hawai'i, spends months out of every year working with a unit to ride pā'ū—and experimenting on his lei-making techniques, like taking apart protea leaves, making them into loops, and sewing them kui style together. Histo has a deeply creative streak when it comes to lei—and pā'ū is one area in which that comes out. "We made sand flowers," he says of one pā'ū costume he made for a rider representing Moloka'i. After collecting sand from two different beaches on Moloka'i, he glued fine layers of the sand on pipe cleaners, then looped them into a flower. Behind the sand loops, he put kukui nuts and miniature kukui leaves and placed it in his rider's hair. The judges saw the glint from the sand and asked if he was using glitter. "I'm like, 'What you mean, glitter? We didn't use no glitter.'"

In 2022, Kea Keolanui won the Merrie Monarch Festival parade, representing the island of Moloka'i. "The whole week before we are making horse leis and foraging," she says, crediting her mentor Scott De Sa with helping with princess training, learning how to make a horse lei, and learning how to use plants in a unique way in the lei. "It's bringing people together to practice the art of lei making, the mana'o (thoughts) sharing of all these different elements."

Keolanui, who comes from a farming family, says she has a large extended network of people who love plants are happy to assist, including friends like Lauren Shearer, who owns Hawai'i Flora + Fauna, a bespoke lei store on Maui, to help with neck lei. For the horse lei, she forages for all the materials, which can be challenging to keep fresh looking as they are gathered during the week leading up to the parade.

"It's one of those things when it's 2 a.m., you're working on these giant horse lei where thirty hands are needed to put it together—all these bundles. It's an incredible thing to work together and get it done," Keolanui says. "Even in those hard moments, you're cherishing it."

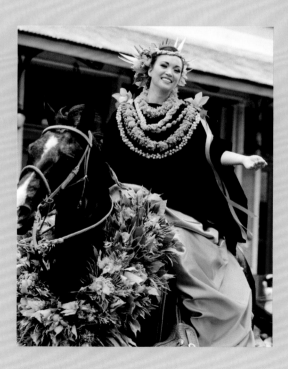

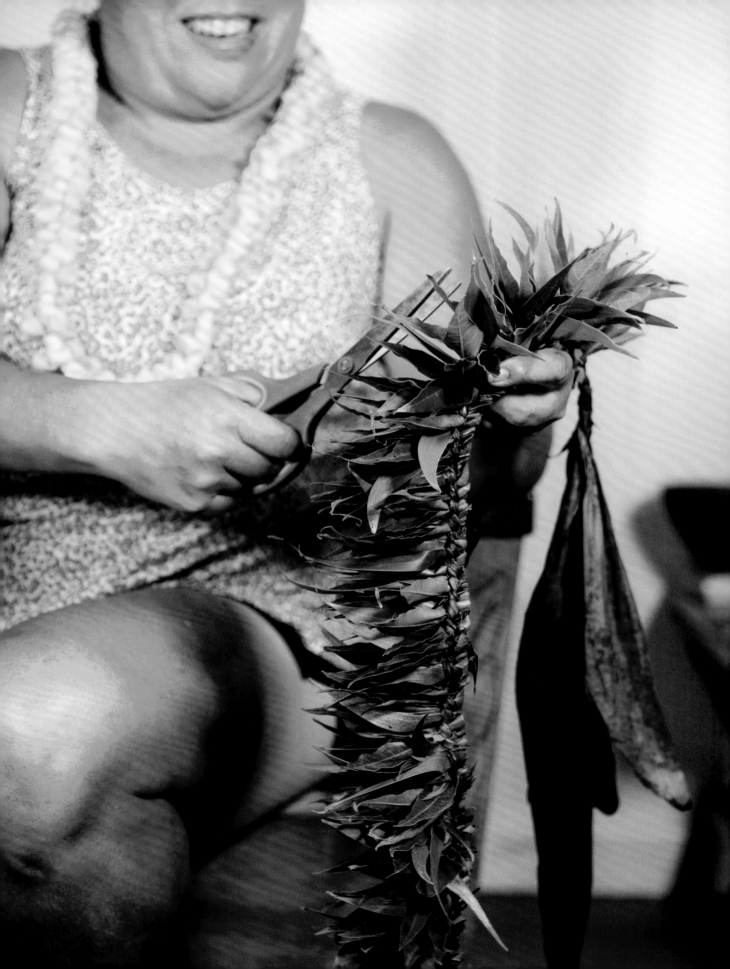

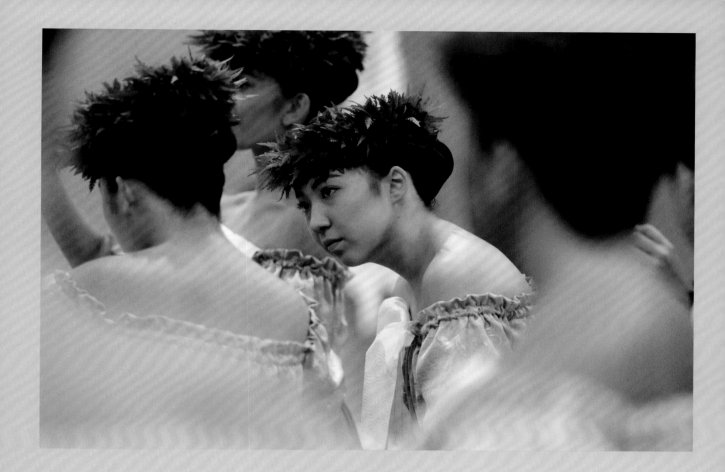

"I think when you're just learning [about Hawaiian culture], plenty of people, they're super sensitive. They're like, 'You can't change tradition,'" says Zane about the discourse around lei and hula, especially at Merrie Monarch. Zane comes from a long lineage of hula practitioners, including Edith Kanaka'ole, his grandmother. His mother and aunt are judges for the contest. His hālau only performs at the hō'ike, or exhibition night. But he says that gives them more freedom to innovate, both in the dance and with lei techniques, instead of trying to perfect a performance for judging.

"I think my mom brings that sort of groundbreaking creativity because of her interests in other areas," says Zane, comparing his mother's choreography and lei-making style to Zaha Hadid's architecture. Because his mother grew up in a strong hula tradition, he explains, she didn't need to relearn the craft during the Hawaiian cultural renaissance—and that freed her to learn more about fashion, sculpture, architecture, and design, all the things that then influenced her hula practice. "She's done things where the maile that we weave in, maybe ten weaves later, we'll bring the maile back in and then kind of have this looping system," he says of one of his mother's memorable lei. Iliahi Anthony adds, "We've made koa [lei] looking like a feather lei. We've used 'ōlapa. I think we've used plants that people don't have access to."

"I think when you sit with tradition for that long, you develop enough of a pillar system to innovate," says Zane. "In a Western context, innovation and tradition are two separate things. But in a Hawaiian context, innovation is within tradition if you sit with it long enough."

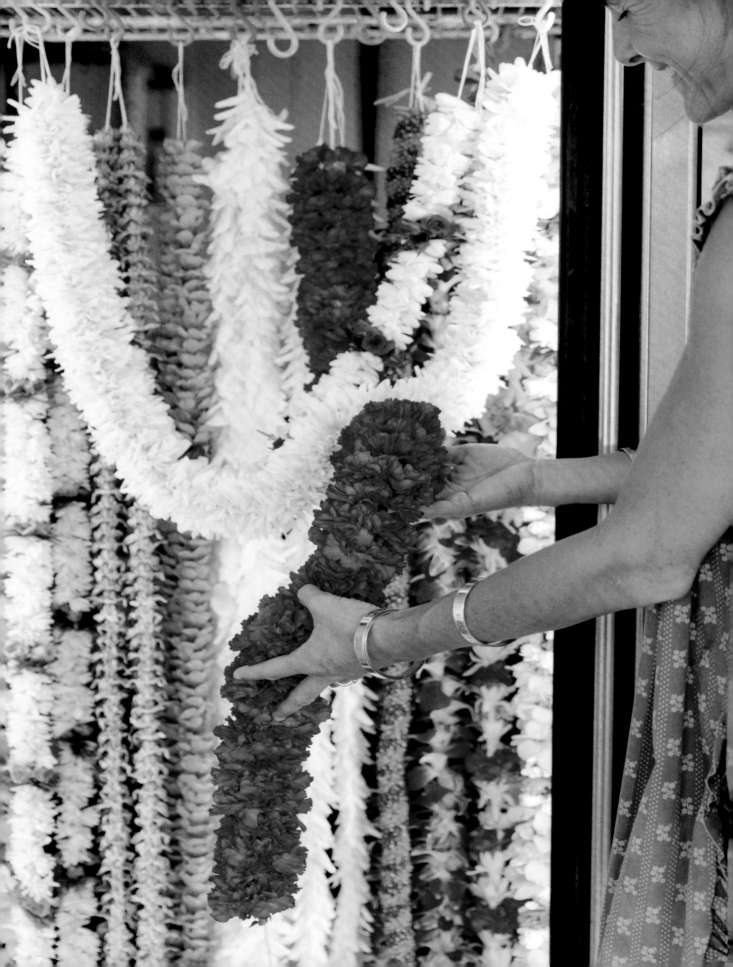

Lei Nani

Beautiful Lei

"When you look at people's photo albums [our lei] are in three generations [of photos]. Happy and sad times . . . We want to continue being in those stories."

More lei tips & tidbits

Lei hit list

Some lei have taken a needless hit over the years:

■ Hala, the fruit of the hala tree (also called pandanus), often is considered taboo among politicians. It is said to symbolize an end, a moving on, so it's right for a retirement or graduation. But, said Robert Cazimero of The Brothers Cazimero, "It's bad luck at election time. The only time you're supposed to wear it is New Year's" — the changing of a year. But I think hala is beautiful." Lei-maker Raymond Wong agreed, adding, "It's a gorgeous lei, with a range of colors, from cream to red. I can't understand the superstition; it's a beautiful lei."

■ Plumeria, also known as frangipani, is often called the graveyard or make-man (dead man) flower because of its abundance in cemetery lots (which are frequently raided by hula halau members). "It's the lei who all made when we were kids — we robbed the graveyards and sewed our own leis," said Wong.

■ Carnation, commonly associated with elected officials, and jokingly referred to as an Ariyoshi lei, since former Gov. George Ariyoshi always seemed to be wearing one. "It's unpopular now, but in the old days, carnations used to be the graduation lei," said lei-maker Bill Char. The thicker, the better.

Prolonging your lei pleasures

With a beautiful lei costing almost as much as a celebratory dinner these days, you may be tempted to try to resuscitate a lei beyond a day's wear. But it doesn't work for some blooms.

Award-winning lei-maker Raymond Wong shared some secrets for lei longevity:

"Pakalana is a one-day lei unless you know how to revive it," he said. "It may look dead, dead, dead — but if you soak it in warm water for 15 minutes, shake off the excess water, store in a plastic bag and in the refrigerator, it will be absolutely gorgeous the next day. I've even done it a second time, too."

Other long-lasting lei include kikania, the string of orange balls often sewn in gradual sizes like a pearl necklace; maile, which is desirable for its sweet scent and is usually a lei without floral combinations. "You can freeze it leaf lei and they become gorgeous — in muted colors," he said.

Even haku lei — often with traditional island flowers and foliage, but sometimes with non-traditional blooms — can have an extended life. Wong had one for six weeks. "I wore it every Friday, and it became a challenge to save it week after week. By the sixth week, I had to let it go."

Of course, dried haku leis are often assured for hala — and can be cherished for months.

Lei that can't generally be kept include those made from flowers with fleshy, easily bruised flowers (plumeria, cigar's beauty, jade).

Techniques that can work: The warm-water soak method described above. Or place the lei tenderly in a nest of wet, crumpled newspaper, cover with more newspaper, and keep it in the crisper.

— Wayne Harada

Types of lei-making

■ Kui — lei sewn or strung with needle and string.

■ Haku — traditional lei, mounted on a natural backing combining foliage and flowers. (Note: Haku does not mean head lei; haku is one method by which head lei are made. A head lei is properly called lei po'o.)

■ Hili — leis that are braided.

■ Wili — leis that are twisted.

■ Hi pu'u — leis that are knotted.

— Wayne Harada

Lei etiquette

When is it proper to reject a lei? (Never.) What's the best lei for the occasion? (Depends.) Here's a primer:

By Wayne Harada
Advertiser Entertainment Editor

We've all worn or given lei — at a baby luau, a birthday party, welcoming a first-timer to Hawaii, bidding aloha to a loved one heading to college.

But even kama'aina may know little about the etiquette of presenting a floral garland — and the superstitions that surround this popular practice.

Do you lei? Do you hug?

Is the plumeria, the favored hula flower, acceptable — or "cheap" because it's plentiful?

Is there such a thing as a men's lei and a woman's lei? Why, or why not?

With Lei Day this Wednesday, it's a good time to talk story about lei etiquette. In Hawaii, any occasion — a birthday, a prom or a departure — involves giving lei (in Hawaiian, plural words do not end in 's'). It's yet another way in which a Hawaiian custom (making and giving lei) has become entwined with Asian ties (the obligation to give gifts).

Of course, it's perfectly fine to wear a lei for no special reason — except to feel good, live aloha, add a little accent into the daily routine.

These days, it's almost a case of anything goes, said entertainer Robert Cazimero, who is seldom seen without a lei.

"I think the new etiquette is changing some old traditions, but nothing's ever been carved in stone," said Cazimero. He knows of no gender rules, though some claim that kika (cigar flower), for example, is a suitable "man's lei," while something frilly like ohai ali'i is a "woman's lei."

"Where ... did that thinking come, when you say that's a woman's lei or a man's lei?" he scoffed. As long as a lei is said ... , veteran lei-maker Bill Char, a judge in this year's Lei Day lei-making contest, agreed. "There's no gender with leis, especially sewn leis," he said.

"I wouldn't give a frilly lei to a male, but that doesn't mean it's wrong," said Char.

"It shouldn't apply," said Raymond Wong, another award-winning lei maker and also a judge in this year's lei contest. "But I myself know that a 'masculine' lei looks masculine — like hala, cigar, kukui nut, ti leaf. Then again, such a lei could be worn by a lady, too — and look smashing."

Wong echoes a fellow veteran lei expert, Marie McDonald (author of "Ka Lei: The Leis of Hawaii"), on the point of appreciating a lei: "A lei, when given, should be worn for the moment.

You may want to try to get an extra day's wear out of the 10 strands of pikake ...

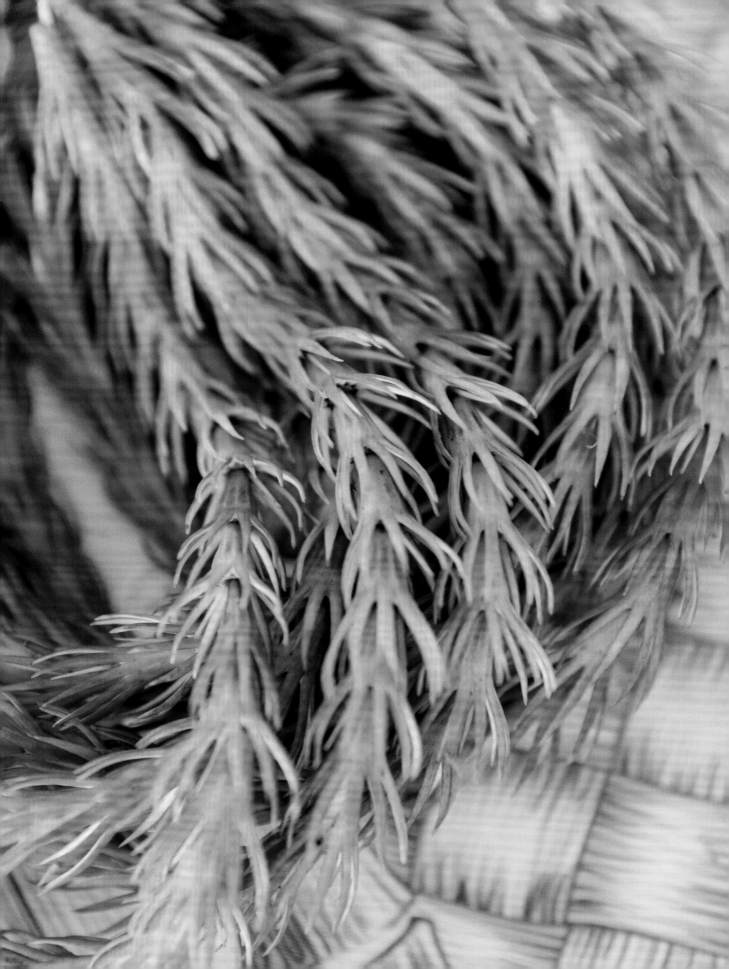

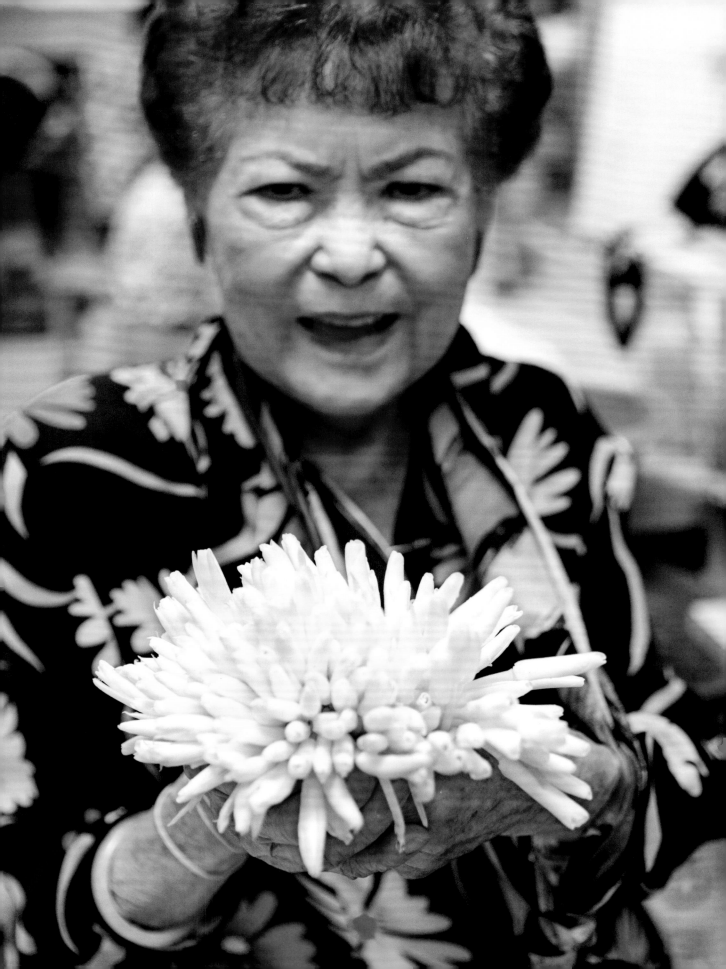

I loved when my tūtū would call me to drive her to Honolulu's Chinatown, where lei shops line the end of Beretania Street and the length of Maunakea Street. Though my tūtū made her own lei, she also bought special lei styles and flowers that she didn't make regularly from her favorite vendors, like maile for a groom or feather ginger for a lūʻau she was hosting. Certain shops specialize in different lei, often depending on long-standing relationships with small growers and lei makers. On our trips we had to stop in at each one to say hello and "talk story" with her longtime community of lei makers. If she knew she would need pīkake in two weeks, she would plant the seed for when her phone order would come in so they would expect her. Cindy's Lei Shoppe, at the end of Maunakea Street, was one of her favorites. Years of my tūtū's Christmas cards still hang on the shop's bulletin boards filled with photos of devoted customers wearing lei from past special occasions. Tūtū would always bring a pua kenikeni lei from home to give to Karen Lau Lee, the owner, who would help her out with lei projects and special orders.

"They would hang these lei on racks with little nails," says Lee, describing her mother's Chinatown lei shop storefront in the 1950s when I asked her about her early memories in the shop. "There weren't these long hours—it wasn't this incessant business, hurry, hurry. If it was a slow day, you put the lei in the paper bags, refrigerate, and then you go home."

Lee, whose mother is from Guangdong, China, has worked at Cindy's since she was eight, when her mother took over the family store after her aunt eloped with a sailor. Her grandparents started what is now Cindy's as a barbershop, but the concept evolved from a storefront for boutonnieres that sailors could buy for dates at the nearby dance halls to a lei shop in her mother's era. Because her mother didn't speak English well, Lee and her siblings would do a little of everything, from taking money to stringing lei, before doing their homework.

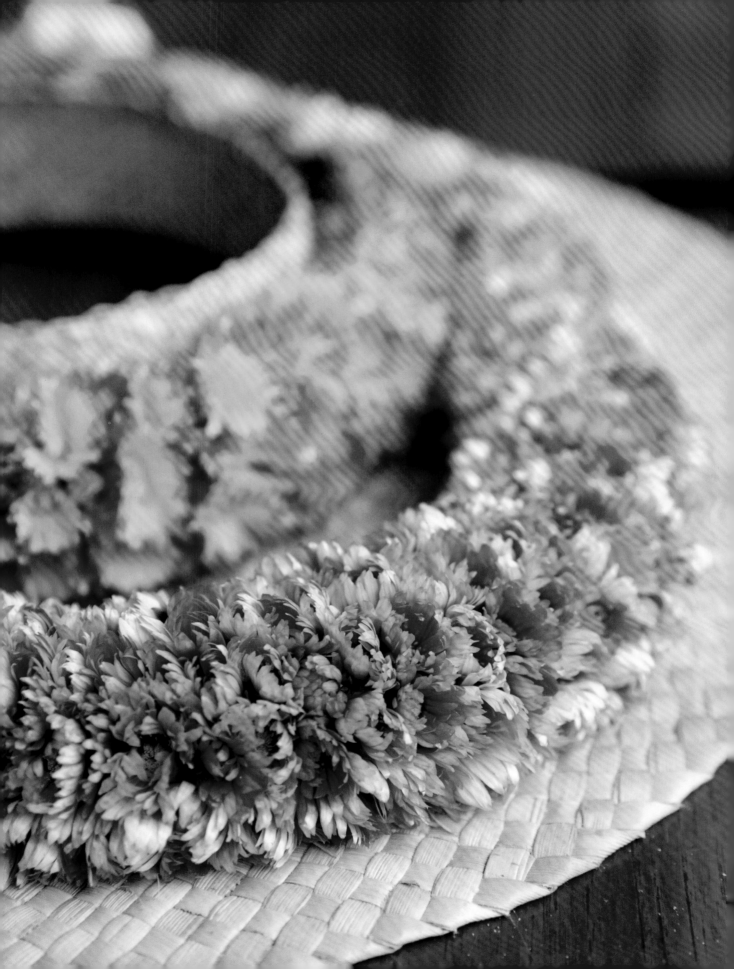

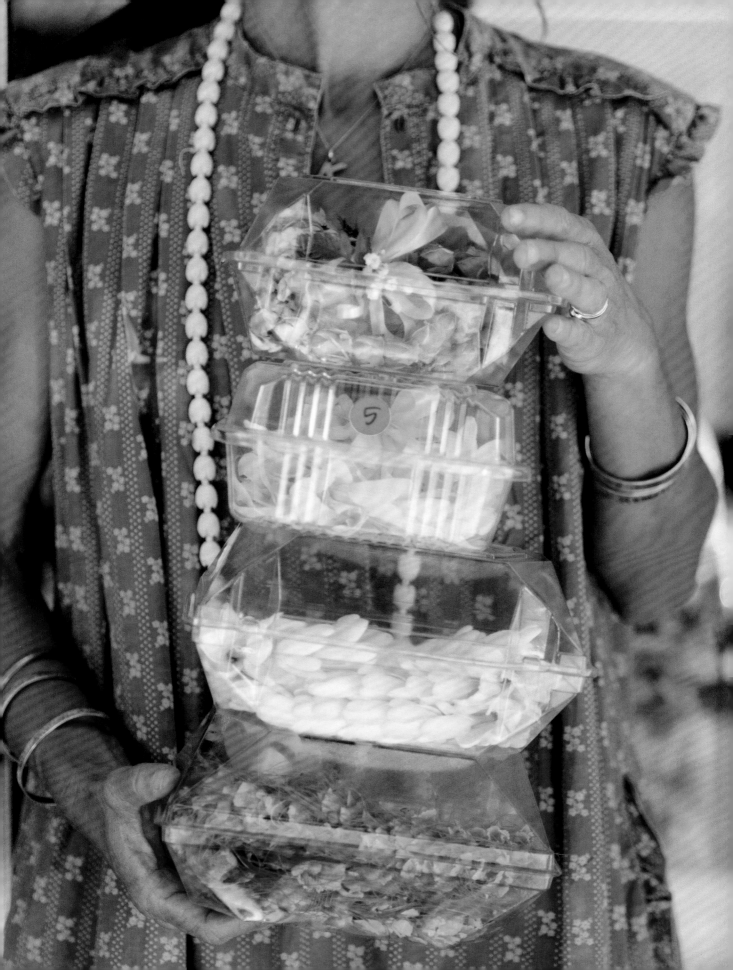

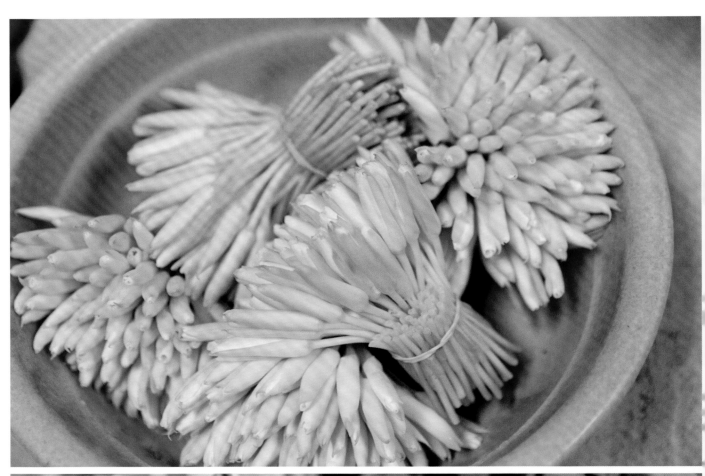

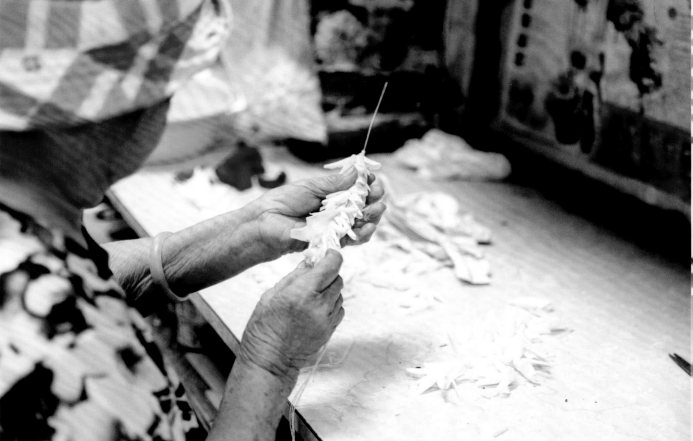

Lee speaks with respect about how her mother, who moved from China to marry her father at a young age, handled the responsibility. "My mom was so eager, so excited, so ambitious, and so happy to get her own money because my father never gave her any money. This was a way for her to become an entrepreneur," she says.

Chinatown, adjacent to Honolulu's downtown business district, has long been the epicenter of commercial lei selling in Hawaiʻi, in part because of its proximity to the harbor. When visitors and tourists began to arrive on steamer ships in the late nineteenth century, a market for selling what had previously been homemade gifts bloomed. Lei sellers packed the streets of downtown, setting out mats and tables on the sidewalks to sell their lei to tourists and locals alike. By 1933, the bustling downtown scene became so competitive that a lei sellers' association was created to help regulate the industry. "My oldest auntie, auntie Haunani Lunn, would always remember him having a lei on his hat," says my sister about our great-grandfather, a fisherman, who loved to trade lei for fish in Chinatown. "He would give fish to the sellers on Maunakea Street and they would give him a lei. Our aunt said that he was popular with the ladies."

Today lei selling is concentrated mainly on Maunakea Street, which is lined with colorful lei shops. The busiest time of the year is graduation season, which quickly follows two other hugely busy lei-sharing days, May Day and Mother's Day. In Hawaiʻi, graduates at every level from elementary school through college, are showered with lei from relatives and classmates, piled up to their eyes and above, draped on their arms, and then held carefully by family members.

High demand during graduation season means an early start for Lee to arrange the lei display in the fridges in the front of the store. "The person who fought to get down here—you got to fight to get to Maunakea Street and get a parking space—I want them to have a selection of lei, so I try to work on that part first," she says, describing a typical day. Next, she consults her chart to see if she has the material to fulfill all the preorders, and if she can't, she's on the phone and writing emails to find acceptable substitutions, what she refers to as "the junky part" of the job. FedEx comes just after lunch to pick up mail orders for off-island purchases, and then she and her team begin stringing lei for the next day. "I'm always making sure that our storefront looks okay," noting that they used to work until 10 p.m., but it's not possible anymore because of her age. "You can see, nothing fancy, just practical and messy."

But the hard work is worth it to Lee, because a lei shop isn't just about selling flowers, it's about being part of people's memories. "When you look at people's photo albums [our lei] are in three generations [of photos]. Happy and sad times, weddings, funerals, birthdays, and graduations. We want to be in people's stories. We want to continue being in those stories. That's really important—the commitment and that integrity to keep it right. Those never go away in people's minds."

In her decades in the shop, Lee has seen certain lei styles rise and wane in popularity, largely due to what is grown in abundance on the island. In the 1950s, plumeria—"the big red floppy kind from a guy who drove all the way from Waiʻanae"—and carnation grown in Kaimukī and Maunalua made up most of the inventory. As those farms got pushed out to make way for housing, other flowers and materials took their place. Lei hilo lāʻī, or ti leaf–twisted rope lei, became popular in the 1990s as a green lei that could be made all year round. The popularity of orchid lei made in Thailand grew in the 2000s—the advent of which both impresses and

worries Lee. She has traveled to Thailand to visit her suppliers and marvels at the efficiency and low cost of the lei. But she would rather rebuild the lei economy in the islands, something akin to the local food movement.

"We shouldn't want people to be buying leis from Thailand. We shouldn't want people buying leis from the Philippines. We want to keep it here, so that's the whole thing. Keep it here," she says, a sentiment many locals support. But that's a steep challenge as growing flowers these days is difficult: As economic pressures encourage development, many would-be growers can't afford the land to farm flowers, and the punishing schedule is a hard career choice. "The pikake, the pakalana, the pua kenikeni, as tedious as those are, those kinds of leis, you're really strapped to a schedule. They only open a certain time, so you only can pick a certain time."

Lee isn't sure what exactly would need to change, but she envisions a vibrant ecosystem in which growers, lei makers, and lei sellers can support one another in the local market. "Cindy's Lei Shoppe, we're just a vehicle," she says. "There's such a much bigger picture. A huge picture. That's why I can't retire yet, and I want to—so badly—exit. I just got to figure out how I can pass on this baton of big picture, because there's such a future for lei here."

Shops like Cindy's Lei Shoppe and Lin's Lei Shop make some of their own lei in-house but also source lei from a vast network of small makers around the islands. For some of these makers, selling lei has been a lifelong way to make a living or have a regular influx of extra income, with the price of each lei determined by the scarcity of the flower and the skill it takes to create. Norman "Buzzy" Histo, a hula instructor and lei maker, recalls that when he was growing up on Oʻahu, he would make lei out of kukunaokalā, the red and yellow calyx of red mangrove, to sell downtown for $2.50 a piece to have money for the weekend. "Money never grows on trees," he says. "Our grandparents taught us that."

Today, Histo lives in Waimea on the island of Hawaiʻi, where he teaches hula and pāʻū riders, and makes lei to sell by word of mouth. His upcountry house is a shrine to performances and lei of the past, with brightly colored seed and plastic lei hung up in the garage, shell lei and other treasures behind glass in cabinets in the living room, and lei photos stacked in many albums. "This is poepoe lehua lei," he explains as he points out a photo of one of his many avant-garde creations for hula and pāʻū. "You see the lehua? It was so thick it was like a carnation."

The days of making lei to send to Oʻahu from his home on the Big Island are over for him, but he does makes lei from the plants in his yard to sell locally. Though he is a master at all styles, ʻākulikuli, a small ground cover succulent with bright yellow, red, pink, and orange blooms is one of his specialties. To make the lei the base of the buds are strung together in a repeating pattern using the kui method; the buds fan out forming a half circle.

Opposite, top left and opposite, bottom right: Graduation photos such as these are a celebration of lei diversity and industry in Hawaiʻi.

Opposite, top right: Cigar lei. *Opposite, bottom left:* Carnation lei.

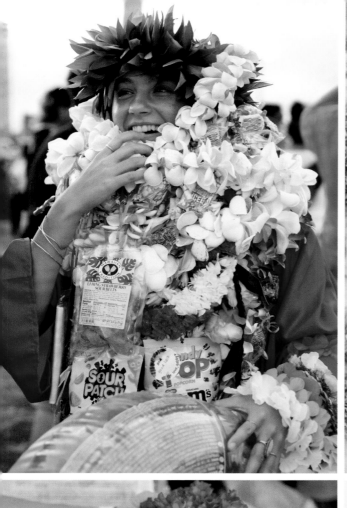
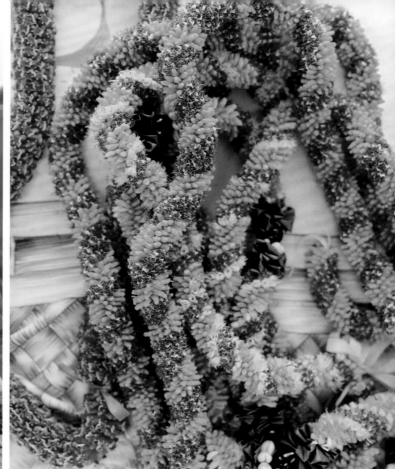
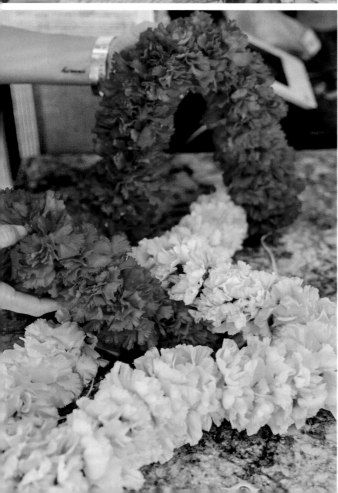
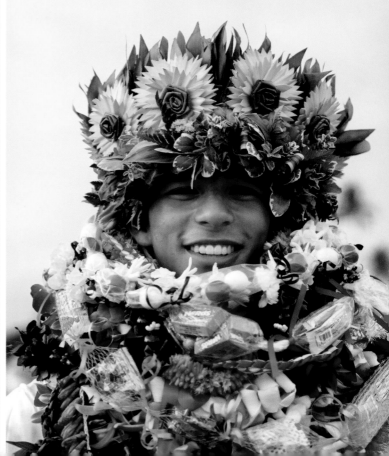

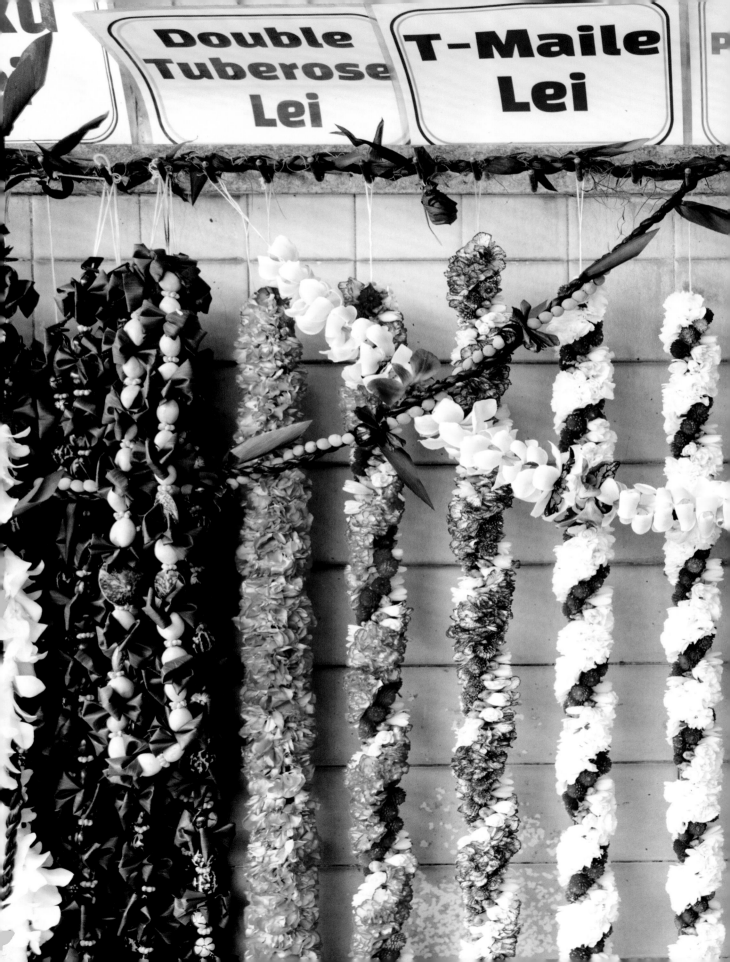

Airport Lei Stands

"I think one of the best parts about travel is that you get to come home. When you come home—and you don't have to be Hawaiian to get this—if you are of this land, if you are kama'āina to Hawai'i, or if your family is kama'āina to Hawai'i, you get off that plane, you can smell the yellow plumerias. From the lei stands somebody's coming to greet you, like in the old days with a yellow plumeria lei," says musician and kumu hula Robert Cazimero, about the practice of giving a lei upon departure or arrival at the airport. "That's really, really special."

One of the most beloved aspects of Daniel K. Inouye International Airport in Honolulu is the fifteen open-air lei stands tucked on a quiet lane adjacent to the main terminal. These stands sell armfuls of fresh lei every day, representing the other hub of commercial lei activity on O'ahu aside from Chinatown. On any given day, at least a few of them will be open to pick up a lei for arriving and departing travelers and offer guaranteed drive-up lei selections for other occasions as well.

"We had fifty plumeria trees so we would pick our own flowers," says fourth-generation commercial lei maker Leimoni Miyahana on her first memories about helping out at Harriet's, her family's airport lei stand. Miyahana's Native Hawaiian great-grandmother had sold lei in Chinatown to the tourists on steamships. But it was her great-uncle and her grandmother who were among the first lei sellers to set up shop in trucks on Lagoon Drive near the airport after recreational plane travel to the islands began in 1936. In 1952, they sold lei out of thatched huts on Lagoon Drive, before being moved closer to the airport ten years later. Today the state of Hawai'i offers shop leases with the contingency that they sell only fresh flower lei. Many of the leases are passed down through families across generations.

"The tuberose comes from Hale'iwa and Waialua," Miyahana explains as she strings plumeria lei in the back of her stand. "The ginger come from Waimānalo. Our carnation comes from South America. And then these are Thailand orchids. Some of the orchids are locally grown—they grow a lot in Wai'anae. The plumerias are all local. We get some from the Mākaha–Wai'anae side."

Miyahana, who now lives in Kailua, didn't intend to stay in the family business. She has a degree in special education and spent fifteen years teaching. But when her mother got sick, she felt compelled to return to the lei stand, where she has been for the last twenty-one years.

"My husband asks, 'Aren't you going to retire soon? Do you really like what you're doing?'" she says with a laugh. "But I like it because it makes people happy. You see them and they're happy with their leis. Especially when you see the tourists come and they're so excited."

"I like it because it makes people happy. You see them and they're happy with their leis."
—Leimoni Miyahana

It takes around 350 flowers to make a lei roughly thirty inches long. "In the olden days, every lei was thirty-six inches, but it's so heavy," says Histo, who likes to finish his lei with ribbon at the end so it can be gently tied around the wearer's neck.

Around five minutes down the highway from Histo's house is another small producer of 'ākulikuli lei, Pohākea Country Farms. This venture is a new direction for Malia Kamaka, who only became a full-time flower grower and lei maker in retirement. Born in Kāne'ohe, on O'ahu, she moved to Waimea as an adult. Her job as a meter reader for the electric company meant traveling throughout the county. "I used to see the ['ākulikuli] all around at the different houses up here, especially the Parker Ranch houses. It was so beautiful, you know?"

One of the electric company linemen she worked with had accumulated 'ākulikuli in an array of colors and offered to plant cuttings in orange, pink, yellow, and red at her house. A neighboring lei maker, Patsy Shioji, taught her how to kui the buds together into a lei. "As she got older, she couldn't bend so I would bring her the flowers because she'd get lei orders."

Today Kamaka takes orders for everything from birthdays to celebrations to hula competitions. Hālau have danced with her lei in the prestigious Merrie Monarch competition. Occasionally she will send lei to O'ahu to sell in stores.

"The yellows and the oranges will close up a little closer to early in the evening so you can pick it at night," she explains, talking with joy about her process. "Then I usually pick the pinks in the morning, because it just gets a little tighter," she says of the delicate buds, which she picks the second day they bloom. She stores the buds in carefully labeled containers in the lei fridge in her garage where they will last for up to two weeks.

"Everybody asks me, 'Do you make other leis,' and I go, 'No, no, I do plenty.'" For Kamaka, 'ākulikuli is enough.

Opposite, top left: Keeping the lei fridges stocked for walk-in customers is a high priority for Karen Lau Lee at Cindy's Lei Shoppe. On any given day, you might find a selection of plumeria, crown flower, orchid, tuberose, cigar, or ginger lei, in both single strand and Micronesian styles.

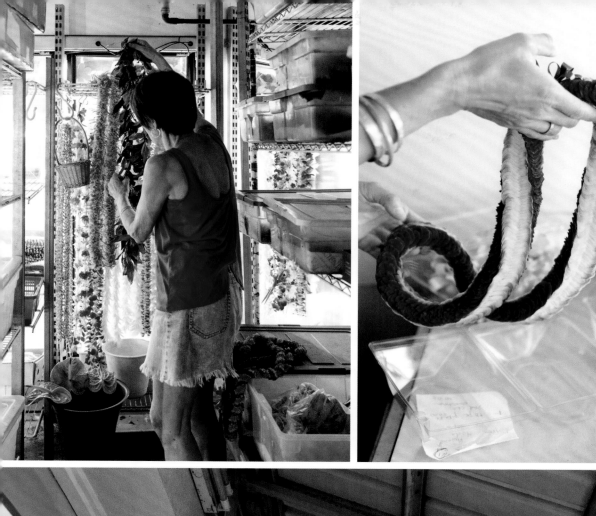

CINDY'S LEI
& FLOWER SHOPPE

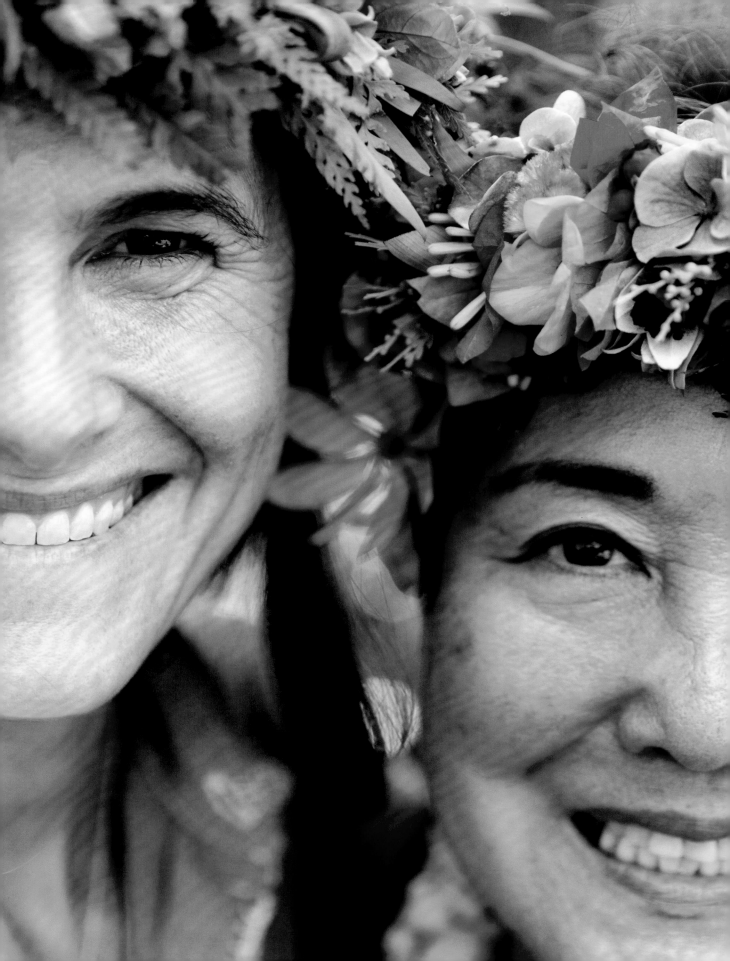

Laulima

Many Hands

"I think the joy comes from
working at it, creating."

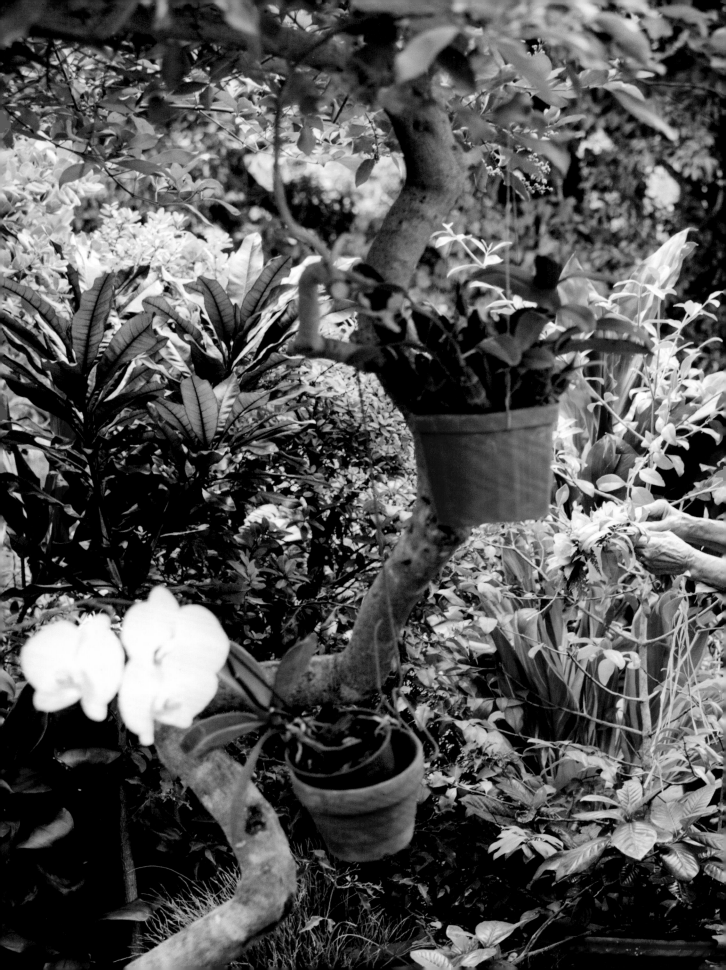

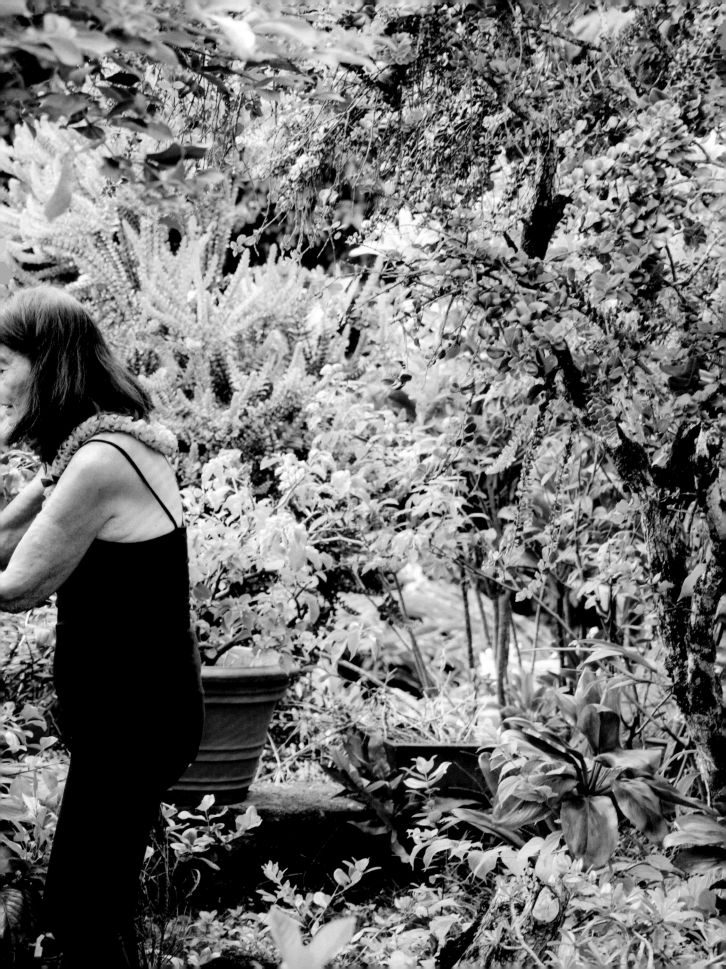

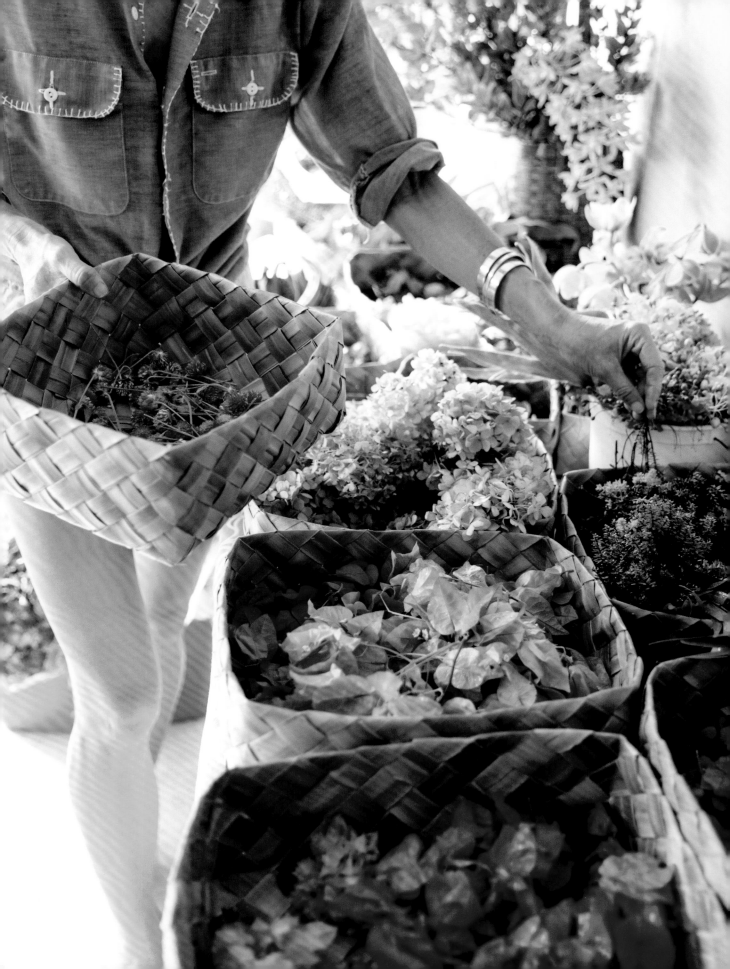

My tūtū loved to wili lei poʻo for her family and friends for every occasion. In her enthusiasm for lei making, she realized that it also offered an opportunity to contribute to her favorite organizations. In 1972, she helped found the lei booth at the Punahou Carnival, the annual fundraiser for the school, where she worked as a costume designer. She recruited her skilled lei-making friends to donate their time and talents to make lei poʻo that were then sold at the fair, amid the Ferris wheel and malasada (a celebrated Portuguese sugar doughnut) stands.

Lei making for the carnival and the many other fundraisers for which she would volunteer was a huge undertaking, often going on for days, and the preparation stretched for days before that. Many volunteers donated plants and flowers from their curated backyard gardens, some traveled to neighbor islands to pick materials that grow in abundance in certain climates to donate for the week of the event. Volunteers didn't necessarily need to have a personal connection to the organization either, their connection was to one another. The most dedicated each make upward of sixty lei, all for the love of the cause, the camaraderie, and getting together with their lei-making hui (group).

"We love to get together so that we can sit, laugh, talk, and share," says Anne Kadowaki, one of the kūpuna (elders) who teaches the annual workshop to new lei makers leading up to the Punahou Carnival. "Sometimes somebody might have a little tip or trick to share. Sometimes we don't like it. You can pick or choose. [But] that's what we like, sitting around talking story."

My tūtū has passed, and her energy and lei are missed, but the gatherings of lei makers and events are ongoing. I treasure the opportunity to join in and make lei with her friends when I can, always learning something new, and marvel at their devotion and the skills they share. This year, a group of longtime friends who used to make lei with my tūtū gathered at a long wooden table on the patio in the backyard of Ann Sato's Mānoa home. The task: making lei poʻo to be donated to an annual fundraiser run by the Daughters of Hawaiʻi, a local nonprofit, to benefit the Queen Emma Summer Palace in Nuʻuanu.

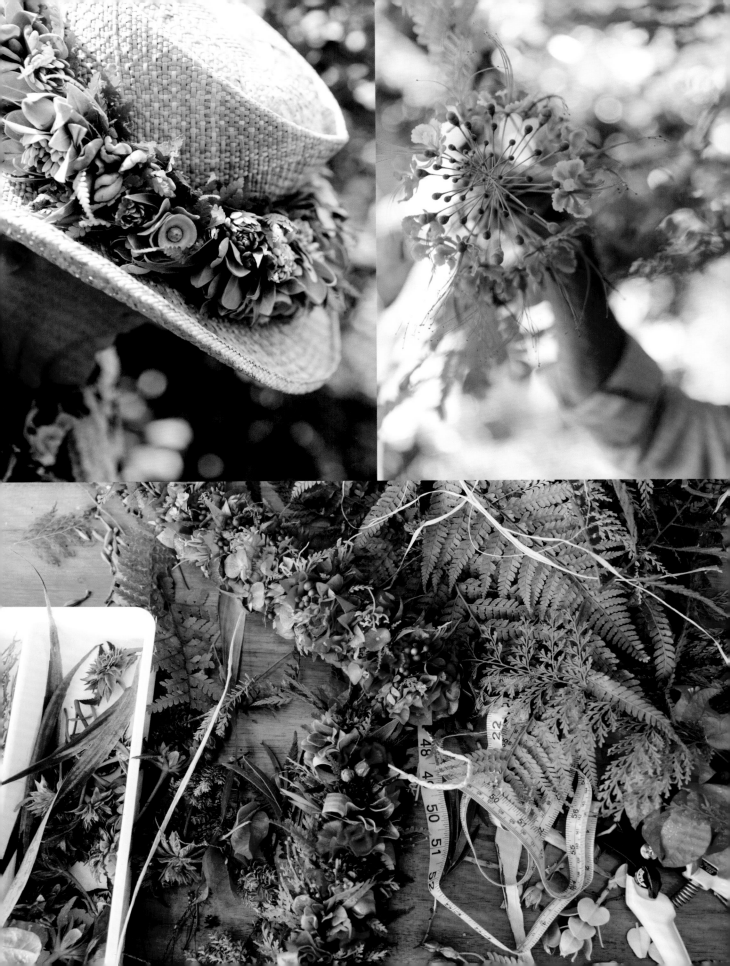

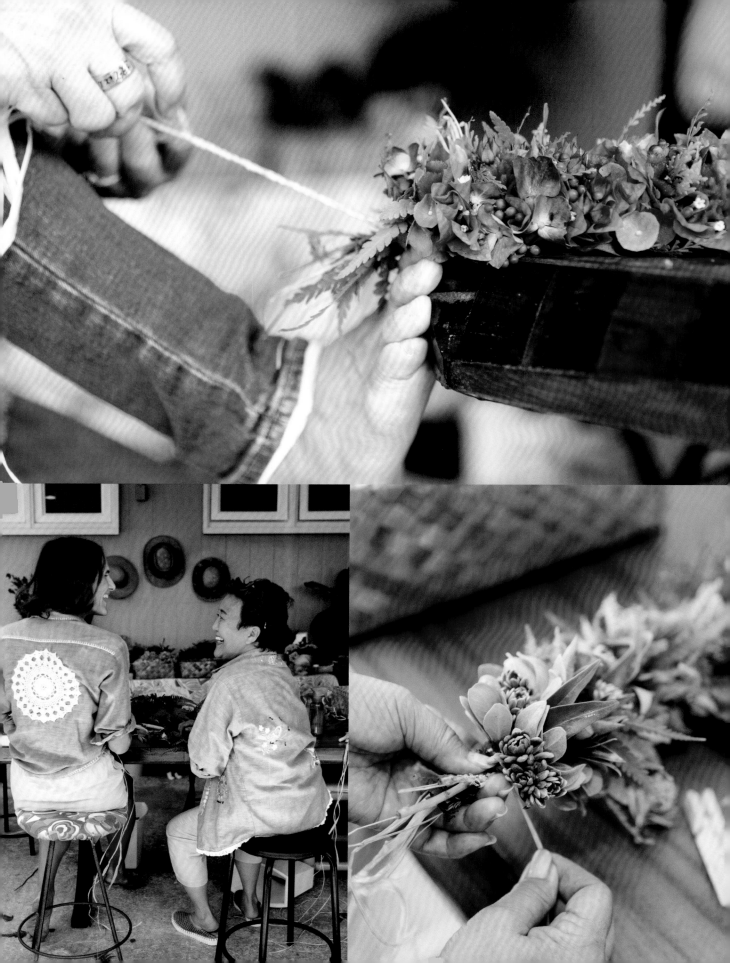

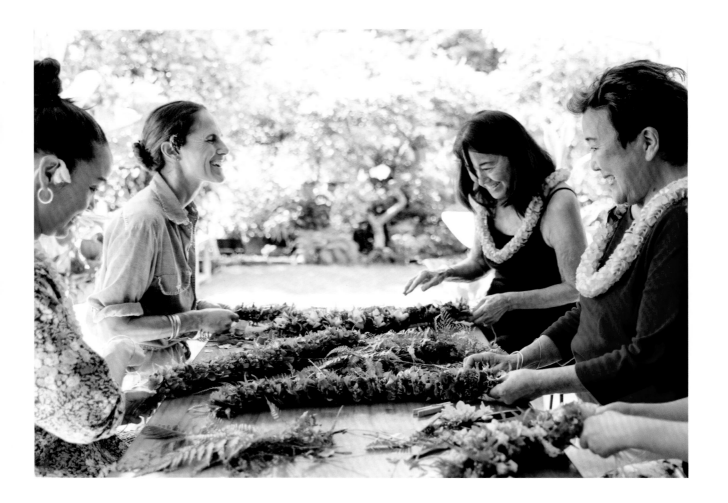

Their hands are busy, but their conversation is quick and full of laughter, one musing about her husband having to hike along the coast the day before to find hinahina (a coastal plant), another laughing about her fridge having too many stashed flowers to fit her groceries this week. "I think the joy comes from working at it, creating it," says Koby Berrington on why she has volunteered her time for more than thirty years to make these lei. But there's the friendship, too: Bonded over their flowers, the group will text one another pictures of rare flowers and swap gardening tips throughout the year.

Kasi Hara, another volunteer, who is a generation younger than the others and to whom the responsibility of organizing some of these events has been passed, explains that because they don't have extensive refrigeration, all the flowers need to be picked and the lei assembled at the last minute. That can mean some late nights, even all-nighters. "When we are in the middle of a project and it's three o'clock in the morning, [they're] like, 'Why did I say yes?'" she says with a laugh, noting that despite any momentary frustration, she can always count on these "aunties" to show up and come together to finish the job. "You've been our surrogate daughter for so long," says Sato to Hara, who has been making lei with them since she was in the eighth grade.

For fundraisers, the lei they most often make are the lei poʻo using the wili method. Each maker will have their own process, but the basic technique is the same: Flowers and greenery are wound to a backing material (usually raffia, but dried ti, hau, hala, banana bark, or cloth can be used) with a string or natural fiber (hau, raffia, and ti are common). A fern backing hiding the wound raffia distinguishes a gifted lei maker's lei from others.

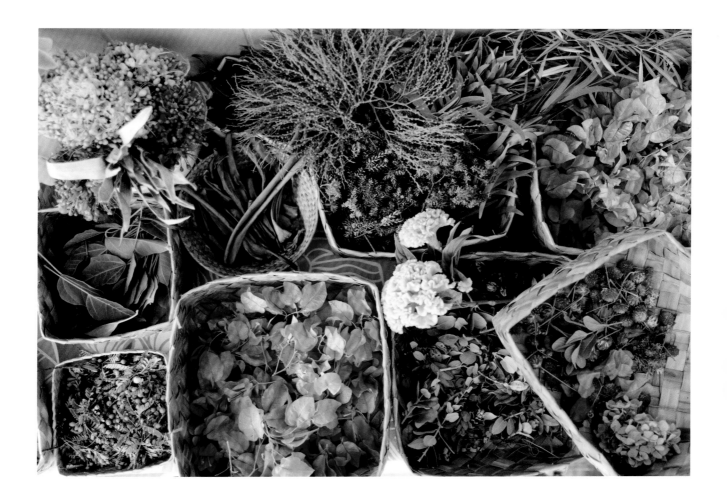

No matter how experienced a lei maker, a lei po'o made in the wili style takes significant time to make. While receiving any lei is always special, a gifted lei po'o made with this commitment and care usually signifies a special occasion. These intricate lei are not commonly sold at lei shops and many relish the opportunity to purchase one at these fundraisers. The abundance and variety of lei at the sales table are an attraction on their own. The proof of their significance is in the demand, where people plan on standing in line for three hours at the Punahou Carnival for the chance to buy one of these intricate creations.

Aside from the technical skills of a seasoned lei maker in assembling the lei, there is a true artistry in knowing how to blend and balance the variety of materials. The idea is to create a mix between starring flowers, ones that add accents or scent, filler material, and greens for contrast and texture. Mastery often comes with years of experimenting with materials. A practiced eye and years of experience noticing natural plant growth yields can make unexpectedly beautiful combinations.

When making a lei po'o for someone in particular, a lei maker might consider a favorite color, or scent, or the outfit of the recipient. But for a fundraiser, the lei making is less about one type of flower or green and more about what is readily available at that time of the year. For these events, abundant materials sourced by many different gatherers offer an inspiring buffet. Many hands, many lei haku is the goal of the event.

For this day of lei making, Sato and Berrington placed all of the harvested flowers and greenery in trays and baskets on a side table; there were so many options that another table

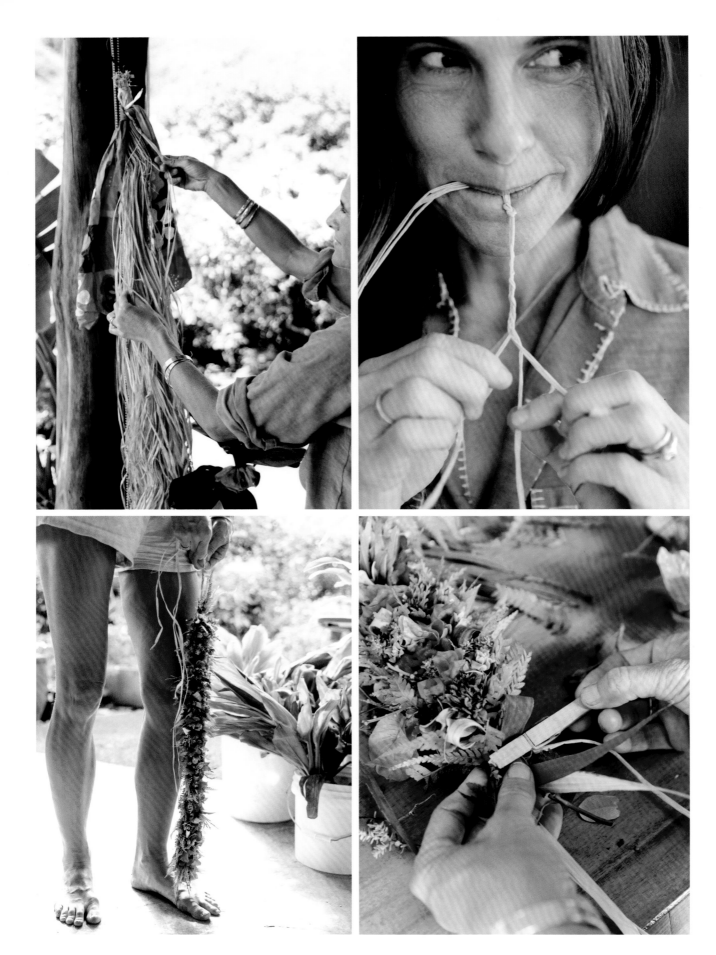

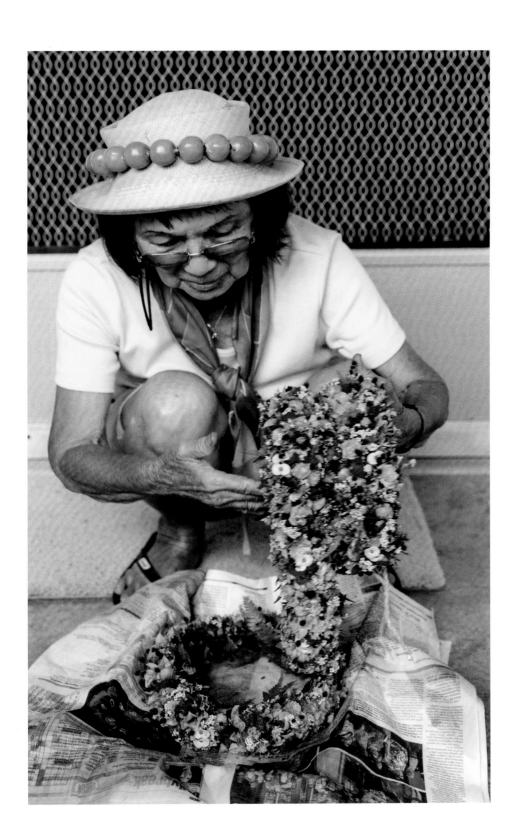

Right: A lei poʻo is best worn on the day it is made but can typically last for a few days up to two weeks depending on the materials used. To care for the lei when not in use, lei makers wrap it gently in wet newspaper or paper towels and store it in the refrigerator.

Opposite, bottom right: Making a lei poʻo takes time. Lei makers often have a clothespin handy to clip the ends when their hands need a break.

"We love to get together so that we can sit, laugh, talk, and share."
—Anne Kadowaki

had to be set up for the overflow. The materials from Sato's backyard garden have already been prepped and trimmed: coral and purple bougainvillea, orange and red ʻohai aliʻi, rust-colored cup and saucer. Store-bought roses, hydrangeas, and statices sit in a water-filled bucket, alongside heaps of gathered palapalai fern and ti leaf in variegated pinks, yellows, and greens.

"The most time-consuming part of it is prepping the flowers," Berrington says. Their group will often gather materials for days up until the event, foraging in their own backyard gardens (often planted with lei flowers) and in friends' yards. "If I don't have time [to gather], I like buying my stuff," she says, highlighting Watanabe Florals, a wholesale florist as a favorite for the group.

Like picking ingredients for a recipe, each lei maker chooses their flowers and greenery, places them on their tray, and replenishes from the table that holds the sorted flowers when needed. I take my time at the table of materials, creating a color combination in my head. Inspired by the green-mauve-speckled hydrangeas gifted to me by a friend who recently traveled to Kula on Maui, I look for accents like lavender bougainvillea, green rose, and tiny liko buds to complete the color combination. With a small pile of palapalai fern ready at my chair, I give my materials a spritz and begin my lei.

Little details show how meticulous these lei makers are about their craft. As Sato wraps bougainvillea into her lei, she pinches the stamens out so the white parts of the colorful flower don't show. Berrington carefully brushes out the seeds from cockscomb to save and plant later. As they work, the three women intermittently—and almost meditatively—use a spray bottle (part of their own lei-making kits) to mist their materials and lei with water to keep them fresh.

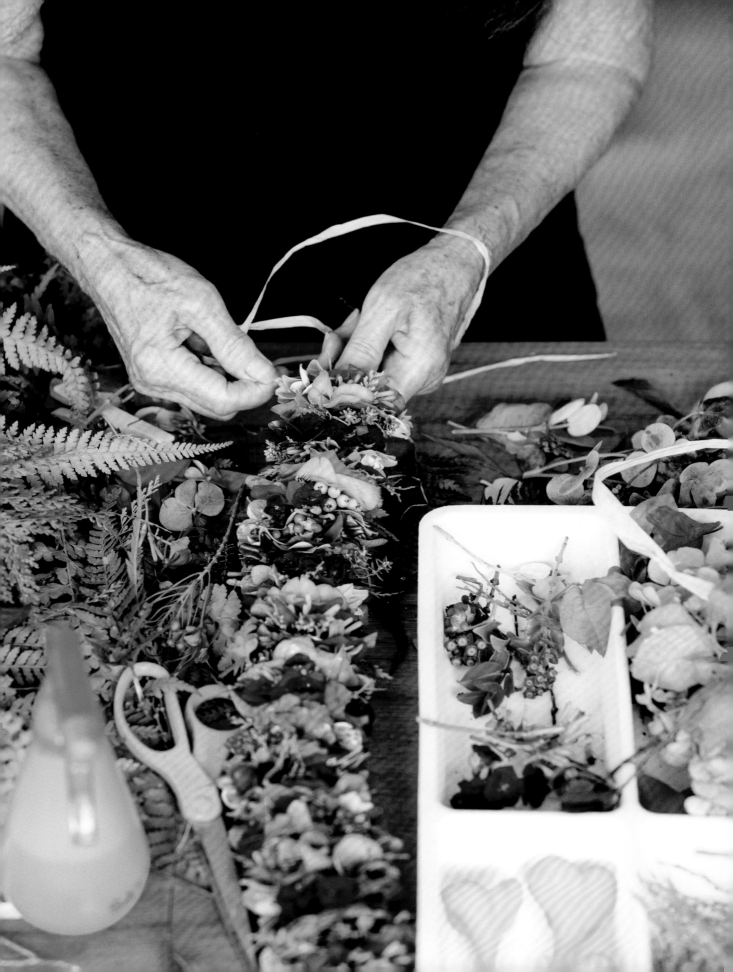

Lei Garden

Lei makers know the best lei materials are not always found in flower shops and they often cultivate beautiful "lei gardens." Walking past the perfectly cleaned rows of palapalai lining the concrete walkway at Betty Ikehara's Windward Oʻahu home, it is clear that a lei maker lives here; every open inch of land, save room for a table and chairs on the small concrete lānai (porch), has been dedicated to lei plants. Brightly colored cockscomb and bozu line the front yard. Spindly moa pokes up through the stone staircase past the shinobu fern along the sides. In the backyard, multiple terraces hold lei-maker essentials, such as potted bougainvillea, red cup and saucer, liko, and small roses.

It's a working garden as much as it is a beautiful one—and it's been the behind-the-scenes partner for Ikehara's six-decade career in lei making. Born in 1934, Ikehara grew up in the plantation communities in Hilo, Hawaiʻi. The first lei she can remember were made by the older kids in her neighborhood who would forage in the forest for material to make "horse style" lei (the large, inches-thick lei horses wear draped around their necks for parades) in May.

After graduating from the University of Hawaiʻi, Ikehara joined the Parks and Recreation Department on Oʻahu, which has been instrumental in perpetuating lei culture on Oʻahu. She was asked to teach lei-making workshops for the department and judge the annual lei contest at the city's Kapiʻolani Park May Day festivities. In the 1950s and '60s, the haku style of lei was still rare to see and her classes on lei wili were in demand from top lei makers for decades. On the side, she built a cottage industry selling lei, mostly through referrals. Ikehara regularly supplied the iconic lei poʻo for the performances of beloved Hawaiian music group Puamana and was asked to make lei for visiting dignitaries such as Ronald Reagan and Michael Dukakis.

Ikehara herself is modest about her reputation, but when pushed to answer, she suspects that her gift lies in being able to arrange colors in a striking way. And it's the colors that Ikehara is drawn to when it comes time to harvest flowers from her garden. "If I'm going to make a light pastel color, lavender, light pink, whatever, I just go and pick a few lavender flowers and a few splashes of red. I always like to put an accent color in my lei that maybe other people wouldn't think of putting in, but I like to because it kind of perks it up instead of just drab, same-old, same-old color."

At eighty-seven years old, Ikehara, who claims she is slowing down, is accepting fewer consignments, and in doing so, her appreciation for lei and her garden is changing. "When I was young, I used to make them real fast because I had to do four lei for [Puamana] in one crack—all the same lei, so I had to learn to work fast to make the four. But now I tell myself, I'm not going to make it fast. I'm going to enjoy all the flowers."

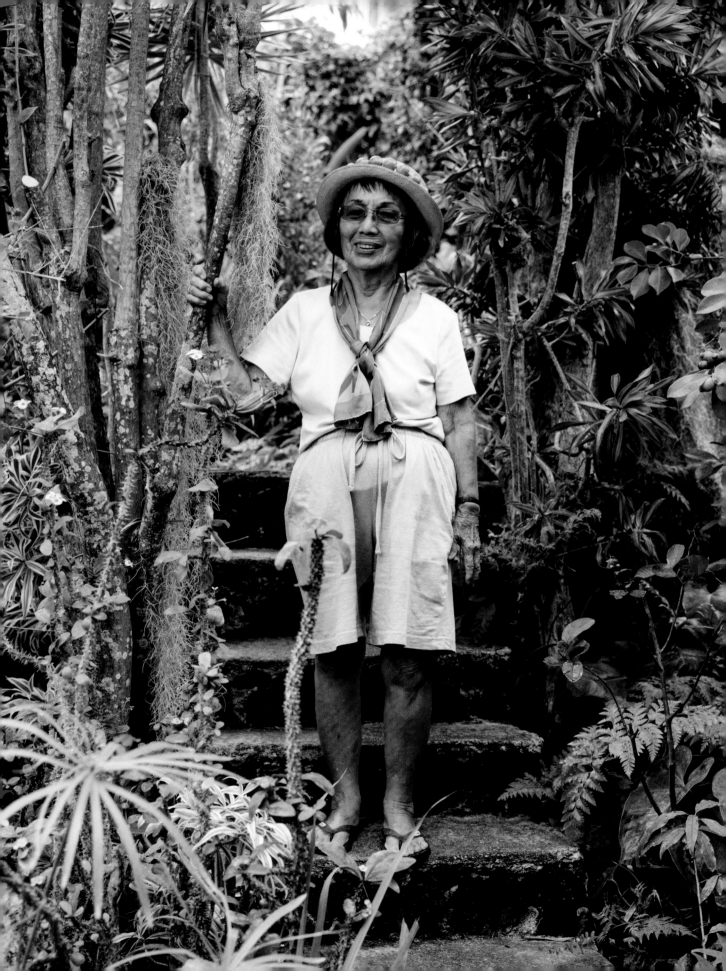

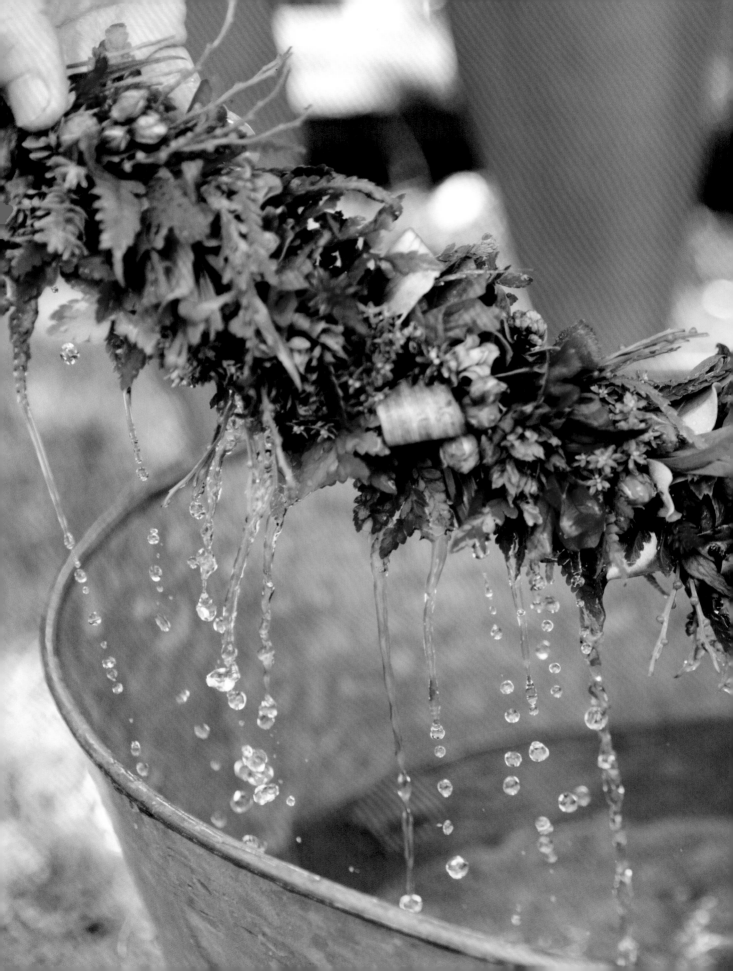

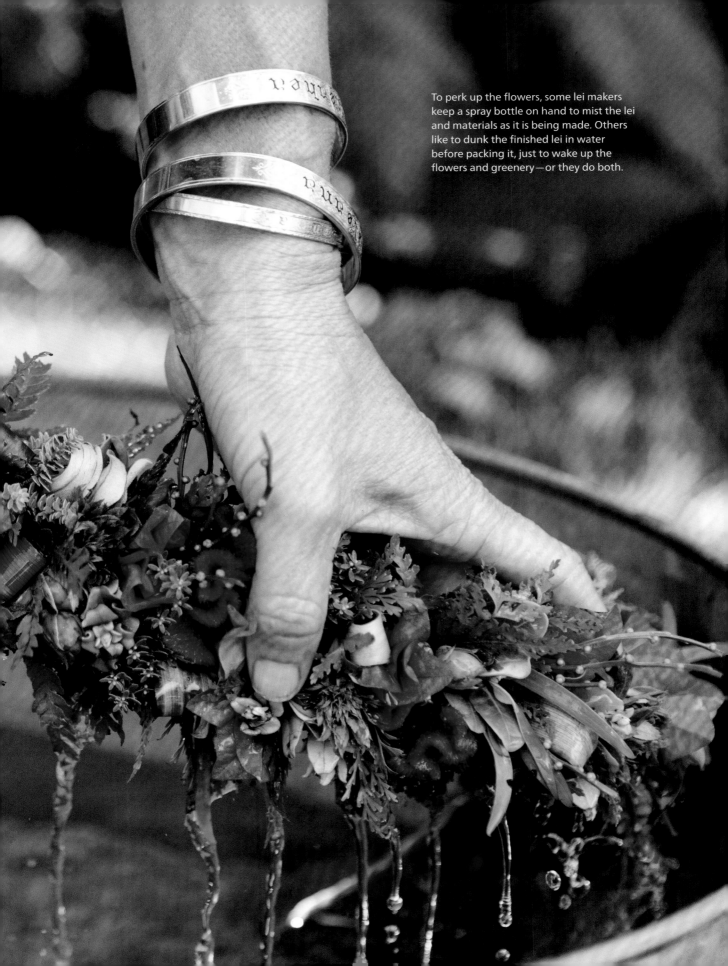

To perk up the flowers, some lei makers keep a spray bottle on hand to mist the lei and materials as it is being made. Others like to dunk the finished lei in water before packing it, just to wake up the flowers and greenery—or they do both.

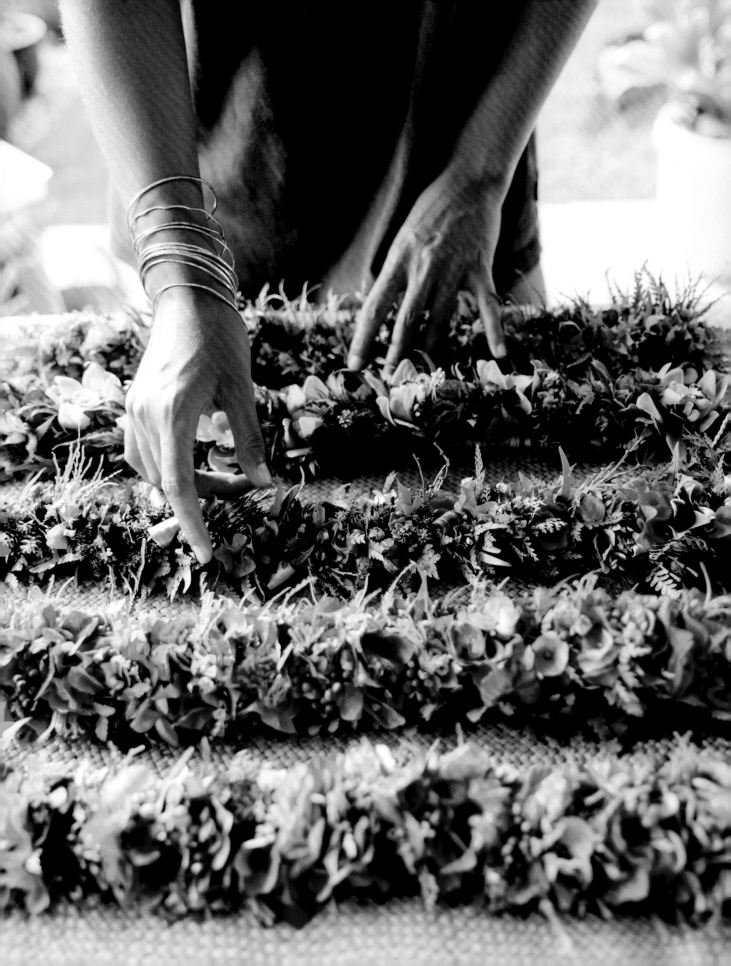

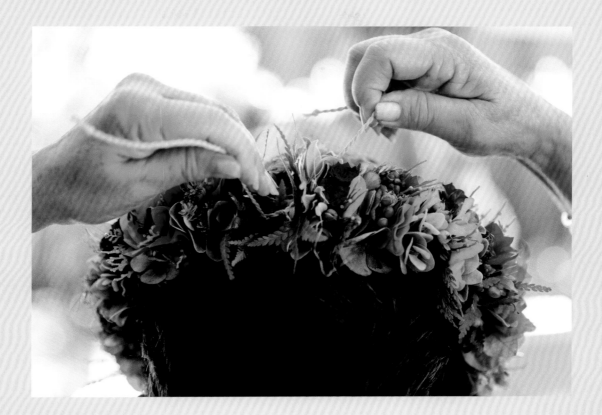

Lei makers love to experiment with new materials, but there are still some traditional elements that Sato insists upon: The lei po'o must be long enough to meet in the back of the head without a gap; to wear it properly, it must sit high on the forehead of the wearer, then be tied at the widest part of the head at the back, at a slight angle. Lei po'o are generally about twenty-one inches, or the width of two newspaper pages if a measuring tape can't be found. A hat lei should be slightly longer, twenty-three inches, while a lei 'ā'ī for the neck, is around twenty-eight inches.

It takes Sato and Berrington an hour or two to make each lei po'o once they start—which they say is slow compared to their mentors, who can make one in less than thirty minutes. "That was Mrs. Bailey. You would watch her make one and there was no wasted motion," Hara says about my tūtū, with the understanding that even with her own decades of experience—she has been making lei with this group since middle school—there are still things to learn or improve upon.

When the lei are finished, Sato and Berrington pack them gently into cardboard soda boxes, then cover them lightly with wet newspapers and a layer of ti leaves before placing them in the fridge to await delivery to the Queen Emma Summer Palace fundraiser. Berrington looks satisfied. She recounts how her husband had watched her pick some of the greenery for the lei she made. "After I was done picking, I said, 'You know what? You asked me the other day what are the happy times—what are you doing when you're really happy? I had a moment then that made me realize as I was picking and looking at each thing—this makes me happy.'"

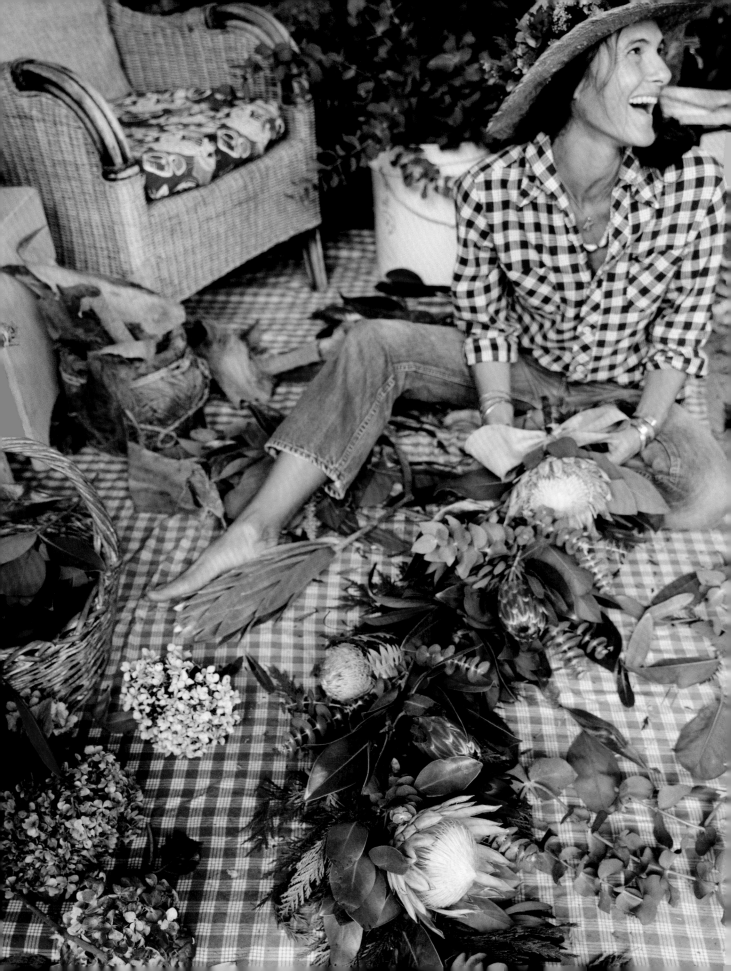

I Uka

To the Mountains

"I feel like we're recreating what our
parents did. We were just always around it.
And now our kids are around it."

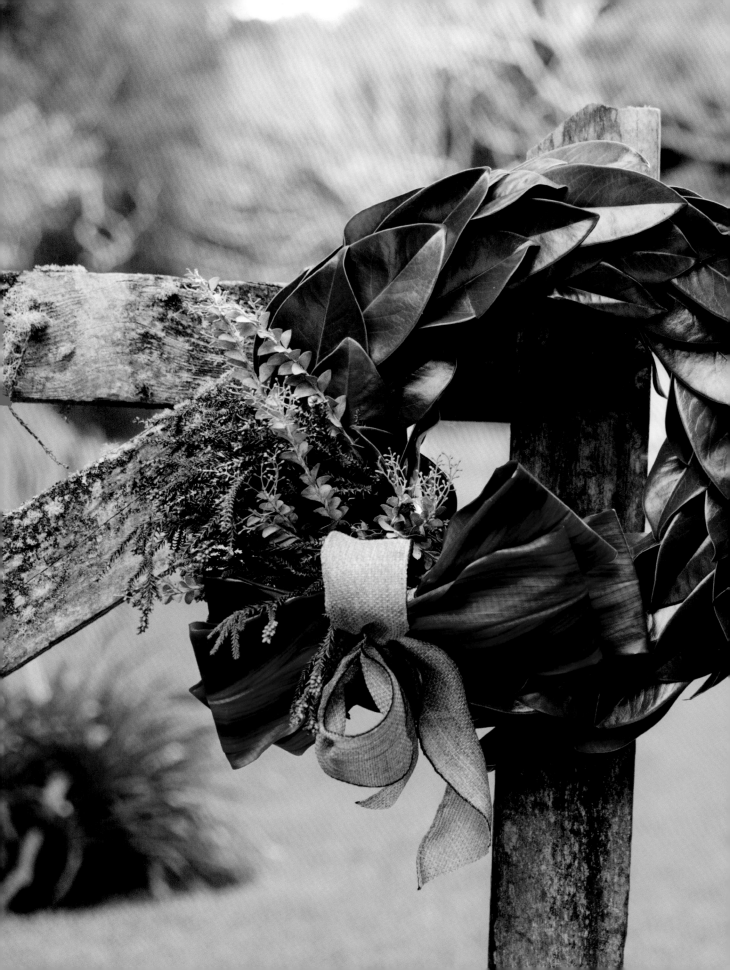

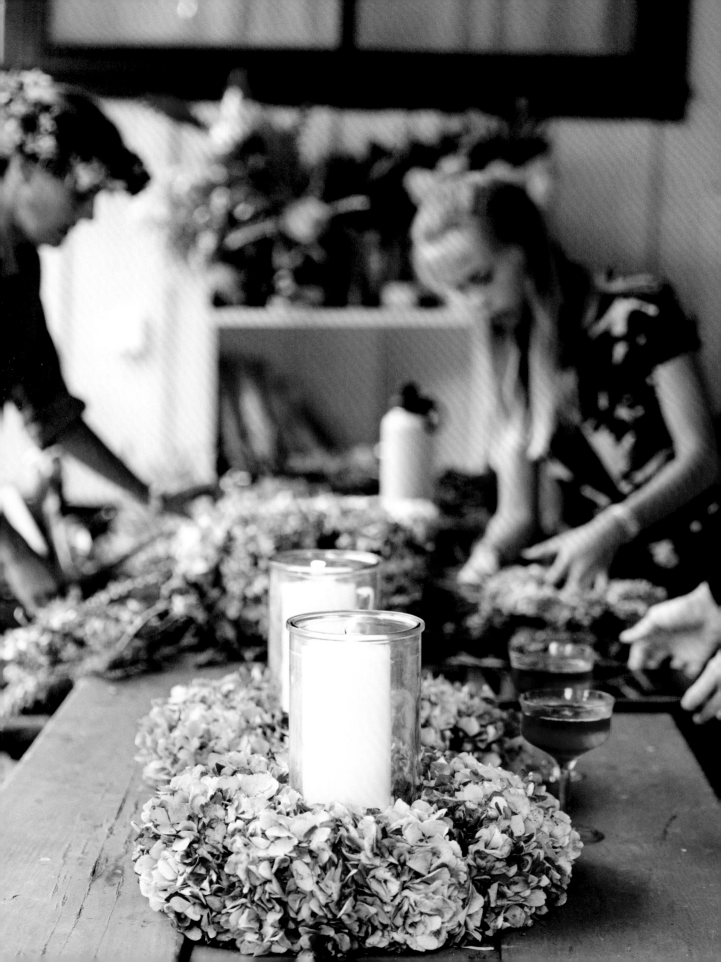

T he first time I got a group of friends together to make wreaths, it was because our silver dollar eucalyptus tree had been trimmed and there was a giant pile of freshly cut branches with beautiful leaves filling an entire bay of the garage. I refused to let the silvery cloud of leaves go to waste, so I turned the material into an impromptu holiday gathering with longtime friends who always get excited for the opportunity to get creative with anything from lei making to tie-dyeing.

Since that day, wreath making has become an annual event for us, another way of bringing the outdoors inside to decorate for the holidays and another chance to hone the skills we use in lei making, such as finding the right color and texture combinations. "I love the tradition of gathering and getting together. We talk story and it really just helps us get into the spirit," says Gina Davidson, an Oʻahu-based designer, noting that in addition to the joy of creating together, these events are about sharing skills and knowledge. "I've learned everything I know about wreath making from watching our friends."

This year, our group took a trip to the island of Kauaʻi to gather at a friends' mountain cabin in Kōkeʻe State Park, home to a lush native Hawaiian rain forest. The high elevation offers a dramatically different landscape for foliage and greens than what can be found at sea level. Native koa forests line the winding road up to the cabin, hāpuʻu ferns cover the forest floor, while hydrangeas grow tall in cabin yards.

Under the roof of the cabin lānai, we placed overflowing buckets of protea, macadamia nut leaves, and eucalyptus. The group quickly organized workstations, separating magnolia leaves and other greens by type and arranging supplies within easy reach. Everyone found their spot on a chair or the blankets laid out on the ground among the materials. As is true every time we gather for our lei-making and craft events, the prep work takes the most time. In wreath making, the first item of business is deboning the ti leaves that will be wrapped around straw-filled wreath forms. "In case you have any parts where there's no foliage, the green [of the ti] will

camouflage the background," explains Lauren Hewett Caldiero, a creative brand consultant, as she strips the leaf from the spine.

Growing up on Hawai'i island, Caldiero used to watch her father make wreath forms out of banana poka vine, which her mother would cover with indigenous 'uki grass harvested from the volcano. "I thought it was super boring—kind of a brown vibe," she says with a laugh, while wrapping the green ti leaves around the form and securing them with wreath pins. "Now I think, 'Oh my god, my mom did this!' When I was a child, I didn't appreciate this."

Once the wreath form is covered, then we begin to add foliage. The goal is to hide the wreath form from all angles that it might be seen while hanging on a door. There are two basic methods we use, and within those, some of my friends have their own techniques. Some wili leaves and flowers to the wreath form with raffia or wire as one might do with a lei po'o. Others use wreath pins to essentially staple greenery to the form.

"Getting started is the hardest part, because once you're in it, you start to get a flow and everything naturally falls into place. And then you'll have a direction that all the leaves are turning, too," says Jennifer Binney, an O'ahu-based creative director. She starts her wreath by lining the interior ring of the form with magnolia leaves before filling in the gaps with a ring of blue hydrangeas.

Cee Cee Simmons, an accomplished lei maker and hala weaver, uses a different technique—she bundles the base of macadamia nut leaves together with wire before pinning each cluster to the wreath form in bunches for a full, lush effect. This approach is not for everyone—it takes hours of prep work. "I started making some last night," she admits as she sifts through a wooden bowl of completed leafy bundles.

Simmons, who grew up between Kaua'i and O'ahu, has been making wreaths as well as flower arrangements and lei with her mother since high school. In recent years, she's been learning more with her kumu for lauhala weaving who likes to make wreaths with materials that dry well. "She has a wreath that she said has been hanging on her door for almost twenty-five years and it still looks incredible," she says. This year, Simmons incorporated her lauhala skills into the wreath event; she prepped a batch of lauhala strips to cover the wreath form.

One of the benefits of using heartier plants—macadamia nut leaves, magnolia, and eucalyptus—is that the wreath lasts longer. "You can choose materials that will [turn quickly], which are beautiful and incredible, or you can use materials that will last a season," adds Simmons, pointing out that even something as delicate as hydrangea can dry nicely or be spray-painted gold for a festive look after it loses its color. The night before, she made a striking long-lasting wreath by wrapping the form in coconut fiber and attaching swaths of Norfolk Island pine and bromeliads for color.

The final touch on the wreaths for many in the group is an accent piece, often with a tropical sensibility. Caldiero fashions what she jokingly calls her "wow piece" out of three folded red ti leaves cinched with fiber, then stuffed with eucalyptus. Binney also makes a natural bow by scrunching two pieces of coconut together.

When asked if wreath making is closer to flower arranging or lei making, Binney chooses the former, as it can take upward of three hours to finish one. "I mean the haku thing is [making] color combinations, but wreath making is a matter of endurance."

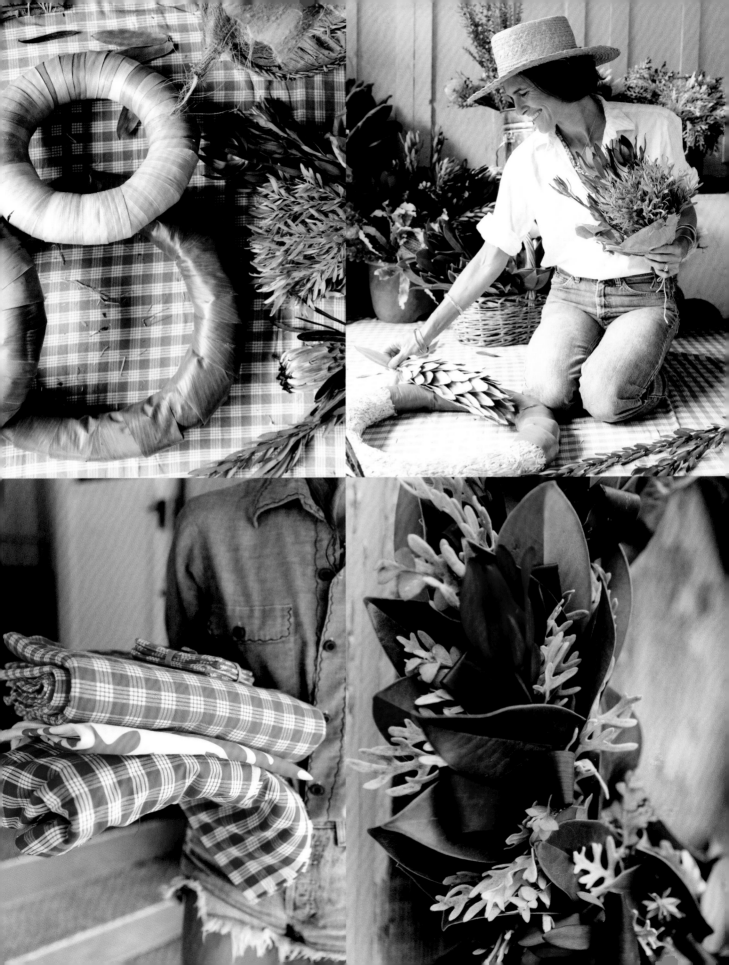

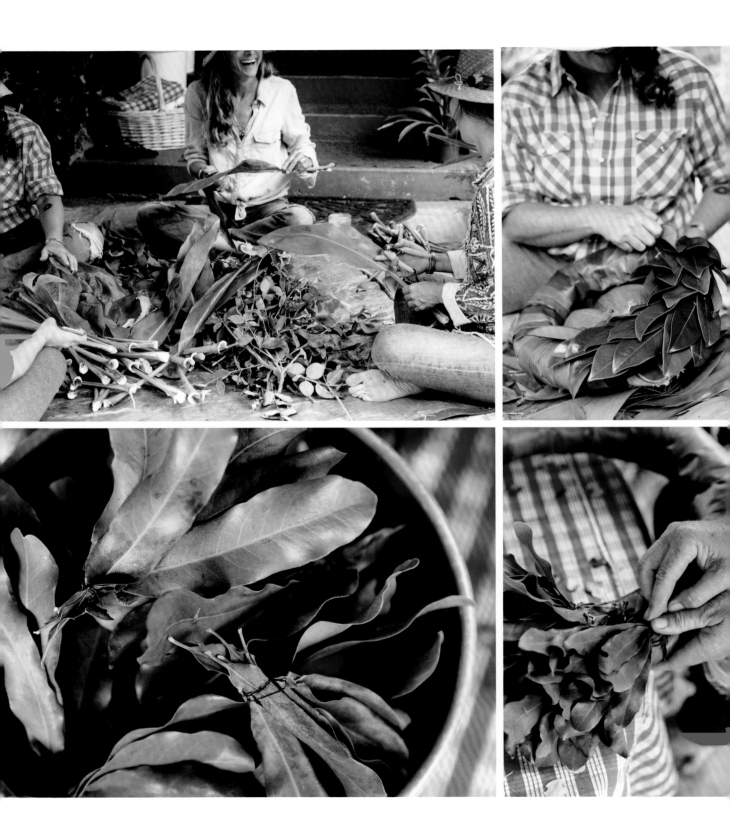

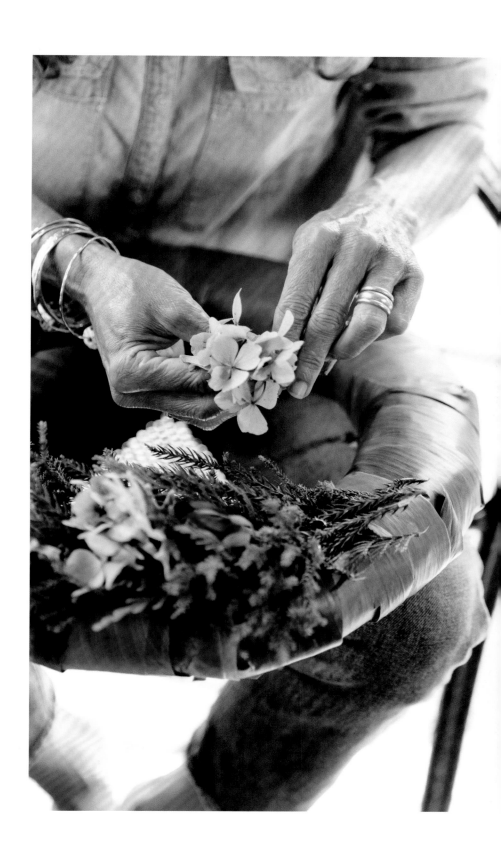

Opposite, bottom left: Some wreath makers like to pre-bundle their materials, as shown with these macadamia nut leaves, before attaching to a ti leaf–covered base.

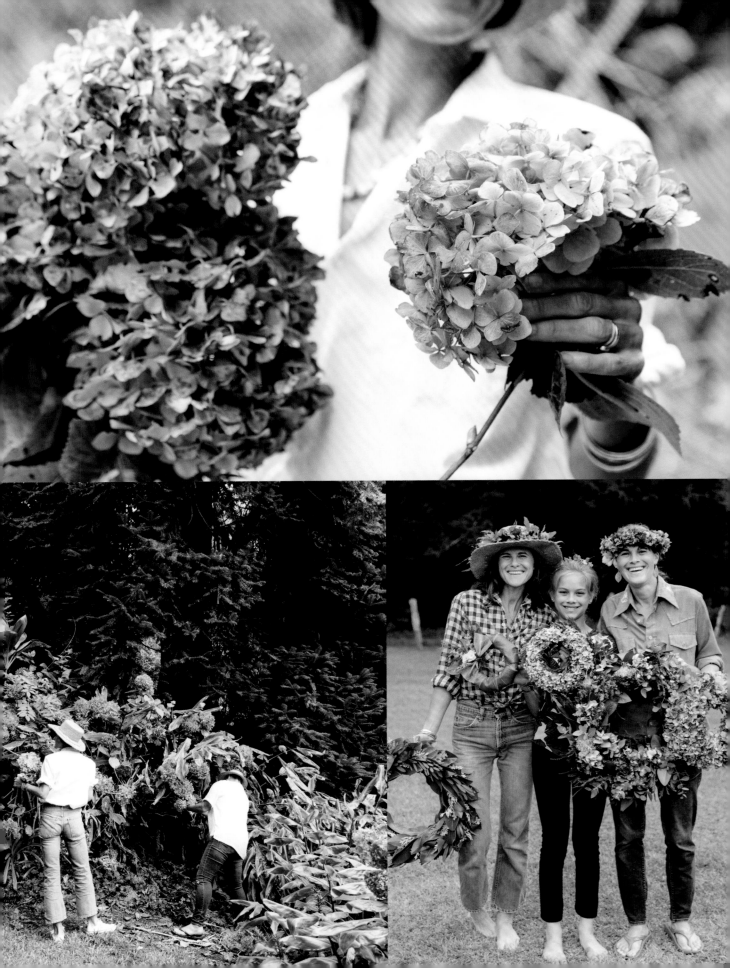

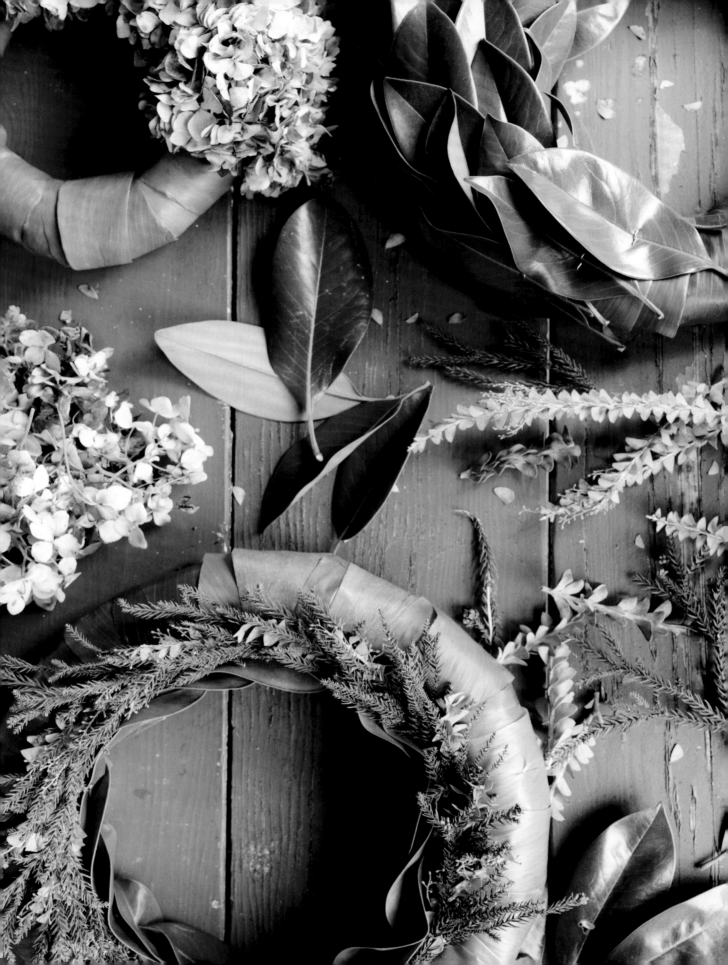

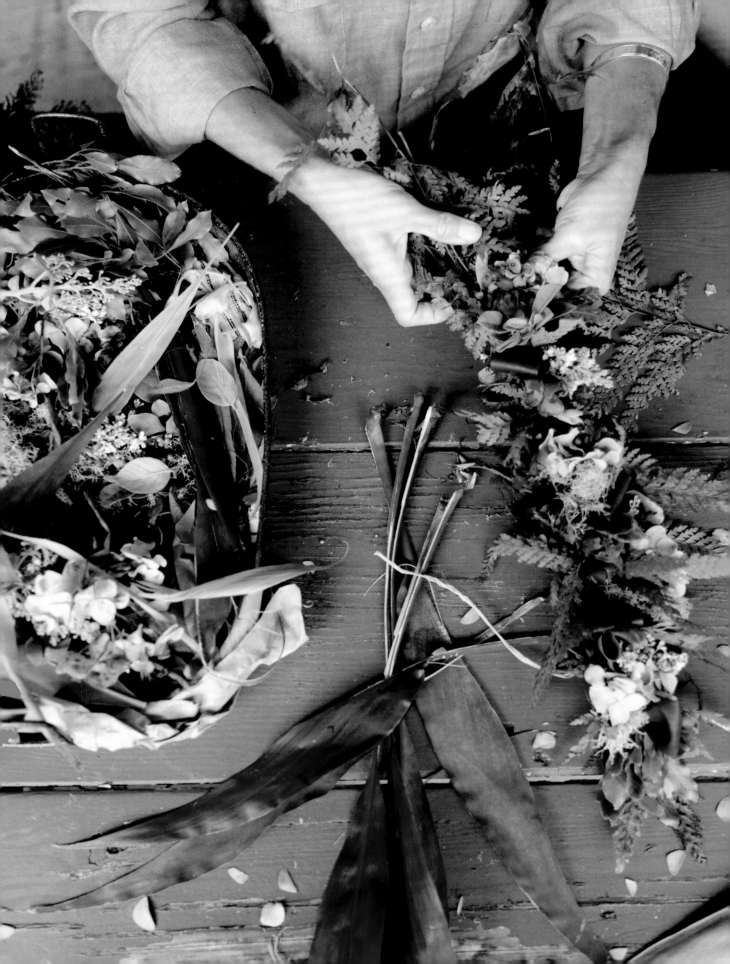

Lei Haku

The lei hili, one of the traditional styles of lei making, is usually made by plaiting three strands of natural material together with no backing material or string. It becomes a lei haku when you add more than one material, like an additional type of fern or flower. While the term *haku lei* is widely used to describe a lei po'o, or head lei, *haku* refers to this particular braided style. My sister, Mehana, says she loves to make braided lei haku and lei hili because she learned while gathering with our grandmother in the mountains. "Tūtū taught us to braid while we were hiking, picking ferns to add in along the way. We didn't sit down and learn it. We learned it on the move," says Mehana. Tūtū always had us make a lei for the forest first before we began to gather anything else.

"When I was older and hiking more on my own and with friends I started using different kinds of ferns, not just pala'ā and palapalai. When you make the lei as you go then you remember the hike by where you were in your lei. The lei becomes a journal of the trail and how the forest changes each time you hike it."

Our tūtū worked hard to plant and tend to beds of palapalai ferns and other natives in her yard. She stopped gathering from the mountains completely in her older years. "It became more difficult for her to hike, but more than that, she worried about the changes she saw in the forest." Mehana recalls gathering one or two bags of fern with Tūtū when they went to the mountains. Now, she and her own children pick just enough fern for their offering lei to leave in the forest, then gather a handful of sprigs from a variety of other natives. "Just enough for my children to know those mea kanu 'ōiwi (native plants) and how to make lei with them. Everything else we can pick from our yard and our friends' yards."

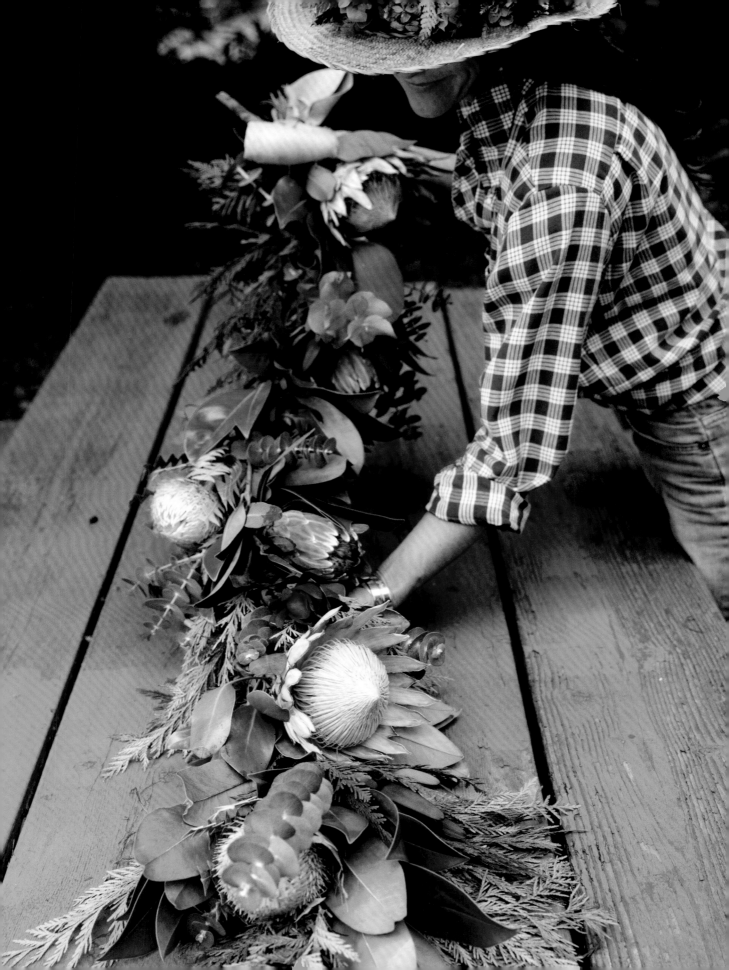

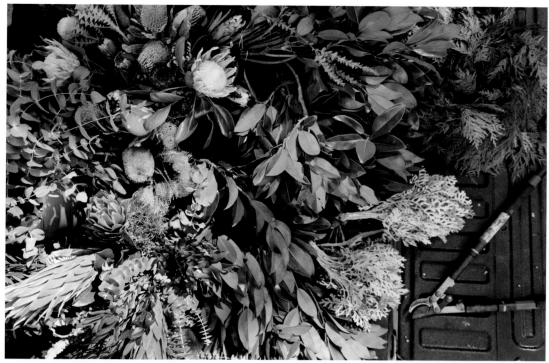

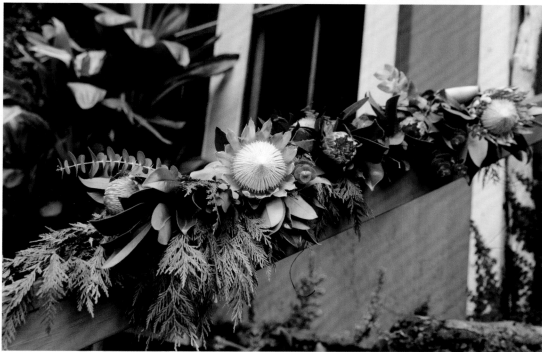

Opposite: Protea makes a beautiful tropical accent to the holiday table. I like to use the wili technique to combine Christmas greens with eucalyptus, magnolia, and protea, making a giant lei for the table. "Table runners are something I always associated with Tūtū and with Christmas and family parties," says my sister, Mehana Vaughan. Our tūtū would decorate every part of the table for Christmas, even making lei wili for the little wooden ducks she would place around the table. "Our mom likes more freestyle stuff, so she would just get whatever from the yard and throw it together. It was less exacting, but she's a great jam-it-out table-runner person. We just adorned it all."

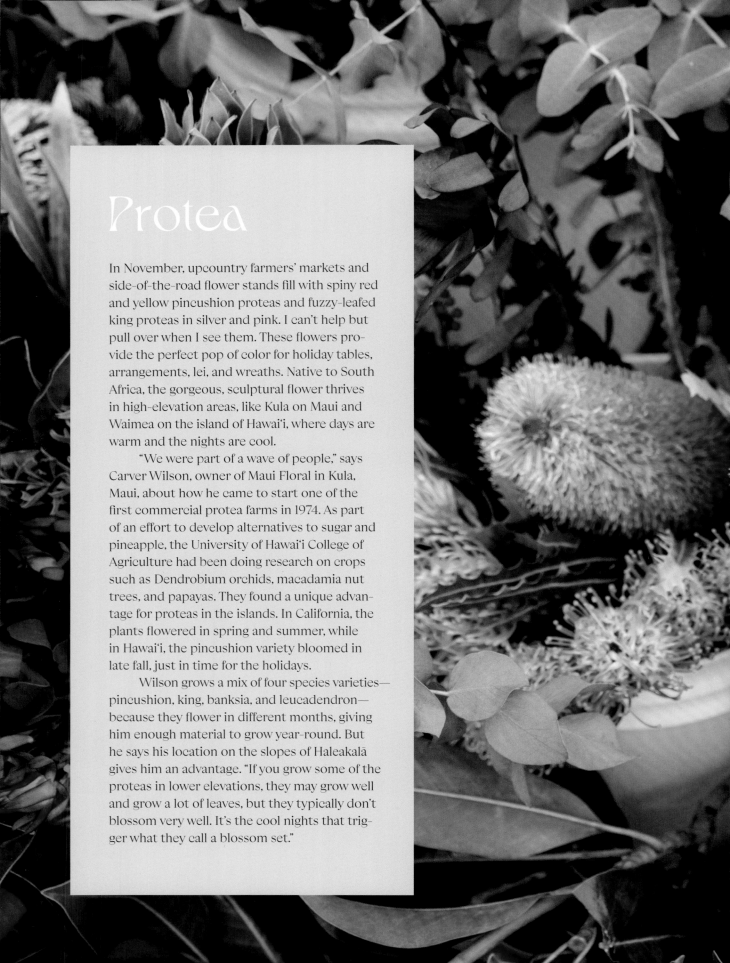

Protea

In November, upcountry farmers' markets and side-of-the-road flower stands fill with spiny red and yellow pincushion proteas and fuzzy-leafed king proteas in silver and pink. I can't help but pull over when I see them. These flowers provide the perfect pop of color for holiday tables, arrangements, lei, and wreaths. Native to South Africa, the gorgeous, sculptural flower thrives in high-elevation areas, like Kula on Maui and Waimea on the island of Hawaiʻi, where days are warm and the nights are cool.

"We were part of a wave of people," says Carver Wilson, owner of Maui Floral in Kula, Maui, about how he came to start one of the first commercial protea farms in 1974. As part of an effort to develop alternatives to sugar and pineapple, the University of Hawaiʻi College of Agriculture had been doing research on crops such as Dendrobium orchids, macadamia nut trees, and papayas. They found a unique advantage for proteas in the islands. In California, the plants flowered in spring and summer, while in Hawaiʻi, the pincushion variety bloomed in late fall, just in time for the holidays.

Wilson grows a mix of four species varieties—pincushion, king, banksia, and leucadendron—because they flower in different months, giving him enough material to grow year-round. But he says his location on the slopes of Haleakalā gives him an advantage. "If you grow some of the proteas in lower elevations, they may grow well and grow a lot of leaves, but they typically don't blossom very well. It's the cool nights that trigger what they call a blossom set."

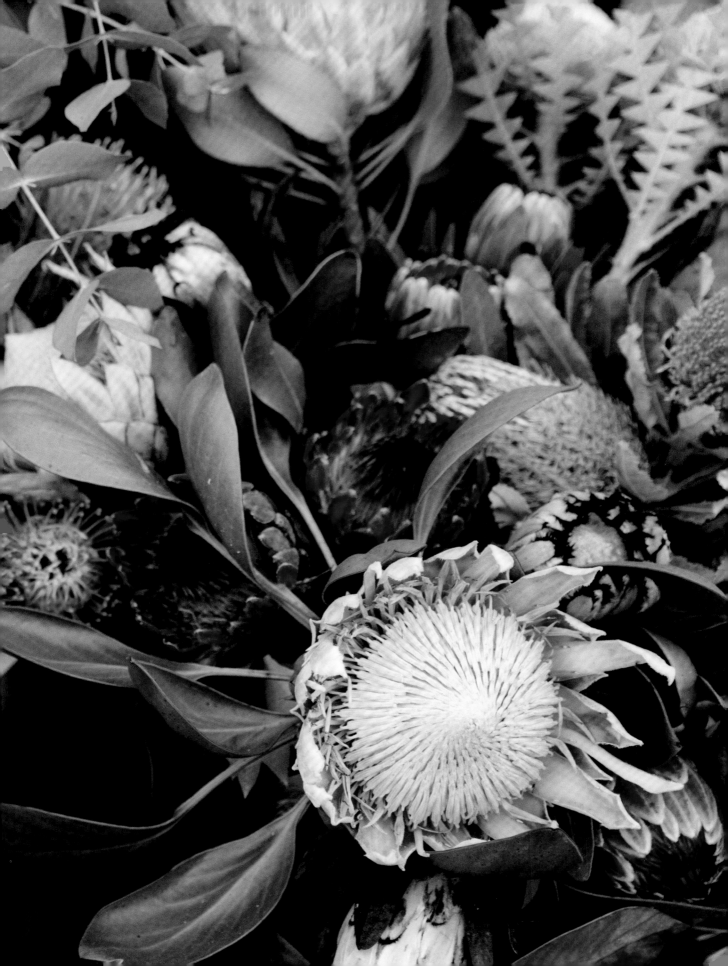

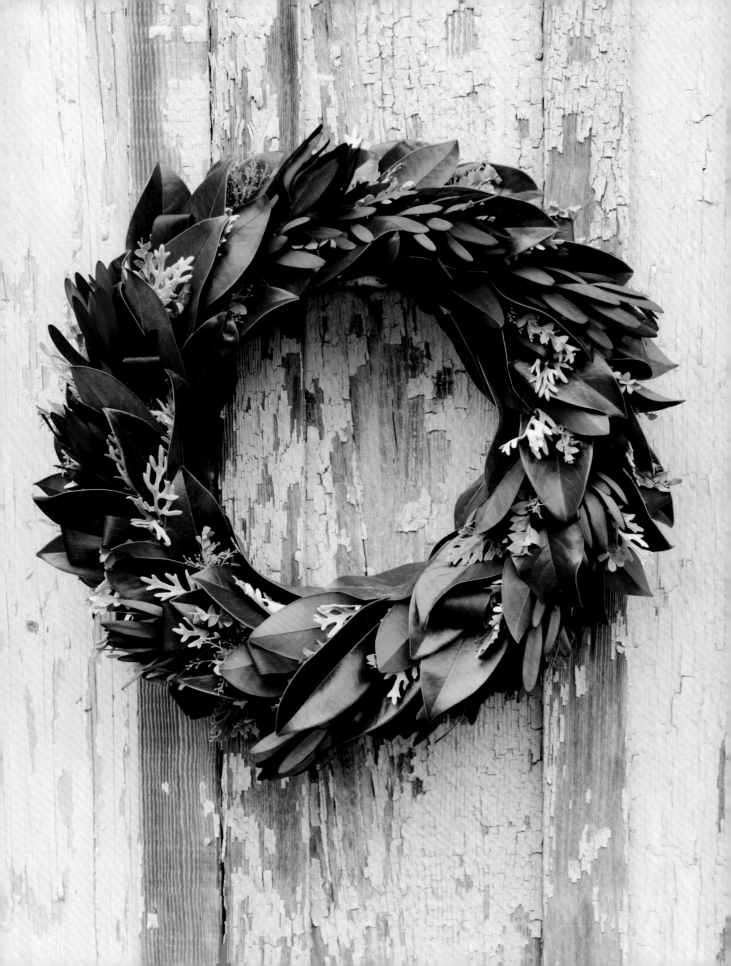

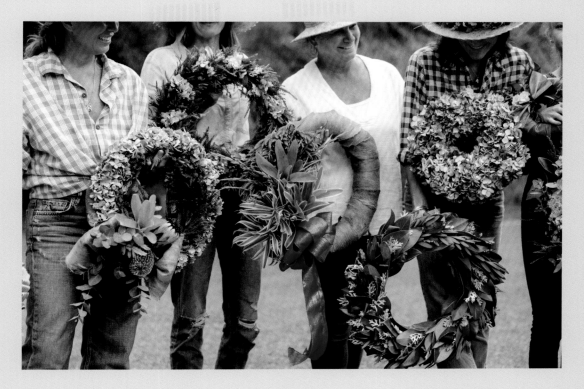

It makes sense to Jennifer Binney that there would be crossover between wreath making, flower arranging, and lei making, especially around the holidays. "I think if you're a lei maker, for the holidays you want to do something different." Binney learned how to make wreaths by watching her step-grandmother, who lived on Maui and worked at C&H Sugar. An accomplished lei maker, she specialized in Vanda orchid, pakalana, and cigar lei, but around the holidays, she would make wreaths from Cattleya orchids, which her brother-in-law grew next door in Kahului. "I didn't know the names of anything," Binney says, noting her grandmother would let her observe the process rather than teach her directly.

"Now I find my kids are looking at me," Binney says of her own two school-age children.

"I feel like we're recreating what our parents did," agrees Simmons about their wreath- and lei-making friend group. "We were just always around it. And now our kids are around it."

"Yes," says Binney. "Good god, I hope it sticks."

"I think if you're a lei maker, for the holidays you want to do something different."
—Jennifer Binney

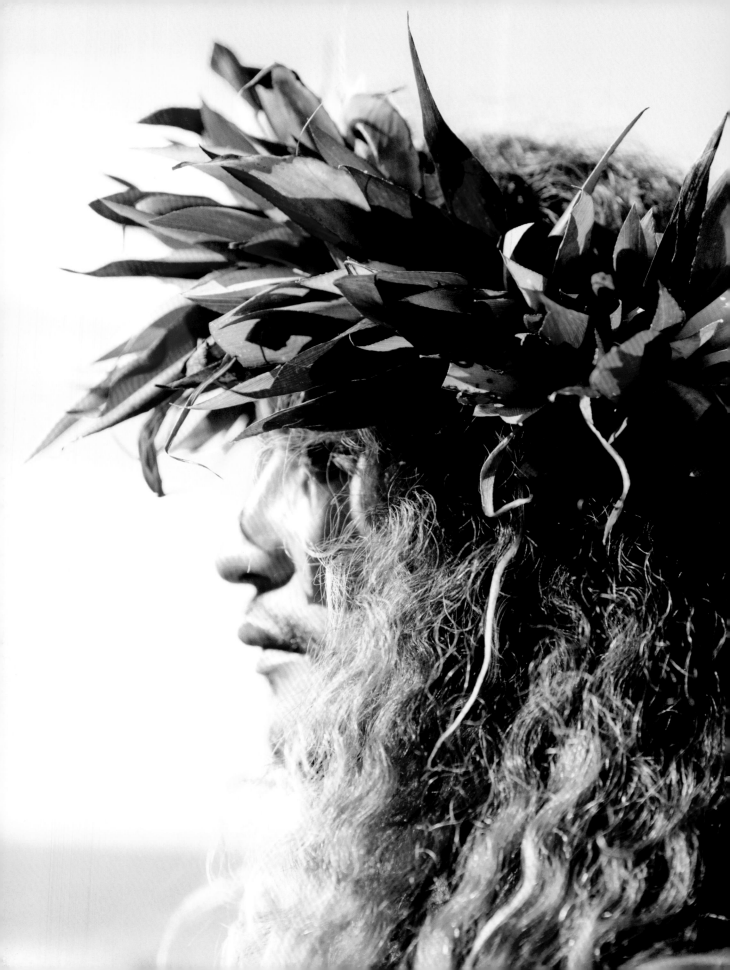

I Kai

To the Sea

"The lei will be gifted to the ocean."

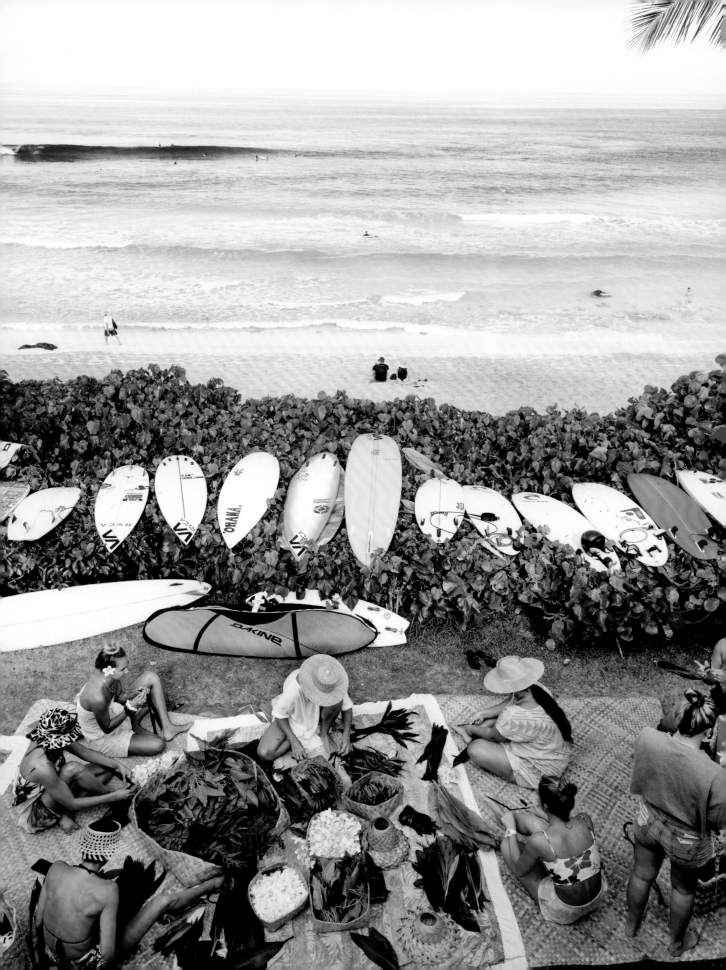

M y tūtū loved making lei for the end of a canoe race. Whether it was her son-in-law paddling in the Moloka'i Hoe, a grueling annual forty-one–mile race from Moloka'i to O'ahu, or me in a six-man outrigger canoe racing to the finish line at the Ala Wai Canal for the high school championships, she would show up with armfuls of pua kenikeni and lei po'o for us and our entire crew.

But it wasn't just our family celebrating ocean sports with lei. "At the Fourth of July [regatta] down at Waikīkī, people are racing all day long and somehow just about everybody has a lei on," says Dale Hope, a respected waterman and author of the renowned book, *The Aloha Shirt*. "Before your race, after your race—people are celebrated by being presented with a lei from their loved ones." At the largest events, the shore is packed as tens of canoe clubs race from morning to sunset in every age division from the under-12s to the over-55s. Family, friends, teammates, and coaches wade into the water greeting the incoming six-man canoes with lei brought from home or made on the beach.

Racing outrigger canoes—and bringing lei to the race—has a deep history in Hawai'i. November 16, 1875, the birthday of King Kalākaua, Hawai'i's last king, was celebrated with barge and canoe races in Honolulu Harbor and marked Hawai'i's first regatta. A 1928 *Honolulu Advertiser* article described the scene at that year's annual regatta day as a pageant of color: "Every island flower of all that bloom was represented in the gorgeous leis worn by those who came to see the boat races. Pīkake, ivory white and pungent yellow ginger 'awapuhi from cool Nu'uanu . . . golden-orange 'ilima, red and yellow lehua, lavender-pink 'ākulikuli, the cowboy's emblem of joy in Waimea, more famous for its Parker ranch; purple pansies . . . carnations twined with maile—one could go on and on indefinitely naming them."

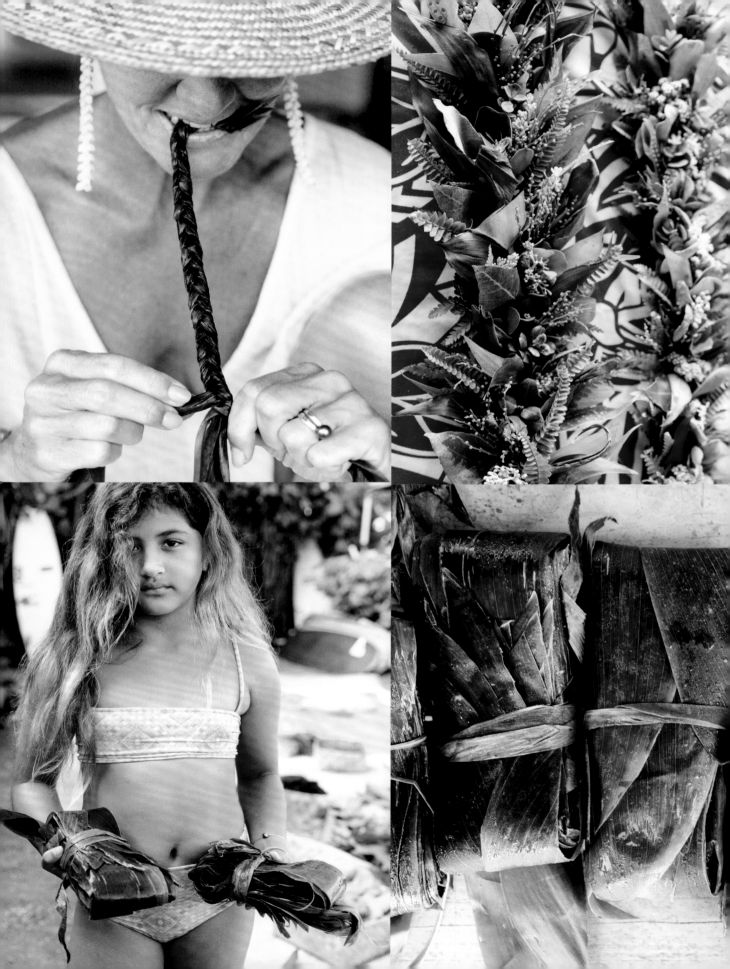

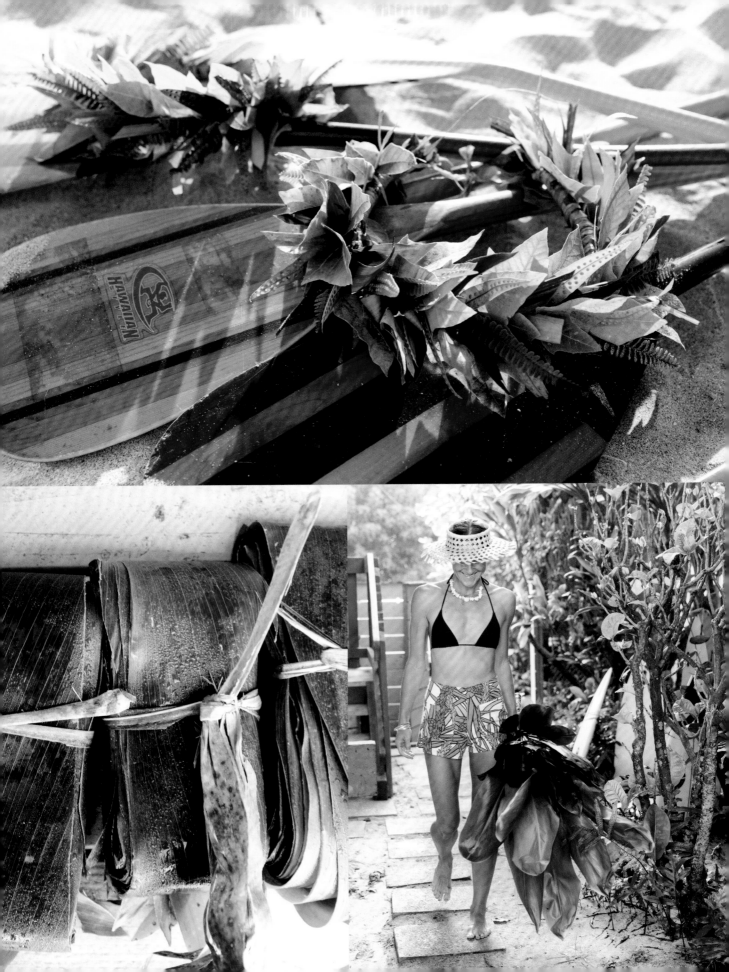

"Before your race, after your race—people are celebrated by being presented with a lei from their loved ones."
—Dale Hope

That spirit of lei abundance is still felt at canoe events today. "Lei is everywhere, whether it's the *Hōkūle'a* [voyaging canoe] celebration or the end of any canoe race. "I remember at Hui Nalu [canoe club], we used to get together—this had to be in the eighties—and make lei for the whole club," recalls Lita Blankenfeld, volunteer for the Polynesian Voyaging Society's logistics committee. Her keiki paddled for Hui Nalu, one of the many canoe clubs, and in those days she says they made lei from whatever materials were in people's yards. "We made lei for all the kids—that was the goal."

In Hawai'i, other ocean events, from surf competitions to surf blessings, are celebrated with lei. "Most every ceremony I've been involved with has something to do with the ocean," says Koral Chandler. Chandler grew up on the North Shore of Kaua'i, where she learned to make lei po'o using ti leaf, for occasions such as ceremonies and blessings. "Almost everybody I'm closest to are water people. Even the passing of people we love, they're usually water-oriented people and so we do paddle outs, a tradition of returning people's ashes to the ocean in which friends and family paddle surfboards into the water as a celebration of life. In those moments, you're always bringing lei with you," she says.

This year, Chandler, who owns 'Ohana Shop Kaua'i with her husband, Moku, and I were asked to make lei for the opening ceremony of the Billabong Pro Pipeline, a surf contest held each winter on the North Shore of O'ahu. The annual ceremony is both a blessing for the surfers and a memorial for Andy Irons, celebrated Kaua'i surfer and dear friend of Chandler's who passed away in 2010 at the age of twenty-two. Each year the ceremony is held on the beach to open the contest.

Chandler began sourcing enough ti leaves to make lei for the contestants, organizers, hula dancers, and chanters a week before the event. The lei she most likes to make needs a foundation of ti, which must be cooked ahead of time to soften the leaves. "If I'm making one lei and it's for that day, I'll go and I'll pick my ti leaf. Before I cut it off the bone, I'll cook it over an open flame," she says, describing her favorite method, noting that it's also possible to cook the leaves in the microwave for around thirty seconds or so. "If I have a lot of lei to make, I'll be prepping the whole week before, and I'll start to bundle them, stack them very neat and clean, tie them with a brown leaf, and put them in the freezer. Then when you're ready to make a lei, take them out way before so they're not sticky and slimy, and they can dry."

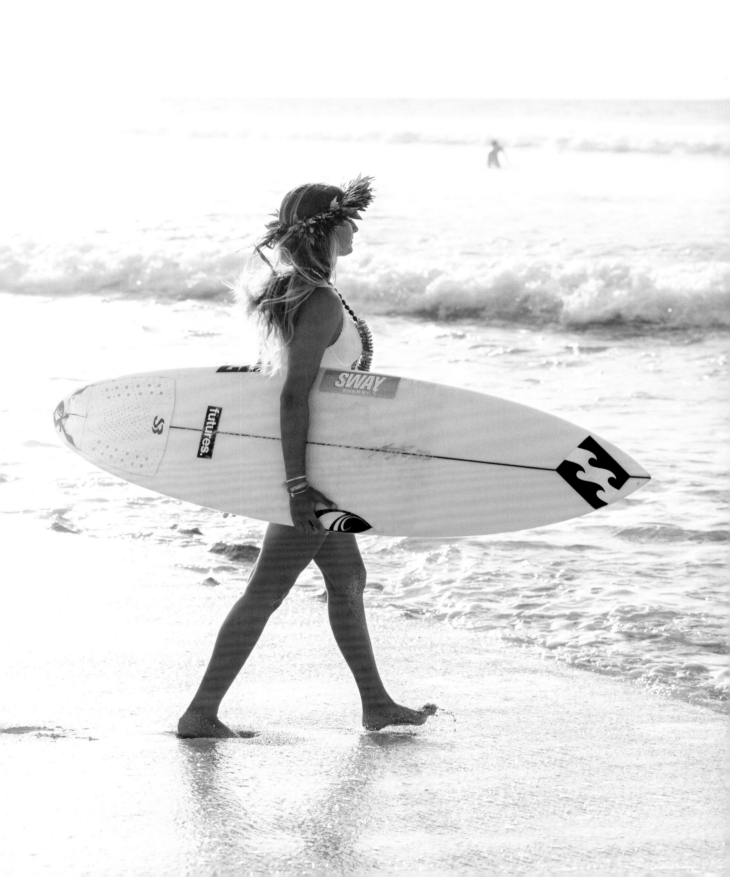

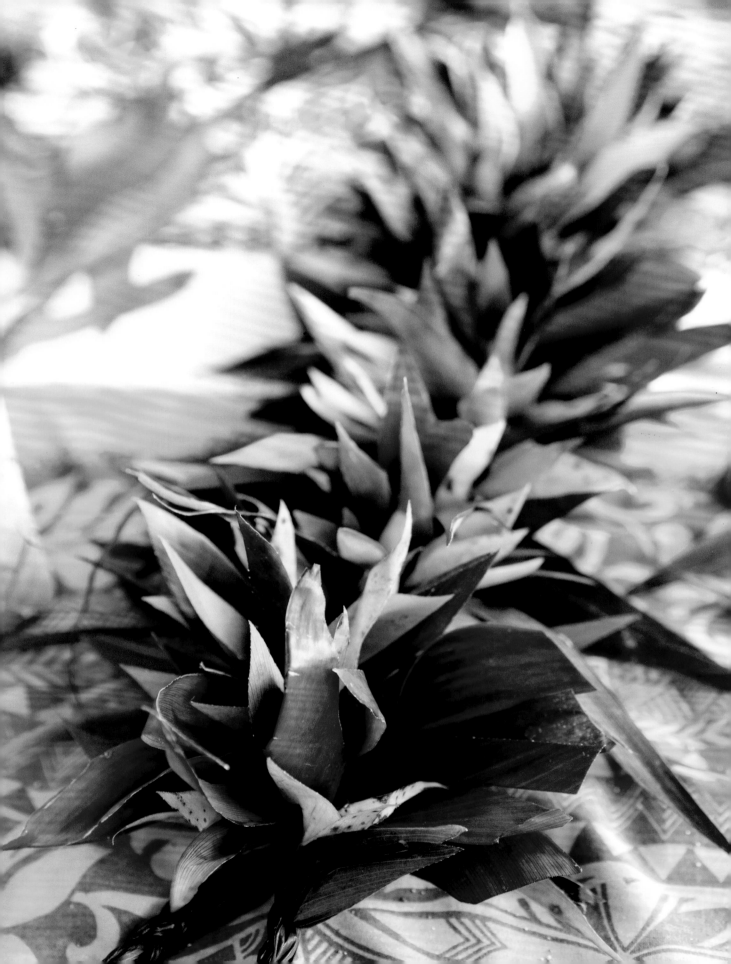

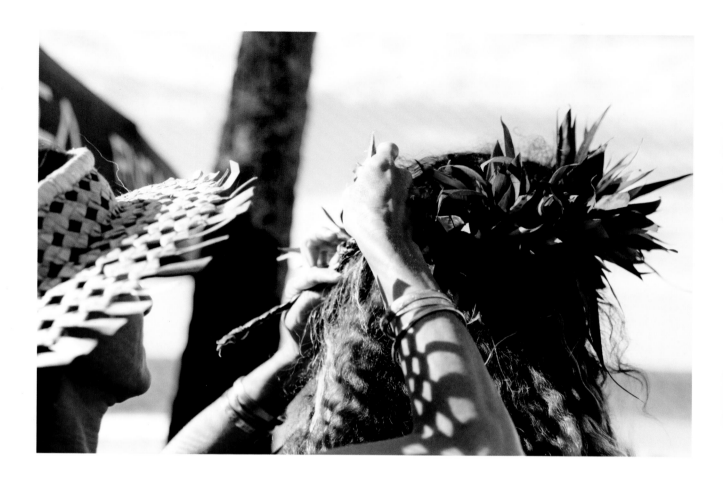

On the day of the opening ceremony, friends from all over Oʻahu came to make lei. Some dropped in to make one or two before a quick surf session. Others found a shaded spot on the porch to settle in for the hours of lei making ahead. A handful of people unexpectedly popped in off the beach to say hello and were excited to join once they saw their friends making lei. Chandler, presiding over the day, would get up to hug a friend, respond to a nephew's request for a surfboard leash, or listen to an excited keiki tell her about their best wave, always with a lei in progress dangling from her hand.

Though I came to help Chandler with the loads of lei she was tasked to make, I also had the privilege of making two special lei poʻo for Andy's wife, Lyndie, and auntie Tammy Moniz, whose husband, Tony, led the ceremony. The day before, I gathered materials I thought would stand up to a ceremony in the sun. I wanted to use Hawaiian materials for this event, natives and "canoe" plants (plants that the Polynesian settlers brought to Hawaiʻi on canoes): dried ʻulu, lauaʻe, pink ti for color, moa for texture, kupukupu—sturdier than gentle palapalai—kukui and a little bit of liko (the young leaves of ʻōhiʻa lehua) from my tree.

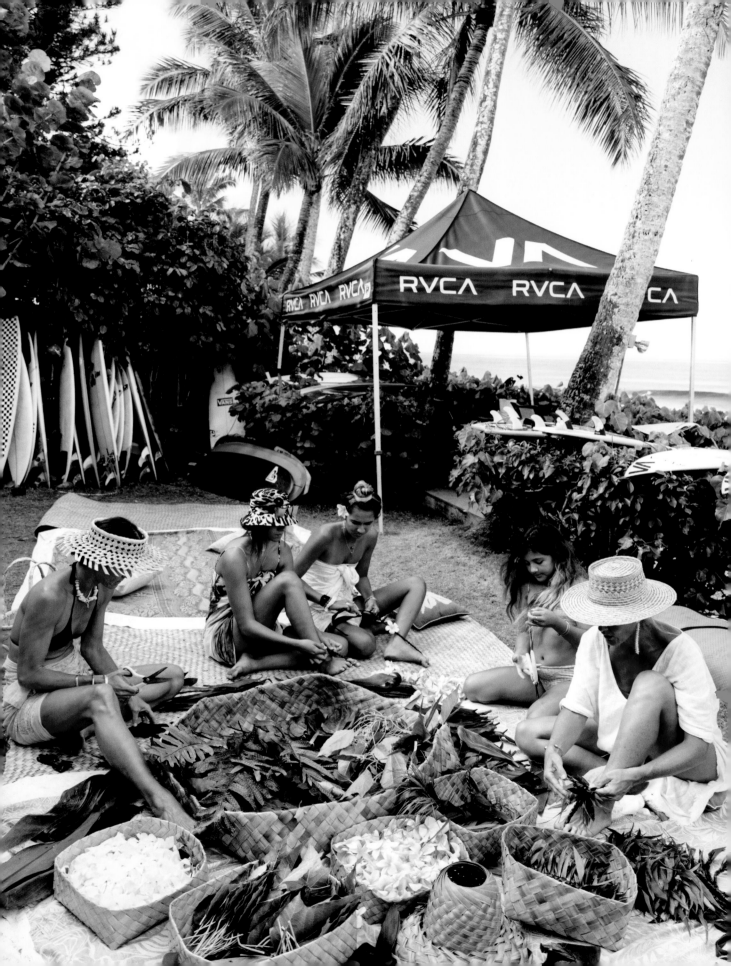

All skill levels were welcome on this day, with seasoned lei makers pausing their lei progress to give quick lessons to eager keiki or tips to friends. Some made lei lāʻī (ti leaf lei) in the hilo style, twisting leaves into ropes and winding them around each other, tucking plumeria blooms in between the twists for a pop of color. Others helped with lei haku, either by prepping ti leaves or braiding their own.

"While I'm learning, they're learning at the same time," says Waikīkī resident Malia Kaleopaʻa about learning to make lei alongside her children, Kelis, seventeen, and Moses, twelve. Though she was raised in Waikīkī, surrounded by lei and tourists, Kaleopaʻa moved to the mainland when she was young and missed out on learning to make lei. Now, back on Oʻahu with plenty of lei maker friends and children who are interested in the craft, she says it's been fun to learn new styles as a family and more generally celebrate through lei. "Ti leaf is probably my favorite material because it's so versatile," she says about the lei lāʻī hilo she made all day long.

Along with niu (coconut), ʻuala (sweet potato), and kō (sugarcane), ti, or kī, was one of the canoe plants brought to the Hawaiian islands by early Polynesian settlers. Traditionally used as medicine, shelter, clothing, cooking, and packaging, the plant was also thought to have great spiritual power. Today ti is still planted or given as protection from bad spirits or to attract the good, either in plant or lei form. "You're sticking a little ti in your bathing suit just to kind of ward off anything, take care of us across the channel," Blankenfeld says, laughing. She and her fellow paddlers would hide a little piece of ti in their suit or tie one to the manu (ends of canoe) for a big race. In ceremonies for new buildings or events, the kahu (the priest), will often carry or wear ti and sometimes use it to scatter salt water for a blessing.

Ti is considered spiritual and essential but also lovely to work with. Chandler explains that she prefers making lei out of ti regardless. "When your lei has ribbon in it, that's not compostable," she says, which is important to consider—especially if a lei might end up in the ocean. Though in the early years of tourism it became popular for visitors departing by ship to throw lei in the ocean, that practice is now discouraged because it pollutes the ocean with string and ribbon.

For the ti leaf lei poʻo, my tūtū believed bigger is better when it comes to size. She got excited to make this style for the annual Molokaʻi Hoe race, where she would greet paddlers' families and friends with beautiful big lei poʻo. She relished the chance to make the wild style, compared to the more composed lei wili she made out of cut flowers and dainty palapalai ferns.

Opposite: Lei makers and friends gather to make lei for the opening ceremony of the Billabong Pro Pipeline, a surf contest held each winter on the North Shore of Oʻahu.

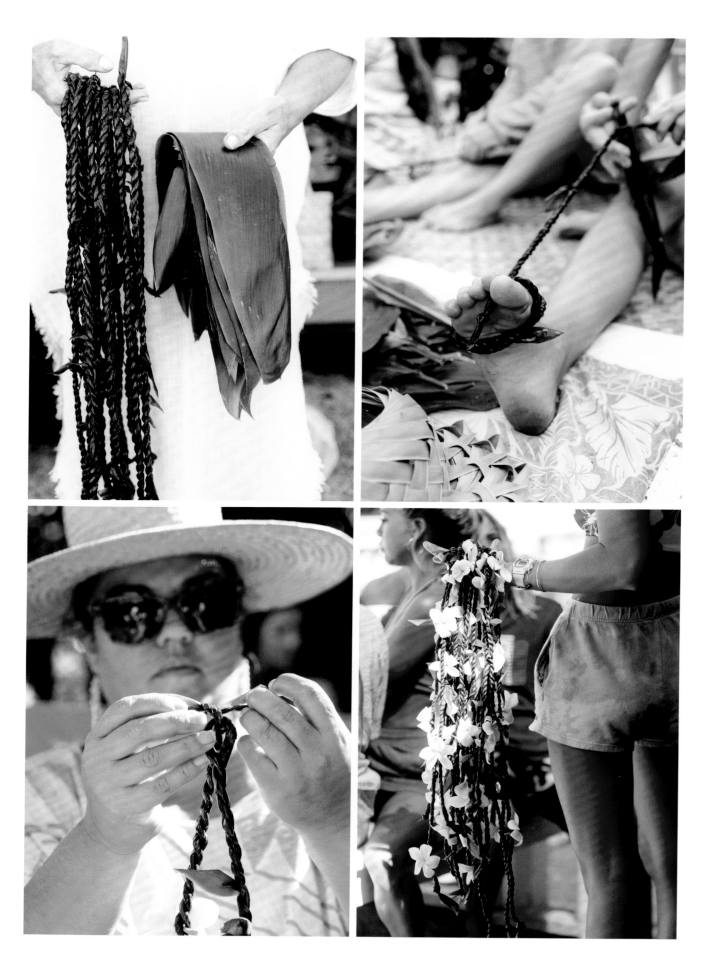

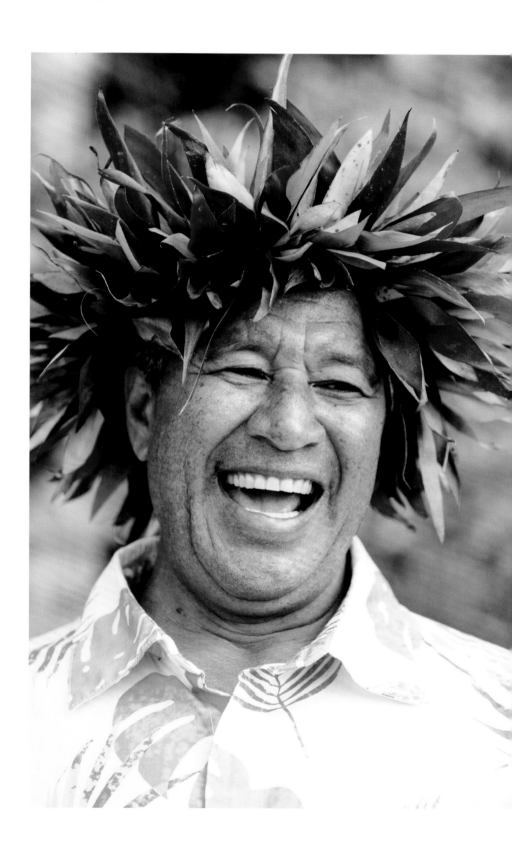

Right: Ti leaves can be made into many styles of lei using different techniques. Lei haku is made by braiding ti and adding smaller pieces of ti as you go.

Opposite, top right: Lei hilo is made by twisting pieces of material together.

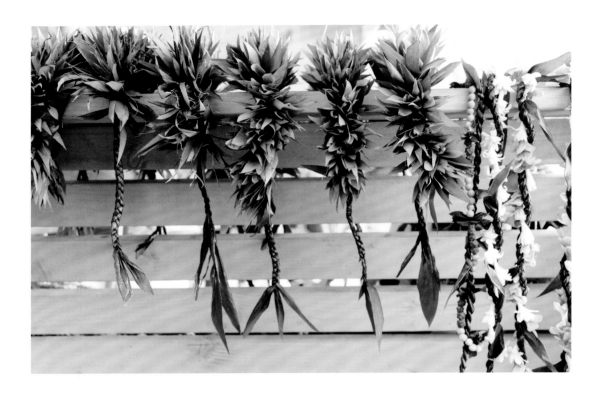

Chandler learned the ripped lei haku style while living in Tahiti in her twenties. "I just remember there being 'whatever you've got, put it together,' but a lot of ti leaf, especially for paddling events, and I loved that." The Tahitian style often extend inches beyond the wearer's head. "When you strip the ti leaves, it's going to be from the top," she says, demonstrating her process in finding the right aesthetic. "If I'm making a wild one, I make them longer before I slice them diagonally in half."

Sometimes Chandler makes lei po'o of ti leaf in one color and sometimes she mixes red, green, and yellow. "[Auntie Haunani's] pet peeve was when there's too many patterns." She laughs about the way my auntie, her hānai grandmother, urged her to not make lei so structured. "Even though there's a pattern in your mind, it's not like one plus two plus three plus one plus two plus three. She said it had to be fluid, not noticeable.

"I want it exactly right. I want a yellow, yellow, green, yellow, green, green," Chandler comments on her own habit in making organized lei but strives to find Auntie Haunani's sense of balance. "She just had a way of doing it, where it looked perfectly even and perfectly nonpatterned but patterned."

Throughout the day, helpers came and went. Friends of her four children wandered up from the water, excited to show Chandler shells they had found while diving in the shorebreak. Chandler always returned to her focus, finishing the final touches on forty lei in time for the ceremony, piling the lei hilo in coolers and lining the lei po'o on the lānai railing. Participants and lei makers, like Lyndie Irons, the wife of honoree Andy Irons, gathered in the yard to help pass out and receive lei, tying lei po'o on a head as one was tied on their own. Malia Ka'aihue, whose children had helped make lei all day and were part of a group of young Hawaiian chanters opening the ceremony, led a quick rehearsal for their oli, or chant, before everyone filtered down to the beach for the ceremony to begin.

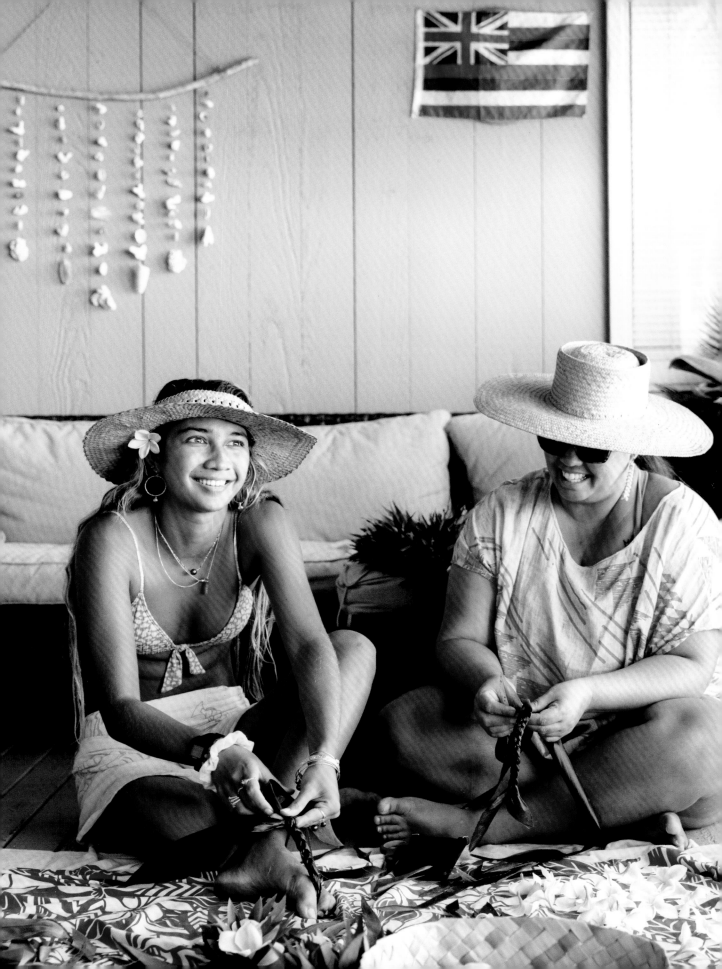

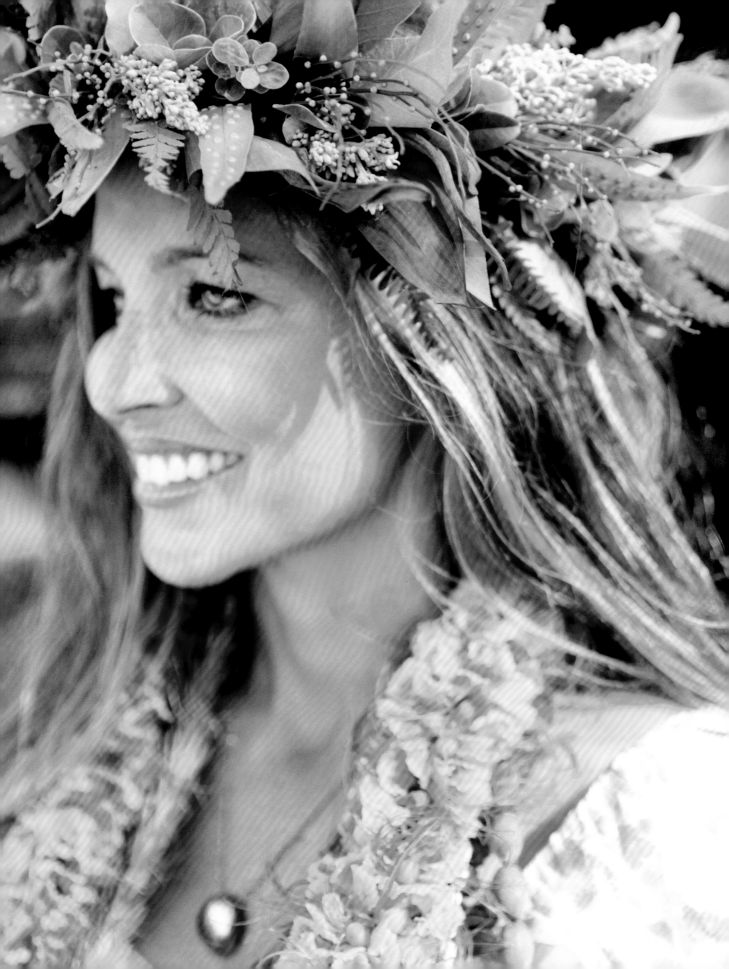

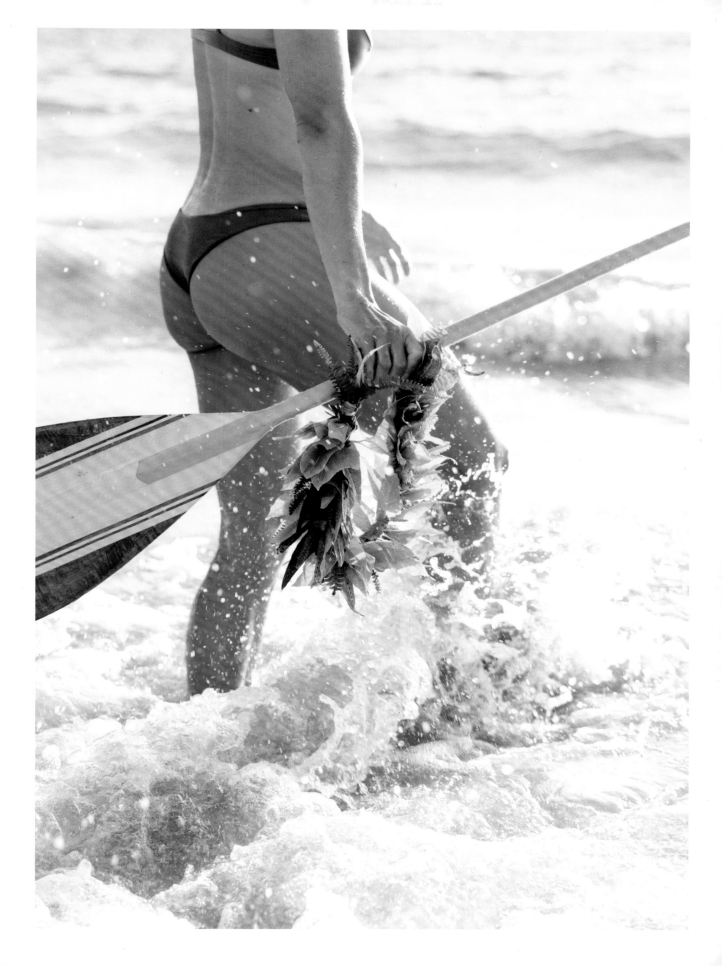

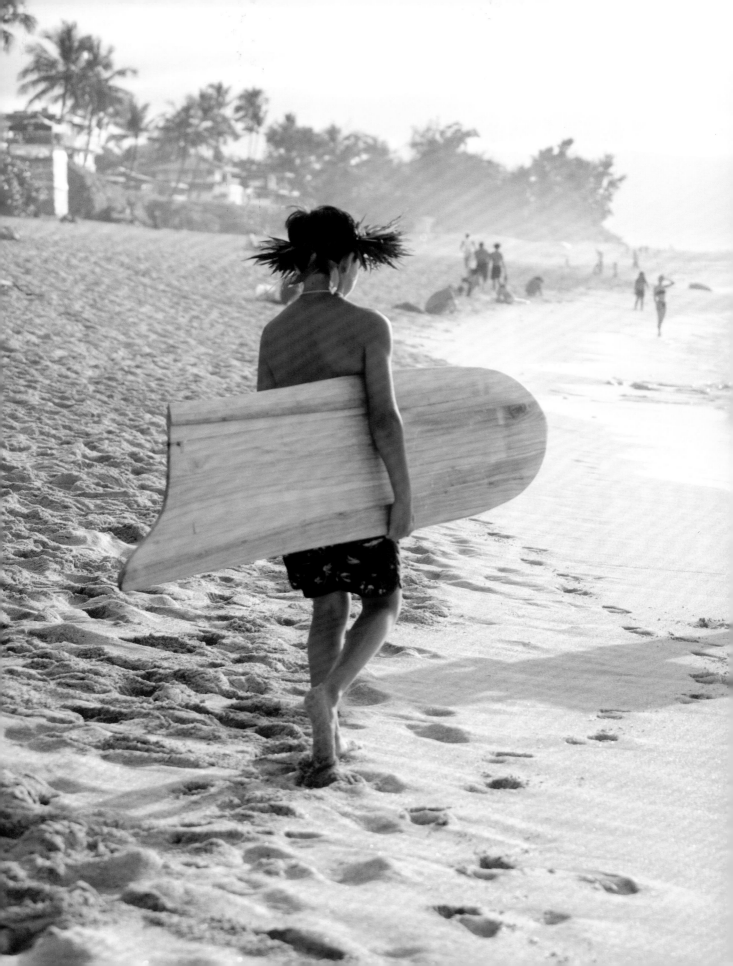

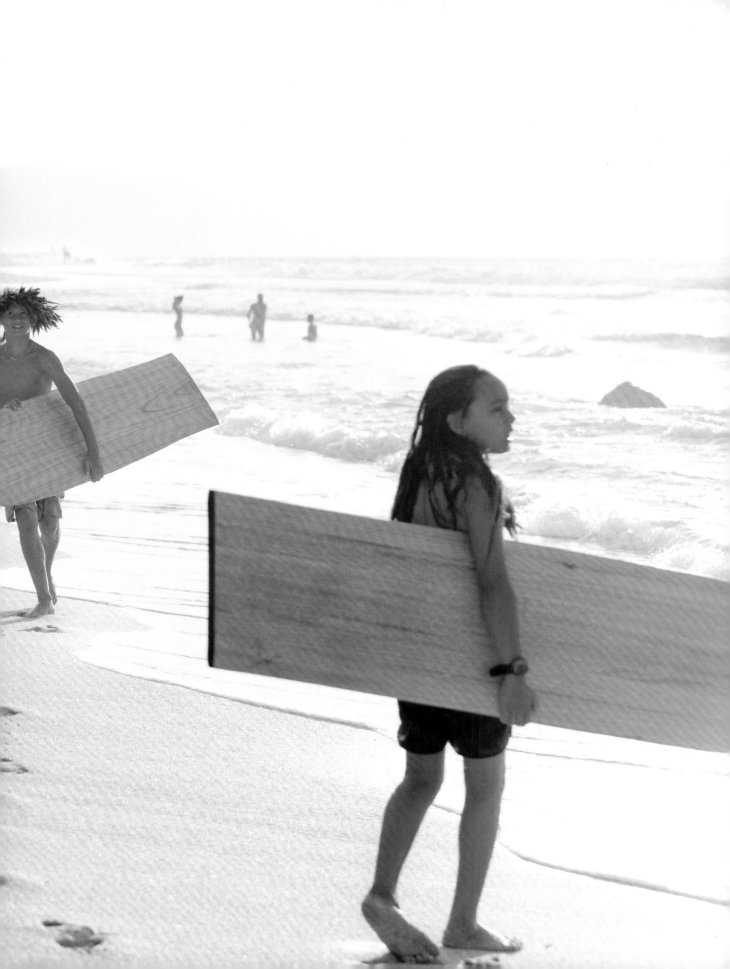

Beyond honoring participants in ocean sports, lei made out of ti or other materials are often used to adorn or bless the vessels that carry them. "We use a lot of ti leaves," Ānuenue Pūnua, a cultural practitioner and educator, says about making lei for *Makaliʻi*, one of Hawaiʻi's voyaging canoes. "The idea is for protection. We want to make sure that it's a safe voyage." Pūnua was one of the all-female crew members on *Makaliʻi*'s voyage to Micronesia in the 1990s. "Lei is everything," she says about the way *Makaliʻi*'s ʻohana honor their canoe. "We were always trained that you don't just jump off the canoe and then pack your bags and leave. The bulk of the work was the canoe. The canoe took you here so you need to make sure that everything is good about the canoe."

Lita Blankenfeld remembers decorating the *Hōkūleʻa*, a traditional sailing canoe, with lei. "On [the canoe's] birthday, I'll make two plumeria leis and flop [them] over the hulls," she says, noting the specific type of lei is less important in honoring the canoe on special occasions, such as a birthday or the blessing before a voyage, than the act of adornment. She recalls a giant lei maile being draped over a canoe in the 1970s for a blessing. "Because the hulls are so big and there are two of them, you want to drape it all over. It's . . . a lot of kukui nut or more leafy things."

For *Makaliʻi*, which is based in Kawaihae on the island of Hawaiʻi, Pūnua says that many of the lei she and her fellow crew members would make were ʻaʻaliʻi, a native plant common to the area, and sometimes liko and lehua flowers as well. "We also use limu sometimes—limu kala, which is a form of limu that is asking for forgiveness," she says. "Before you leave the island, you've got to make sure everything is good, is pono with the people, everything at home is good. You cannot take that with you on the voyage because it could potentially hurt everybody, right? Because your mind is not there.

"We make her all festive. Yeah, we can look pretty on the canoe, too, but the canoe needs to look better than you," she says. Before leaving on a voyage, they drape the manu, the nose on the hull, with lei. "When we sail, we expect that along the way, that the lei will be taken by the ocean, or the lei will be gifted to the ocean. That the lei, it'll wash up and then the lei will fall off, and that's just our hoʻokupu, our offering, to the ocean that we get to sail across."

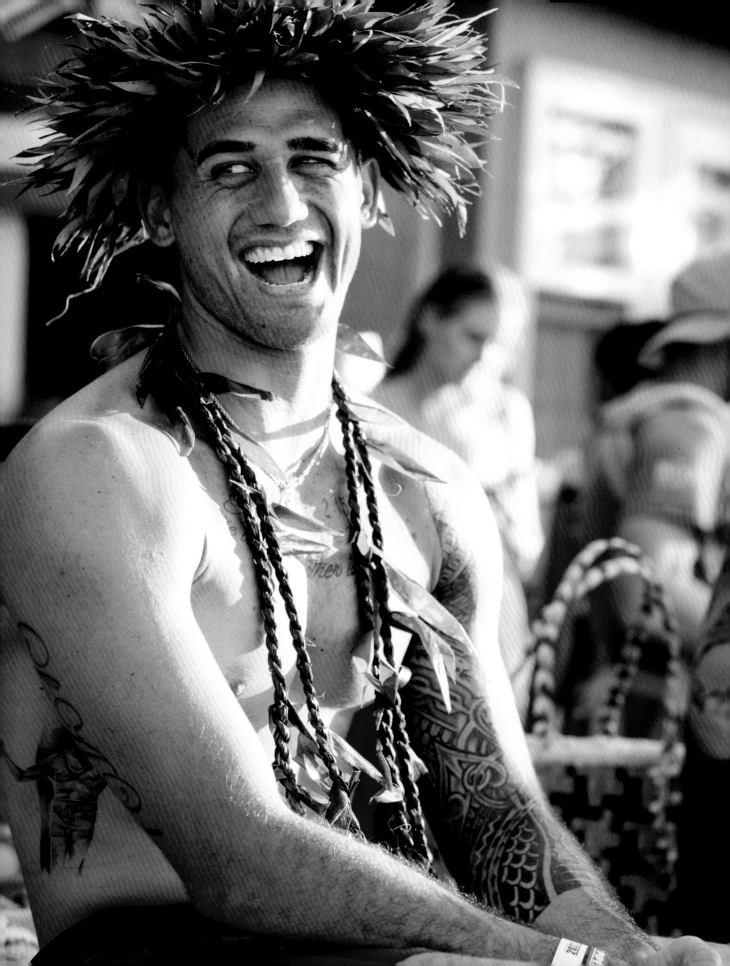

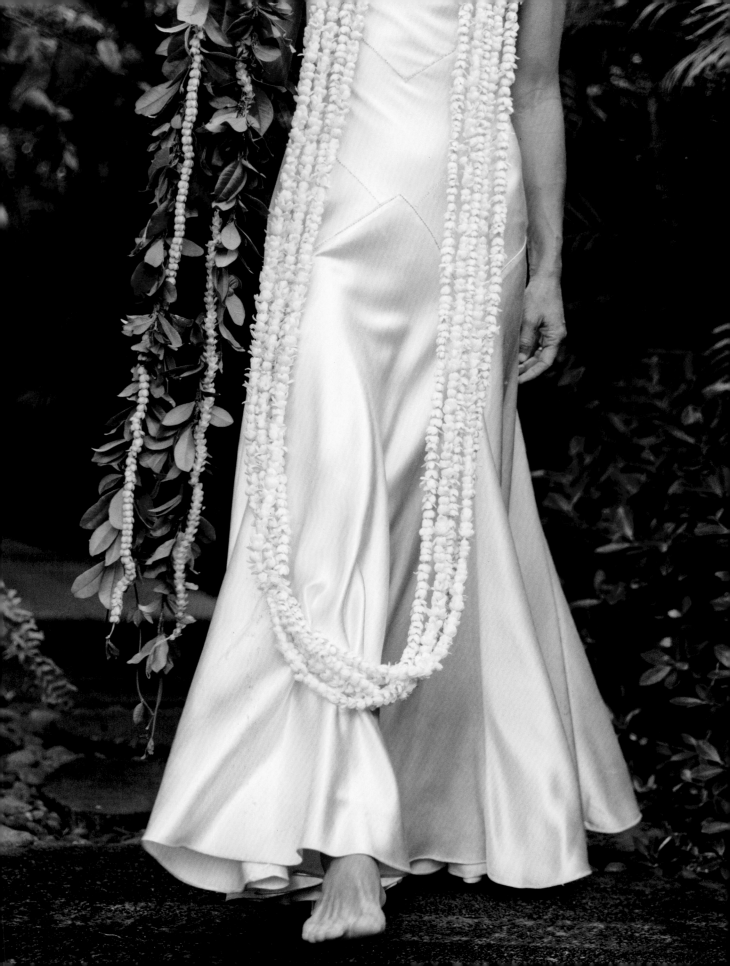

E Maliu Mai

My Lei of Love

"Lei means aloha, love, . . . it touches everyone's senses. First you see it and you smell it and then you hold it close to you . . . and it is the best way to bring someone close to you."

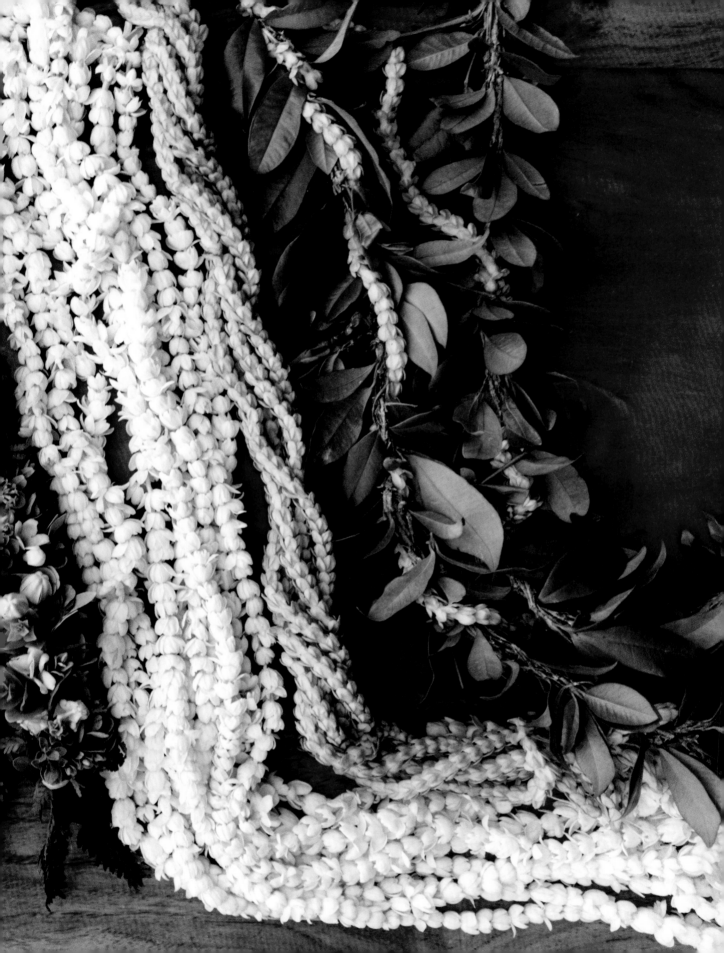

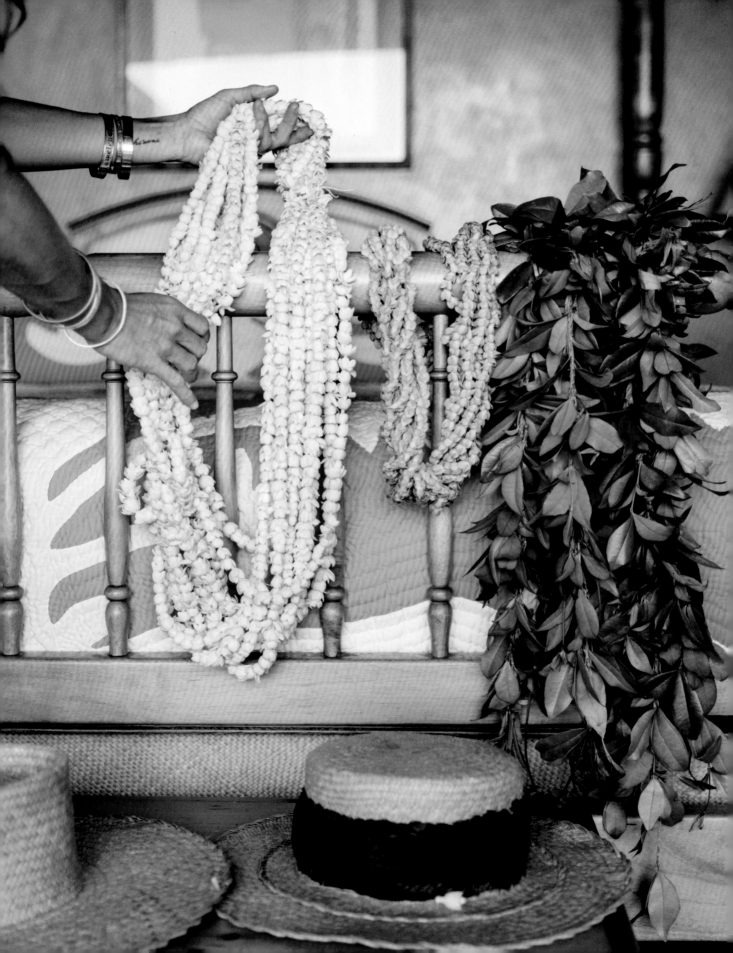

Tūtū not only made lei and wreaths; she was often asked to do floral designs for weddings—altar, aisles, bouquets, and, of course, lei, which in her mind dictated the decor for the ceremony and reception and even the season when the wedding should take place. In her first meeting with the bride, who was usually a niece or family friend, she would ask, "So, what are you going to wear?" She didn't mean style of dress, she meant lei. If the bride said the expected answer, pīkake, she would suggest that the mothers of the bride and the groom should then wear pakalana and the wedding should happen midsummer so that she could make sure it was all available. If the bride loved ʻilima (Tūtū would light up, it was one of her favorites), she would suggest bright touches for pews and bouquets to make the ʻilima pop. It was all composed beautifully in her head and the lei was the inspiration.

"It goes back to the sense of smell," says Manu Boyd, kumu hula and cultural consultant, describing how pīkake, an introduced Indonesian jasmine, ended up becoming one of Hawaiʻi's most beloved flowers, often worn in multiple strands by the bride at weddings. "That is important in Hawaiian culture. Hanu. Honi. ʻAla. Onaona. All these different words have to do with fragrance. So how could you not love the pīkake when it was introduced?"

Pīkake gets its name from Princess Kaʻiulani's beloved peacocks, which used to rest underneath the jasmine bushes at ʻĀinahau, her estate in Waikīkī. Boyd's grandfather, who was the princess's nephew, grew up on the property. When it was sold in 1917, the yardman who moved to Kapahulu with him took cuttings of the pīkake. Boyd can remember his grandmother collecting individual buds in a Jiffy peanut butter jar over many days to store in the icebox until she had enough to string a lei. "My brother still has cuttings of that ʻĀinahau pīkake. It's growing up, almost like a trellis," he says. "That pīkake is the sweetest pīkake I've ever smelled."

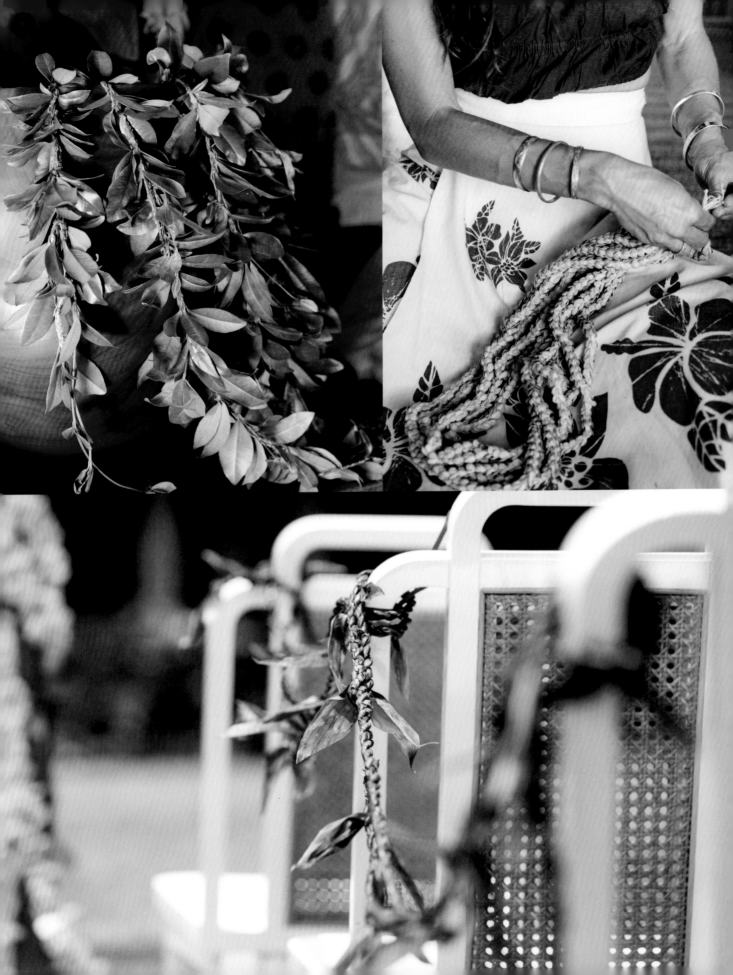

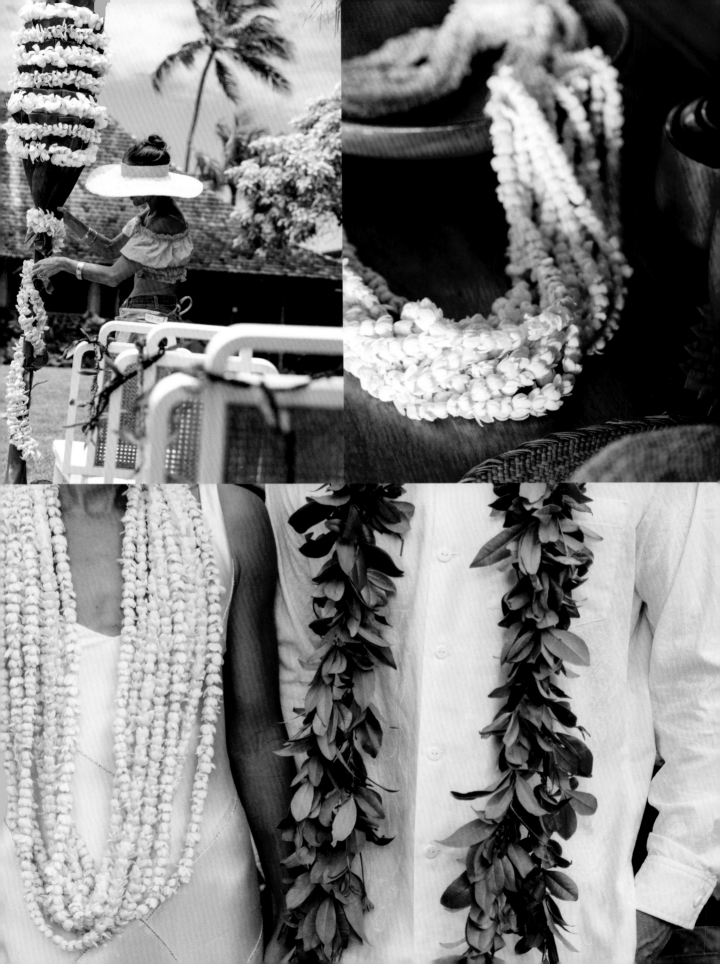

Likely brought over on steamer ships by Chinese immigrants in the nineteenth century, pīkake quickly became popular throughout the islands. Boyd says many mele (songs) were written about the sweet-smelling small white flowers, most notably "Ku'u Lei Pīkake" by Charles E. King. By the 1930s, the *Honolulu-Star Bulletin* was full of references to brides wearing pīkake. "The bride was lovely in a white satin holokū . . . she wore many strands of pīkake and ginger and her hair was banded with pīkake," reads one 1934 wedding announcement. Another from 1939 describes an upcoming wedding: "The bride will wear a long white gown with a pīkake girdle falling to the hemline. Garlands of the same flower will hold her fingertip veil in place."

Though pīkake is a popular choice, there are no rules when it comes to choosing lei for a wedding. A bride might choose pakalana because it reminds her of it growing at her parents' house or 'ilima because her grandmother wore it at her own wedding. But Boyd sees commonalities in the now traditional wedding lei—pīkake, pakalana, 'ilima, and maile—in their fragrance. "Auntie Maiki Aiu said 'Hula is life and expresses all that we hear, smell, taste, touch, and feel,'" he says, recalling his kumu hula's famous saying. "But of those senses, it's the fragrance that is considered a term associated with [the hula goddess] Laka—ho'oulu, which means to inspire, and that has a lot to do with fragrance."

"[Pīkake and maile] are examples of something extremely fragrant. Indian jasmine or Chinese jasmine and maile and then you put that together. Just the fragrance alone says to me, man, woman—or these days, man, man, woman, woman, whatever. It's the coming together, and the use of the word *wili*, to wrap, in Hawaiian poetry," he says, drawing an analogy between the two type of lei—and their scent—wrapped together in marriage.

"It's all preference," says Native Hawaiian–Chinese fashion designer Danene Lunn, who runs the Manuheali'i label with her husband, my uncle Pono, on how choosing lei for a wedding should be the choice of the people getting married.

For Lunn's own wedding, scent played a big role in her flower choice. My tūtū made her a lei po'o of gardenia and other white flowers, and Lunn wrapped a strand of pakalana around her wrist for the perfume. "Maybe it's my favorite because it was just something unattainable," she says of the yellow–lime green buds. "I'd have to go to the store and buy it, where we had stephanotis growing all over, plumerias all over, gingers all over. You could pick [ginger] on the side of the Pali Highway."

That idea of personal preference extends to the mother of the bride and other relatives, too. When I got married, I wore pīkake, but looking back through the family wedding pictures, I see my mother always wore pakalana and my tūtū, 'ilima.

Opposite: Lei 'ilima is associated with royalty and is often worn in multiple strands. A single-strand lei requires hundreds of the shrub's paper-thin blossoms to be harvested.

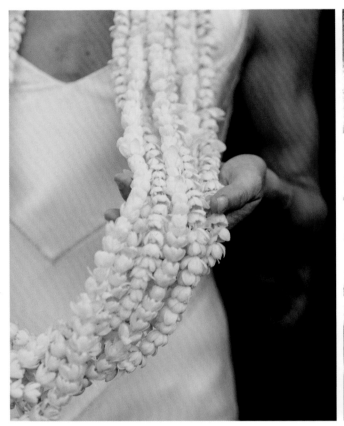

When Lunn attends a wedding as a guest and brings a lei—because she brings lei to every event—she's still thinking about fragrance. "Whatever is in season," she says about what she likes to give to the mother of the bride or the hosts of the wedding, who are often grateful for the aroma. "Pua kenikeni, pīkake, pakalana, Micronesian ginger—you bring the lei because it makes you smell good."

Many of what could be considered "wedding lei"—which aren't limited to weddings and are often shared on special occasions such as birthdays, graduations, and anniversaries—are also cherished because of the skill and time they require to put together. Pīkake and pakalana are so small and delicate that to make a full lei requires painstaking care to both harvest and string. 'Ilima, an indigenous, delicate member of the hibiscus family that grows best in arid, dry areas, requires hundreds of blossoms picked to make just one lei. A favorite of Queen Emma, the softly draped ropes, often worn in multiple strands, are associated with royalty.

"When we got married, all of my bridesmaids carried three strands of 'ilima," says kumu hula Māpuana de Silva of the beautiful orange-colored lei. "My dad's friend lived in Foster Village and grew 'ilima so we had lei 'ilima at our access anytime we needed them.

"I never wanted the traditional Western wedding flowers. I loved that my bridesmaids each carried lei 'ilima." When de Silva entered Maiki Aiu's hula class soon after her wedding, the graduating class was named 'Ilima. She still wonders about the coincidence. "Oh my gosh. This all just fit together so beautifully."

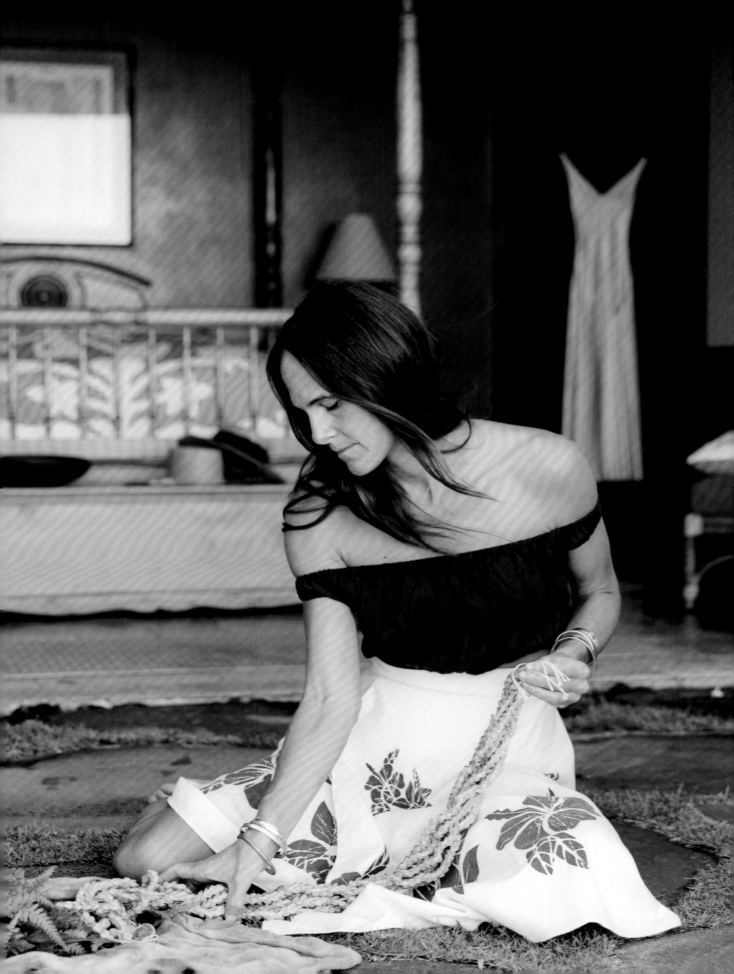

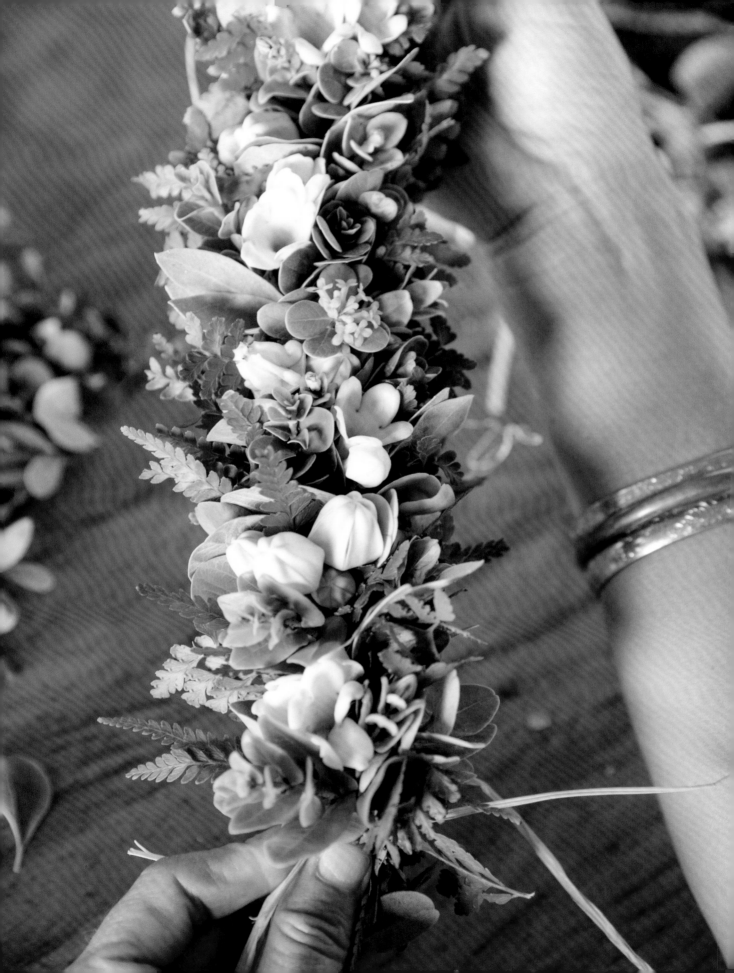

"Just the fragrance alone says to me, . . . It's the coming together, and the use of the word wili, to wrap, in Hawaiian poetry."
—Manu Boyd

Traditional, delicate, and meticulously composed flower lei of pīkake, pakalana, and 'ilima are often complemented at weddings by wild-looking endemic maile, sometimes worn on its own and sometimes entwined with the lei choice of the bride. Nake'u Awai, a Hawaiian fashion designer, often advises couples on what to wear at a wedding and recommends maile. "I would suggest either just carry maile or share maile. And when you get together, you can give each other the lei as part of the marriage."

Maile has been used in Hawaiian ceremonies for centuries. As one of the kino lau of the hula goddess Laka, maile, which grows throughout forests on the islands, has great spiritual meaning, in particular for hula dancers. The dark green leaves and bark have a cool herbaceous aroma that is more pronounced when made into a lei and have come to be associated with modern-day ceremonies, where two lei maile are untied for home blessings or used in place of ribbon cuttings for store openings.

Maile should only be harvested by regular practitioners. Kuana Torres-Kahele, a musician and prolific lei maker, grew up just north of Hilo on Hawai'i island and says that making lei maile from foraged leaves for special occasions was a regular occurrence. "We were all up at Kahua [Ranch] and I was getting ready for a pā'ina," he remembers about one occasion at the ranch where his father, descended from ranchers, was raised. The cowboys had been moving the horses and cattle all day to make space. "Then they had a break and they said, 'Okay, we'll go get maile,' and about fourteen of them—all the cowboys—went in the bush and they all came out with maile. And they all know how to make lei. I [thought]—that's beautiful.

"When I go home, if I need it, I will get my own. I don't normally buy it," says Kahele, who makes many of the lei he wears during performances as a Hawaiian musician. "On Hawai'i island, [we] get plenty. But every 'ohana gets their spot [to pick]."

But Torres-Kahele notes that some foragers are less careful or knowledgeable about how to pick well, which has become problematic. "There are plenty of times I go to certain forests where public access is allowed and I've seen how people pick kāpulu [carelessly] with the maile. I always have my little pruner with me, and whenever I see that, I go in and I put all my stuff down, and I go in there and fix them—I always do that."

Lei maile are made by stripping the outer bark and leaves from the vine, then twisting the vines into strands that are further wound together. However, many gatherers neglect to clip off the remaining center stalk, which can rot when left on the vine, killing or stunting the whole plant.

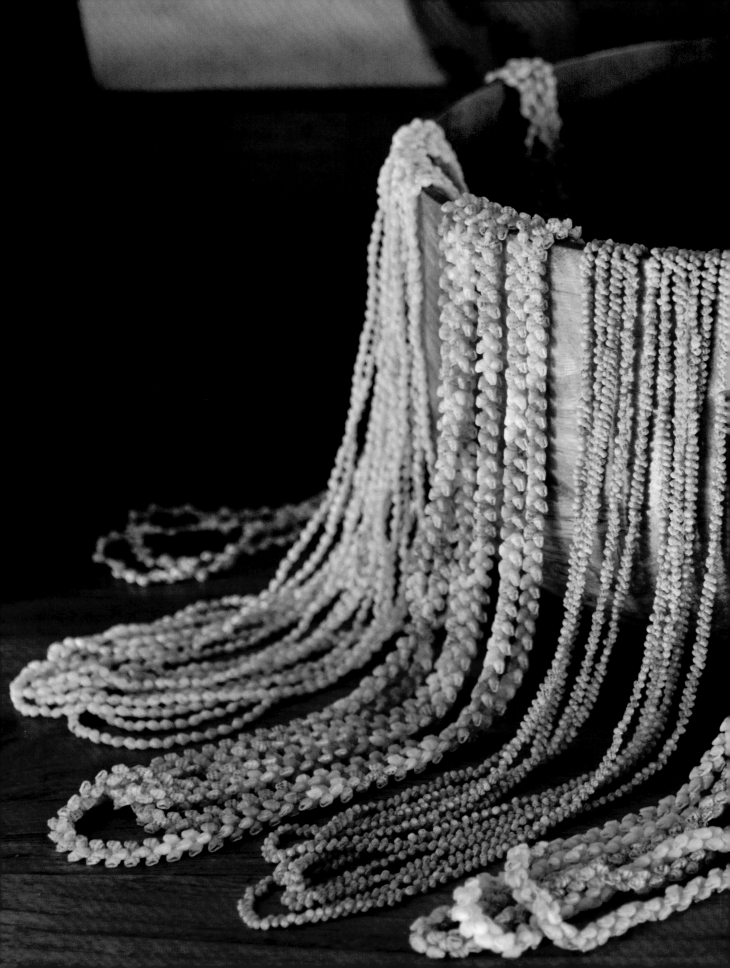

Niʻihau Lei Pūpū

"[Kaulakahi] is always looked on as the lei of Niʻihau because it wraps its arms [around the island]," says musician and lei maker Kuana Torres-Kahele, about the channel that sweeps small, delicate pūpū (shell) from a nearby atoll onto the beaches of Niʻihau, which the residents then make into beautiful, keepsake-worthy lei that are often worn on special occasions, such as weddings.

The western-most inhabited island of the Hawaiian chain has been owned entirely by the Robinson family since 1864. Only Hawaiian ʻohana descended from the island live there, speaking their own dialect of ʻōlelo Hawaiʻi (Hawaiian language). Torres-Kahele learned about Niʻihau shell from his hānai mother, who was from the island. His connection has, at times, made him what he calls "an unofficial spokesperson" for helping to connect the islands' families with buyers.

The shells don't just land on Niʻihau, which Torres-Kahele says can complicate identification of the true Niʻihau shells. The current can sometimes push them to Kauaʻi and farther down the island chain, but they lose their color and luster as they travel. "What should have been hot pink is now dull pink. And by the time they reach Molokaʻi and down to Hawaiʻi island, what used to be red is brown."

It's not only the color that identifies authentic shells. The luster, what Torres-Kahele compares to almost a lacquer, is important. "You could have a fifty-, sixty-, seventy-year-old piece, and if it's dull, you just take warm water, soapy water, a toothbrush, and you just brush them and the luster comes back," he says.

Torres-Kahele says that in the early years of the Niʻihau shell lei, from the monarchy era to the mid-twentieth century, only two types of shells were regularly seen: lāiki, which is often compared to grains of rice, and momi. Both were seen usually in white and in long draping styles. "It wasn't until the 1970s and the '80s [that] kahelelani started to make its grand entrance and people started to realize, 'Oh, [there's] more than one color.'"

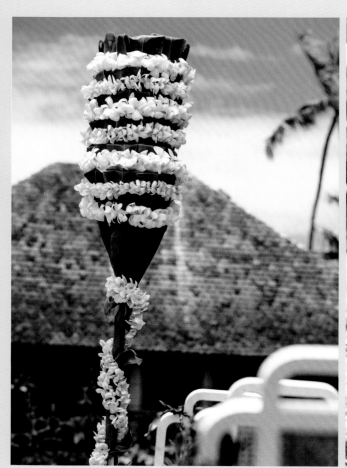

Careless pickers also trample maile and other plants when the ideal is not to leave a trace that the maile patch was ever visited at all.

Improper harvest of maile is one reason horticulturist David Miranda has spent his adult life developing a maile plant that can be cultivated sustainably and pesticide-free in greenhouses. "My thought is simply, 'If we don't do something, all of these really incredible places are going to be destroyed.' I'm deliberately trying to formalize how this plant is cultivated so that others could ultimately duplicate it," he says about his greenhouse maile.

Born on O'ahu, Miranda attended the University of Hawai'i for horticulture before moving to Volcano on the island of Hawai'i to start his business, Big Island Maile. He has fine-tuned his main variety, which he got originally from Ka'ū, for the shape, size of leaf, and vigor of growth and fragrance, and he has plans to add greenhouses for five or six other varieties from Kohala. "I don't do any cross-pollinating. I'm maintaining this as pure as I possibly can, in the same way that it [grows] in the forest."

Throughout his decades-long project, Miranda has made sure he is respecting Hawaiian traditions. "I had a chance to ask the kūpuna, 'Was the lei appropriate for what I presented it to them for," he says about a recent order he fulfilled for a funeral. "They came back, 'Yes, it was beautiful.' They [told me they] forgot what maile smelled like, if you can believe that."

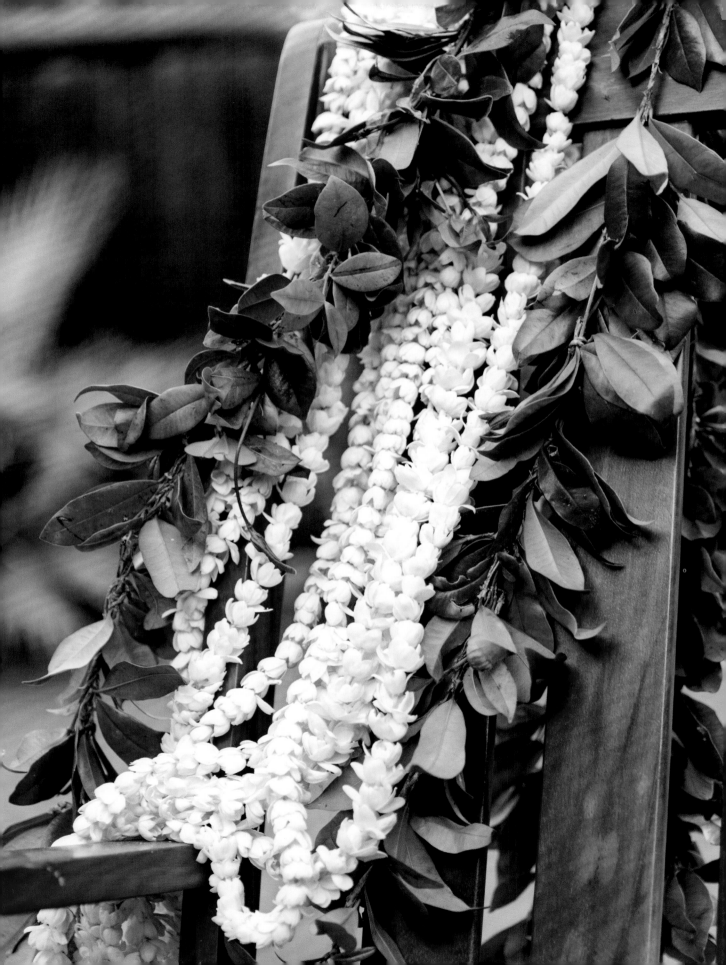

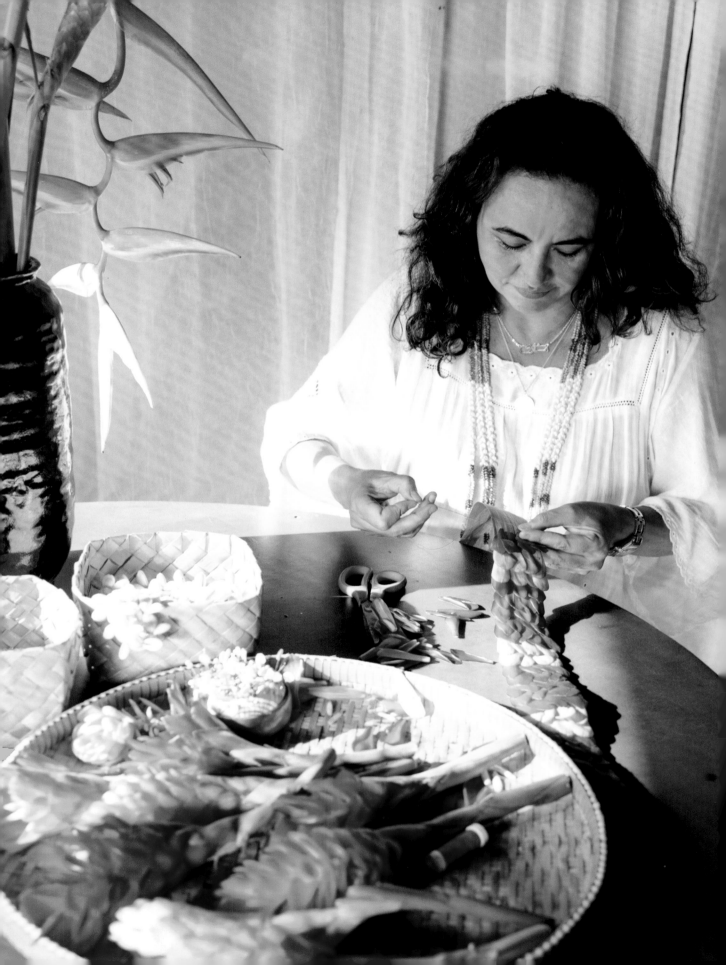

Lei 'Ohu

Adorned with Lei

"It's to honor your ancestors before you,
now, and after you. It's all the generations
that you're carrying on with them."

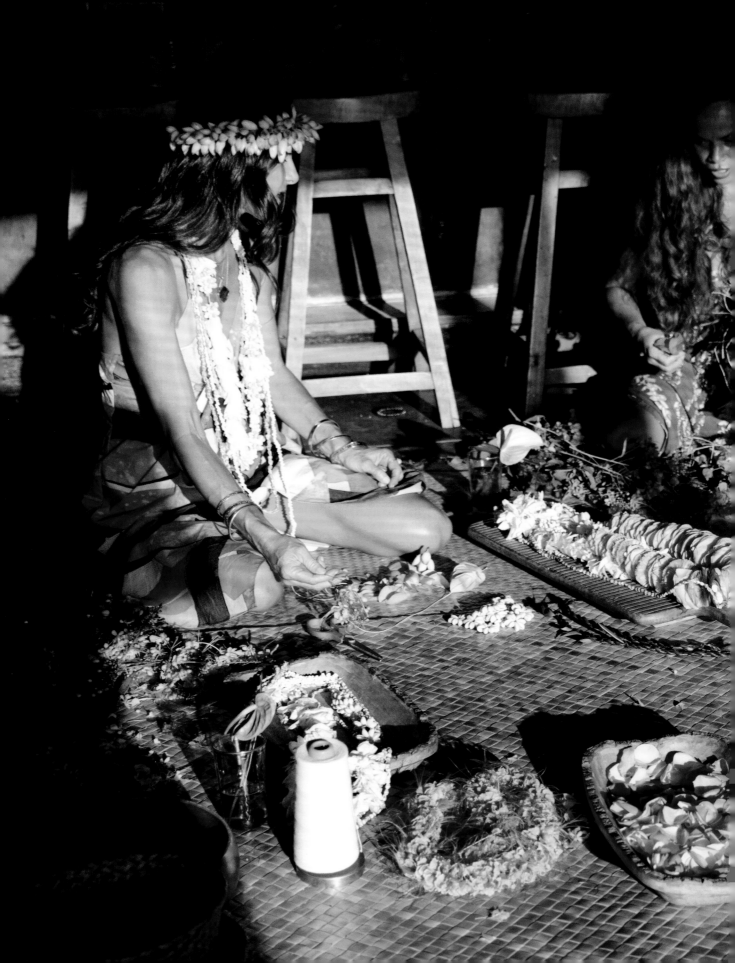

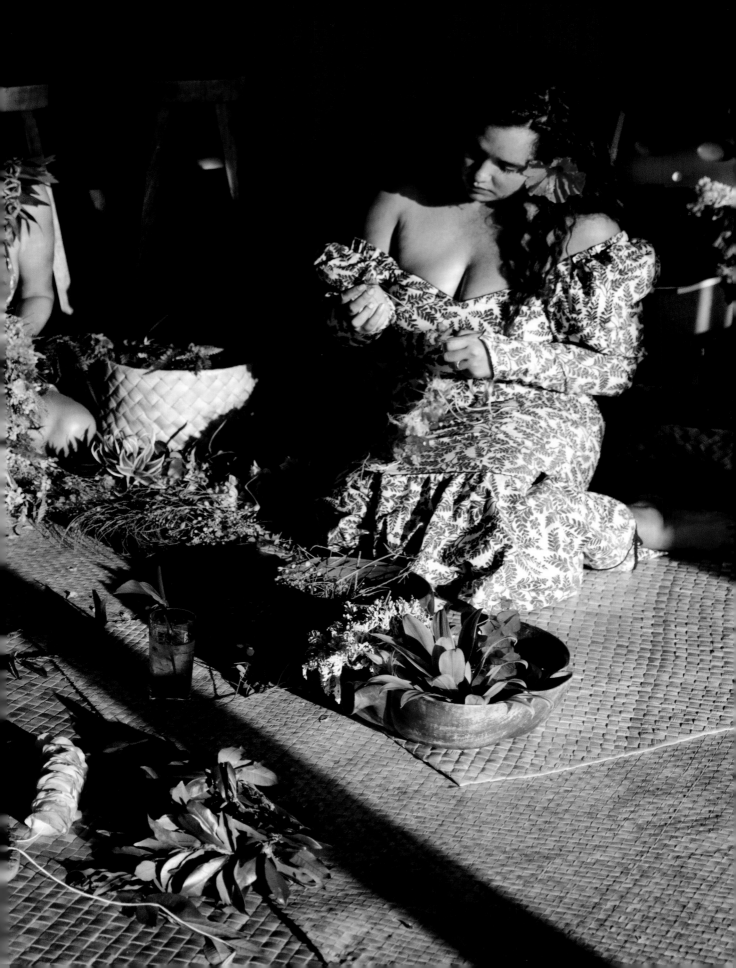

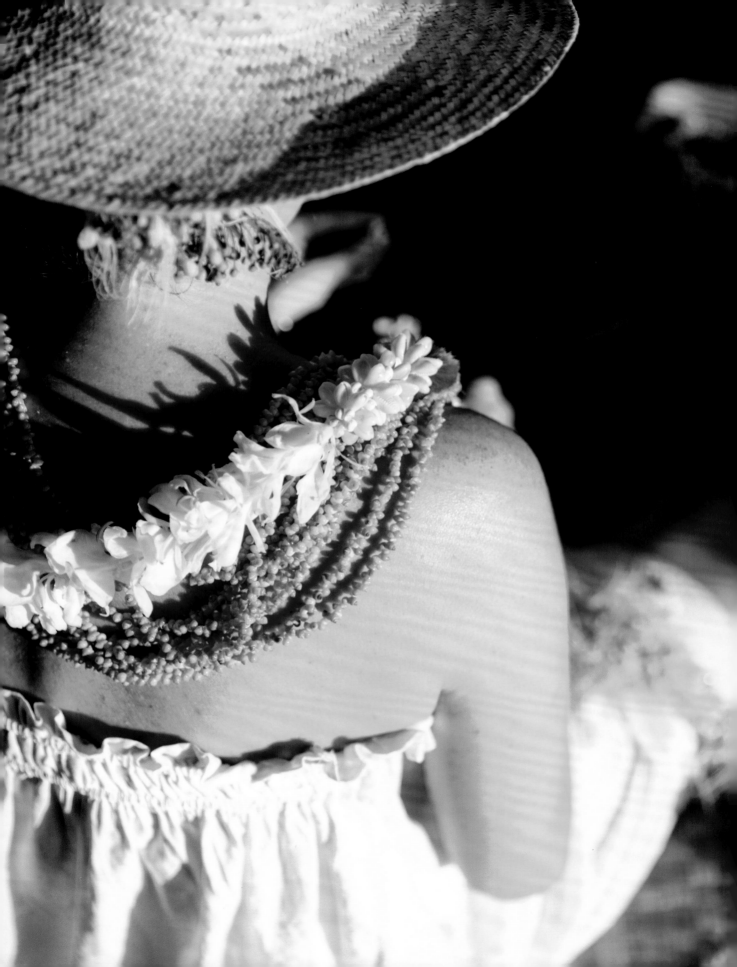

I feel so inspired by the lei makers of my generation. We grew up making lei the way our kūpuna taught us, but in years of practice we have integrated creative twists that represent us. Our lei-making community is similar to the one my tūtū had. Each lei maker has a very distinct style along with huge respect and admiration for one another. Social media has really helped this generation of lei makers' relationships bloom; some of us were friends on Instagram, commenting on one another's inspiring lei, long before we ever met in person.

"I think, like anything for our culture, that's what you wrestle with a little bit: how to do things like add in your creativity, but still treat it with the honor and respect that it needs," says Amanda Iaukea about the innovative mixed-medium lei kui she makes out of flowers and shells under the name Live a Lei Life.

Iaukea, who grew up on Queen's Beach in Waikīkī where her parents ran a boogie board stand, says that the current iteration of her business almost didn't happen. Four years ago, the Sheraton Waikīkī offered her a kiosk to sell her beautiful fresh lei creations in the lobby. Iaukea had a vision of it becoming a hub for friends and family to drop off one or two lei when they had fresh flowers. But the storefront only lasted a summer, she says, because tourists weren't interested.

On the last day the shop was open, she took apart a few Tahitian shell lei, the remaining fresh strands she had on hand, and some ʻōhai aliʻi she had brought from home and gave the material to her daughters, who had helped her string lei all summer, just to keep them from being bored. Together, they assembled the shells and flowers in segments, making strands of distinctive, colorful patterns with what she thought were the remains of her business. "We made five and layered it all up. Then we dressed up and took pictures of ourselves to make ourselves feel better," she says. "Then I put [the photos] on my Instagram—and people loved it. That last photo turned [out to be] the whole beginning of a new era."

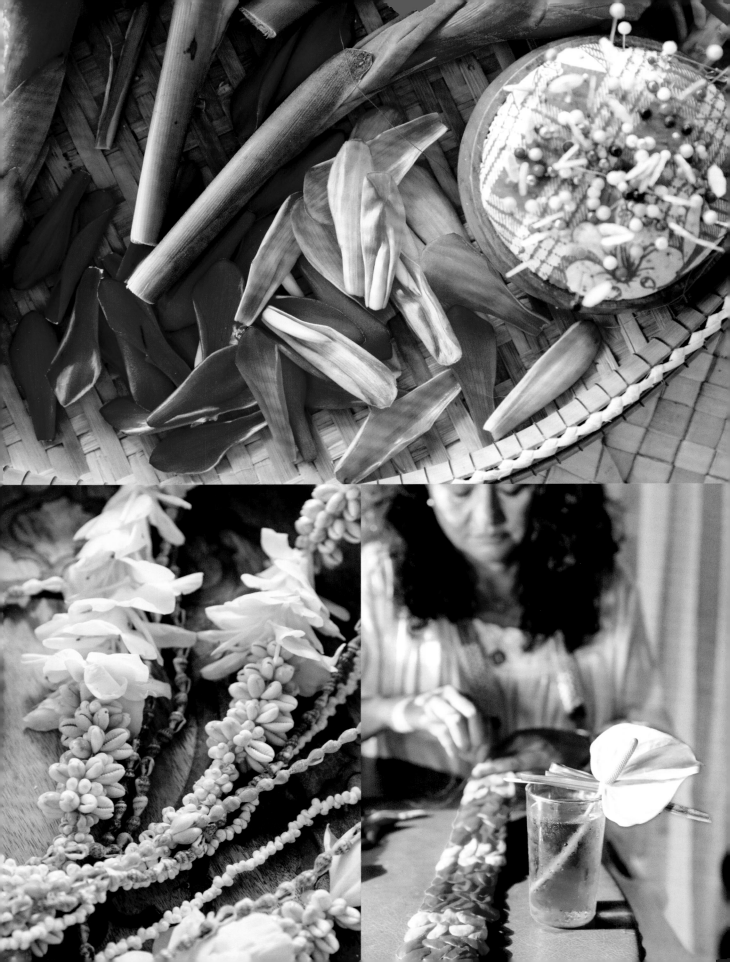

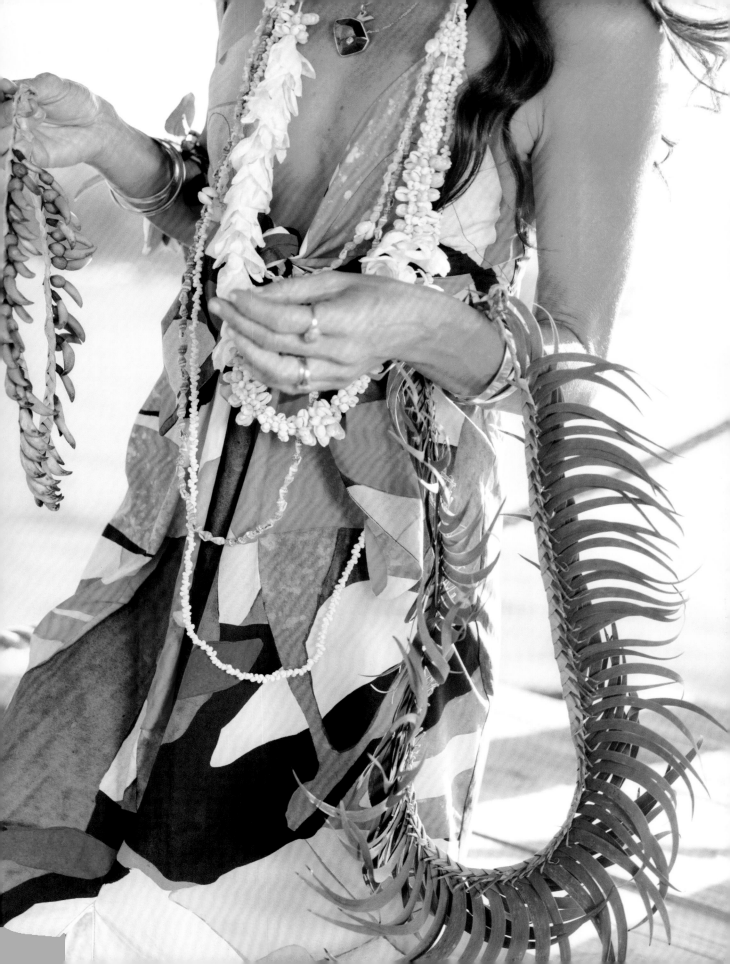

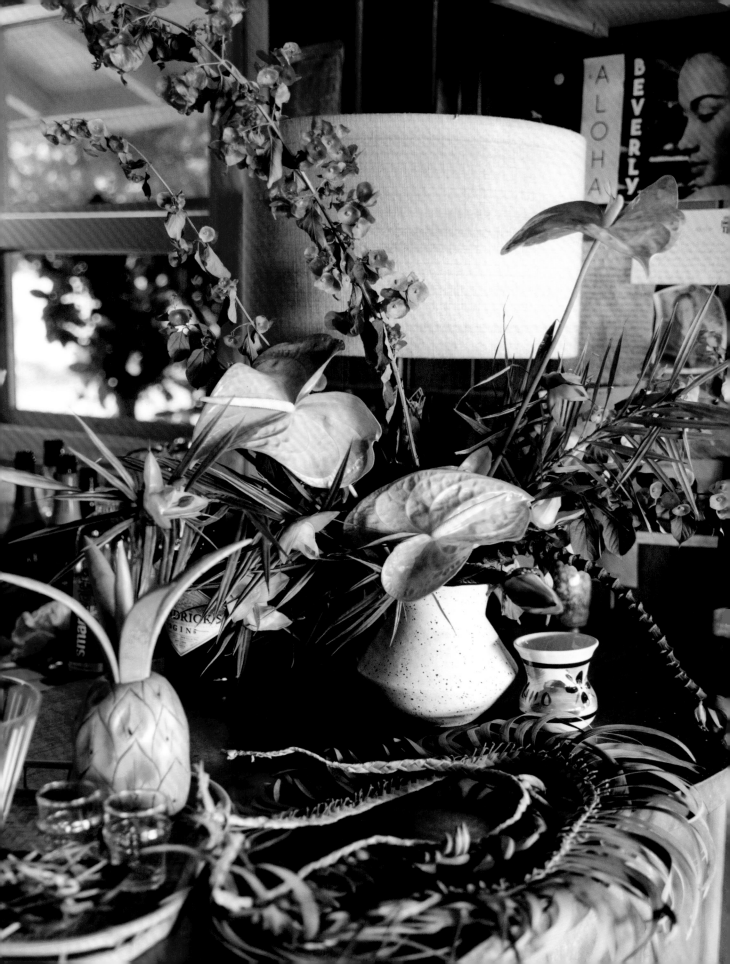

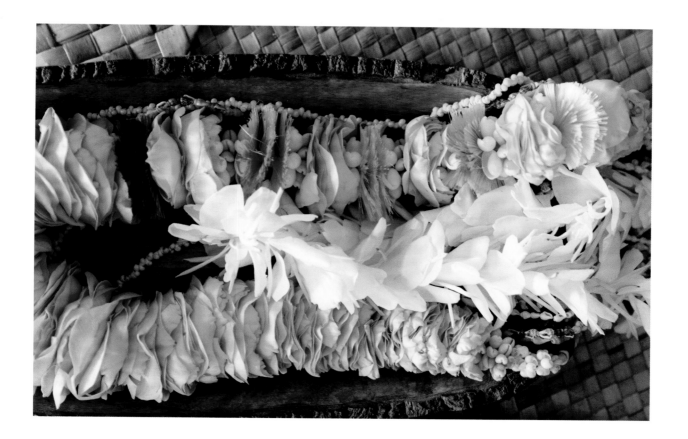

Within a few months, she had orders rolling in and her lei placed in shops around the island. "When I first started doing it, I was kind of scared that people would be mad at me," she comments about the way she pushed the boundaries of "traditional" lei making. She notes that while her creations may look new, they are still rooted in the tradition of making lei out of materials like kukui nut and ti together. "Of course I would never do it for a certain hula [that requires a more traditional lei]. Those things have to stay the way they're meant to be," she says, "but everyone was so nice and lovely about [the new style]."

Amanda Iaukea is one of a growing number of young lei makers who are bringing a fresh sensibility to the art of making lei, a burst of creative energy reflected across many types of Hawaiian arts, including lauhala weaving, paipo-board making, and fashion. On the lei-making side, there is a wide spectrum of practitioners: Some combine traditional lei-making styles with unexpected materials like hibiscus, blue jade, and sea grape. Others share historic styles and traditional techniques that are less well remembered or carry on lei-making traditions their parents taught them. The common thread that links these creative artists is that all are continuing to find ways to celebrate and carry on Hawaiian cultural arts amid the bustle of modern life.

"The reason why I do it—it's to honor your ancestors before you, now, and after you."
—Pamakani Pico

"I did not know that the lei business would be my thing," says Pamakani Pico, owner of Ocean Dreamer Floral Artistry, who has become well known for making eye-catching bold head lei out of hibiscus flowers. But she's never been far from the lei-making world.

Born and raised on Moloka'i, Pico learned to make lei from her mother, who was known for her innovative ti leaf lei styles, particularly a rose shape fashioned from coiled ti. When the family moved to Maui, people were so enamored by her mother's lei, she began taking orders. Pico and her five siblings were frequently conscripted to help make lei for extra money. "Lei making—we ate, breathed, slept it," she says. "[Ti] was all that was in the freezer."

Pico moved to Kailua on the island of O'ahu. She worked as a bartender and Zumba instructor to support her four children, then began to sell lei on the side. Proficient in many styles, she made one in particular—a head lei of brightly colored large tropical flowers—that caught on. "At that time, in 2009, no one was making the style lei that I was making, so people [wondered], 'Okay, where is this coming from?'" she says about the now-iconic look, a meld of her Tahitian, Hawaiian, Samoan, and French ancestry with her mother's stylistic creativity. "I just wanted to incorporate all that into the style, just to elevate and modernize it."

"It just exploded over one year," she says of the response when she began posting pictures to social media. "I was so surprised at how many people were contacting me over Instagram. 'We want to order this and that.' I [thought], wow, can I really do this?"

Pico, who loves to garden, made lei to sell the flowers she had in her yard, where she grows almost every variety of hibiscus. "I was a big collector back in the day. I even had a friend from Tahiti send me a bunch of seeds. You can graft them to grow faster. But if you grow it from seed, it takes three to four years to see the first bloom. And you don't know what color it [will be]. When I see it, I'm so giddy—I'm almost crying, 'Oh my god, my baby,'" she says. "It's pure excitement."

Today her business is multifaceted; Pico makes lei to order, does floral design for weddings and events, and runs lei-making workshops, where she teaches people about the meaning of flowers and lei styles and that brings her joy. "The reason why I do it—it's to honor your ancestors before you, now, and after you. It's all the generations that you're carrying on with them," she says.

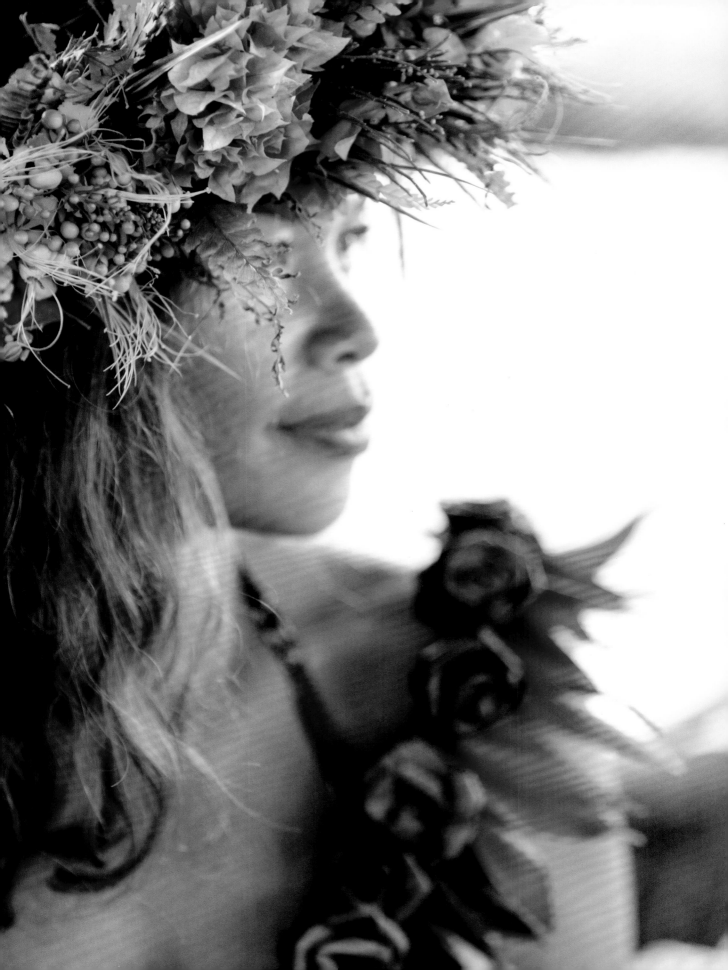

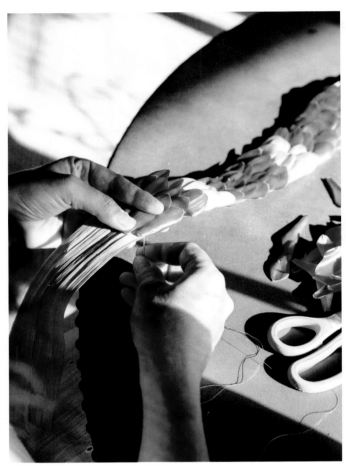
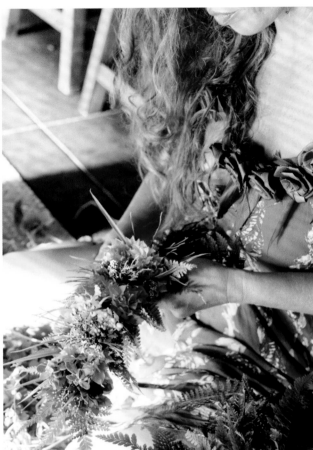

"I really feel grateful," says Pico, reflecting on the past decade and watching others make similar style lei and start their own businesses. "If you can inspire another person to do something, and you see your kind of work in that, that's so amazing."

The long culture of lei making is so varied that sometimes just referencing a different era in lei history can come off as fresh and new, as with the case the Kaimukī Lei Stand, an O'ahu pop-up store on Wai'alae Avenue. "One of our goals when creating this lei stand was to try to replicate as much as possible the lei stands of the 1960s and '70s with their hanging garlands of colorful, fragrant flowers," says Makamae Williams of their retro movable kiosk that sells lei such as plumeria, pua kenikeni, and 'ohai ali'i.

Williams and his husband, Keoni, started the stand to stay busy during the pandemic when they both were out of work and, in his words, to "spread happiness." Williams credits his love of lei to both his mother, whom he calls a mentor, and to his elementary school's May Day pageant. "I vividly remember celebrating May Day at Kapunahala Elementary by making our own lei and dancing a hula every year."

Outfitted with a closet full of vintage aloha wear from the 1960s and '70s, Williams leans into the retro vibe and sees the lei experience at his stand as a way to help people step outside of their regular lives. "We hope to bring happiness and a nostalgic feel of old Hawai'i to the public," he says. "A vibe that transcends you to simpler times and easy living."

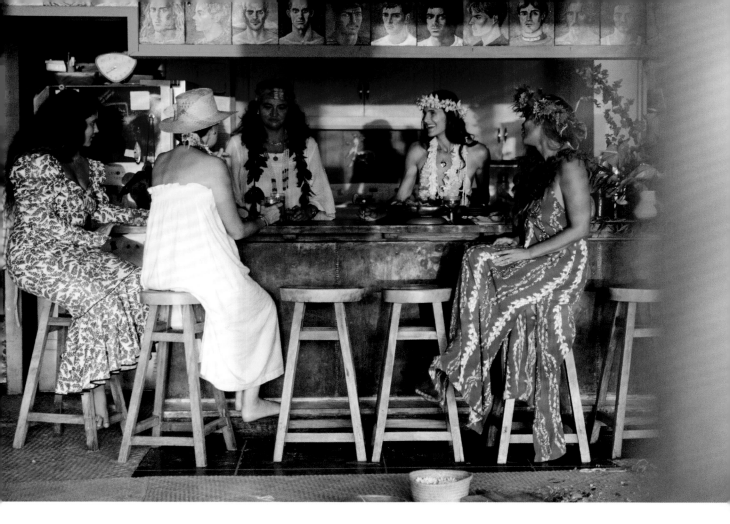

"I think it pushes your creativity to try different things, using what we have versus importing or buying more things," says award-winning lei maker Mary Moriarty, co-owner of Hele Mele Botanicals, who crafts intricate lei using traditional techniques. Moriarty, a civil engineer and floral designer, grew up with me in Kīlauea on Kauaʻi surrounded by lei. Her grandfather, who was from ʻAnini, taught her how to make lei out of hala using hau, which were common in the area. Her mother, Linda Paik Moriarty, who was friends with lei scholar Marie McDonald, became one of the foremost experts on Niʻihau shell lei and wrote *Niʻihau Shell Leis*, the definitive book on the subject. "We would go out to the ʻEleʻele Big Save parking lot and my mom would buy from the Niʻihau ladies. . . . She collected and collected and collected," Moriarty says about her mother's pathway to learning about the valuable shell necklace.

Despite the perception that Niʻihau shell lei are traditional, Moriarty says there is a streak of innovation and evolution among the community of makers. Because of escalating prices, her mother has only bought one shell lei in the last fifteen years precisely because it was something she hadn't seen before. "It was the design of it that she liked. This young girl had made it and [it] was really interesting and new," she says. "They change. I'm perpetually changing, which is good, because it keeps the art alive, you know?"

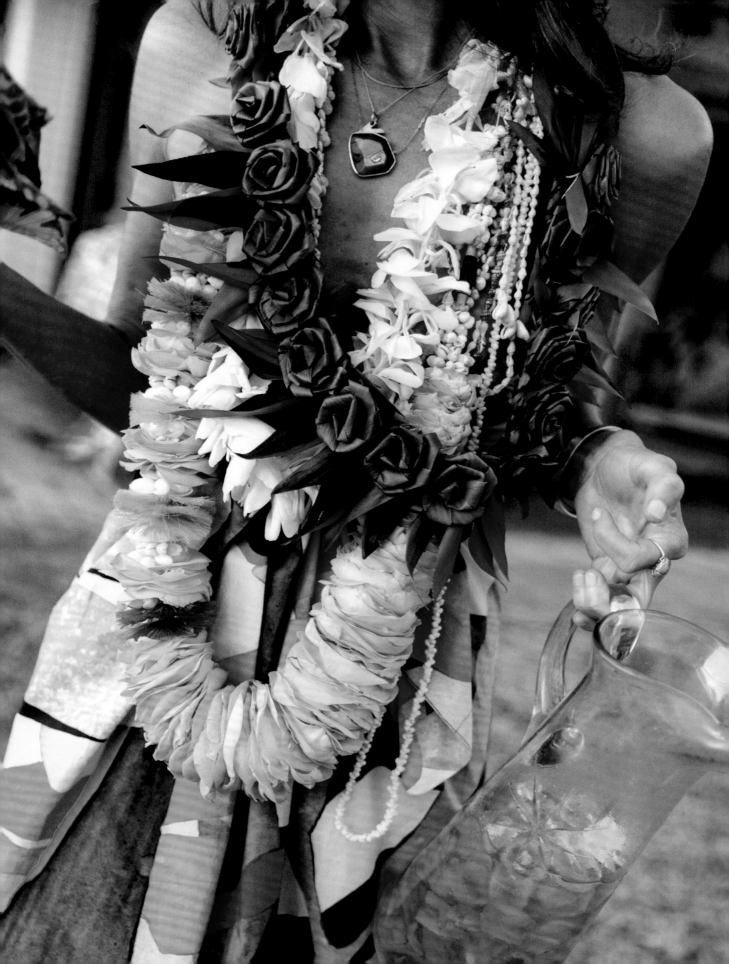

"People doing different things and keeping the spirit of lei making is what makes it special."
—Mary Moriarty

A few years ago, Moriarty entered two lei contests with a lei humupapa made from petals of red and pink torch ginger. "It's not very common because it takes forever to make," explains Moriarty, about humupapa (or kuipapa), a technique in which lei materials are sewn piece by piece to a foundation and then usually worn as a head or hat lei, perhaps most commonly seen in lei hulu (feather lei)." I'm stoked to see lots of different lei makers out there," she says, noting that she has plans to enter more contests in the same style, perhaps with a different material. "People doing different things and keeping the spirit of lei making is what makes it special."

Another young lei maker I admire, Leilani Pearson, also draws inspiration from her childhood. "There are hundreds of people standing in the lagoon and then all the paddlers come in and throw flowers in the air and everybody's cheering," says Pearson, describing the end of the Hawaiki Nui Vaʻa race in Bora Bora, Tahiti. Pearson, who makes lei and pāpale out of niu on Maui under the name HakuLeilani, grew up near the finish line of the legendary canoe race through the lagoons of Tahiti—essentially the Tour de France of Polynesia, where the best teams from all over the world come to compete. "All the Hawaiians would come and camp in our yard and we'd have a huge feast—it is such a huge childhood memory. There's lei everywhere, everybody's covered with lei and lei poʻo," she remembers. But at the same time, she says one of the biggest lessons was the way you didn't need an occasion to wear a lei. "You see so many people just wearing [lei] doing their town errands. Right now the fashion is the bigger the better. So it's these massive, massive haku."

Pearson's lei are full and vibrant, often made in the haku style with gardenia or ti with seasonal florals. She also uses lauhala to haku a striking lei ʻāʻī made from more unusual materials like koa and blue jade. She hopes to impart that everydayness in her workshops,

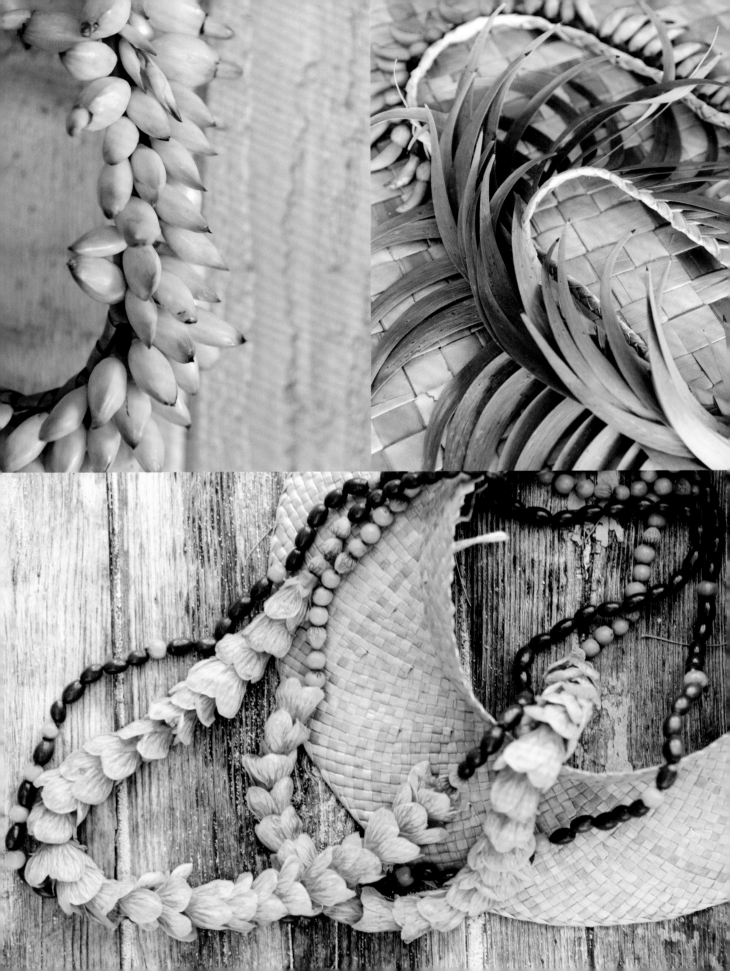

"The Hawaiian belief is that a lei of flowers and leaves would eventually die, but a lei of poetry will live on forever."

—Kumu hula Kimo Keaulana

where she teaches people lei making and how to make niu pāpale. Pearson explains, "In Tahiti, most people know how to make a hat. It's part of culture … But here, nobody knew how to weave coconut, so it became a passion to teach the cultural thing that was lost. They want to know how to weave because they're Hawaiian or they're local. Learning how to do it is super important and reconnects you to your culture."

"We still do pua kenikeni and we haven't really altered it from what my mom made," says Ānuenue Pūnua, a cultural practitioner and educator. Her family makes lei to sell from the trees her grandfather planted in the 1940s at his home in Kāneʻohe, where she raises her three daughters. Pūnua doesn't recall where her mother learned to make lei but remembers her being very meticulous about the process. "I realized how in sync she really was to everything. Even up to the moon. On full moon nights, she would go out and pluck all the big leaves off the tree."

"Every lei maker has their way, their style, and their protocols," Pūnua says about the kui technique she learned from her mom. "For my [mother's style], we use four or five strands of yarn. I feel like she used more, but I've tried to do it and it doesn't come out the same. And [all the flowers] were really close together. We don't just cut at the end of the ball. We cut in the middle."

Her family's lei-making tradition is being passed on through Pūnua's daughters, who help her kui lei that they sell by word of mouth, over social media, or at shops like Kealopiko, in Honolulu. "My daughter is a really good wili lei maker. She likes to make lei poʻo, and she is extremely creative," says Pūnua. Her daughter, Koʻiahi, learned to make the style from her kumu, Manu Boyd, but then took it to the next level through her observation skills. At age eleven, she decided to make a lei poʻo out of lehua mamo they had in their yard. "I was shocked because she did it pretty much all on her own," says Pūnua.

"I see the way she's kind of elevated her practice. She's so picky, so finicky, and she's very particular with certain materials. I really admire that in her because that's just kind of like a natural thing. It reminds me of my mom. But it's her. It's coming out through her in her own way."

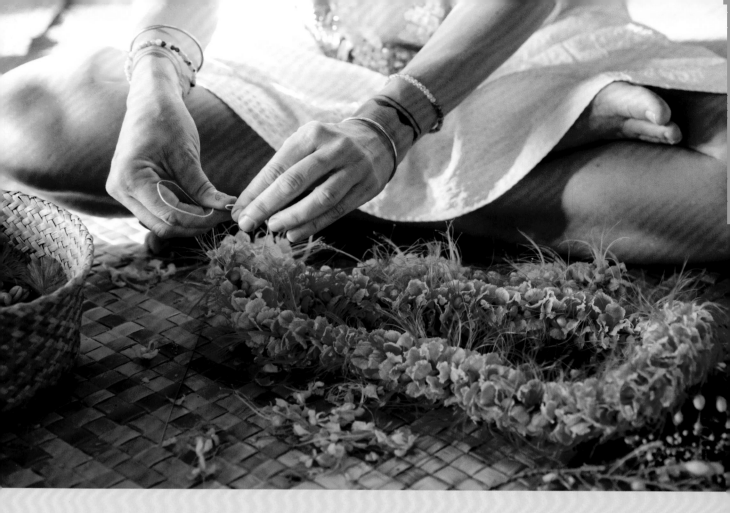

When travel was restricted in the early days of the pandemic, Pūnua, Iaukea, and their friends would take their daughters to surf after online school at Waikīkī Beach, which was almost entirely empty of tourists. For one of the girls' graduations, Iaukea brought her materials and the whole group spent the afternoon making lei. "It just turned into a beautiful afternoon of making lei [and] I told her, 'We've got to do this all the time,'" says Pūnua.

"I think it's [about] reclaiming spaces, and just doing what we normally do, without thinking. It's not a big deal to us. But it's everything for people who are visiting," Pūnua says about the response they received, noting one couple watched for the better part of an hour. The local families at the beach—some who had never made lei before—joined in. Some made plumeria, others more intricate strands of seeds, shells, and greens.

"I just like the idea that people make their own lei, as much as possible. I always tell people, I say, 'Make a lei.' Trying to make a lei for somebody is way better than going and buying a gift. It's as simple as that."

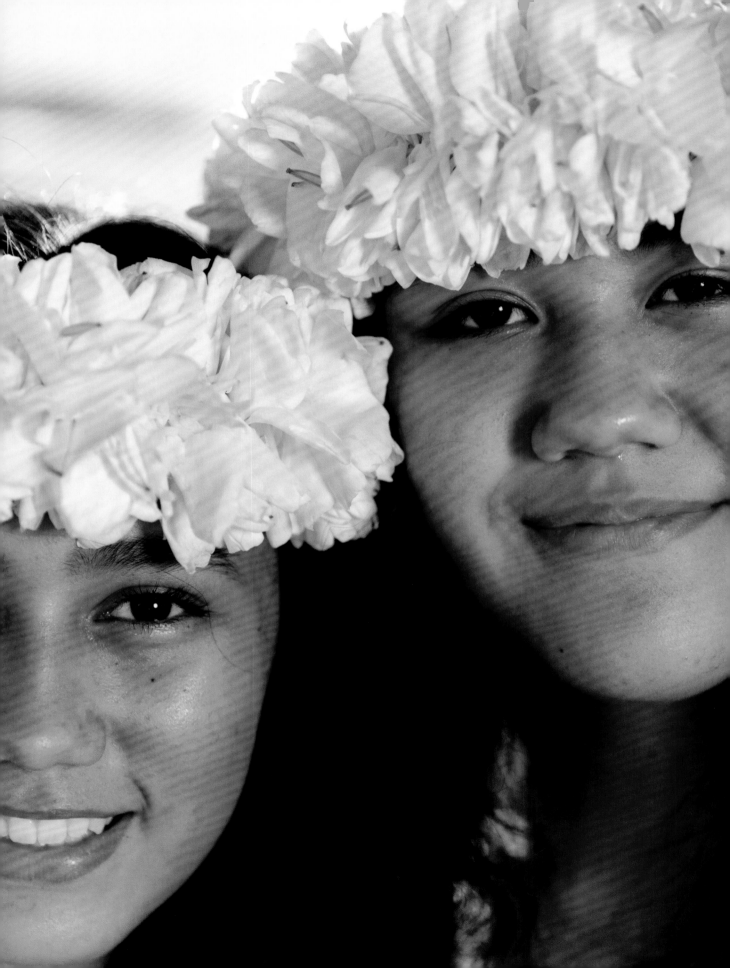

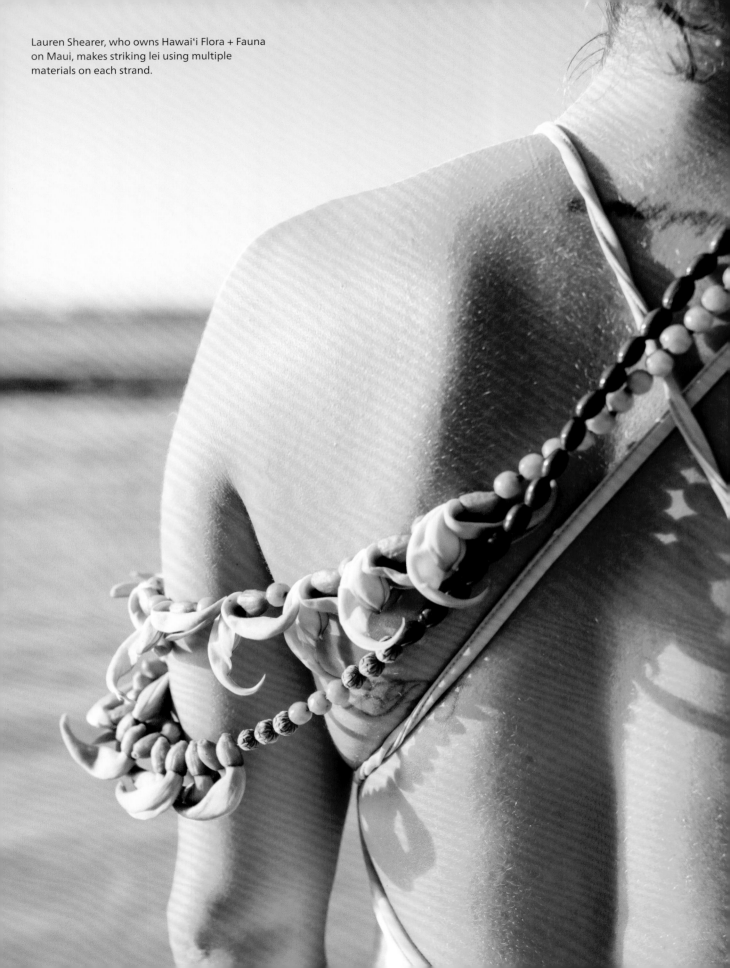

Lauren Shearer, who owns Hawai'i Flora + Fauna on Maui, makes striking lei using multiple materials on each strand.

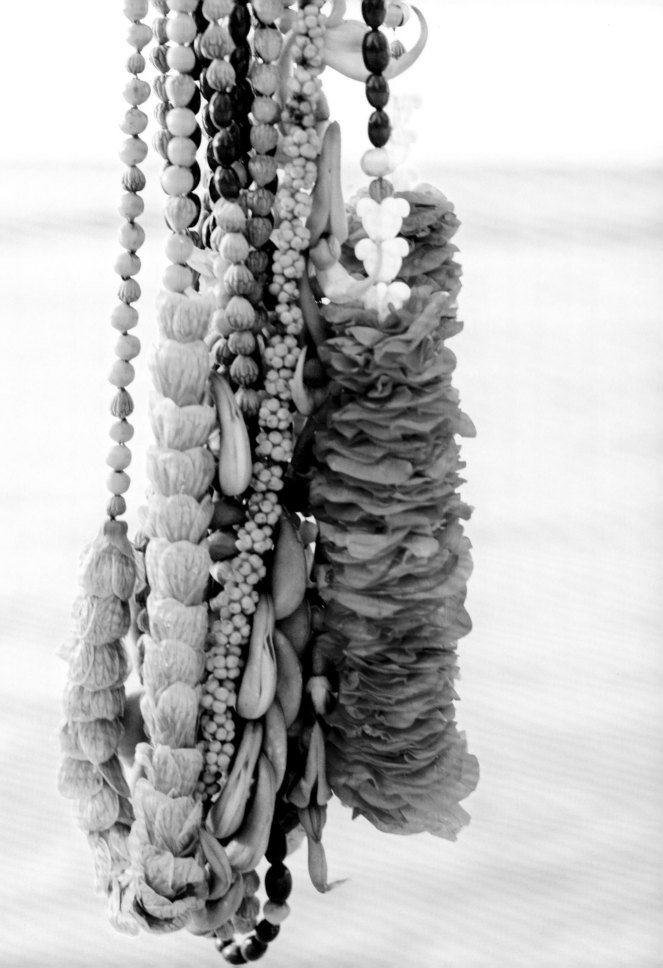

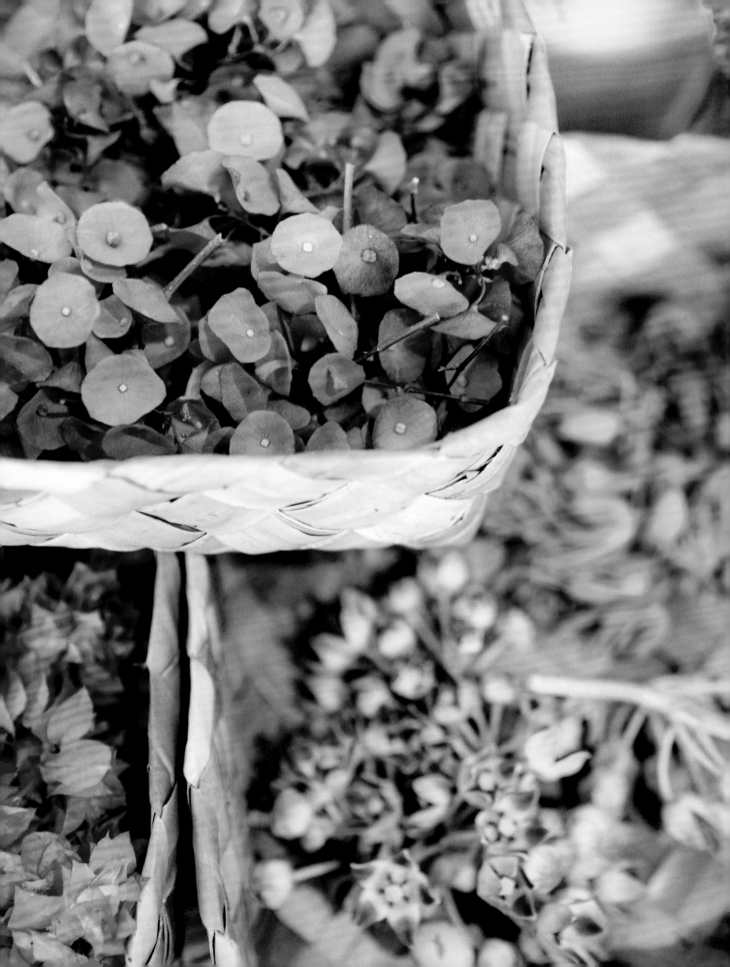

Lei Glossary

Hawaiian words often have multiple meanings. For translations in this book, we attempted to choose the best interpretation of a word for the context as it is used in each sentence, but please note that there might be more than one meaning for a word. Definitions for Hawaiian language terms used in this book are consistent with *The Hawaiian Dictionary* by Mary Kawena Pukui and Samuel H. Elbert unless noted otherwise. For further research, Ulukau, a Hawaiian electronic library, can search through the most widely used Hawaiian language dictionaries and other established resources simultaneously (wehewehe.org). Papakilo, another digital database, is also a great resource for further understanding of the Hawaiian language, history, and culture (papakilodatabase.com).

A note on spelling: To indicate pronunciation, many writers of the Hawaiian language use two marks, the ʻokina and the kahakō. The ʻokina, symbolized by the (ʻ), represents a glottal stop, a short break between vowels in speech and is considered to be the last letter in the Hawaiian alphabet. The kahakō, a horizontal line over a vowel (-), indicates the stressor or long syllable in a word or sentence.

For further information on lei in Hawaiʻi, these books are valuable references: *Niʻihau Shell Leis* by Linda Paik Moriarty; *Ka Lei: The Leis of Hawaii* by Marie A. McDonald; *Nā Lei Makamae: The Treasured Lei* by Marie A. McDonald and Paul R. Weissich.

Lei Terms

Haku: To braid or plait using two or more materials. Ti or native ferns often form the base of the braid while other materials are woven in.

Hili: To braid or plait using one material, as seen in lei made from fronds of palapalai, palaʻā, or kupukupu.

Hilo: To twist pieces together in a helix shape. Lei hilo is often made from maile, lāʻī (ti leaves), or kaunaʻoa.

Hīpuʻu (or kīpuʻu): To knot the lei material together, most often seen with kukui and ʻōlapa leaves.

Humupapa: To sew lei material to a backing, most frequently seen in lei hulu.

Kui: To sew or thread lei material together. In its classic garland form, the lei kui is perhaps the most recognizable and easiest to make style of lei, often seen with plumeria, pua kenikeni, crown flower, or ginger. You can kui almost anything, from seeds to petals of a flower stacked together.

Kui pololei: To sew with a needle and thread in a straight line (as opposed to being strung poepoe, in a rounded shape).

Kūpeʻe: A small lei worn around the wrist or ankle. Also a marine snail shell.

Lei ʻāʻī: A lei worn around the neck.

Lei hulu: A lei made from feathers, usually made in the humupapa style.

Lei poʻo: A lei worn around the head.

Lei pūpū: A lei made from shells. The most famous example is the lei pūpū o Niʻihau, in which the tiny shell is strung in an array of patterns and designs.

Poepoe: To make in a round shape, either by kui or wili. Many flowers can be used in a lei poepoe, including tuberose, plumeria, and tiaré.

Wili: In a lei-making context, *wili* refers to a style made by wrapping or winding material to a backing. Natural fibers, such as hau, raffia, or banana bark, are more traditional, but ribbon, string, or wire is also used.

Lei Lookbook

Any plant, flower, seed, shell, or even paper or cloth can be used in lei making, from native shrubs to introduced annuals. Here is a selection we have included in the book, but don't let this list limit your imagination. Because of the dangers of overforaging in Hawai'i's delicate ecosystems, growing a lei garden in your backyard is the best way to assure access to quality materials. If you're considering foraging in the wild, consult knowledgeable experts on protocols first. Remember to respect local laws, landowners, and communities, ask permission each time, use what's in abundance, and take only what you need.

'A'ali'i

This indigenous shrub can be found on all the islands and in a number of eco-systems, from sand dunes to mountain forests, but it prefers dry conditions. With shiny green leaves attached to a red stem, the plant most often grows as a shrub or small tree. Lei makers harvest the seedpods, colorful bundles in light green, pale pink, or burgundy red, to wili or string in a single-strand lei kui.

'Ākulikuli

This introduced succulent thrives in upland areas, like Waimea on the island of Hawai'i. Because the brightly colored buds open with exposure to heat and the sun, many growers pick the blossoms in the early morning or after sunset and store them in refrigeration for up to two weeks. Flower colors include pink, rose, orange, white, red, magenta, and yellow.

Anthurium

Native to Central and South America, anthurium were brought to Hawai'i by Samuel Mills Damon II in 1889, and have thrived under commercial cultivation. Horticulturists have developed hybrids in an array of colors from red to pink to green, mostly for the cut flower and indoor plant market, but also as ornamental pops of color for gardens. Their waxy spade-like blooms last for weeks, making them a favorite for arrangements, wreaths, and bouquets, but lei makers sometimes use them in lei po'o as well.

Bougainvillea

Native to Brazil, this tropical vine grows well in Hawai'i's hot, dry areas. Often used in landscaping for hedges and ground cover shrubs, the resilient plant can also be trained to grow in a pot. It blooms year-round in an array of bright colors, from deep purples, pinks, light reds, magentas, whites, and oranges, a boon for lei makers looking for a pop of color in the winter. The colorful part of the plant is the bract, which protects the small, true-white flower.

Bozu

Also known as globe amaranth, this brightly colored annual is best cultivated from seed in gardens. The spiky flower balls of purple, pink, and white keep after harvesting for seven to ten days and dry nicely, making them a favorite filler for lei wili makers. Sometimes the flowers will be sewn in a round style for a garland lei (kui poepoe).

Carnation

Brought by missionaries in the 1850s, this introduced flower called ponimō'ī in Hawaiian became one of the major flower crops in Hawai'i, with more than eighty growers selling more than two million flowers a year in the 1950s. Rising land prices and development have forced growers to close or sell their farms, and many of the carnations used in lei today are imported, though a handful of growers still exist. A thick double carnation lei is sometimes called an "Ariyoshi Carnation," after Governor George Ariyoshi, who popularized wearing it in the 1980s.

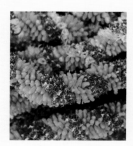

Cigar Flower

Known as pua kīkā in Hawaiian, this Mexican shrub has tiny tube-like blooms, most commonly in orange. Lei makers painstakingly kui poepoe hundreds of the cigar-like flowers into a single lei, which can be found frequently for sale in Chinatown lei shop refrigerators.

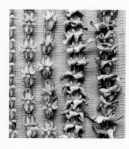

Crown Flower

In both white and dusky purple this member of the milkweed family is a hearty perennial that favors dry, hot habitats and makes a striking ornamental plant. The sap-filled leaves are toxic to humans, but a big draw for monarch butterflies and caterpillars that love to eat them. The sturdy purple flowers, or pua kalaunu, were said to be a favorite of Queen Lili'uokalani's; she praised them for their shape and soft scent and kept them in her lei garden. Lei makers often take apart the flower to string in array of patterns.

Cup and Saucer Vine

Originally from India, this introduced perennial is a member of the mint family. The flower is made up of a saucer-shaped calyx, with a small tubular flower sitting on top, and is often used as a beautiful accent in lei wili.

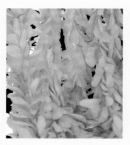

Ginger (Yellow and White)

Originating in Asia, these highly invasive plants were brought to the islands in the mid-nineteenth century by Chinese immigrants and quickly became adopted by the lei community. Thriving in wet, cool areas, the sturdy green stalks bloom with delicate, easily bruised but enchantingly perfumed flowers. Ginger can be strung in a single strand, doubled up for volume, or strung poepoe for maximum effect. Micronesian-style ginger is woven with ribbon into an intricate pattern.

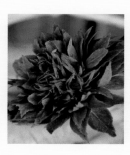

Green Rose

This introduced perennial is a classic in a lei maker's garden. The dusky green bloom only looks like a rose if you squint, but is a variety of the common lokelani rose. Its unique petals are serrated, green, leaflike blades, which make for a striking textural accent in lei haku.

Hala

This indigenous Pandanus tree is deeply important to Hawaiians. The leaves of the coastal, low-elevation plant are dried and woven into mats, sails, and hats, often adorned with lei. The edible fruits come in a range of reds, oranges, and yellows, and when strung on a lei, because the word *hala* means "to pass," are used to celebrate transitions such as promotions, graduations, funerals, and new beginnings.

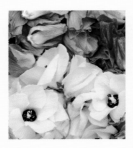

Hau

Growing along the coastline and wet areas, this oval-leafed shrub is a member of the hibiscus family. For a lei maker, the plant offers many options: bark peeled from the wood may be used as backing or wrapping material for lei wili, the leaves can be knotted in the hīpu'u style or braided into lei haku, and the sunny yellow flowers, which turn into a dusky red-purple after they are picked, can be made into lei kui.

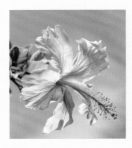

Hibiscus

Hawai'i is home to a number of varieties of the hibiscus, coming in colors like white, orange, and red; the endemic and endangered ma'o hau hele has been the state's official flower since 1988. But horticulturists and home gardeners have also had great success in crossbreeding and experimenting with non-native varieties. The delicate flowers wilt quickly, but some lei makers like to use the full blooms in lei po'o.

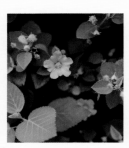

'Ilima

This indigenous member of the hibiscus family can be found at all elevations in Hawai'i but thrives in coastal and dry areas. A single-strand lei requires hundreds of the shrub's paper-thin blossoms to be harvested. Highly valued by early Hawaiians, the beautifully textured lei is often associated with royalty and worn at weddings.

Kauna'oa

The designated flower of the island of Lāna'i, kauna'oa is a native Hawaiian species of dodder. Because it has no leaves and produces no chlorophyll on its own, it must attach itself to other plants to survive. Found most often in dry arid coastal regions atop plants like pōhuehue, the tangled yellow strands can be fashioned into lei hilo or used as accents in lei wili or lei haku.

Kīkānia

Though this introduced perennial could be considered a weed, the bright orange fruits from the kīkānia plant make a striking and distinct lei kui. All parts of the plant, which is native to Brazil, are considered poisonous, especially the fruit.

Koa

This majestic endemic hardwood tree can be found in a wide range of elevations in wet and moderately-dry forests, with a canopy that towers above other trees. The hardwood is prized in woodworking; an entire canoe can be carved from a larger tree. The phyllodes' striking sickle shape make beautiful lei haku or lei wili and may be used to decorate the kuahu at the hālau hula.

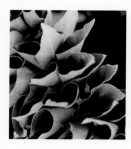

Kukui

One of the canoe plants brought to the Hawaiian islands by early Polynesian settlers, the kukui is endlessly versatile. The nuts can be harvested for oil or used to dye textiles or used in lei. The distinctive pale foliage comes in a variety of shapes and work well in lei haku or knotted together in the hīpuʻu style.

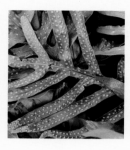

Lauaʻe

The native lauaʻe fern, also known as peʻahi, is rare but can be found in wet, cool forests. A weather-tolerant introduced fern also bears the name lauaʻe, and grows in a wider array of climates throughout the islands. When using the common lauaʻe to make a lei haku, some lei makers prefer picking the younger leaves without spores, while others appreciate the texture and color contrast. Lei lauaʻe are a staple of both hula and ocean sport celebrations.

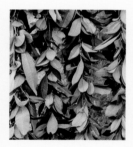

Maile

With beautifully scented dark green glossy leaves, this endemic vine can be found in the forests on all islands. All parts o the plant contain coumarin, which is responsible for he distinct fragrance. Most maile production for lei sales is foraged, but a few growers from the island of Hawaiʻi are experimenting with growing the woody vine in greenhouses. Lei maile is often used in ceremonies, including weddings, blessings, and graduations.

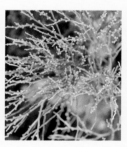

Moa

This gangly indigenous perennial has no roots or leaves but has spores held in the distinctive yellow balls on the stem. It can be cultivated in pots, though it often sprouts up on its own in cracks in the sidewalk or rock walls. The green stems with yellow nodes make a beautiful textural accent in lei poʻo. The name, which means "chicken" in Hawaiian, reflects how the smooth stems when held upside down resemble chicken feet.

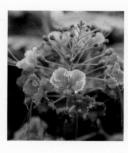

ʻOhai Aliʻi

Thought to be native to South America, this shrub or tree with lacy green leaves, also known as dwarf poinciana, thrives in arid, coastal regions in Hawaiʻi. The seasonal orange, red, pink, and yellow blooms can be sewn into lush lei poepoe, or used as an accent in lei poʻo.

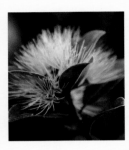

'Ōhi'a Lehua

An endemic plant that can be found at all elevations on six islands, the 'ōhi'a lehua is a critical part of the ecosystem. One of the first plants to grow on lava fields, the 'ōhi'a lehua root system helps convert lava rock into soil, allowing other plants to take hold. Covered in moss with aerial roots, the tree helps capture mist and rain, gently allowing the water to soak into the ground, feeding the aquifer. Lei makers treasure the brightly colored pom-pom–like blossoms in red, yellow, and orange, and the liko, the young leaves.

'Ōlapa

Sharing the Hawaiian word for *dancer*, the round or oval-shaped leaves of this endemic plant are said to look like they dance when the wind blows. Found in wet forest land, the plant has blue-black fruits that are used to dye cloth, but it is the leaves that are more traditionally used in lei making for hula, often in the hīpu'u style, in which the stems are knotted together to make a chain.

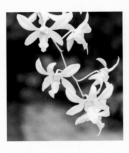

Orchid

Orchids are the largest flowering plant family in the world, and all types are popular in Hawai'i. Though the ubiquitous purple Dendrobium orchid lei and many of its cousins are often imported from Thailand or the Philippines, there are a number of orchids grown locally that work well for lei, including Cymbidium, Epidendrum, and Vanda. Orchids may be strung kui style or used as accents in lei haku.

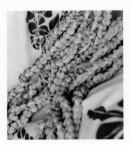

Pakalana

Pakalana, a delicate lime green flower from the milkweed family with roots in Asia, was likely introduced to the islands by Chinese immigrants. Prized for its beautiful scent, Hawaiian lei makers quickly adopted the flower. Because of its small, delicate bud and short late-summer growing season, it's often associated with special occasions and sewn in single strands that can be combined or twisted for a fuller look or wrapped around another lei, like pīkake or maile, for accent.

Palapalai

This indigenous fern can be found throughout the Hawaiian islands, where it thrives in cool, wooded mountain forests, often growing around the base of shade trees. As one of the plants associated with the goddess Laka, the plant is deeply important to hula practitioners, who use the lush green frond to decorate the kuahu and fashion them into lei. In recent years there has been a concerted effort to cultivate the plant in gardens to avoid overharvesting in the wild.

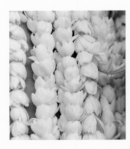

Pīkake

This sweetly perfumed Indonesian or Chinese strain of jasmine was likely brought to the islands by Chinese immigrants around the turn of the twentieth century. The small white buds quickly caught on, becoming a favorite of Princess Ka'iulani's. Today pīkake is often given as a special-occasion lei with peak flowering season running from March through September.

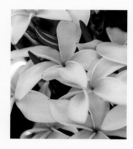

Plumeria

Endemic to Mexico, Central America, and the Caribbean, the flower was first brought to the islands by German physician Dr. William Hillebrand in 1860, where it quickly thrived in the warm, temperate climate. There are more than four hundred different varieties grown today, from the classic yellow and white "Singapore" or "Graveyard" flower (so named because it was commonly planted in graveyards) to the deep red "Hilo Beauty," and rainbow "Kaneohe Sunrise."

Pōhinahina

This indigenous coastal crawler with a spicy scent can be found on sand dunes and rocky coastlines throughout the Pacific but is also easy to cultivate. Both the leaves and the beautiful purple flowers can be used in lei making.

Pua kenikeni

Found throughout the Pacific, pua kenikeni is thought to have first arrived in Hawai'i prior to 1900. Locals quickly came to covet the heavily fragrant waxy yellow blooms for lei, earning the plant its name, which translates to "ten-cent flower." The tree or shrub can be found growing across the islands, from beaches to valleys, but prefers warm areas with a mix of sun and rain. While it can grow into a shade tree, most home growers trim the plant into a shrub or hedge to be able to pick the flowers for lei.

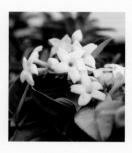

Stephanotis

Stephanotis, native to Madagascar, is a sturdy vine with a fragrant, waxy flower that tends to bloom best in spring and early summer but can be found all year round in the islands. The climbing vine thrives on fences and trellises but can also be potted. Its beautiful perfume, bright color, and abundance makes stephanotis a favorite in wedding lei po'o, though it is frequently found in lei kui as well.

Ti

With a spindly stalk topped with a shock of long, glossy leaves, the ti (or kī or lā'ī in Hawaiian) plant provides an abundant source of lei material all year long. One of the canoe plants brought to the islands by early Polynesian settlers, the versatile plant was used for medicine, clothing, and food preparation. The long leaves, sometimes called lā'ī, offer lei makers an array of different colors, including greens, reds, and pinks. Even the yellowing and browning leaves can be used in lei either for their color or for the core braid of the haku style.

Tuberose

Often strung with carnation, rose, or lantern 'ilima, this waxy, white flower has become one of the most popular choices for commercial lei makers because of its sweet scent and longevity once cut. Thought to be native to Mexico, the flower can be found throughout the world, from France to Japan. In Hawai'i, the sturdy member of the agave family thrives in hot, dry areas and is a favorite in local gardens.

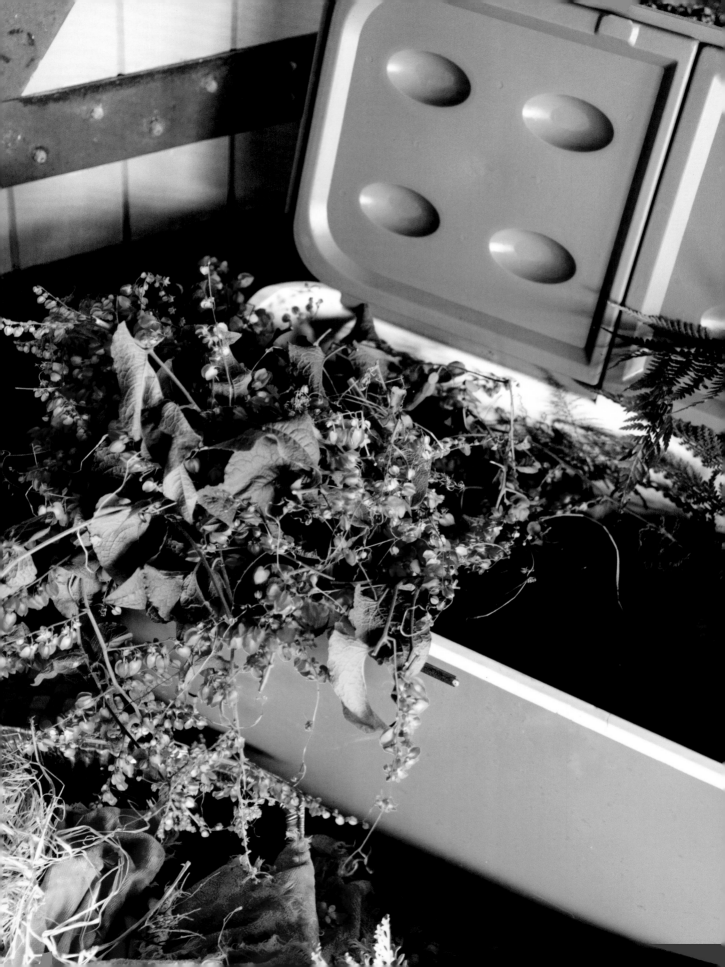

Source Book

For lei, floral arrangements, and lei workshops

Ah Lan's Lei Stand
Hilo International Airport
2450 Kekuanaoa Street
Hilo, HI 96720
ahlansleistand.com

Amanda Iaukea at Live a Lei Life
@ *live_a_lei_life (Instagram)*

Big Island Maile
davidmiranda7.wixsite.com/maile

Cindy's Lei Shoppe
1034 Maunakea Street
Honolulu, HI 96817
cindysleishoppe.com

**Daniel K. Inouye International
Airport lei stands**
300 Rodgers Boulevard
Honolulu, HI 96819

Green Point Nurseries
811 Kealakai Street
Hilo, HI 96720
greenpointnursery.com

HakuLeilani
hakuleilani.com

Hawaii Flora + Fauna
870 Haliimaile Road
Makawao, HI 96768
hawaiiflorafauna.com

Hele Mele Botanicals
helemelebotanicals.com

The Kaimukī Lei Stand
@*thekaimukileistand (Instagram)*

Kuana Torres-Kahele
kuanatorreskahele.com

Lei By Dillyn
leibydyllin.com

Leis By Leilani
leisbyleilani.com

Lin's Lei Shop
1017 Maunakea Street, A
Honolulu, HI 96817
linsleishop.com
hichinatown.com

Maui Floral
198 Makani Road
Makawao, HI 96768
mauifloral.com

Mei Day
meidayflora.com

Molokai Plumeria
1342 Mauna Loa Highway
Kaunakakai, HI 96748
molokaiplumerias.com

**Nā Lei Hala, Kumu Ipolani
Vaughan**
@*ipolaniv (Instagram)*

Nita's Leis and Flower Shoppe
59 North Beretania Street
Honolulu, HI 96817

Ocean Dreamer Floral Artistry
oceandreamerhawaii.com

'Ohana Shop
ohanashopkauai.com

Paiko
675 Auahi Street, Suite 127
Honolulu, HI 96813
paikohawaii.com

Pohākea Country Farms
Kamuela, HI 96743
@*pohakeacountryfarms (Instagram)*

The Pua Bar
3-2087 Kaumualii Highway
Lihue, HI 96766
thepuabar.com

Pua Hana Flower & Lei
3434 Waialae Avenue, #2
Honolulu, HI 96816
puahanahawaii.com

Watanabe Floral, Inc.
1618 N. Nimitz Highway
Honolulu, HI 96817
watanabefloral.com

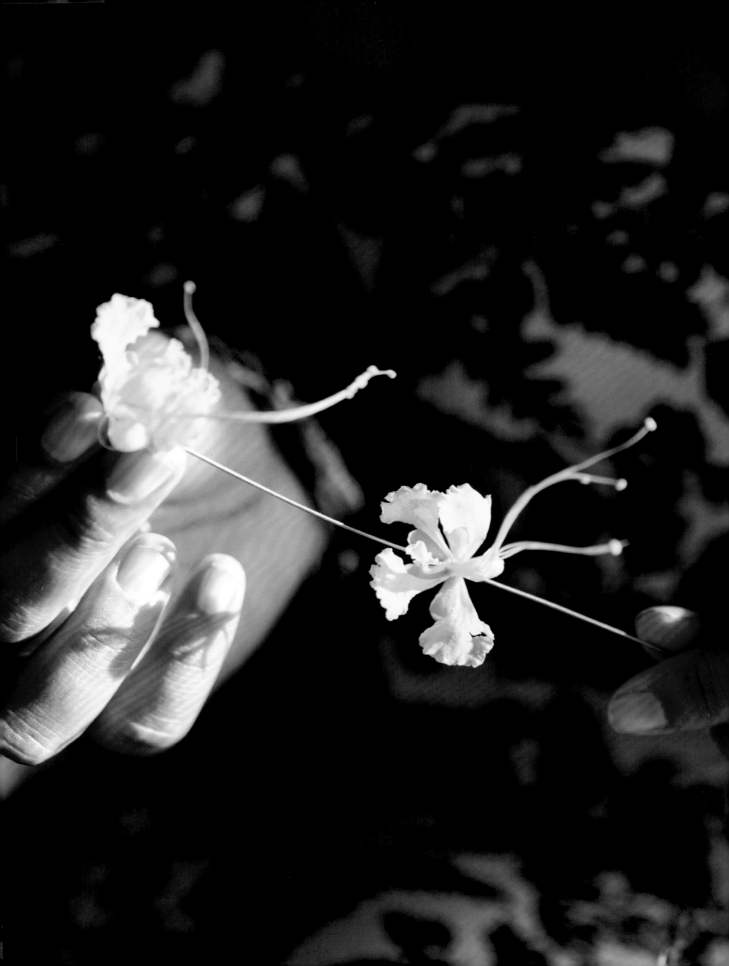

Lei Makers

Amanda Iaukea (Live a Lei Life): white ginger and shell lei (vi–vii, xii, 206, 208, 209); lei poʻo (75); rose petal lei (211, 216); lei ʻohai aliʻi (220); lei poʻo of white ginger (221)

Anne Sato: lei poʻo (i, 133, 138)

Ānuenue Pūnua: lei poʻo (56, 59, 74)

Betty Ikehara: lei poʻo (37, 49, 131)

Cecily Kaiu: tiaré lei (4)

Cee Cee Simmons: hydrangea wreath (144)

Cindy's Lei Shoppe: lei pakalana (ix, 184, 186, 188, 190); lei maile (ix, 184, 186–187, 188, 189, 190, 194, 201); lei pīkake (ix, 184, 187, 188, 191, 194, 201); white ginger lei (36, 37, 39, 42–43, 45, 50); lei assortment (104); lei kukunaokalā (107); cigar lei (115); orchid lei (119)

Dillyn Kiana Lietzke (Lei By Dillyn): crown flower lei (19, 20, 23)

Gina Davidson: wreath (158)

Hālau Hula Ka Lehua Tuahine: lei ʻāʻī of palapalai and ʻaʻaliʻi (78, 82, 85); lei poʻo of palapalai (78, 82, 85, 87, 103)

Hālau Mōhala ʻIlima: lei ʻāʻī (93); lei poʻo (93)

Iliahi Anthony: lei haku of koa and kukui (91, 102)

Kasi Hara: lei poʻo (i, 128)

Kea Keolanui: horse lei (99)

Koby Berrington: lei poʻo (i, 120, 138, 139); lei pāpale (126)

Koʻiahi Pūnua: lei hīpuʻu (56, 64); lei poʻo (72, 62, 70)

Koral Chandler: lei hilo of ti (174); lei haku of ti (176, 177, 183)

Kuhaoimaikalani "Kuhao" Zane: lei haku of koa and kukui (80–81, 84, 85)

Kūlaʻilaʻi Pūnua: lei hau (56, 59, 71, 74)

Lauren Hewett Caldiero: wreath (142–143)

Lauren Shearer (Hawaiʻi Flora + Fauna): lei ʻāʻī (98, 101); lantern ʻilima and seed lei (218, 223); jade and seed lei (222, 223)

Leilani Pearson (HakuLeilani): lei haku of jade (8, 209, 218); lei haku of koa (8, 209, 210); lei haku of shell ginger (8, 218)

Lin's Lei Shop: lei assortment (111); carnation lei (115); lei ʻilima (193)

Maʻaloa Pūnua: lei hau (56, 59, 71, 74); lei pōhuehue (66, 67)

Mary Moriarty (Hele Mele Botanicals): lei humupapa of pink and red torch ginger (202, 208, 214)

Mehana Vaughan: pūʻolo (52, 53); lei haku (152)

Meleana Estes: lei poʻo (i, 130, 136–137, 138); green and white lei poʻo (ix, 196); lei haku of ti (7); lei poʻo of ti (7, 160, 170, 171, 175); lei pua kenikeni (22); lei poepoe of pua kenikeni (27); table lei (30, 32–33, 40, 55); plumeria chandelier (47); lei hilo of kaunaʻoa (63); lei poʻo (75); table haku (153, 154); lei poʻo coastal (167, 178); kāhili (191, 200)

Molokai Plumerias: lei poepoe of pua melia (10, 14)

Nita's Lei and Flower Shoppe: yellow ginger lei (39)

Pamakani Pico (Ocean Dreamer Floral Artistry): lei poʻo (213, 214); lei ʻāʻī of ti leaf rosettes (213, 216)

Pauline and Speedy Bailey: lei pua kenikeni (ii, 3, 17)

Pōhakea Country Farms: lei ʻākulikuli (x–xi, 110)

Punahele Dawson: lei poʻo (97); lei ʻāʻī of ʻōhiʻa lehua (97)

Tamra Rigney (Mei Day): flower arrangement (210)

Acknowledgments

This book is a lei woven of manaʻo shared generously with us by those we were so blessed to spend time with and interview. We marvel at their lives of lei and their precious gifts which have made Lei Aloha a collective effort to illuminate a treasured pastime in our culture.

Those we were so privileged to interview include: Keane Akao, Iliahi Anthony, Nakeʻu Awai, Beryl Bailey Blaich, Speedy Bailey, Ane Bakutis, Koby Berrington, Jennifer Binney, Lita Blankenfeld, Manu Boyd, Lauren Caldiero, Robert Cazimero, Koral Chandler, Gina Davidson, Māpuana de Silva, Kasi Hara, Shannon Hiramoto, Buzzy Histo, Dale Hope, Roen McDonald Hufford, Leilani Huggins, Amanda Iaukea, Koi Iaukea, Wahineʻaukai Iaukea, Betty Ikehara, Malia Kaʻaihue, Anne Kadowaki, Cecily Kaiu, Malia Kaleopaʻa, Kimo Keaulana, Kea Keolanui, Karen Lau Lee, Danene Lunn, Maile Meyer, David Miranda, Leimoni Miyahana, Mary Moriarty, Malia Nobrega-Olivera, Leilani Pearson, Pamakani Pico, Ānuenue Pūnua, Koʻiahi Pūnua, Kūlaʻilaʻi Pūnua, Maʻaloa Pūnua, Ann Sato, Cee Cee Simmons, Mihana Souza, Conne Sutherland, Kuana Torres-Kahele, Ka Lehua Tuahine, Leilehua Utu, Ipolani Vaughan, Kilipaki Vaughan, Mehana Vaughan, Kaʻilihiwa Vaughan-Darval, Makamae Williams, Carver Wilson, Lauliʻa Ah Wong, and Kuhaoimaikalani Zane.

A huge mahalo to my team at Ten Speed Press for helping these stories come to life. To my editor, Dervla Kelly, and art director Emma Campion, thank you for trusting Hawaiʻi's story of lei and giving us the opportunity to share it with the world. Your respect and admiration for Hawaiʻi's culture mixed with your creative genius helped bring this book into fruition. To my production editor Sohayla Farman, copyeditor Nancy Bailey, proofreader Lorie Young, and cold reader Sarah Etinas; the extra care and effort you took with this project shines.

Mahalo to my Hawaiʻi team, including my brilliant writing partner, Jenny Fiedler, who brought the stories in this book together in the most beautiful way, and to our photographer Tara Rock, who uncovered timeless magic in every shot.

To my agent, Laura Lee Mattingly, who helped set me on this path with enthusiasm, encouragement, and discernment at all the perfect moments.

Mahalo to those who contributed their loving presence and shared their kōkua and hospitality: Tamarah Binek, Heidi Bornhorst, Legend Chandler, Moku Chandler, the lei makers of Cindy's Lei Shoppe, Keānuenue DeSoto, Puamakamae DeSoto, Capucine Esguerra, Josie Esguerra, Tiana Gamble, Kate Growney, Hālau Hula Ka Lehua Tuahine, Eva Hand, Rosie Jaffurs, Kelis Kaleopaʻa, Cheyenne Kanani, Kai Malik Kandell, Nanialiʻi Welch Keliʻihoʻomalu, Cathee Kukea, Ciara Lacy, the lei makers of Lin's Lei Shop, Chelsea Loeffler, Jyoti Mau, Aʻima McManus of Puamana, Judy Pietsch, Mike Pietsch, Sara Saffery, Eliza Shaw, Nancy Shaw, Lauren Shearer, Patsy Wilcox Sheehan, Mahina Souza of Puamana, Tyler Rock, Catherine St. Germans, Maggie Twigg-Smith, Timmy Twigg-Smith, Anaualeikūpuna Vaughan, Piʻinae Malina Vaughan, Carol Wilcox, Tanya Winter, Keiki Worthington, and Mataariʻi Worthington.

Deep gratitude for photo contributions from Mike Coots, Bruce Omori, and Crystal Thornburg-Homcy to help complete this story. To Lāiana Kanoa-Wong, Kilinahe Coleman, Holo Hoopai, and Jane Beachy, your combined expertise of ʻōlelo Hawaiʻi and plants of Hawaiʻi were an invaluable reference.

Thank you to my endlessly supportive husband, Will, who is always game for an airport flower pickup, a late-night tree raid, packing and unloading the trunk of my car repeatedly, but most of all, for devoting extra love and energy to our son, Kaiea, when I am on the go.

To Kaiea, whose observations, sense of humor, and sweetness fuel me.

To Pilipaʻa, whose strength and love grounded me in the last phases of making this book.

To my mom, whose taste and creativity anchor and inspire me.

A special mahalo to my sister, Mehana, whose memories, manaʻo, and shared love of lei—inherited from our tūtū—helped tell this story.

And finally to the lei makers, lei students, and lei lovers of Hawaiʻi and beyond who help keep our beautiful tradition of lei aloha alive.

Index

For a list of lei shops and lei makers based online and in Hawai'i refer to the Source Book on page 233. For an index of the lei makers featured and photographed in this book refer to the Lei Makers on page 235.

Text copyright © 2023 by Meleana Estes with Jennifer Fiedler
Photographs copyright © 2023 by Tara Rock

Photographs copyright © by Mike Coots: pages 52, 53
Photographs copyright © by Bruce Omori: pages 85 (bottom), 87 (bottom), 93 (bottom)
Photographs copyright © by Crystal Thornburg-Homcy: page 115 (top left and bottom right)
Photograph copyright © by youli (Adobe Stock Images): page 230 (ʻŌlapa)

All rights reserved.
Published in the United States by Ten Speed Press, an imprint of Random House,
a division of Penguin Random House LLC, New York.
TenSpeed.com
RandomHouseBooks.com

Ten Speed Press and the Ten Speed Press colophon are registered trademarks
of Penguin Random House LLC.

Typefaces: Latinotype's Apparel, Monotype's Neue Frutiger World, and VJ-Type's Dahlia

Library of Congress Cataloging-in-Publication Data is on file with the publisher.
Library of Congress Control Number: 2022040044

Hardcover ISBN: 978-1-9848-6089-7
eBook ISBN: 978-1-9848-6090-3

Printed in China

Editor: Dervla Kelly | Production editor: Sohayla Farman | Editorial assistant: Zoey Brandt
Designer: Emma Campion | Production designers: Mari Gill, Faith Hague, and Claudia Sanchez
Production manager: Dan Myers | Prepress color manager: Jane Chinn
Copyeditor: Nancy N. Bailey | Proofreader: Lorie Young | Cold reader: Sarah Etinas
Indexer: Ken DellaPenta
Publicist: Jana Branson | Marketer: Chloe Aryeh

10 9 8 7 6 5 4 3 2 1

First Edition

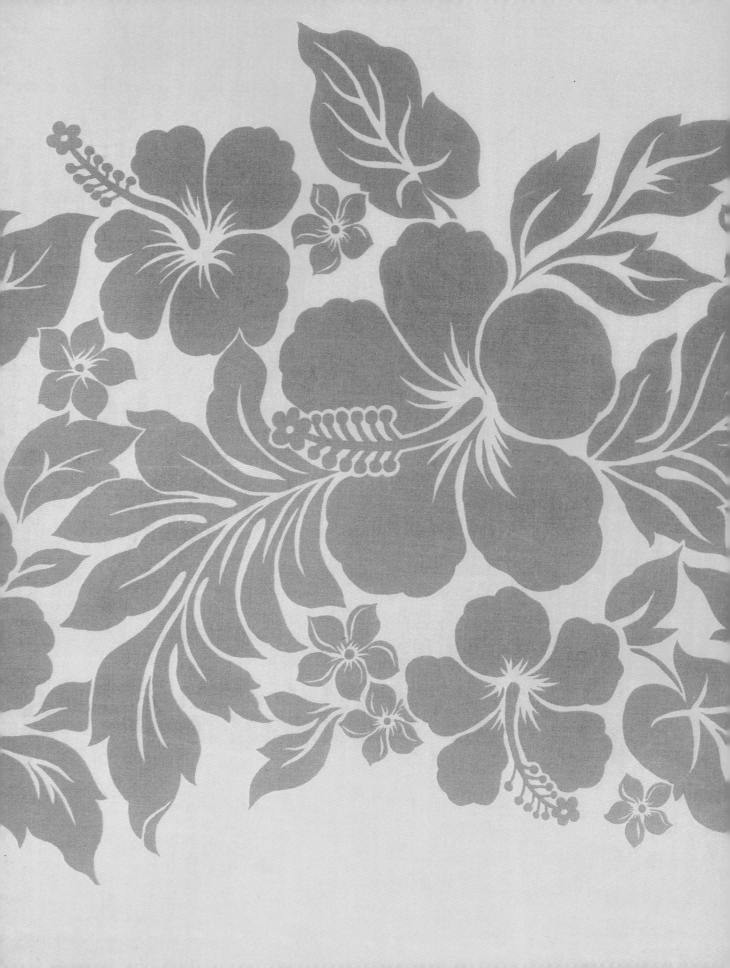